Jane's Window

Number Fourteen:
Clayton Wheat Williams
Texas Life Series

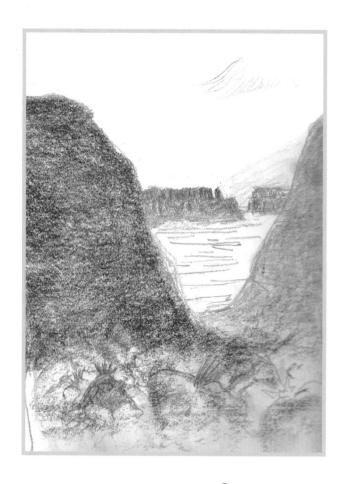

J.D.F
2013

Jane's Window

My Spirited Life in West Texas and Austin

Jane Dunn Sibley
as told to Jim Comer

Foreword by T. R. Fehrenbach
Introduction by James L. Haley

TEXAS A&M UNIVERSITY PRESS
College Station

This paper meets the requirements of ANSI/NISO Z39.48-1992
(Permanence of Paper).
Binding materials were chosen for their durability.

Frontispiece: *Jane's Window*, pencil sketch by author

LIBRARY OF CONGRESS CATALOGING-IN-PUBLICATION DATA

Sibley, Jane Dunn, 1924–
Jane's window : my spirited life in West Texas and Austin /
by Jane Dunn Sibley as told to Jim Comer ;
foreword by T.R. Fehrenbach ; introduction by James L. Haley. — 1st ed.
p. cm. — (Clayton Wheat Williams Texas life series ; no. 14)
Includes index.
ISBN-13: 978-1-60344-802-4 (cloth : alk. paper)
ISBN-10: 1-60344-802-0 (cloth : alk. paper)
ISBN-13: 978-1-60344-979-3 (e-book)
ISBN-10: 1-60344-979-5 (e-book)
1. Sibley, Jane Dunn, 1924– 2. Women music patrons — Texas — Austin —
Biography. 3. Music patrons — Texas — Austin — Biography. 4. Women
philanthropists — Texas — Austin — Biography. 5. Philanthropists —
Texas — Austin — Biography. 6. Austin (Tex.) — Biography. 7. Fort Stockton
(Tex.) — Biography. I. Comer, Jim, 1944– II. Title.
III. Series: Clayton Wheat Williams Texas life series ; no. 14.
F394.A953S53 2013
976.4'063092 — dc23
[B]
2012034310

To my grandchildren:

Shiloh Jane Sibley-Cutforth,
Rachel Anne Sibley,
Kiowa Sehoy Sibley-Cutforth,
Sarah Elaine Sibley,
Christopher Michael Sibley,
and
Elizabeth Victoria Sibley

Contents

Foreword

Jane Sibley is indeed like no other.

Nor is this memoir. It is hopefully a work of literature, but it is also a significant history of times and places and people too little recorded or remembered in a Texas that has changed within her lifetime from a rural state to a crowded urban one. People, places, things—Jane has seen a great deal and has penned it with a native Texas ability to combine keen intelligence untrammeled by conceptual notions.

If you knew the Sibleys you will find this book entertaining. As an historian of Texas, I found it fascinating. But if you know neither the land nor the people, I think you will discover the world of Jane Sibley is a part of Texana you will not forget.

T. R. Fehrenbach

Introduction

Late in 2008 I was working hard against a deadline to finish my biography of Jack London. I came home one day to find a telephone message from Jane Dunn Sibley, asking me to call her regarding a memoir she was writing. I had met Mrs. Sibley several months before when I gave a talk about the arts in Texas history to an Art League gathering. Having lived in Austin for thirty years, I was familiar with her elegant countenance from the society pages of the local newspaper, and being a fan of the Austin Symphony, I knew that she had been president of the Symphony's Board of Directors for twenty-five years.

I had been asked over the years to edit family memoirs at various times, but had always declined, citing the lack of commercial viability in such books, be they ever so well written. Using my Jack London manuscript's due date and the approaching holidays, I asked if we might defer the matter for a bit.

Mrs. Sibley contacted me again after the New Year had begun. I was somewhat surprised by her persistence; we met, and I took away the manuscript of her book. Once I began reading it, I was rather surprised that it was not just good, but it reminded me in many respects of its literary predecessors from earlier in Texas history. When I was writing my biography of Sam Houston, the most fascinating tidbits that I found about him were not in his papers or in the existing biographies, but in the vignettes of him contained in personal and civic memoirs of others, from Judge Guild's "Old Times in Tennessee" to Noah Smithwick's "Evolution of a State" about frontier Texas. Such personal recollections are not often published any more because it is no longer profitable to market them, and it is sad that society is no longer as literate or as curious as it once was. Beyond that, we seem to feel that the nineteenth century was worth recording because something that happened so long ago must be "history," while discounting more recent events.

However, I found Mrs. Sibley's reminiscences of West Texas during

the Great Depression and World War II to be moving and meaningful. I have spent a good deal of time in Texas history, and here she was, describing some aspects of those times that were new to me. Contained within the memoir she explored her encounters with astronauts and movie stars, politicians and philanthropists—many of them front-rank names in Texas and American history—first-person encounters that would never be recorded elsewhere.

Her recollections of important Texas icons such as Lady Bird Johnson and Miss Ima Hogg add to the historical record in the same way that Guild and Smithwick did. And here and there, unexpectedly, her no-nonsense West Texas sense of the absurd would strike like desert lightning and I would find myself laughing out loud.

Equally striking was the portrait I was left with of Jane Sibley herself, a lady who embraces her roots even as she has transcended her background. Through hard work, good sense, and some good luck she rose to social prominence, even as she not only survived, but grew from personal tragedies that would have crushed most people. Ultimately hers is an inspirational story, one that deserves an honored place in Texas letters.

James L. Haley

Jane's Window

FAMILY TREE

Milligan Family Tree

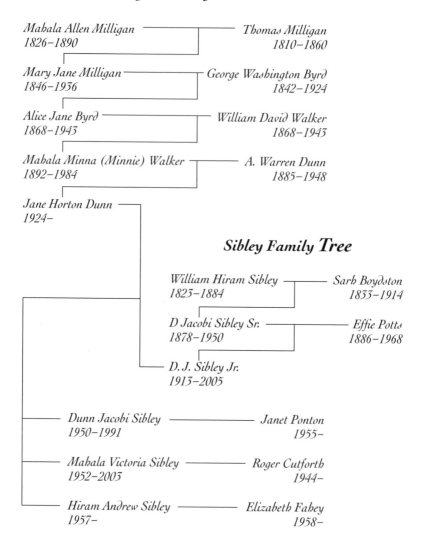

Mahala Allen Milligan
1826–1890

Thomas Milligan
1810–1860

Mary Jane Milligan
1846–1936

George Washington Byrd
1842–1924

Alice Jane Byrd
1868–1943

William David Walker
1868–1943

Mahala Minna (Minnie) Walker
1892–1984

A. Warren Dunn
1885–1948

Jane Horton Dunn
1924–

Sibley Family Tree

William Hiram Sibley
1823–1884

Sarh Boydston
1833–1914

D Jacobi Sibley Sr.
1878–1950

Effie Potts
1886–1968

D. J. Sibley Jr.
1913–2005

Dunn Jacobi Sibley
1950–1991

Janet Ponton
1955–

Mahala Victoria Sibley
1952–2003

Roger Cutforth
1944–

Hiram Andrew Sibley
1957–

Elizabeth Fahey
1958–

Mahala Milligan

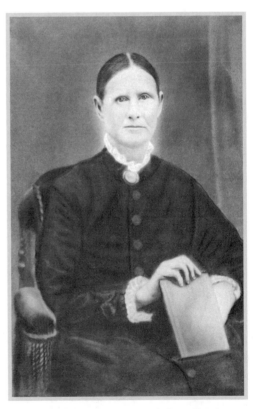

THOMAS JAMES MILLIGAN, the first elected sheriff of Mason County, Texas, a rancher and keeper of a stage stand on the Camp Colorado and San Antonio Road, was attacked by a small band of Comanche Indians in February 1860. Sheriff Milligan was afoot, accompanied by his small dog, "Sargent." It is said that he fired several shots before being mortally wounded by a Comanche lance within sight of his cabin. His body lay outside all night, Sargent remaining by his side.

Sheriff Milligan's wife, Mahala, their four young daughters, and baby son, were trapped inside the cabin, which was surrounded by Comanches. The marauding Indians set fire to a separate kitchen cabin, then throughout the night circled the home menacingly.

Great-great-grandmother, Mahala Milligan, who read Shakespeare to her children while raiding Comanches circled their cabin

To help her children to remain calm during the siege, Mahala lighted the lamp and read aloud to them from a book of Shakespeare plays. When morning came, she realized the Comanches were gone. After the family went out to recover Mr. Milligan's body, they removed the fatal spear point which had killed him. That sharp flint spear point and the book of Shakespeare have remained in the Milligan family ever since, always reminding us who we are and from whence we came.

I

𝕜

Gifts from the Past

I HAVE BEEN blessed with good genes, a strong, independent family, and the legacy of my great-great-grandmother Mahala. She was among the early settlers in Central Texas during a time when Indians often attacked those who had "Gone to Texas" to find land and start new lives.

After marauding Indians killed her husband, she faced the challenge of rearing five children by herself on a farm without electricity, running water, or indoor toilets. There was no help from the state in those days, and within a few months of her husband's death, Texas seceded from the United States. Mason County had been largely settled by Germans, most of whom supported the Union, so the area was deeply divided by the war. But Mahala had little time for politics as she plowed the fields, ran cattle, and made a living for her family. She had strength of character and determination that I have always admired.

One of her daughters, Mary Jane, married George Washington Byrd of the renowned Byrd family of Virginia. Their daughter, Alice, was my grandmother. She married Bill Walker, who was foreman for the Schreiner Brothers, a prominent ranching family with vast land holdings in Central Texas. Bill ran the Schreiners' James River Ranch and each year he was in charge of driving as many as 3,000 head of cattle seven hundred miles to market in Kansas City.

My grandfather was a real cowman at heart. There is a substantial difference between "cowboy" and "cowman": a cowman owns cattle and a cowboy works for the cowman. Bill had at least twenty cowboys under him on one of the Schreiner ranches. "Cowboying" was never the

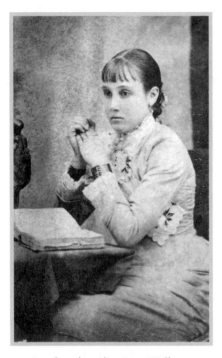

Grandmother Alice Jane Walker,
at age eighteen

glamorous job portrayed in movies, where the men were handsome and wore clean shirts. In reality, cowboys worked exhausting twelve- to fourteen-hour days, often in blazing heat or numbing cold. As foreman, Bill worked as hard as the cowboys, but his real aspiration was to own his own operation, an ambition that motivated him for many years.

Walker was a natural leader who knew how to handle his cowboys. Along with that more famous cowman, Charles Goodnight, he never allowed them to drink on the drive north. The cowboys needed all their wits about them to deal with the cattle, Indians, and unpredictable weather. Lightning was a special danger, for a sudden strike could stampede the herd, and then the cattle would run for miles in every direction. Having a good lead steer that the other cattle instinctively followed was a key positive element on cattle drives.

Cowboying was such demanding labor that Walker did not allow them even one drop of whiskey until they had safely delivered the cattle to Kansas. Then they could drink all they wanted, and many of them made up for lost time—hence the wild reputation of the Kansas cowtowns. In fact, getting the cowboys home was sometimes more difficult than driving the cattle north to Kansas.

Although the Indian wars with the Comanches and Kiowas ended around 1875, even after the US government forced them onto reservations, they still had a reputation for being sullen and dangerous. For many years after that, trail drivers were wary of them. My grandfather did not have trouble with the Indians he encountered along the trail, unlike other trail drivers. Many of the Indians were starving after the demise of the buffalo. They deeply resented the white man for taking

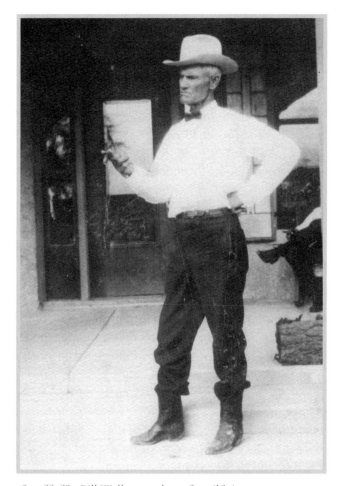

Granddaddy Bill Walker, rancher and trail driver

their land, so it is hardly surprising that they disliked the settlers and the cattle drovers.

This was their country until we arrived and made it ours. I suppose some would say we "Christianized" it, but I doubt that the impulse was ever religious. Knowing that, Bill went out of his way to show his respect to the tribal leaders. Whenever a group of Indians approached Bill's men on the trail, he would ride over to meet their leader, usually the chief, and let him go through the herd and cut out the few cattle he wanted to feed his people. By showing respect and giving the tribes

some tribute, Bill gained good rapport with the Indians. Word of his generosity moved ahead of him like a prairie wildfire. As a result of his diplomatic gestures, Bill never had a problem with the tribes along the trail.

During these cattle drives Bill saw the beautiful country of North Texas and Oklahoma, and he liked it. When the federal government opened the last available Indian lands in Oklahoma to settlers, Bill wanted to get some of that land for himself. Soon, the government announced a land lottery for 13,000 sections of Kiowa territory in southern Oklahoma. Bill Walker put in his name for 160 acres of free land.

He had lots of company; more than 165,000 people registered for the drawing to be held at Lawton, Oklahoma, on August 6, 1901. Bill headed for Oklahoma in a covered wagon and buggy. He brought along his wife, Alice, and their four children: my mother, Minnie, her sister, Bird, a younger brother, Johnny, and a baby boy, Seth Bird Walker.

One night, while they were camping near a pond full of water moccasins, Bill decided to teach young Minnie how to shoot. He handed her a rifle and told her to shoot the snakes as their heads popped out of the water to catch bugs. She had quite a time killing water moccasins and remained a good shot for the rest of her life.

The odds of winning that land lottery were about fifteen to one; Bill Walker was not among the lucky winners whose names were drawn. His family must have been terribly disappointed, but they had little time to feel sorry for themselves. They were in a strange, barely civilized land. They had to find shelter and figure out some way to make a living. Instead of indulging in self-pity, they played the hand they were dealt. The whole family worked together to create their new home.

At first, Bill housed his family in a dugout, a dwelling literally dug into the side of a low bluff or hillside for protection from the elements, especially the cold north wind that blew across the Oklahoma prairie every winter. Across the front of their dugout they hung tarps. They had settled close to water, so each day someone in the family had to carry a full bucket from the nearest stream for cooking, washing, and occasional bathing. The family had settled on land near Elk City, Oklahoma, a "city" in name only. At the time, it was hardly even a spot on the map. Bill bought some cattle and soon began ranching, but missed out on his dream of having a spread of his own.

The nearby Indian reservation was not fenced and the Kiowas came and went as they wanted. They often wandered by the Walker dugout to observe their white neighbors. My grandmother had lost her grandfather to the Comanches, who were close affiliates of the Kiowas, and she was terrified of them—with good reason.

They would creep up silently behind her while she cleaned the dugout and she never heard them coming. When she turned around they would be standing two feet away. According to her, the myth of the "silent" Indians was a fact. She said they could slip up on anybody or anything.

My mama was an object of great fascination to the Indians; they loved her hair, which was naturally curly, while theirs was straight. Soon after the Walkers arrived in Oklahoma, their baby boy—my uncle Seth—became terribly sick and they had no idea what was wrong with him. His head was thrust back and was rigid, as if he was paralyzed. His mother knew he was close to dying. There was no physician within many miles and, given the frontier conditions, a doctor could probably have done nothing for the boy anyway.

When the Indians saw the child, they knew he was gravely ill. They communicated with my grandmother and explained to her that they could take the baby to their healer in order to make the child well. Despite her deep fear of Indians, she was so desperate to save her child that she agreed to let the Indians take the baby. She had little choice, because she knew she could not save him herself.

I can only imagine how hard it was for her to let her baby go, but she took the Indians at their word and handed over the child. In a few weeks, they brought him back to her completely healthy. She had no idea what they did or how, but their cure worked. Grandmother's baby was well.

When the chief brought him back, he announced, "He is a blood brother and shall be named for me, Kiowa Bill." My grandmother agreed, so they changed his name legally from Seth Bird Walker to Kiowa Bill Walker.

The family stayed in Oklahoma for three years and made a living from ranching, although my grandfather still longed to have his own land. In 1904, he attended the famous St. Louis World's Fair along with twelve million other Americans—one out of every eight people in the

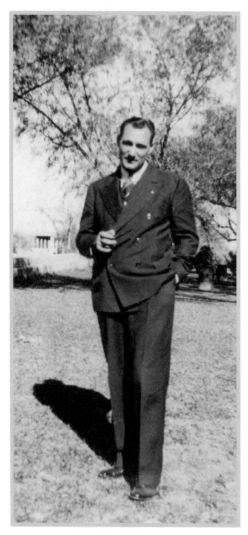

Kiowa Bill, home from Burma, where he worked in the oil business

country—but did not take his family with him. I feel sure that my grandmother had some words with him about that. It was the largest world's fair in history up to that time, and introduced to America the hot dog and the ice cream cone.

When he returned home from the fair, my grandfather brought my mother a commemorative locket that she treasured. Not long after she received it, though, her best friend, a little Kiowa girl, died suddenly. At the funeral, Mama placed her locket in the casket with her friend.

After the grave was covered, the Indians brought the child's pony to the grave and slashed its throat. While that may seem cruel to us, it was the Kiowa mourning custom and made perfect sense to the Indians. It was that child's pony so it must never belong to anyone else.

My family moved back to Central Texas in the early nineteen hundreds and continued ranching. Bill had a long-time business partner in a Texas cattle operation that had expanded during his absence. The partner sold the herd for the substantial sum of $4,000 (which equals at least $400,000 in today's money), moved to Alpine in West Texas, and bought land. However, he neglected to pay my grandfather his share of the sale.

Bill contacted his partner, who amiably offered him a ranch in West Texas as payment if Bill would come to Alpine. That was fine with the family, as they would finally have their own land. They packed up once again and headed west. It was a four-hundred-mile trip in a horse-drawn wagon and a surrey over primitive roads, and I use the term "roads" loosely.

In those early days, West Texas was sparsely populated. There were probably more rattlesnakes than ranchers. As the family approached Sheffield Hill, which descended to the Pecos River and had a danger-ously steep slope, Bill tied the back wheels of the wagon. He did that so the wheels would not turn too fast and cause the wagon to gain speed, topple over, and crush the horses.

Having grown up on a ranch, my mama, Minnie, was a fine rider who handled horses beautifully. Although she was only sixteen, her fa-ther told her to drive the wagon. He trusted her with that important job, while he drove the surrey carrying his wife and three younger children.

Mama had never seen a mountain that high before and was terrified of making the descent. As she drove down the narrow road, tears were streaming from her eyes so she could just barely see. Despite her fears, she came through safely, although she was hollering at the top of her lungs all the way to the bottom of that steep hill.

When my grandfather got to Alpine, he discovered that his former partner had suffered a terrible tragedy. He had lost his only daughter when her husband found her in bed with an army officer from Camp Marfa and shot them both dead on the spot.

My grandfather felt so bad for his old partner that he just walked away from the entire situation. He said, "That man has too much trouble to handle. I can't give him any more." Bill had every right to ask for the land but did not have the heart to press his old friend for the promised ranch. The man never offered it to him again.

My grandfather never recovered from losing that cattle money and he started drinking heavily. However, he was an excellent tracker, a skill he had perfected with knowledge gained from the Indians. After Bill was hired to track a murderer into New Mexico, he never came back. My grandmother divorced him, almost unheard of in that day. Hers was one of the first divorces in Pecos County, and many in the community considered her divorce scandalous.

She had to find work to feed her family, so she refused to let the gossip bother her. Once Bill Walker left my grandmother and his children, no one in the family heard another word from him until forty years later, when he made a surprise visit to Fort Stockton to see my mother for a few hours. They had a tearful reunion, then he left town and disappeared again. Eventually, the family learned that he and my grandmother had died on the same day.

My grandmother demonstrated the same grit her own grandmother had shown after losing her husband to the Indians. She was stuck in a frontier town in West Texas, hundreds of miles from her family, with no husband and four children. There was no unemployment office or "Bureau of Deserted Wives," so she took a job at the Kohler Hotel in Fort Stockton.

The hotel building was F-shaped. There were ten rooms available in the Kohler. The dining room and kitchen were in the center of the building, along with a parlor and entrance hall. The price for "half a bed" was fifty cents a night. Normally, two men slept in the same bed and thought nothing about it.

The patrons never knew who was going to crawl in beside them. It might be a drunk or a killer, but somehow that arrangement worked. Every room had a double bed and each man slept on his own side. They slept with their clothes on and would probably never again see the person they shared the bed with. If you wanted to rent a room all to yourself, a private room cost a dollar, but few cowboys ever had an extra dollar to spend on a hotel room.

The manager back then, Annie Riggs, was a most formidable woman. My grandmother, Alice Walker, had much in common with Annie Riggs, who also owned the hotel. They had both suffered from husband trouble. Annie Riggs was successful in business, but not with men.

Her first marriage to James Johnson ended in divorce, leaving her with four children to rear. In 1891, she made the mistake of marrying Barney Riggs, with whom she had four more children. Unfortunately, Barney turned violent when he drank—and he drank a lot.

Barney was a hired killer with a quick pistol. In fact, Barney Riggs is the only man in Texas history who killed one man, which landed him in a federal penitentiary, then killed another one for whose death he got out

of prison, a free man. While Barney was in the Arizona Territorial Penitentiary serving a life term, there was a riot and a prisoner was holding the warden hostage. Somehow, Barney got the warden's gun and shot the prisoner dead. The warden was so grateful that he arranged for Barney to receive a full pardon from the governor. With luck like that, you might think Barney would have reformed.

He got lucky, all right, but he did not get smart. Barney went to work for "Judge" Roy Bean, a self-appointed Justice of the Peace for Pecos County. Bean owned a saloon in Langtry, Texas, called the "Jersey Lilly," named, but misspelled, after Lillie Langtry, a famous actress of the day. Bean was as mean as a polecat, but he kept order.

The officials in Fort Stockton, the county seat, let him keep the job since no one else could survive it. At the time, chaos reigned along the Pecos River at its juncture with the Rio Grande. When the Southern Pacific Railroad was under construction, the Chinese coolies laid track from the west and the Irish laid track from the east. When they met, they drank, and after that they fought. Bean usually managed to keep them from killing each other.

While Annie looked after her guests, her boys ran the ranch and some of them helped their mother at the hotel. Young Barney, Annie's son, regularly got up at 4 a.m. After finishing his ranch chores, he rode to town on horseback, still wearing his dusty clothes, to serve breakfast at the hotel.

One day, a judge who was riding circuit had spent the night in Annie's hotel. As he sat down to order his breakfast, he said to a cranky Young Barney, "I want my eggs over easy."

The surly boy grabbed the judge's plate and flipped it over, eggs on the bottom, right onto the table in front of the judge. Not one more word was said; none needed to be. That judge knew better than to complain, because the son had obviously inherited his father's temperament and most likely was carrying a pistol.

My friend Mary McComb's mother, Theodora, was about five years old, attending the first school in Fort Stockton. She asked the teacher if she could go to the restroom, which meant a trip to the outhouse. While she was in the privy, she heard a lot of noise outside. Looking between the cracks in the wall, she saw Barney Riggs staggering past the school, mortally wounded.

11

Theodora was scared to death, so she ran back into the schoolhouse screaming. Barney had been arguing about money with Buck Chadborn, Annie's son-in-law from her first marriage. He had threatened Buck's life. When Barney reached for a handkerchief in his back pocket, Buck thought he was going for his gun and shot Barney, more or less in self-defense.

Some of the onlookers carried Barney into the hotel, where he died the following day, cursing Buck to the end. Annie used the assets of Barney's $3,000 estate to make a down payment on the Kohler Hotel, paid off the remaining $2,000, and changed its name to the Annie Riggs Hotel.

My grandmother arrived in Fort Stockton in its last days as a frontier town and witnessed the waning of the Wild West. She worked hard, reared her children, and made a good life for them as Fort Stockton grew in population, in prosperity, and in civility.

2

↙

Growing Up in Fort Stockton

MY MAMA, MINNIE, and my father, who was always called by his last name—Dunn—lived happily near Comanche Springs in Fort Stockton. By the time I came along in 1924, life in our town had calmed down considerably from its Wild West period.

Given our geographic isolation, it only made sense for folks to get along. We were way out in far West Texas, four hundred miles west of San Antonio, two hundred fifty miles east of El Paso. When I was a little girl, Fort Stockton's population was around three thousand. Outsiders always said we were "good people" and for the most part, we were.

As far as I can remember, my childhood was pleasant. I was an only child, which I highly recommend. For one thing, you get lots of attention, sometimes a little too much. But, on balance, I liked that. The biggest negative is that an only child always has to do everything right, because you can never blame the naughty things you do on brothers or sisters. Pretty much, I learned to do things right early in life, and that early training became a habit.

We had a milk cow and a barn; I always had a dog or two, and our barn was usually full of cats. I think the most we ever had was twenty-one; each one was a barn cat, but tame. As a joke, I once named one of our cows "Magnesia."

One of my earliest memories was visiting the bank where my daddy was general manager. It was an impressive building with polished marble counters.

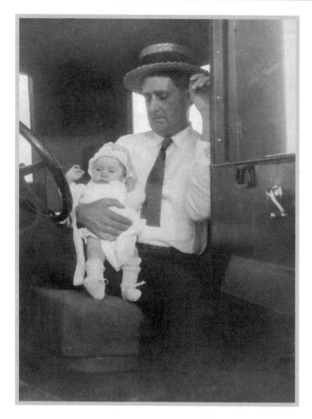

I am a young girl, trying to look like Shirley Temple.

Daddy holding me in his new car, 1924

After the stock market crash of 1929, my father met with the board of directors. He told them, "We have a strong bank and we can make it through any crisis, but you must be more cautious about borrowing from the bank." Unfortunately, the directors' self-interest was stronger than their common sense; some of the directors went right on borrowing recklessly. Eventually, my father went back to them and declared, "I will not have any part of this." He resigned.

As the Depression grew worse, the bank became overextended. The directors were personally responsible for the bank's debts, but not all of them could meet their obligations. One of them tried to hide his assets by claiming that all of his sheep belonged to his wife! Before long, the bank closed its doors forever. Daddy left the bank voluntarily before the Depression got really bad, and he never returned to banking.

His next position was postmaster of Fort Stockton, a highly desirable

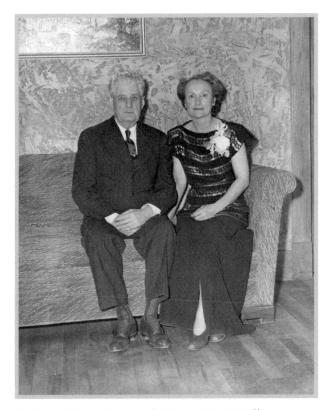

*Daddy, A. Warren Dunn, and Mama, Minnie Walker Dunn, on
their twenty-fifth wedding anniversary*

federal appointment. Everyone living in Pecos County respected my fa-
ther. People often said, "If you are looking for an honest man, you don't
have to look any farther than Sam Dunn." His actual name was A. Warren
Dunn; where that "Sam" came from, I have no idea. He never told me
and I never asked him.

During those sad days, I was so young that the Depression meant
little to me. Never in my presence did my father or mother say anything
about "hard times." I am sure they were concerned about the economy,
although we never suffered as so many other families did. I do remem-
ber my father paying grocery and milk bills for folks who were worse
off than we were.

Several of those recipients were ranchers who had to operate on an-
nual budgets. In normal times, they would get a loan from the bank

to carry them for the year. Then, after they sold their cattle or their wool, they would repay their loans. But lately, the ranchers had been struck by a terrible set of circumstances: cattle prices were down, wool prices were at the bottom, and our area was suffering from a long-lasting drought. Remember "The Dust Bowl" times?

However, for our family, the Depression was more difficult for the ranchers in our county. After all, we knew the post office would never close.

During the thirties, a dollar was a dollar, so all the folks kept track of every dime. My friend, Dorothy White, whose husband, Lee, was in the oil business, was living in a dreary little oil boomtown. They had no children, just the two of them. One day, Dorothy noticed a dime stuck in a crack in the floor. She could see it plainly enough, but could not pry it loose, it was stuck so tightly. She tried all day, digging at that dime with scissors and a butcher knife, finally retrieving it. Deciding to splurge, Dorothy took her new-found wealth downtown and bought herself a *Saturday Evening Post*, the first new magazine she had read in months.

Later, the Whites moved to Fort Stockton, after the Yates Oil Field was discovered nearby, and there was a lot of oil and gas exploration going on. They moved into the Hotel Stockton, owned by Effie Potts Sibley and her husband, Dr. D. J. Sibley, Sr., parents of my future husband.

Effie told me that the Whites went for two years without paying one cent on their hotel bill. Lee, Dorothy's husband, needed a proper location from which to conduct his oil leasing business, so they took a room on the southeast side of the hotel where they could usually catch a nice breeze.

For $3 a day, they had a lovely place to live and do business, including three good meals a day for the two of them. In all that time, Effie never asked them to pay. She felt she was so good at reading someone's character that she was certain the Whites would pay her when they could. Sure enough, they did. After their fortunes changed, they paid the entire bill in full.

When I was growing up, our post office was a lively place. There was no home delivery back then, so everyone came to the post office every day to pick up their mail. Because it was such a center of activity, Daddy enjoyed working there.

"General Delivery" was for non-residents who did not have their own

post office boxes. If you were out of town and wanted to send something to yourself in Fort Stockton, you sent it "Care of General Delivery."

Then, after you got back home, you would stop at the post office and say, "Do you have any mail for Sam Jones?"

A postal clerk would look through the General Delivery stack, and say, "Sure, Sam, here's your letter." Of course, back then, the postal clerks knew everybody in town, so they never had to ask for identification.

During the thirties, when some gangsters from Chicago felt the heat from law enforcement, they often headed for the Mexican border. Since our town was close to Mexico, the FBI checked with my father so often that our post office became their unofficial headquarters. My father never talked about it, but when the feds were searching for criminals in our area, he was always the first to know.

Maybe those mobsters came down to Texas with the idea of seeking safe haven in Mexico, but then pulled back to think about it once they got a good look at the border region. One place they liked to congregate was a resort at Madera Springs.

Knowing that the crooks were well-off, one poor, down-at-the-heels cowboy named Henry Wilbanks, who worked on a neighboring ranch, set a tin can next to the gate of that resort under a sign that read, "Help a Poor Cowboy Buy a Ranch."

Unbelievable as it sounds today, the gangsters began putting money in Henry's tin can, and he either bought or financed his way to his own place. He was a little offbeat and looked like a total hick in his brogans without socks, but Henry was a kind soul, who we often saw in the Fort Stockton coffee shop with his pet baby cottontail bunny peeking out of Henry's shirt pocket.

Some people might have considered Henry "simple," as they used to say. Except at one point, Henry did own a ranch about fifteen miles north of our Salt Grass Ranch, so we got to know him a little better. Two New York "investors" came to Henry one day, offering to buy his mineral rights (the subsurface rights are separate from surface rights).

Many ranchers succumbed to unfair leases and lost their underground property for as little as a few thousand dollars. One family sold their mineral rights, then went right to town and bought a big car. Later, after oil was produced from their former property, they could only watch. No income.

17

When those Eastern promoters offered Henry a million dollars for all his minerals and wanted to lease the subsurface rights, Henry replied, "W-e-e-l-l-l . . . I don't know, . . ." and scratched his chin.

Next, they offered him $2 million. He repeated his hesitation and they offered him $3 million. When their offer hit $4 million, Henry said, "Well, I owe more than four million."

That ended the negotiating and Henry never did sell his drilling rights. Even though eventually he owned four ranches, Henry got into financial difficulties because he never wanted to sell anything.

Besides occasional gangsters passing through, we had a few townspeople who also kept us entertained. One of our more colorful characters was Zema. No one ever diagnosed precisely what her mental issue was, but I'm pretty sure she had a big one. No one ever met or heard of her husband, though she had a lovely son. Zema wore English riding jodhpurs, boots, and a tight shirt. She would have been right at home in the age of t-shirts, except she was fifty years ahead of that style.

Often, Zema would walk up to you and start talking a mile a minute. She was never malicious, merely eccentric. Then, one day, she went into the post office, received a package and opened it. Inside was a pair of britches and some new boots. Eager to try on her new things, Zema took off her clothes right there in the post office lobby and put on her new britches and boots. All of her actions were done right in front of a stunned crowd. Everybody noticed her, for sure. I remember being at the swimming pool when Zema took her boots off and jumped into the pool, clothes and all. She had a cake of Ivory soap in her hand, washed her pants, got out, and dried off. She only ever owned one outfit.

You never knew what might happen at the post office. There was a lovely lady in our town named Mary, who was pretty and so well-endowed that she looked like a Petty Girl, one of those pin-up drawings so popular during World War II.

One day, Mary was walking out of the post office as the Baptist preacher was strolling toward her down the sidewalk. Apparently, he had a fixation on the female figure and was observing hers intently. He was studying Mary, twitching and bobbing her way down the street, so intently that he walked right into a column in front of the post office that supported the storm doors. He smacked that pole so hard he bounced off it. News of his wandering eye was all over town within the hour.

In his play, *I Ain't Lyin'!*, Jaston Williams, who grew up in our neighboring West Texas town of Van Horn, describes his unsuccessful attempts to get his aging mother to stop driving. I understood his problem completely. We had a number of older drivers in Fort Stockton who should never have been allowed behind a steering wheel. However, no officer ever dared to arrest them. The police would go after drunken cowboys and a few husbands trying to murder their wives, but never any eighty-five-year-olds driving a big Packard. Whenever we saw one of those elderly drivers coming, we got off the street in a hurry.

When I was about ten, I broke my arm on Halloween night by stumbling over a "ghost," and landed on my elbow. My parents took me to see the elderly doctor who served the whole town. No such thing as an X-ray machine in Fort Stockton back then. The doctor felt my arm gently and announced it was broken.

A few days later, he put a fancy new two-piece aluminum splint on my arm that had two screws that were supposed to meet in the center, with a nut to hold the sides together. I never saw a splint like it, before or since. It might have been an experimental device someone was trying out. Unfortunately, after I had it on my arm, the old doctor's hands were so palsied he could not screw the thing together tight enough to protect my broken arm.

Frustrated and upset, he looked out into his waiting room and spotted Charlie Devlin, one of his patients, a well-known aviator who had flown with Eddie Rickenbacker in World War I. Charlie was a graduate of MIT, an inventor, rancher, and farmer—a true renaissance man. His family had Colorado mining money and had invested in Fort Stockton.

When the doctor said, "Charlie, would you come in here and do something for me?" Charlie looked up, and even though he had descended into alcoholism, he could do almost anything mechanical when he was not drinking. Luckily for me, he was sober that day. Charlie got my splint screwed on in two minutes flat.

Today, many families are labeled "dysfunctional." I am pleased to say ours was always "functional," and that was true of my friends' families as well. We kids had no serious problems with our parents, and were never sassy to our fathers. Maybe that doesn't make exciting reading,

but our childhoods gave us all a foundation of love and discipline that served us well over the years—a real testimonial to the positive influence of solid family values.

I'm sure I grew up in a more innocent age, because my friends and I did not drink alcohol and there were no drugs. Of course, we did think about smoking; all the grownups smoked back then. When I was eleven, we built a log cabin out of cedar posts that were stacked outside the home of my friend, Mignon.

One girl had swiped her mother's Camels. We smoked the whole pack, but—as Bill Clinton said many years later—we did not inhale. We did not even know how to smoke, so the inhaling portion never occurred to us. No doubt that was a blessing. Another time we pulled the bark off cedar posts and tried to smoke that, but soon found that did not work at all.

We had a good time growing up, because we had so much more freedom than kids today. Our front door was never locked and I am not sure if we even had a key. Our town's wilder days were in the past and no one ever thought about crime.

We lived pretty close to the Santa Fe Railroad tracks, so there was some apprehension about the transients who came to back doors asking for food. My mama always fed them. She never turned away a hungry person, but sometimes I would hide under the bed when they showed up.

She never asked them to do any work and they never offered to. They just got some food and went on their way. In the thirties, the trains had almost as many non-paying passengers as paying ones. We called them "tramps" or "hoboes" and I am sure some of them were mentally ill, as so many of the homeless are today, but the men who came to our house never caused us any serious problems.

Aside from an occasional smoke, my friends and I led a wonderfully unsophisticated life. One of my favorite childhood memories involved playing in an old-style retail establishment called The Rooney Mercantile. The building was owned by my friend Jean Ivey's grandfather. It featured hardware and groceries downstairs, and fashion and dry goods upstairs.

The second floor had been closed to the public for years but was open to Jean, Mignon Rachal, and me. By the thirties, few townspeople had money for fine clothes, and anyway, the styles had changed. Ladies

no longer wore pointed-toe boots or corsets, and those items would not have sold even in a clearance sale, but that did not matter to us. We had an entire floor full of ladies' wear all to ourselves. To a girl like me, who was certain she was born with a love of fashion, it was like landing in paradise.

Rooney's upstairs was our own private Neiman-Marcus. It was the grandest place to play dress up, where we could create outfits from our own imagination. While there were no gowns, I do remember beautiful lingerie, hundreds of pairs of shoes, and long kid gloves that stretched above my elbows. Oh my, in Rooney's, I was in my element. My love of fine fabrics and beautiful clothes came as naturally to me as breathing.

Even more fascinating than our trove of ladies' ready-to-wear was Jean's access to jewelry. Her aunt's husband was a hard-rock geologist, who had developed an intense interest in gemstones. As he was able to, he began buying pieces for Jean's Aunt Dorothy.

After the Russian revolution, he managed to obtain some of their crown jewels—not any crowns or scepters, I am pretty sure. However, I became acquainted with emeralds and sapphires, and I also learned about Fabergé and his enamelware, all of which gave me a pretty high frame of reference when it came to accessorizing. I also learned about jade—real jade, not the carved soapstone with which I was already familiar—and I acquired an appreciation for it that has stayed with me. So between that aunt and Jean's other aunt, who had a black limousine and a chauffeur, we were able to bring off a most realistic fantasy of high society fashions.

I never remember a time when I was not interested in fashion. My mother's good friend Myrtle Mendel had no children, so she had a little extra spending money during the Depression. She would buy *Harper's Bazaar* and *Vogue* and share them with us. They were beautiful magazines with marvelous fashion photographs. Even as a child, I was enchanted by the photographs I saw in them. As I read the magazines, I began to develop my own sense of style.

One of my most vivid memories of Rooney's was when Mama and I were driving down Main Street and we heard some gunshots. Mama made a quick U-turn, drove to Rooney's, and we ran inside for shelter as fast as we could. Some folks were trying to settle a family dispute at the courthouse and one of the parties did not care for the verdict. He had

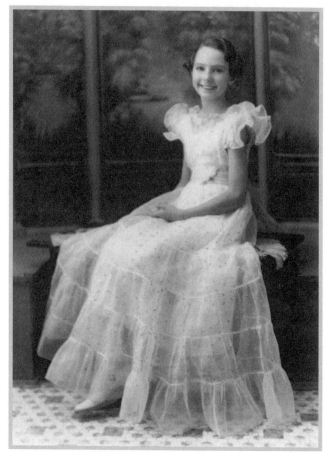

Wearing my very first long dress, purchased at Neiman-Marcus, for a piano recital

brought a gun to court with him and he started shooting. No one was killed, but his shots cleared the streets of Fort Stockton in record time.

I got a good education in our public schools because of the quality of our teachers. We had an excellent curriculum that included two years of Latin, four years of Spanish, and four years of English. We may have quoted Shakespeare with a Texas accent, but we quoted him accurately! I am amazed when I look back on all the cultural opportunities I had as a child in our small town hundreds of miles from any city. Upon

reflection, I think that what the cities offered were not always the most refined choices for children who lived there.

There was always an intense rivalry between Dallas and Fort Worth, and even more so during the Texas centennial celebration in 1936. In order not to miss anything, people went to both cities' celebrations. Sally Rand had a spectacular production at Casa Mañana in Fort Worth, where she did her famous fan dance. She performed in a costume that was flesh colored to give the illusion of nudity. She held her fans so they covered those areas of hers that most needed covering. In those deeply conservative days, her act created a huge sensation. The Baptists were outraged, but many of them showed up to witness the glamorous sinner in action.

I had two outstanding male teachers: Garland Casebier, who taught seventh grade history, and N. S. Patterson, who guided me through high school English. They were demanding and made us work hard. More important, they taught us to think for ourselves. We all memorized Henley's "Invictus":

> *Out of the night that covers me,*
> *Black as the Pit from pole to pole,*
> *I thank whatever gods may be*
> *For my unconquerable soul.*

This poem, of course, ends with the famous line, "I am the master of my fate; I am the captain of my soul." Who knows how much of my own character was instilled by that work? Somehow, these two devoted teachers managed to live off their salaries, which were not much back then, but the cost of living in Fort Stockton in the thirties was quite modest.

Most folks in our town did not make much money, but anyway, there were few ways to spend it. We kids could go to the movies for ten cents, a soft drink cost a nickel, and our town swimming pool was free—and we made good use of it!

We were in the Comanche Springs swimming pool every warm day and almost all of the really hot ones. It was a large public pool owned by the irrigation district. The main spring—the "Comanche Chief"—flowed

fifty million gallons of water a day. Those springs were the reason Fort Stockton existed at all. The fort was located there because of that abundant source of water. Nomadic tribes had been camping there for thousands of years for the same reason.

In 1936, when I was twelve, the Lion's Club produced Fort Stockton's first water carnival to celebrate the Texas centennial. Naturally, my friends and I swam in it. In Fort Worth, they had Esther Williams, who was already famous, but she was swimming in a pool that was only perhaps six feet deep. We felt superior in Fort Stockton, because we swam in fourteen-feet-deep spring water.

Those were wonderful times. At the fiftieth anniversary of Fort Stockton's water carnival in 1986, I came back with Jean Ivey and her daughter, Dru Kincaid, to revisit my youth and to swim again in the water carnival. I will admit that I huffed and puffed, but I made it. We swam to the inspiring music of "Diamonds Are a Girl's Best Friend." Just like Carol Channing, we all believe strongly in that philosophy.

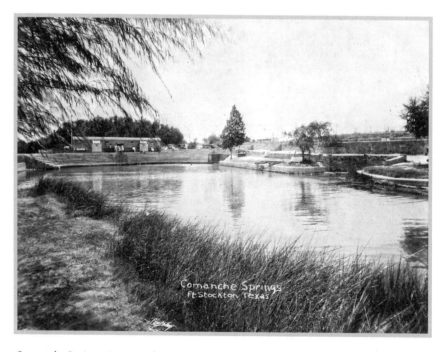

Comanche Springs, Fort Stockton, Texas, back in the thirties, was my childhood playground.

I studied tap dancing and enjoyed it. I was not, however, destined to become the next Ginger Rogers (who came from another small Texas town). We never had a ballet class in Fort Stockton because almost no one in our town had ever seen a ballet. It was as foreign to us as escargot. I would have loved to study ballet for the beauty of the movement and for a chance to wear those exquisite costumes.

Several ballerinas have told me I have the body shape and balance of a dancer. At eighty-seven, I'm thrilled just to be ambulatory. Some have also said that I walk like a ballerina. However, I will take them to mean that I move with grace. One thing I have learned is that it is far better to enjoy compliments than to analyze them.

Many of my childhood memories focus upon music. My parents were determined that I should have full exposure to the arts, so I began taking piano lessons in the third grade, continuing right through high school. I enjoyed playing and I practiced many hours a week, but sadly, I was never a gifted pianist.

I seemed to lack the natural flair of a really good musician. However, practicing taught me discipline. Playing the piano was absorbing and trained my mind to concentrate. Whenever I was playing, I thought of nothing else.

I had a beautiful baby grand piano. It came from a man in Odessa who had married a much younger woman who demanded a piano from him. Her husband did his best to please her and had the piano shipped all the way from Dallas. Soon after it arrived, she divorced him anyway. So the poor fellow was left without a wife and with a piano, which we bought from him for a good price.

My piano teacher, Maggie Willoughby, survived the entire Depression by giving piano lessons. She could not depend on her husband for much income, because he was a commission man who arranged the sale of livestock. With the Depression made even worse by an epic drought, he had few sales to arrange, so his wife had to keep the family going.

Maggie charged each student ten dollars a month. If she could keep at least ten students, her family had a decent income, but with the economy in such bad shape, not many parents could afford her fee. When things got really tight, I would notice that she was not wearing her lovely diamond rings. She had taken them to the bank to secure a loan. Whenever things got a little better, Maggie would be wearing her diamonds again.

From my own years of taking piano lessons, I learned that parents will do whatever it takes to give their children those things they feel are essential. I am sure my parents had to skimp somewhere, but they always found the money for my lessons. They wanted me to have every advantage they could provide. Their love of learning and of the arts was their greatest gift.

3

❦

The University in Wartime

T HERE WAS NEVER any discussion in my family about where I would go to college. One day, my father said, "You are going to the University of Texas, because it's going to be a great school someday."

So, in the fall of 1941, when I went to Austin as a freshman, everybody in Fort Stockton declared, "That poor little girl is going to that great big school." I decided to study art.

Back then, we all called UT "*The* University." That was how many Texans felt about it and how they still do today. Although the campus had more than 10,000

Jane as a student at the University of Texas

students, a vast number in those days, it did not seem too big to me. I liked it immediately, and I was never homesick, not for one minute.

Coming from a little town where people knew and respected my parents, I had grown up with everyone in town knowing and accepting me. When I got to the University, nobody knew me, so I had to make it on my own. That was the best thing that could have happened to me because it forced me to grow up.

When I first got to Austin, its population was only about 90,000. It was our state capital with but two industries: government and higher education. We students had no idea at all that in a few months our world would change, Austin's along with it. My freshman class spent only ninety days of pre-war innocence before December 7 changed everything for us as it had already for people living in Asia and in Europe.

While life in a dormitory would have been fine with me, instead, I had the good fortune to live in a delightful boarding house just off campus. My father had known the housemother's husband many years earlier. That became my connection as well. Today, I realize "boarding house" is an unfamiliar term to most people, which is their loss. A good boarding house, like the one where I lived, combined the best features of a dormitory, a sorority, a hotel, and an extended family. We residents ate our meals together, and I remember those rum pound cakes very fondly. They became quite a luxury after sugar was rationed during the war.

For more than sixty years, my college friends and I have laughed about the cultural divide between our extremely dignified housemother and her lively young charges. She valued propriety, good pearls, and above all else refinement. Sadly for our wonderful housemother, we were a group of fun-loving free spirits. She expected us to be ladylike at all times, never easy for those of us who had a wide streak of mischief and a craving for independence.

I am not at all sure how we managed to coexist without being bounced out on our ears, but somehow we did. My friend Mignon from Fort Stockton was sent to a girl's school in Mississippi for her first two years of college, but for her junior year was reunited with the rest of us at our Austin boarding house.

Life there for us was a lot like living in the antebellum South. Our African American butler, cook, and maids were dignified, reserved, and wonderfully helpful, and we loved them all. Our house rules were typical of that era. We had to be in the house by ten o'clock on weeknights and by twelve on Fridays and Saturdays, standard hours for university girls back then, whether they lived in a university dormitory or a boarding house.

At our parents' request, we were closely supervised. They wanted us to return home with our values intact, by which they almost surely

meant "our virginity." Even the concept of coed dorms in our day was as unthinkable then as landing a man on the moon was much later.

Three months into my freshman year, war came to America on a lazy Sunday afternoon. I heard the news on the radio at our boarding house when normal programming was interrupted by a news bulletin. Of course, we were all shocked and horrified by the brazen Japanese attack at Pearl Harbor. We had never anticipated America being drawn into the war that began in Europe two years earlier.

Within twenty-four hours, three girls were ordered by their parents to leave school to go home. The next day, we all listened to President Roosevelt's historic address to Congress declaring war. It was a great speech, just what the country needed. Even though we had lost much of our Pacific fleet, and Hitler had joined Japan in declaring war on America, we could not imagine losing. No one I knew even considered that possibility. But none of us had any idea how bad things really were in the Pacific or how unprepared our country was to fight a world war on two fronts.

True, the newsreel footage of the Pearl Harbor attack terrified us, but even so, it was hard for us in Austin to connect that grisly scene five thousand miles away with our still-peaceful life on the UT campus. At first, the war did not affect me as deeply as it might have if I had been older and more mature. After all, I was a brand new freshman, still learning the ropes at a college whose student body was larger than the town where I had spent my first seventeen years. Of course, we continued with our classes, exams, dances, and Christmas parties, but there was no escaping the growing impact of the war.

The Selective Service draft had begun even before the war began, but most boys on campus volunteered for military service. They knew they were likely to be called on to fight. We had a Navy ROTC unit at UT, as well as a few young men with 4-F draft status who had failed their pre-induction physical exams.

However, within a year, not many male students were left on campus. Gradually, UT became a campus of coeds, especially in my art department, which had few male students anyway. As the months went by and more men enlisted, the campus began to resemble a girl's school. Many of my male professors were young and were quickly drafted. In

my government class, I had a different teacher for every exam, including the midterm and final. In some classes I barely got to know my teacher's name before he was called up. Soon the rapid turnover of professors began to seem normal. Within a few years, almost every able-bodied young man I knew was headed for Europe or the Pacific.

Despite the war and the absence of men on campus, we still managed to have an active social life. The exodus of our male students was offset by the huge influx of soldiers and airmen who were training nearby. We met a lot of young men from the local army bases in and around Austin. There was Camp Mabry on the edge of town, Camp Swift in Bastrop, thirty miles east, and Fort Hood in Killeen, sixty miles northwest.

My future husband's great-grandfather, Hiram Sibley, was buried on the gunnery range ("rest in peace" would not be quite accurate) at Fort Hood in what had been a small family cemetery. Remaining is a big oak tree, an iron fence, and several graves. Once a year, the post commander of Fort Hood invites the families to visit their cemetery.

The Army Air Force was growing rapidly. Bergstrom Field, named after an Austin boy who was killed in an early battle of the war, was located five miles southeast of town. We girls met a number of officers from Bergstrom. Our introductions were often second- or third-hand, but that never mattered to us. Somebody would know somebody who would know somebody who would say, "Look up Jane or Mignon when you get to Texas." They did.

Of course, when Jean's aunt was in town with her chauffeured limousine, its presence gave us the inside track when it came to flirting. We met boys from all over the country and got used to hearing strange accents and learning their different points of view. Just like the Texas boys in the service, our ideas of America began to expand.

The mountain troops from Camp Swift were the best-looking boys. They had all been skiers before they joined the army. Once they got to Bastrop, not exactly hilly and never snowy, they all asked, "What are we doing here?" There was not a mountain in sight. These boys were from Vermont, New Hampshire, or upstate New York. Many had gone to eastern schools like Dartmouth and Yale, but were not expecting our relatively flat Texas landscape.

I met some good dancers at the USO, a club for enlisted men downtown near St. David's Episcopal Church. Coeds from the university

were invited to go to the club to dance with the boys and help them feel at home. Most of them were terribly homesick and had arrived in Texas with great trepidation. More than a few told me, "I was afraid to come to Texas because of the Indians."

These young men who were about to face the German and Japanese war machines, said they were terrified of Indians, who were Americans and who had not been any kind of a threat for fifty years. Many of them served with fierce distinction throughout the war—fortunately on our country's side.

As the months went by, some of our friends headed overseas. We were concerned about them, but staying in touch was difficult, because we had no idea where they were going. In addition, even the news was heavily censored, and in the early days of the war, much of it was bad news.

General MacArthur was forced by the Japanese to flee the Philippines and Hitler's armies were moving deep inside Russia. We did not know much more about our successes. For example, in the summer of 1942, few of us realized the importance of the Battle of Midway. American planes sank four Japanese aircraft carriers in one day, a feat that proved to be a major turning point of the war in the Pacific. However, at the time, this great victory was little known to us at home.

By then, we were dealing with gasoline and food rationing, but we adapted to that pretty quickly. After all, when your friends are risking their lives in battles, using less sugar or gasoline seems like a petty inconvenience. Federal rationing authorities allotted fuel to Texans at the same rate that they did people in New England, who drove many fewer miles than we did, but we soon found ways to get around the gasoline shortage. If we wanted to go to a movie or a dance, a bunch of us would pile into a taxi for ten cents a ride each. There were no regulations on how many fares a taxi could carry back then. We often squeezed four in the back and two in the front next to the driver.

In the forties, downtown Austin was where everything was happening: from night life to shopping. Back then, Austin had a limited variety of eating places. There were Mexican restaurants, barbecue joints, and steak houses. For fine dining, there was the Driskill Hotel.

Whenever our parents came to town, they always tried to stay at the Driskill, a lovely place for birthdays, celebrations, and special occasions.

Far out on the other end of the spectrum was the Hofbrau on West Sixth Street, which was already serving those enormous, leathery steaks. I have not eaten there in years, but it has a loyal following and remains just as popular almost seventy years later.

We met boys from Texas A&M, which was definitely not coed back then. A&M was for men only, most required to be members of the corps of cadets. Few people know that A&M has trained more military officers than any other public university in the country, including West Point. The boys from A&M wore beautiful English boots and riding breeches and looked so handsome. Of course, a proper uniform can do wonders for any man.

All the time I was in college, I never had a steady boyfriend. There were one or two boys I was temporarily crazy about, but I had no interest in getting married until after the war was over. Too many girls back then went on a date and next thing they knew they were getting married.

I could never understand that. Maybe they were less interested in getting a degree than a husband. Not only did I like school, I knew my parents had sacrificed to give me a good education, so I made sure to get one.

Even though I never had art classes when growing up, from an early age I knew art was what I wanted to study in college. As an only child, I often had plenty of time to myself, and drawing became my favorite pastime because I could draw anywhere—even at the post office with my daddy or at the bridge club with my mother. While I loved reading and enjoyed playing the piano, I could always lose myself in art.

All these years later, that pleasure has stayed with me. Ironically, as a child, I never had art lessons, even though I had private lessons in "expression," where I learned breathing, vocal inflection, and projection. That particular training came in handy much later, when being a good communicator was an important skill in fundraising, running boards of directors, and persuading people to become more involved in the community.

Fortunately for me, at UT I learned from some outstanding professors, completely unlike any people I had ever met. The art department at the University of Texas was unique. Instead of teachers with advanced degrees, the department hired practicing artists who might not even have degrees. They were real artists who liked to teach and who were very

good at it. They went right on with their own art while they taught, sometimes selling their works through galleries in New York and other cities.

The official who initiated that concept at my university was William Doty, appointed the university's first dean of the College of Fine Arts when he was still in his mid-twenties. At the time, he was the youngest dean at any college in the United States. Despite his youth, Dean Doty ran such a strict program that we art students were terrified of him. I never saw him smile until forty years later, when he spoke to me after attending a symphony concert, praising what we had accomplished with the Austin Symphony.

In my freshman year, I was greatly influenced by one professor. The subject was life drawing, and he was Charles Umlauf. His parents had emigrated here from Poland and he grew up in Chicago's Polish ghetto. He had studied at the prestigious Chicago Art Institute and was determined to be a sculptor. As a result, sculpture was all he knew and all he cared to know.

The art department in my student days occupied part of the old library building, where our life drawing class had models who posed nude. The presence of nude models was a delicate matter in a Bible Belt state like Texas. After all, the legislature was meeting a scant mile away and most of its members always expressed suspicions that our university was overrun by communists. For some strange reason that defies logic, having models who posed in the nude was a sure sign of rampant communism.

We students had to be particularly careful when life drawing classes were in session. They were held in a dingy, somewhat dismal corner of the old library building. My mother would surely have labeled the place a "rat trap," and I am certain it violated every fire code on the books.

The library's main advantage was that it was well out of the path of passing strangers. Even despite our obscure location, we took no chances and set up a system of lookouts. If one of them noticed a state legislator coming, the models were alerted and had time to drape themselves appropriately. At this point, I do not recall exactly how we were supposed to identify a member of the legislature. Most likely, he would be an overweight man wearing a white suit and a black string tie in our pre–air conditioned Texas. Our complicated plan must have succeeded, because we were never caught by a legislator while we were drawing our naked models.

For all four of my years at the university, I studied with Charles Umlauf. Those were certainly not easy years for me. Umlauf did have such a brutal personality. Provided you could look past his brusque temperament, you would discover that his candor was what made him such an excellent teacher.

Even so, when I describe his manner as "brutal," I do not exaggerate. For example, I might have worked diligently for hours to build up my clay on the armature until I was totally positive I had it just right. Then *he* would come by my stand brandishing his wooden sculpture tool.

"Miss Dunn, can't you see anything?" Then he'd whack my creation to pieces.

His critiques could be so scathing that some of the more timid souls fled the classroom, jumped onto a bus home, and never came back. Regardless of his fierceness, I vowed I would not let him push me out. I just stood my ground and I never argued with the man. After all, he was my teacher. I thought, "I am here to learn, and if this is the way I learn, then this is the way I learn."

Since I usually took Umlauf's cruel comments in stride, I grew from his critiques instead of dodging them. Ultimately, he and I became good friends. The main reason I never took offense at his comments was that I realized he was trying to tell me something I really needed to know. Over time, his greatest influence was that he taught me how *to see.*

The ability to take in a painting, a room, a building, or a piece of jewelry—to possess an "eye" that never fails you—is such a precious quality. If I learned nothing else at the university, that skill alone made all my years at UT worthwhile. Charles Umlauf taught me a sense of discernment that I have treasured and have employed all my life.

That is why I encourage everyone to study art: because you can apply what you learn every day and everywhere. That visual engagement allows you to see things as you never saw them before, and to view life itself differently and far more intensely. Sometimes, that ability can become a bit of a handicap when you may not like what you are experiencing. When, or if, that happens, then you become aware you have begun to learn two other even more useful arts: tact and diplomacy.

Eventually, I found I did not enjoy painting, but preferred design, sculpture, and art history. As a child I had become fascinated by history,

when one of my best friends was Judge O. W. Williams. He spent hours regaling me with his tales of southwest history. He made those stories come alive for me because he himself had personally lived so many of them. At UT, I found the stories of the great artists and their works just as intriguing as the judge's captivating yarns of the Old West.

My years at the university were enriching in so many ways. Although I was invited to a number of sorority affairs, I chose never to become a member of one. By the time their invitations arrived, I was already a junior and I had a close group of friends, so joining a sorority was just not that important to me. After all, the main advantage of membership was the opportunity to meet an eligible young man who might become my future husband.

Thank goodness I chose not to go down that road. So many girls back then met someone their own age, were swept off their feet, and ran too quickly down the aisle. While their lives may have been romantically exciting for a while, those couples had promised to remain together for a long time, supposedly "till death do us part."

Serial marriages had yet to come into style. For myself, I wanted more than transitory romance. I had met few boys my own age who ever stimulated me intellectually, not even the young military officers I danced with. Most of them were often only twenty years old, and some were only eighteen or nineteen. They might have known how to fly, but were certainly *not* ready to become husbands. When I went to the University of Texas, my goal was to acquire a good education as well as to have some fun. Unlike many of my peers in those days, I was not yet in the market for a marriage partner.

During my years at UT, if I wanted to go home for a visit or for the holidays, I had to ride the bus to Fort Stockton, unless someone I knew from home was driving back after being in Austin on business. The state senator from our district was the father of my friend, Mary McComb. Whenever he was in Austin, he would call Mignon and me to see if we wanted a ride home.

Riding with Senator Heine Winfield was a true joy. He was a delightful companion and he had a good sense of humor. We made the trip home in about seven hours, unlike the bus, which was a fifteen-hour trip. Besides, when we had to ride the bus, there was a two-hour

layover at four in the morning in McCamey, Texas, a little oilfield town. Stuck there, we would sit in the lobby of the Bender Hotel in straight-backed chairs.

In the middle of the night in McCamey, there was nowhere to go and nothing to do. On the way back to Austin, luckily, the bus stopped in Fredericksburg, where we would dash into Dietz's Bakery, buy some delicious bread, and bring it back with us to UT.

Life back home in Fort Stockton could be just as zany as when I left for college. I remember one cowboy, Truman Foster, who managed to find money enough to buy a new pickup truck, which then as now might be the largest investment a cowboy would ever make. After showing off his new truck in Pecos, Truman got on the highway to Balmorhea, about fifty miles west. He had almost arrived there when he encountered one of those West Texas thunderstorms of indescribable violence.

When great big hailstones started denting his beautiful new pickup, as the stones got bigger and bigger, Truman spotted an old cotton gin by the side of the road. Certain his new truck was saved, Truman zoomed straight into the bay where the big cotton trailers were weighed—only his new truck crashed into a pit because someone had removed the scales that once filled the opening.

Just then, a car full of tourists, who had been following Truman on the highway, and thought he must know what he was doing by getting out of that storm, zoomed into the bay as well, crashing down on top of poor Truman and what was left of his new truck.

Truman was a good little cowboy, who worked on my friend's Pack-saddle Ranch near Balmorhea. Except he didn't always think things through before acting. Once, he was having trouble loading a horse into a trailer—and when a horse becomes afraid of going into a trailer he can be almost impossible to move. Truman decided he'd fooled with the animal long enough, so he jammed the reins in his teeth to bend down and grab a stout board without dropping the reins.

When he gave that horse a solid whack on the hindquarters with the board, the animal shot into the trailer, taking with him Truman's front teeth.

His wife was a sweet, patient lady, whom Truman fondly called "Lady Gray," but Truman did not always exercise the best judgment around women either. One time he was driving the stretch from Fort

Stockton back to Balmorhea, long before I-10 straightened the drive. That old highway twisted in right angles that mirrored surveyed section lines. When Truman encountered a long, long line of cars, and not knowing if it was a funeral or what, he zoomed around them, screeching to a halt just in time to avoid getting hit by a train at the crossing where the other vehicles were already stopped.

Back in the coffee shop at Balmorhea, Truman was relaying that story to the other cowboys at the counter. "And that was the biggest caboose I ever saw." Unfortunately, that was the only part of his story overheard by a rather hefty waitress, who misunderstood him and proceeded to empty her pitcher of ice water over Truman's head.

In 1942, the army air corps established a training school for pilots at Fort Stockton. The instructors were privately trained pilots from all over the country. The field was one of the primary aviation schools for the army, but you would never have guessed it from the planes they flew. They were mostly old Stinsons, maybe even some left over from World War I, with double wings on each side. Those biplanes looked like the Wright Brothers could have flown them — maybe they had.

Those poor young flyboys from cities back east got to Fort Stockton and stepped off the train looking sharply each way for cowboys and Indians. Like the boys we met in Austin, they actually believed what they had seen at the movies. Instead of Indian warriors, they got something far worse: dysentery from our water, which had excessive minerals.

Those fledgling airmen were in open airplanes, learning to fly, and scared to death. I hate to think how they handled their dysentery spasms while flying. To make things even worse, there was no canopy over those ancient cockpits, so the pilots also got terrible sunburns in the days before sunscreen.

During my college years, I was home in the summer. Some of us coeds were invited to dances at a GI club at the Pyote Air Field near Monahans, Texas. The army air corps had built a huge B-17 pilot school there and paved an entire section of land for runways. It was a perfect site for an air base because rain was scarce and the land was flat. The base was named for the peyote cactus, which grew there and had been used by the Indians for centuries for its medicinal and hallucinogenic effects.

Whenever the base held a dance, we Fort Stockton girls would get

all gussied up and pile into an army truck. That was no small contribution to the war effort, because those seats were hard on our derrieres. We always took a blanket because it was always chilly on the ride home, no matter the time of year. We would dance until after midnight; we always had a great time with the airmen.

After the dance, we climbed back into that army truck and headed home. We would seldom get back before three or four in the morning. Even though some of us had jobs the next day, we went anyway. We laughed all the way over and back. Some of the girls were great wits, and laughter helped keep our minds off the cold and our bouncing behinds.

We met a lot of attractive boys at the Cadet Club in Fort Stockton during the summers and at Christmas time. My mother and her friends organized the club for the airmen and got permission from the county to have a dance every Saturday night. While they wanted the boys to have a good time, our mothers were terrified that we might marry one of them.

We would go there and dance for hours, but never walked outside to smooch. After all, regardless of how good looking they were, those boys were perfect strangers. We stayed inside and had a great time dancing to the jukebox. We did not drink in Fort Stockton because no alcohol was allowed at the Cadet Club, and all the dances were amply chaperoned by the mothers and fathers of the town.

Usually, someone would invite the boys to Sunday dinner to feast on fried chicken and homemade pie. There were no taxis in Fort Stockton, so the airmen had to depend on us girls for rides. Mignon's mother had a big Packard that we loved because it held so many people.

In fall 1942, the song "White Christmas" was released. The cadets may have been brave in the sky, but I can still see their sad, homesick faces when they heard Bing Crosby singing that song. As they faced Christmas far from home and those they loved, some of them had tears in their eyes. That was one of my most poignant memories of the war years. Those Yankee boys got a happier shock on December 25, when our temperature was in the seventies and we all went swimming. Ours was certainly not a white Christmas, but we did our best to lift their spirits at eggnog parties in our homes.

Once, I met a boy from Wisconsin who was interested in art. Someone told him about me and we rendezvoused at the Cadet Club. He was

a big old boy, with feet to match, and a big, red nose that had peeled from being sunburned all the time. He was not only a good dancer, but he loved Fort Stockton. His name was Jim Avery, and he told me, "If I live through the war, I'm going to come back to Texas and move as close to these people as I can."

Well, don't you know that after the war, Jim Avery did return to Texas, becoming a highly respected designer of gold, silver, and bronze jewelry. Today, he owns James Avery Jewelers, a successful chain of stores throughout the state. He did just what he said he would.

In 2006, more than sixty years after we met at the Cadet Club in Fort Stockton, James Avery and his wife took me to dinner. He is still the same sweet guy and he still has that big nose, but it is no longer sunburned. After all these years, he is the only army flyer with whom I have kept in touch.

Along with most of my generation, I started smoking when I came to the university. I had a friend from El Paso, a quiet, shy girl who said, "Jane, I'm older than you and it's time for you to learn how to smoke. Come in here and lie down on this bed and I'll give you a cigarette."

She thought I would get dizzy and fall on the floor. "All you've got to do is inhale, then just blow it out." We thought we were such sophisticated smokers with our Camels and Lucky Strikes. In the forties, smoking was not considered dangerous to your health and there was tremendous peer pressure to become a smoker. Today, I am glad to see the strong social pressure against smoking. I have been a nonsmoker for almost thirty years, and choosing to quit was one of the best decisions I ever made.

One of my college friends who had to wear glasses so strong he was not accepted into the army, just loved to dance. He often asked me out whenever one of the big bands played at UT's Gregory Gym. We went there to listen and dance to Tommy Dorsey, Artie Shaw, Glenn Miller, and Les Brown—the biggest acts in the country—right there on campus. Although we had no cars or gasoline, we girls managed to attend the dances wearing our finest evening gowns. During the war, we had trouble finding pretty fabrics, but always tried as hard as we could to look our best.

When nylon stockings first came out, we were told to keep them in the refrigerator so they would be less likely to run. I doubt that kept the

hose from running, but I remember how cold my legs were when I put them on.

Three items were essential for a fashionable college wardrobe: saddle shoes, a string of fake pearls, and a fur coat. War or no war, we managed to get them. My coat cost $200, which was a lot of money back then. I earned it over several summers selling chickens that my daddy raised. It took hundreds of broilers for me to earn that coat.

In the forties, we college girls enjoyed dressing up for special occasions. We always wore gloves and hats, even on airplanes. Back then, you did not dress down to fly, you wore your finest. Most of us were so afraid of crashing that we wanted to meet our Maker in style.

I had my first airplane ride when four of us decided to fly all of seventy-seven miles to San Antonio to see Jean Ivey, who was visiting her aunt there. We went to the airport wearing gloves, but carried no fountain pens, as people said they would leak in the air. In those days, when most Americans had never been on an airplane, there were many strange myths about flying.

We waited for hours at the airport and the plane never came, so we went back to the boarding house. Finally, they called us and said, "It's coming!"

We hurried back to the airport and flew Braniff Airlines to San Antonio. When we got off the plane, Jean met us in her aunt's Cadillac convertible. The plane ride was fun, but that convertible made our hours at the airport well worth the wait. We spent two days riding around San Antonio in a borrowed Cadillac, flirting with the boys. Remember, I *was* nineteen.

In my senior year, the war news got better each month. I will never forget V-E Day, May 8, 1945, when the Germans surrendered. I was on a train heading to Dallas after visiting relatives in East Texas. As news of the surrender spread through the train, people were overjoyed. There were no strangers on board that day as we shared our happiness and relief. Our troops in the Pacific still had to face four more months of hard fighting. After that came the ominous possibility of an invasion of the Japanese mainland that might claim hundreds of thousands of casualties.

Throughout the war, we wrote the soldiers we met using lightweight onionskin paper, as our letters were being transported by the thousands

by air. They were the first air mail letters to be used by large numbers of Americans. It was hard to write those letters, since our lives seemed so mundane compared to the men in combat. It felt silly to scribble, "I went to a dance last week and had a good time," when I knew the soldier, who was far from home living in cramped quarters, was fighting and possibly dying for us.

Nevertheless, we were told that the soldiers wanted to hear any crumb of news from home, so we wrote to them and they wrote back. The letters we received were heavily censored by their officers. In fact, the officers even censored their own letters. We learned little news about the war from their correspondence.

In June 1945, I was graduated from the University of Texas, three weeks after we had defeated Hitler, three months before the Japanese surrendered. Far too many boys I knew or had danced with at the USO or Cadet Club had been killed or wounded in combat. After four years of fighting, I was no longer shocked by the news of death. Like millions of others, I had learned to accept the awful reality of war.

The war affected everyone differently. In Fort Stockton, there was a dentist I knew only by his nickname, "Sundown." Whatever his experience had been in the war, after he returned, both Sundown and his wife Myrtle took to drinking heavily. One night they got it in their heads to visit California and set off in their car, and after hours on the road checked into a little motel. Not realizing they had driven a huge circle, they had come into the east side of Fort Stockton, which had been built up only during the war, and they didn't recognize it.

When they did not come out of their room for three days, the proprietor was concerned they might be sick or dead, so he sent for the sheriff, Charles Baker. The sheriff knocked on their door and Sundown opened it. "Why, Charles Baker, what are you doing out here in California?"

4

D. J. Sibley

D. J. Sibley, who became my husband, was an only child. He was eleven years older than I. While we were growing up, I did not know him well, though he loved riding horseback with my mama and her friend, Myrtle Mendel. When he was a little boy, D. J. often rode a burro he had bought for fifty cents. D. J. pretty much grew up in the saddle, riding back and forth to his family's ranches. At a time when millions of other little boys only fantasized about being cowboys, he grew up being a real one.

When Dr. Phillip King's geological survey was mapping the Glass Mountains near Fort Stockton, D. J. followed the crew around, fascinated by their work. The surveyors liked the boy, and began asking him the names of local mountains. When D. J. answered them with great authority, the surveyors were impressed. If a mountain had never been named, D. J. made up one on the spot, and the surveyors wrote it down and put it on their map.

D. J.'s father was named Jacob. In the biblical tradition, the seventh son would become a doctor. The family's reliance on Bible teaching was hardly surprising. The father was a traveling preacher—Church of Christ, if my memory serves. His mother was an invalid, and although the family did not have much money, they possessed a powerful thirst for education and an unquenchable desire to succeed.

As the youngest of twelve children, Dr. Sibley was determined to become prosperous, and never to do without. One of his older brothers, Andrew, an established ear, nose, and throat specialist, helped to

finance Dr. Sibley's college education. He enrolled at the University of Tennessee at Memphis, then transferred to Vanderbilt University in Nashville, from which he was graduated first in his class. After graduating from Texas Dental School in 1910, he remained on the faculty as professor of prosthetic dentistry. When he was offered a prestigious position teaching at Washington University in St. Louis, he was unable to accept the job because he "broke down"—to use the vernacular of the day—with tuberculosis. Back then, TB was the equivalent of a complete physical breakdown. Leaving those afflicted unable to work for months or even years, it was often fatal.

Characters in nineteenth-century operas and literature often expired romantically from tuberculosis, but there was nothing romantic about the disease. It was called "consumption" at that time because it literally consumed the bodies as well as the day-to-day lives of its sufferers.

D. J. as a young boy with "Beans," his Boston terrier, outside the Stockton Hotel

Dr. Sibley's doctors suggested that he start a dental practice in a small town where he would have a limited workload. He chose Bertram, Texas, about forty miles north of Austin, where he became acquainted with John Potts, a local merchant.

John had met his future wife, Emma, in a dramatic fashion. As a petite young girl living in Liberty Hill, Texas, she was riding her horse on the main street of town when the animal spooked and started running away. Potts saw what happened, ran after the horse, caught up with it, grabbed the reins, and took control of the animal. Eventually, he married the young rider he had saved so dramatically. Their daughter, Effie

Potts, was the town beauty; newcomer Dr. Sibley fell in love with her. They married. Their only child, D. J., was born in Bertram in 1913.

When Dr. Sibley's TB did not improve in Bertram, his physicians recommended a regimen of outdoor exercise, advising him that fresh air would help restore his health. However, that conventional wisdom was the exact opposite of what he needed medically. Desperate to get better, Dr. Sibley followed his physicians' advice. He spent several months camping along the nearby Guadalupe River with his wife, small son, and his in-laws—only to find himself in a near-death state.

Finally, he entered Homan Sanitorium in El Paso, where he was given bed rest for an entire year, at last receiving the quality medical advice and care he needed. While his father was fighting for his own life, D. J. and his mother lived in a small apartment in El Paso. At the end of the year, Dr. Sibley's TB was arrested. He was one of the lucky victims of the disease who had a full recovery. He lived into his seventies.

Dr. Sibley decided to stay in West Texas because of its hot, dry air, thought to be beneficial for tubercular patients. He chose Fort Stockton after hearing about its famous Comanche Springs. Once he arrived with his wife and son, Dr. Sibley continued to practice dentistry, but his deep desire—like so many newcomers drawn to the region—was to own land.

Ironically, he became one of the directors of the bank where my father was vice-president of operations. In partnership with his father-in-law, John Potts, who had retired and moved to Fort Stockton, Dr. Sibley bought substantial tracts of ranch land in Pecos County. With the help of his outstanding foreman, Jeff Lyles, they developed a large and successful livestock operation.

To buy the land, Dr. Sibley needed to borrow money. As a director of the bank, he was able to borrow without limit. When the bank failed during the thirties depression, unlike some directors, he paid back all of his loans, even though it took him more than twenty-five years to do so. His final loan payment was made in 1950, only a few months before he died.

By the mid-forties, Potts and Sibley controlled 100 sections of land. A section comprises 640 acres, or one square mile, so the partners owned 64,000 acres, or 640 square miles of West Texas. Most of their sections were contiguous, on which they raised Hereford cattle, Rambouillet sheep, and Angora goats. In books and movies about range wars, the hostility between cowmen and sheepmen is overstated. It is true that

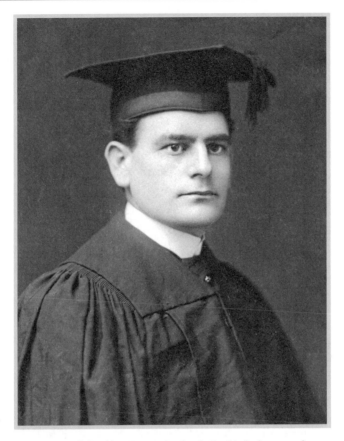

Dr. D. "Jacobi" Sibley Sr., my husband D. J.'s father, a graduate of Vanderbilt U.

across much of the frontier there was a certain cultural antagonism and even some violence, but in arid West Texas, it made sense to raise whatever creatures the land could support.

Cowboys lived on four of the Sibley ranches. As foreman, Jeff Lyle ran the entire operation. He was a fine rider and trained his own cutting horses. He and his horse worked as one. Jeff would indicate to the horse which cow or steer he wanted moved out of the herd, and the horse would nose around and soon that cow was off by itself and the herd was not disturbed. Jeff did it all with his fingers on the reins and pressure from his knees that his horse sensed.

Years later, when D. J. and I were dating, I worked the roundup. I

enjoyed being part of it, but I was scared to death of Jeff. Everybody
was scared of Jeff. His word was law and if you made a mistake, he
would let you know it in no uncertain terms. Then everyone within ear-
shot heard how stupid you were. Jeff was tough, but he could also be
gentle. I adored him and was in awe of him, but always did whatever I
could to avoid his wrath.

D. J.'s father and his father-in-law also bought the only decent hotel
in Fort Stockton, built by the railroad in 1910. The Sibley family ac-
quired it in 1917.

The Stockton Hotel was a two-storey building that erected by the
Kansas City & Missouri Pacific Railroad when it reached Fort Stockton
in 1910. In the early nineteen hundreds, as railroads came west, ranch-
ers offered them free land when the railroads were surveying their rights
of way. (A lot of people have forgotten that this, plus probably some
cash in a suitcase, was how Abilene, Texas, got its start.)

Communities in West Texas were desperate to have a railroad, since
ranching was the backbone of their economy. Ranchers needed railroads
to ship their cattle to market up north. Railroads also saved them from
the long cattle drives that took months and caused cattle to lose weight
and sell for less. Ranchers thought the railroad was the greatest inven-
tion ever, because it allowed them to ship millions of head of livestock at
a lower cost and at higher profit. The railroads set up watering stations
for their steam engines and built loading pens and ramps about every
twenty miles so the ranchers could load their livestock more readily and
get them to market in Kansas City and Chicago.

Later, they shipped cattle to Fort Worth, which, as a result, became
known as "Cow Town." It still is! The railroads owned and maintained
the right of way, but the system was mutually beneficial for them and
for the ranchers.

The railroads built depots and developed town sites, hotels, and
stores in the towns along their routes. That heavy-handed approach also
put them in direct competition with the very merchants and businesses
in the towns that had given them free land. Often, the railroad-owned
businesses failed, so eventually, the railroads sold many of their proper-
ties to local residents like the Sibleys.

Dr. Sibley once said to his wife, "This will be just fine, Effie. You'll
run the hotel and I'll have my dental office and we'll all live here in the

hotel." Mrs. Sibley was not happy with this arrangement, but never did argue with her husband. His parents moved into the hotel and D. J. grew up there.

For the next twenty-six years, Effie worked herself almost to death in that hotel, hating every minute. She also disliked her maiden name, Potts, and she had no middle name. Maybe that is why she was not too particular about naming her only child. D. J. never had a full name, but he did just fine known only and always by his initials.

Effie was unhappy about running the hotel, but felt she had no

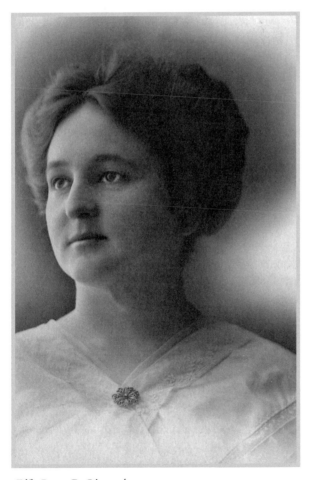

Effie Potts, D. J.'s mother, as a young woman

choice. In 1917, most women would never say "no" to their husbands. If your husband asked you to do something, you did it. Dr. Sibley did not force Effie to run the hotel, but he expected her to do that. Besides managing the hotel, she kept the ranch books and ran their household. They ranched, he had a dental practice, and she ran the hotel from 1917 until they sold it in 1943. Dr. and Mrs. Sibley worked hard their entire lives.

When I was in my teens, D. J.'s father was my dentist, and his mother and I became friends. Often, she called me if a couple staying at the hotel had teenagers with them. It was a small town and she thought the guest's children would enjoy knowing someone their own age. Through her, I met a lot of interesting people and made some lifelong friends.

D. J. lived in the Stockton Hotel for ten years, from age four to fourteen. His life changed most dramatically, however, the day he shot Burt Rainwater. Burt was a quiet man, a mechanic who owned a machine shop in Fort Stockton. His business was located in the old Pace Garage Building, a one-story structure built from well-cut limestone.

D. J. had brought one of his hunting rifles to Mr. Rainwater so he could work on the sight. When D. J. went by to pick up his gun a few days later, he tested the trigger, but had no idea there was a bullet in the chamber. His gun fired! That bullet ricocheted all around inside that stone building — around and around and around — while everyone inside stood transfixed. Finally, it landed in Burt Rainwater's forehead.

That did not bother Burt a bit, as he knew it was only a surface wound. Another half inch, though, and it might have killed him. Fortunately for Burt — and for D. J. — the bullet had already lost much of its momentum by bouncing off the stone walls of the garage.

D. J. was terribly upset and did not know what to do, so he took his gun and went home. He never said a word about the accident to his parents, hoping against hope that the news would not reach them. Living in a town of fewer than 3,000 people, he should have known better.

When Mrs. Sibley read in the local paper that Burt Rainwater had been shot by one D. J. Sibley, she was horrified. The editors had little news to fill their paper, so that one became a major story. After his mother recovered her composure, she and Dr. Sibley promptly sent D. J. away to school at New Mexico Military Institute (NMMI), thus

D. J. riding at the Ghost Ranch, which his family leased from Myrtle Mendel during the thirties

concluding his career as a notorious gunman. Although he loved telling stories, D. J. rarely told that one.

That accident had a major impact on D. J.'s life. At the military school, he spent a lot of time on the rifle range and the constant firing began to damage his hearing. When he graduated from NMMI at eighteen, he was awarded a commission in the US Army that could be activated when he reached twenty-one.

D. J. spent his last two years of college at the University of Texas, going on to UT Medical School in Galveston, and then to Baltimore City Hospital in Maryland, for his residency. He was in his third year of residency, specializing in internal medicine, when the war broke out in 1941.

D. J. thought if he signed up early, before he being called, he would get to choose his assignment, but things did not work out that way. He was assigned to the medical corps as a second lieutenant, and sent to Fort Bliss in El Paso as a lab officer. From there, he was shipped to Australia, directly in harm's way.

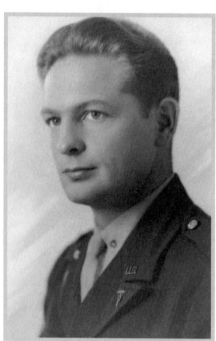

Captain D. J. Sibley of the US Army Medical Corps in 1941

Most Americans were unaware how close Japan came to invading Australia in 1942. The enemy had already taken the Philippines and most of the nearby Dutch and British islands in the South Pacific. Only Australia remained unconquered.

D. J. sailed across the Pacific on a passenger liner that had been converted into a troop ship. More than five thousand American servicemen were on board and it had to have been so packed that most of that crowd must have stood up the whole way. Many were in their twenties, slim, and in good shape. If they had made the same trip thirty years later, the ship surely would have sunk.

Somehow they dodged the lurking Japanese submarines and reached

Australia safely. D. J. spent a year training for the invasion of New Guinea in an outback village called Charlottesville. When the invasion came, he was in the thick of the battle. He was a portable surgical hospital officer stationed on the front lines, except there were no real lines.

The war in the South Pacific was the first time in our history that US troops had engaged in jungle fighting. Even members of the medical corps carried .45-caliber pistols at all times, even while performing operations. Our soldiers were not prepared for the terrain or the enemy they faced. For example, each member of the medical unit was given a hammock in which to sleep. Wisely, D. J. threw his away, because he had heard that Japanese soldiers were known to infiltrate our camps, slip underneath a hammock with a knife, and make permanent his victim's sleep.

D. J. gave the missionaries a lot of credit for their work in New Guinea. They had taught the natives pidgin English and Christian concepts, although most of the local tribes were still living in a Stone Age culture. Other than a few strategically placed leaves that almost covered their private parts, they were virtually naked.

The missionaries had lived and worked with the natives for two or three generations and built a genuine rapport with them, but progress was slow. The natives hated the Japanese, who had tried to make them slaves and treated them cruelly. As a result of this mistreatment, the natives welcomed the Americans warmly.

Buna, where D. J. was stationed, was a rural Roman Catholic mission that suddenly found itself the scene of fierce fighting near the church. The Battle of Buna lasted for weeks and was one of the great battles of the war in the Pacific. It was also a key victory in re-taking New Guinea from the Japanese.

His portable surgical hospital was staffed when D. J. first arrived in Australia. His unit was composed of five surgeons and eighteen enlisted men. They carried all their equipment on their backs and could set up and be ready for emergency surgery in forty-five minutes.

In New Guinea, the conditions under which they worked were terrible. Where roads existed at all, they were rutted and filled with thick muddy water so treacherous that only jeeps could get through. The roads were far too rough for transporting wounded soldiers.

Our medics soon found that the natives were superior to our own men in making litters from bamboo trunks for carrying wounded GIs

back to the field hospital for treatment. The tribesmen had developed the muscles and sure-footedness to transport heavy objects through the dense jungle. They also possessed a familiarity with the terrain that our men lacked.

The first time our medics set up their operating tent with its big red cross, a Japanese plane bombed it immediately. Right then, D. J. realized that the Imperial Japanese army cared nothing about the rules of war, nor for the Geneva Convention. After that bombing, our doctors never displayed a red cross again.

Instead, the natives built bamboo sheds with palm-thatched roofs, where the doctors could operate out of sight of Japanese planes. That almost relentless bombing, plus his practice on the rifle range at NMMI, and the frequent firing of nearby heavy artillery during three years as a surgeon in a combat zone, left D. J. hard of hearing for the rest of his life.

The surgeons often found themselves operating while they stood in water and mud under their open-sided tents, owing to the nearly incessant tropical rains. Sometimes, they were so tired they had to lean against the operating table to keep from falling over. D. J. once went six weeks without changing his clothes. That was the reality of working in a portable surgical hospital in the jungle. When one surgeon was near exhaustion, another took his place.

Even though D. J. was trained as a specialist in internal medicine, everyone who goes to medical school learns to perform surgery. During the war, he performed hundreds of operations.

D. J. participated in eleven campaigns, first in New Guinea, then in the Philippines, and it was always terribly slow going. Our forces took back the islands inch by inch.

When the US retook Corregidor in Manila Bay, D. J. was in command of the medical troops. One day, while his men were setting up their equipment, D. J. collapsed on the beach. That was when his hepatitis infection was diagnosed. He was sent to Australia for a month's rest, then returned to full duty. A few weeks later, atom bombs were dropped on Hiroshima and Nagasaki, and a week after that, World War II was over.

During the seventies, D. J. could never bear to watch *M*A*S*H*, the popular TV comedy about a mobile surgical unit in the Korean War. He said they romanticized everything and that life in a portable medical unit was serious business, not the stuff of humor.

During the war, I was not writing to D. J., but when I visited his mother, she always brought me up to date on what she knew, which was usually very little. She had no idea how bad things really were for him, which no doubt was a blessing. Despite that, she was terribly worried, because her only child was in the middle of a jungle war almost ten thousand miles from home.

5

On My Own

FTER MY GRADUATION from UT, I moved to Dallas, because I felt it was a better fashion town than Houston or San Antonio. My goal was to work at one of the large downtown department stores, so I applied to the advertising offices of the three largest stores: Neiman-Marcus, Sanger's, and Titche-Goettinger. Finally, I was hired by Sanger's.

It took me some time to be hired, because I faced the usual problem of any recent college graduate: all the stores wanted to hire new people, but they also preferred to hire new employees with experience. Problem was, most recent college graduates had none, unless they lied on their resumes.

Sanger's had a thousand employees in their downtown Dallas store. When they offered me a position in their advertising department, I took it. For the first time in my life I had a real job.

I really liked writing ads and quickly began to realize the more practical value of my UT education. Because I was a college graduate, the store buyers were relieved to have me writing their ads. Many of them had only a high school education, if that. Most buyers had moved up the ladder after first working as sales clerks. They knew how to buy clothes, but not so much about how to write ad copy.

At last! All those papers I had written at UT were paying off. Also, my work was appreciated, which really felt good. However, the best thing about that first job was seeing the veterans I knew from Fort Stockton and UT coming back home after the war ended.

Once they discovered where I was working, they all wanted just one thing: a new white shirt. Right after the war, there were few white shirts to be had, because during the war, most manufacturing had been converted to the war effort, so there was a limited supply of consumer goods, especially white broadcloth to make men's shirts.

Fortunately, the men's department buyer was a lovely gentleman who became my friend. Although all civilian men's clothing was still in short supply, and white shirts were especially hard to get, he was kind enough to stash some away for my friends.

Whenever a veteran I knew came in begging for a white shirt, my friendly buyer would say, "Just give me a little time, Jane, and I'll find him one."

I know he bent some rules, but he came through for me again and again. If we had not become friends, those boys would not have gotten their white shirts. That early experience taught me some valuable lessons about business: I learned it is not always what you know, but who. It also helps to make friends with co-workers.

In Dallas, I shared a room on Gaston Avenue with Doris Keene from Sonora, Texas, not too far from Fort Stockton, an arrangement that ended abruptly when Doris quit her job and moved back home.

After that, I moved into a house where I had my own room, but no kitchen privileges, so I had to eat out all the time. That was a lonely time for me, because my friends lived on the other side of Dallas and none of us owned a car. I rode the bus downtown to work each morning and back again every evening. There was no television yet, so I did a lot of reading. Except at twenty-one, I had no wish to spend every night with a book.

Luckily, my friend Patsy Kelley lived in Dallas, and on weekends, I often stayed with her family. Patsy's mother was a counselor at Highland Park High School, one of the best schools in Texas. Patsy's grandfather had been a rancher in Pecos County. After all these years, Patsy and I still stay in touch two or three times a week.

In 1945, Dallas was hardly the vast metropolis it is today, but it had lots of character. Then, as now, Highland Park was *the* place to live. Its residents had prestige and carried a certain attitude about themselves. More than sixty years have passed, but that old attitude prevails.

Downtown Dallas was bustling and lively. We would go to Neiman's

for lunch in its famous Zodiac Room. Even if we were only window-shopping, as we usually were, when we went to Neiman's we all dressed up. Weekends, we might go dancing at the Adolphus or Baker hotels.

Patsy and I liked the Golden Pheasant, a delightful restaurant owned by a man whose sister lived in Fort Stockton. He was one of the first members of Alcoholics Anonymous in Dallas in the early forties, and a friend of Bill Wilson, one of the two men who founded AA in 1935. Although he was alcoholic, he was anything but "anonymous." He was so proud of his sobriety that he wanted everyone to know that they, too, could become sober.

My time in Dallas was never unpleasant, more of a typical early post-war life. Nevertheless, after a year, I realized I no longer enjoyed advertising, neither was I getting where I wanted to at Sanger's. They insisted that I continue writing copy, but I had no desire to remain a copywriter. I had studied art and I wanted to practice the skills I had acquired at UT.

Furthermore, I really hated office politics, soon discovering that advertising breeds petty jealousies, and ridiculous rivalries. After a year in Dallas, I had had my taste of big city life. I decided to go home to Fort Stockton.

My friend June Beeman had also returned home. She had gone to Stephens College in Missouri, married a Missouri man, and brought him back to Fort Stockton. That fall, June and I decided to start the first preschool in our town. It was a natural fit: she had studied education, I studied art. I also had enough education credits to be certified as a teacher. Having a teaching certificate was my insurance policy. We artists do not have a guaranteed income when we leave college — or ever. I certainly did not need any "wise elders" to tell me that; there is a good reason why we are usually called "starving artists."

Our preschool was not affiliated with the Fort Stockton public schools. We wanted to remain private, so we could run it ourselves, without interference. In today's terms, our "school" might more properly have been termed a "day care center." Once established, we registered about twenty children, charging their parents $20 per child each month.

We never had to advertise for students, because in a small town news does travel fast, so we got all our students by word of mouth. As the preschool pioneers of Fort Stockton, we did not make much money.

Twenty students at twenty dollars a month grossed $400, which June and I divided after paying expenses. We broke even, but not by much.

Then June got pregnant. "Jane, I'm going to give it up."

I carried on alone for another year, which I was able to do only because I lived at home and had no rent, no car, and no other major expenses.

In reality? I learned a lot from the kids June and I looked after. It was amazing how much their drawings revealed to me about their lives. If a child was unhappy, it all came out in his art. The happy ones always used lots of bright colors: yellows, reds, and oranges. The unhappy children used black, brown, and murky colors.

There was not much I could do to improve things for the troubled children, but I always tried to give them some extra attention. Because I played the piano, we had a lot of music and singing. All my years of piano lessons had come in handy at last.

My Introduction to the Oil Business

In 1948, I realized I needed steadier income, so I shut down the preschool and went to work as a secretary for W. E. Lawrence & Sons, an oil and gas leasing firm. At the time, I had zero experience in the oil business, or as a secretary, but I did not let that hold me back. I made $25 a week, about the same as my peers in Fort Stockton. I probably took home about $100 a month, which came to $1,200 a year, so it was a good thing my expenses were few.

At the leasing office, I read the morning papers so I could clip pertinent articles, especially from the *San Angelo Standard-Times*, which ran the best oil and gas coverage in West Texas and New Mexico.

Fortunately, I had already learned to type, which was a great advantage. I had never been exposed to shorthand and, fortunately, they never asked me to use it. One of my greatest assets was my skill at deciphering the owner's handwriting, which was almost illegible.

What I liked best about working at Lawrence & Sons was the array of interesting people who came and went. When an oil company representative, their "land man," came to town, the first place he visited was our leasing office. We had all the maps and local information he needed. The main things every land man wanted to know was what land had

already been leased, what had not, and who held those leases. He could then scrutinize our current maps and note the expiration dates for each lease.

In our card file, we kept a record of every well being drilled in Pecos County. The men who worked in our office also had their own files and maps as well as many years of personal knowledge. Naturally, I paid close attention to what was going on, because I realized early that I was obtaining a master's degree in the oil business while being paid to learn about it.

Our office acted as the leasing agent between landowners and oil companies, or for any individual who wanted to lease the land for any purpose. We would represent either one, depending on circumstances. It was a good business years ago and it still is. I quickly picked up the oil industry lingo. For instance, I learned that when you are "drilling tight," that means there is no information available because the drilling company does not want anybody to know what they are doing. One word that oil people loved was "show," which meant they had found oil or gas. "Production" was the ultimate goal in the oil business, signifying that a well had begun producing oil or gas—and income for everyone involved.

The petroleum business is made up of oil companies, independent operators, and a surprising number of naive individuals who think they are going to get rich quick. There are not as many independents in the business today, since almost all of them quickly lose their entire investment. It is just as risky as putting money in a Broadway show, only without ever enjoying the glamour of opening night.

Oil companies usually offered land owners a lease for three to five years with an option to renew. They might lease a section of land for $20 an acre. A section is 640 acres. At $20, that is a $12,800 bonus to the landowner, which was a nice bit of money back then. Every year, the oil company pays a landowner a rental fee for holding the lease. The renewal fee used to be $1 an acre per year, but has increased since then. When time comes to renew a lease, the negotiating process is a lot like playing high stakes poker.

The oil company may begin by saying, "We are going to drop your lease." Or they may try to get it at a lower price per acre.

The landowner may counter by saying, "No."

Depending how much drilling activity there is in an area, and how much the company wants to hold on to that lease, they might choose to make a better offer.

Obviously, land owners would rather have a lease than not, but the lease does not claim the lessor is going to drill. These are leases that merely reserve the right to explore a leasehold with seismographs, and only possibly to drill. That go-or-no-go is completely up to the oil company.

In some ways, this process resembles the movie business. When a producer or a studio options a book or a screenplay, that does not mean the movie will be made. All it means is they have the right to make the movie some day. In the oil business, as long as the lease is in effect, the lessor must pay an annual rental fee.

However, once the oil company decides to drill, then begins a major investment of time and money. If they drill and achieve production, which means the land produces oil or gas, the land owner then receives a percentage of that production's value. The land owner royalty used to be an eighth, but is now up to three-sixteenths or more. If the company holding the lease gets production, they no longer have to pay a rental fee or to renew the lease on that land.

During my less than two years of working in the Lawrence & Company office, I learned valuable details about the oil business, never imagining how vital that would become later on.

One of the most memorable characters in my life during these years was Fort Stockton's veterinarian, Dr. Ben K. Green—who was short in stature, gruff, and barrel-chested. There were always rumors floating about town that Dr. Green was self-taught, but had that even been true, his reputation would have been the same, because he was a skilled vet, especially with large animals. Of course, that was the ability we local folks needed most during the war.

However, it was Dr. Green's chickens that always drew our attention—they were the most beautiful chickens we had ever seen, all exotics that came originally from China.

We all knew him as "Doc," but called himself the "village horse doctor." No one in town had any idea he would become a famous author of short stories, or that *Village Horse Doctor West of the Pecos* would be a best-seller.

Most afternoons around three, Doc Green came by the Lawrence office and treated my friend Nig (she sunbathed a lot and got very dark) and me to a nickel Coke at the drug store. Doc was a bachelor, but he was a perfect gentleman to us, although it was his joy in life to be cantankerous, so he could be very rough with others. His only eccentricity was that he would never sit with his back to any door.

In a way, Doc was a bit of a catch. He had a thriving vet practice, and his sheer orneriness made him just the kind of man some women long to tame. Eventually, he presented an irresistible challenge to just such a woman, who was as tall and stately as he was short and stout.

She was also a little man-crazy, and because of that wee flaw, her first husband had left her. Despite her reputation, Doc humored her and let her dress him up for social occasions, and they later married. As far as I know, they were quite happy, at least for a time.

On one occasion, D. J.'s father, who had retired from dentistry, needed to have a tooth pulled. He couldn't do it himself, and there was no one else at hand, so he went to Doc Green, coached him through the process, especially what *not* to do, and Doc did the job. Dr. Sibley later said that Doc had performed well, a tall compliment from D. J.'s father.

An Unconventional Romance

D. J. SCARCELY HAD time to be delighted by the prospect of coming home after the war before he was told some terrible news. During his discharge physical, the army doctors discovered that, besides hepatitis, he had contracted tuberculosis. Immediately, D. J. received orders committing him to Fitzsimmon General Hospital in Colorado, where his TB would be treated by army doctors for the next year.

After that year was up, he came home to Fort Stockton, having been ordered to "take it easy." That order was equally easy for him to obey, since he had little energy for anything else. After six months at home, he went back to Fitzsimmon for another six months, a routine that continued for three more years until the cycle ended in 1948.

Most likely, D. J. had contracted tuberculosis in the Philippines. At the time, after the severe Japanese occupation, the Philippines did not have good sanitation. Neither were the Filipino people known for their personal hygiene. They expectorated on the dusty ground, and when that dust was disturbed by barefoot people, airborne diseases such as tuberculosis could and did spread easily.

Even though he contracted TB on active duty during the war, D. J. never received disability payments after his discharge from active army duty. The army had decided D. J. was exposed to tuberculosis during his medical residency in Baltimore, and could have caught it then.

That was not true, but D. J. was philosophical about their decision. He said the disability payments did not matter to him since he could

always make a good living as a doctor, *provided he survived!* D. J. was not only suffering from active tuberculosis, but his father was diagnosed with active leukemia.

Dr. Sibley had the lingering form of the disease that some elderly people contracted, and he endured it for at least five more years. To make matters worse, D. J.'s father was profoundly deaf. At sixty-six, after years of ranching, practicing dentistry, saving, buying, and selling, he became terribly ill and could no longer enjoy his life fully.

His wife, Effie, must have been very lonely. Dr. Sibley had been growing increasingly deaf for twenty years, so her ability to talk with him became minimal. Now that they had sold the hotel and finally had some free time to spend together, his health was failing and he could not hear a word she said. He bought hearing aids, but in those days they were pretty much junk. One of my mother's friends carried hers in her purse, where she reported it did her as much good in there as in her ears. She also hated all that squeaking they used to make.

In 1946, while taking his father for an examination at the Mayo Clinic in Rochester, Minnesota, D. J. came through Dallas.

We arranged to go out one evening to attend the ballet. Because he was eleven years older, I had never really thought much about him, nor had I ever spent any time alone with him. Eleven years' difference in age is a lot when you are in high school. Besides, D. J. had also been away for four years during the war.

Although I had never had a date with him, I really was looking forward to getting to know him better. Perhaps strangely, that he was a TB patient at the time of our first date did not faze me. On our first outing D. J. even brought along his new puppy—a dachshund.

How that man loved his dogs! I had a fur coat, a mink-dyed muskrat that looked pretty *D. J.'s 1937 graduation* darned good, especially to his dog! That puppy *photo, UT medical school* just loved my fur coat. He must have thought he

was back with his mother, because he kept trying to suckle my coat all night.

Our evening began at a party in the Adolphus Hotel. The head of my art and advertising department at Sanger's was holding a soirée for his mother, who completely dominated her son. She also tried to run the rest of the world and seemed to get by with it. We stopped briefly at the party, before going on to the ballet.

While I have no idea which ballet we saw, I knew right away that I liked D. J. After that evening, our age difference no longer seemed important to me at all.

When he came home from the war, D. J. was desperately ill, but on our date in Dallas he did not look at all sick. He had really good genes; despite growing up in the hotel, he also worked on the family ranch, often riding horses. He had a powerful physical presence: horseback riding kept his spine straight, and at military school, he learned gymnastics and built up his muscles.

Not only was he an imposing, handsome man, I also thoroughly enjoyed his conversations. That was when I began to realize what a keen mind he had, the quality I always liked best about him.

Even though we had not really known each other until after the war, I soon realized how much we had in common, D. J. was shipped off to New Mexico to school when he was fourteen and I was three, so when I saw him again after the war, it was like meeting a new person. After going out with him that first time, I knew he was a man I *could* marry, but in all the time we dated, I never mentioned that even once. If I had, I was pretty certain that might have scared him half to death.

After sharing our delightful evening in Dallas, and he left to bring his father to the Mayo Clinic, I did not see D. J. again for months.

I am glad I returned to Fort Stockton when I did because that gave me the opportunity to get to know D. J. He was home whenever he was out of the hospital, so we started dating regularly. I was also able then to spend several years living at home, having no advance idea that they would be the last years of my father's life.

Only two years after I returned to Fort Stockton, my sweet daddy died of a heart attack. He was only sixty-three, and I was still his darling little girl. His heart attack came totally out of the blue, a terrible shock for our family. This may sound odd, but I believe a sudden death is

easier on the person who dies than on those left behind. Someone who dies in a few seconds does not suffer, but that is not true for his or her family. My parents had been married for almost forty years and Mama was in absolute shock.

Daddy died instantly, and I was at home when he passed away. I tried calling D. J., but he could not hear the old country phone ringing in his parents' home at the edge of town. At that time, all calls went through operators, and I urged her, "Keep ringing, keep ringing," but D. J. was too far away from the phone to hear it.

I called another physician and had to explain where we lived, which was no easy task. At that time, none of the streets in Fort Stockton had signs. We residents all felt street signs were unnecessary, because we all knew where everyone lived, at least everyone we cared about.

Mama took Daddy's place at the post office after she had been appointed postmistress. At first, that job was a real trial for her, especially because one of her employees had wanted to be named postmaster and was deeply resentful that she obtained the position. To cause her trouble, he added extra change that altered each day's cash total to make her look bad. He well knew the total had to come out right to the penny.

Finally, she caught on to what he was doing. "I want to check your account separately," she told him. "Let's go over it together."

He realized the jig was up and soon things straightened themselves out.

Whenever D. J. was being treated for TB, I dated other men, but never seriously. During those times, D. J. and I would date for six months, then not see each other for six more months. Hardly an ideal situation for sustaining a romance, but it made us appreciate even more the times we did spend together. When he was home, I had no interest in seeing anyone else. We never talked about getting engaged, but I knew he was dating no one else in Fort Stockton. Of course, there was not much competition, because by that time almost everyone we knew was already married.

A typical date for us in Fort Stockton was not exactly what anyone would call "sophisticated." Some couples went to the country club. Some played bridge. We usually went to the ranch to check the water gaps.

These days, I doubt if more than five out of every hundred Americans even know what a "water gap" is: fences that stretch across an arroyo but do not quite touch the ground. They are high enough so water

can flow under them in case of a heavy rain or flash flood and to keep waterborne debris from blocking the fence. At the same time, they must be low enough to stop livestock from squeezing under the fence and getting away.

We usually rode out to the ranches in his father's old 1938 Chevrolet and it always managed to get us there and back. We would check to see if all the fences and gaps were up and in good shape, or if some bull had gone through one of them and pulled it down. Sometimes, we rode in D. J.'s little Plymouth, the one he left in Fort Stockton when he went overseas in the army.

Often, we drove out to the Coyonosa ranch to check water levels in the stock tanks. Nothing is more important to a rancher than a reliable supply of water. On most West Texas ranches, there are no steadily flowing creeks, streams, or springs. All the water must come from windmills, drawing the water into metal or stone or concrete storage tanks that can hold several thousand gallons. From there, the water passes through pipes into troughs that use gauges that keep the water level constant. The troughs do not hold much water and are scattered around the ranch so livestock will have water available without having to walk too far to get a drink.

In the Glass Mountains, the water table is 1,300 feet below the surface, so the wells had to be drilled at least that deep.

One day we went out to Coyonosa in D. J.'s little Plymouth in the middle of the afternoon, because he usually rested in the morning. This trip took place during the first year of a disastrous drought that started in the late forties and continued through the mid-fifties. We stopped at a metal tank, checked the water level, and found it too low. That tank had sprung a leak around the bottom, the most expensive and most difficult kind of leak, because to fix it, you had to empty the tank of its valuable treasure: water.

D. J. was unhappy enough about that leak, but then things got a whole lot worse. The water had soaked into the ground around the tank, and somehow his car became mired in that mud. Once it was stuck, after trying everything we could think of, we could not get that car unstuck.

We tried our best to push the car out and then we gathered some greasewood brush to tuck under the wheels, but that muddy ground was still sucking ferociously at the car wheels. The car would not budge and

soon we were each covered in muck. It was not easy to get a car stuck in a mud hole during a drought, but we managed.

Nearby, we saw a starving cow. She was a young heifer, but her hip bones were already sticking out. She had collapsed, and we knew if she stayed down, she would die because she could not reach enough water or grass to survive.

D. J. said "We have got to get her to stand up." We took her tail and twisted until it was so painful she started lifting her rear end to get away from the pain. We pulled and pulled until she got onto her front feet: an ancient practice cowboys call "tailing a cow." We were proud to see her up on her feet, which meant she might survive, until not five minutes later, down she went again. This one was definitely not turning out to be our most successful date.

D. J.'s car was stuck, we were slathered with mud, the heifer was dying, and the sun was setting. The approaching sunset probably does not mean much to you modern couples, but we were not yet married. Back then, Fort Stockton mores were hardly modern. According to the strict social code of our day, an unmarried couple could never be alone out in the country after sunset.

"D. J.," I said, "nobody is going to believe we were stuck in mud. I have trouble believing it myself. But I have to get home. I can't be out here alone with you after dark."

In Fort Stockton, that alone would have ruined my reputation forever; the tough women in my family tree always cared what people thought of them, and I did, too. Luckily, we got the car out of the mud, and after breaking the speed limit for many miles, I reached home soon after dark.

Mama understood, but a lot of people would not have, including D. J.'s mother. Back then, people in small towns were very rigid about the behavior of their young people.

On happier dates, we usually went to the movies or to dances. D. J. was a wonderful dancer, but we did not go to many dances because it took so much energy for him to dance, and he had little to spare. Mainly, we would sit and visit or look through books together. And always, we loved to eat Mexican food. That was a given. D. J. and I loved that food and there was a marvelous Mexican restaurant in our little town called "The Original."

I really enjoyed being with D. J. Our only problem was that he did not know how his future would turn out. He was beginning to doubt whether he would ever have enough energy to practice medicine full time. Being a doctor is strenuous enough, and running his family's ranches was physically taxing, too. He was unsure he would ever be well enough to do either, let alone both.

He decided against concentrating on ranching because the Sibley's foreman, Jeff Lyle, was getting up in years. Without anyone to replace Jeff, and with a severe drought underway, D. J. thought it made more sense to sell the livestock, and lease the land to someone else.

Jeff was a fine man. I believe he was from Georgetown, Texas. He packed his saddlebags and went west while still a young man. As I said before, not only was I always in awe of Jeff, in fact I was scared of him,

D. J. (left) and a cowboy holding a live eagle roped by the cowboy at the Glass Mountain Ranch. The building in the background is the Stockton Hotel, built by the railroad right after World War I.

In his prime, Jeff Lyle was a man never to be crossed. Even in his waning years, he learned how to take advantage of both his gruff reputation and his age.

One time, years later, D. J. and I were considering buying or leasing a ranch in the Delaware Mountains near Van Horn. He climbed into a sports car with a young lawyer, then asked me to ride in the truck with the horses and Jeff.

That was when Jeff turned to me. "Jane, I wish you'd drive. You know, I've had a few coronaries."

So I drove, from Fort Stockton on toward Van Horn. When I pointed out to Jeff that we were running low on gasoline, he said it was fine, because if we ran out, he would just switch to the truck's backup tank. Sure enough, we did run out of gasoline, but when we switched tanks, the engine only coughed, then quit.

Jeff said, "Well, I'll just sit here in the shade, and you can catch a ride up to the service station"—about twenty miles away!

As it turned out, the first car that appeared was a limousine with a chauffeur bringing a Florida couple out to California. Almost breathlessly, they asked if I were a real Texas ranch girl.

There I was, standing in my boots, next to a truck with four horses riding in it. I had to admit that I guessed I was "a Texas ranch girl." The two Floridians were completely enchanted, and delivered me to the nearest service station, twenty miles down the road. That was where I found D. J. and the lawyer, calmly chatting as though nothing at all had happened to me.

Jeff Lyle was indeed a savvy foreman. He had always run with a firm hand the ranches for which he was responsible, but it was becoming clear that he would not be able to do that much longer. After he retired, he would come into town to see us, and would get exasperated because he never could remember our daughter Mahala's name, so he started calling her "Shiloh," after the Civil War battle.

"Shiloh" was the only nickname she ever had; after Mahala became pregnant and was puzzled over what to name her daughter, I suggested "Shiloh," which delighted her. That is how our first granddaughter received her name.

Although D. J.'s physical condition was causing him to doubt

whether he would be up to running the ranches after Jeff retired, there was also the ongoing severe drought to consider. Because we had no idea how long it was going to last, D. J. opted to practice medicine.

"There is one thing about being a doctor," he told me, "to make a living depends on what you have between your ears. I know medicine and I can always barter my medical services. In ranching, you are dependent on weather and so many other things beyond your control. No matter how hard you work, you can reach the end of your rope and go broke. You can lose your land, your livestock, and everything you own."

When the Fort Stockton Bank failed during the Depression, D. J.'s family went into debt. He was determined not to repeat their experience. True to his word, D. J. and I were never in debt. We bought nice things, but we always paid cash. As some say these days, D. J. was debt-averse, and I believe that is a good way to live.

His mother could no longer manage the ranch bookkeeping. She had her hands full just taking care of his father. They had sold the hotel in 1944 for $100,000, and received a certain amount of cash down and the balance monthly. A few years later, the hotel burned, so they never received the rest of their money. If the new owners had fire insurance, it was not enough.

The hotel dated back to 1910, and its wiring was in terrible shape, which is what caused the fire. Soon after its lower floor was restored by businessmen with farming interests, the hotel burned again. Today it is only a pile of charred rock.

D. J. decided to stay in Fort Stockton and open his medical office. His father was still alive, though gravely ill, and somebody had to look after the ranches and make decisions. Like me, D. J. was an only child who never had any siblings to help him. We were a couple throughout 1948 and 1949, without any official engagement. In 1949, D. J. received his discharge from the army at last, after seven years' service. That year, his health improved enough so he could begin his medical practice, albeit at first in a somewhat limited way.

Shortly before Christmas that year, D. J. said to me, "Well, let's get married." He did not drop to his knees, there were no candles, or violins playing in the background, but I required no such ambiance. I knew we were right for each other.

7

An "Old Maid" No More

IRST THING D. J. and I had to do was pick a date for our wedding, not an easy decision: one of my friends was about to deliver her fourth child and D. J. was her doctor, so he had to estimate when her baby might be arriving.

In those days, doctors never induced labor. The baby came when it came and it was the doctor's duty to be on hand to deliver it. D. J. felt my friend's birth date would certainly occur by the end of February. He suggested, "Let's try for the first of March."

We did not plan a large wedding, because Mama was neither financially nor emotionally up to producing one. If we followed tradition, I could not continue my work at the leasing office and simultaneously have enough time to prepare for a big wedding. I had participated in enough traditional weddings to know they demanded a lot of work.

One thing I knew from experience: every tiny detail had to be perfect. You had to have showers and a bridesmaid's luncheon. There had to be little bows here and little bows there. I had been a bridesmaid too often to select my own wedding party without making somebody unhappy. I could not invite twenty bridesmaids, so we settled on none.

Besides, I had no desire to star in a big wedding. D. J. had recently opened his medical practice, but was not yet in tip-top physical nor financial shape. After careful consideration, we decided to be married with only our immediate families present. Of course, that choice disappointed everybody we left out. Given our circumstances, there was no way we could possibly please all the uninvited.

Present at our wedding was my mother, Dr. and Mrs. Sibley, and Mrs. Russell, a friend of D. J.'s mother who came out to Fort Stockton from Central Texas. She was uninvited, but arrived anyway. We were married in front of the fireplace in one of the officer's homes at the old fort. The location of our wedding was the 100-year-old home of Myrtle and Hood Mendel.

The Mendels had restored their house beautifully. They attended, too, though Uncle Hood was obviously ill. Dr. Sibley, leaning on his cane, was also terribly sick. These men were only in their early seventies, but in 1950, they looked quite old. When they were born, life expectancy for men in America was only around forty-five years.

We had the not-so-minor problem of selecting a minister to marry us. I was reared a Presbyterian. My daddy had been an elder and was the church treasurer. Dr. Sibley was the son of a traveling Church of Christ preacher, and he had heard enough sermons to last several lifetimes. As an adult, he never bothered going to church. He would send them a little money now and then, but would not attend. D. J.'s mother was a Methodist, who went to church regularly after they sold the hotel, when she was freed at last from her endless duties.

D. J. had become an Episcopalian at medical school, when he was living at a priest's home in Galveston. One of his classmates was the nephew of the priest and both medical students attended church together. I had enjoyed the Episcopal services I went to while at UT. I told D. J. I would be happy to join his church. There was only one problem: there was no Episcopal church in Fort Stockton.

That discovery caused me to remind D. J. that it was proper for us to be married by the minister of the bride's church. We paid a call on the Presbyterian minister and his wife, Dr. and Mrs. Thomas Brewster, who were of Canadian parentage. They were very proper Presbyterians, and the night before our ceremony, while we were visiting in their home, D. J. and Dr. Brewster got into a bitter argument about King Henry the Eighth.

Although Dr. Brewster's father had been a member of the Church of England, apparently he did not approve of his father's faith. He said to D. J. that Henry had no right to create the Church of England.

D. J. said that he did. That exchange began a long and heated discussion that included the laying on of hands of bishops all the way back

to Saint Peter. Their voices kept getting louder and they were about to come to blows when I realized we would not be getting married if they continued their ferocious debate.

I interrupted their shouting match, declaring, "D. J., we have to go!" I led him forcefully—almost pulling him—out of their house. My maneuver must have worked; the preacher did show up next morning to marry us. Everyone hewed to the plan, including my pregnant friend, whose baby D. J. delivered the night before our wedding.

Twenty-five years later, we had a lovely anniversary luncheon on the lawn of our home in Austin for friends from all over Texas. After everyone left, I said, "You know, D. J., it's been a wonderful twenty-five years. By the way, what did you ever pay Dr. Brewster?"

"I didn't pay him a damn thing."

"D. J., you know we are not really married. Oh, Lord!"

The preacher was dead by then so I could not send him a check. But I told D. J., "Wait till you get to heaven. You will pay!"

We were married the morning of March 1, 1950, and I wore a beige linen Christian Dior suit that I can still wear. For accessories, I wore navy straw shoes and a custom-made hat.

After a small reception, we left town in D. J.'s snazzy new Buick coupe for our honeymoon. Come to think of it, it was *our* new Buick. We drove to San Antonio that afternoon and stayed at the St. Anthony Hotel. When we asked for the bridal suite, they said they did not have one. We did manage to get a large suite, though, so large that we invited our friends, Jean and Mercer Ivey, to join us from Taft, Texas.

We stayed in San Antonio for three days, so D. J. could examine his medical records at Brooke Army Hospital at Fort Sam Houston. For the first time, I saw his lung X-rays and marveled that he had survived.

We went to New Orleans, then on to Bellingrath Gardens in Mobile. It was early spring and the flowers were already blooming. I had never seen rhododendrons and there were masses of them. The azaleas were out of this world, too, certainly out of the West Texas world where I had spent most of my life.

We drove down the west coast of Florida to visit D. J.'s old chief of medicine, Dr. Schmink, from Baltimore. He had retired to Orlando, which, in those days long before Disney World, was one huge retirement hotel. Everybody sat in their chairs on the hotel porches all day

and rocked. "Rocked," of course, had a slightly different connotation back then. Elvis was still a good five years into our future.

Dr. and Mrs. Schmink were lovely people and we enjoyed them. Then we drove on to Miami, because D. J. wanted us to visit the Bahamas for our honeymoon.

When we tried to get a hotel reservation in the Bahamas, a travel agent told us, "This is the height of the season and you cannot get a room. Everybody has gone to the Bahamas."

D. J. was floored. He had never had trouble getting a room anywhere. The travel agent insisted, "It is absolutely impossible. But you could go to Cuba."

D. J. asked me, "Do you want to go there?"

"No, not when we are so close to the Bahamas."

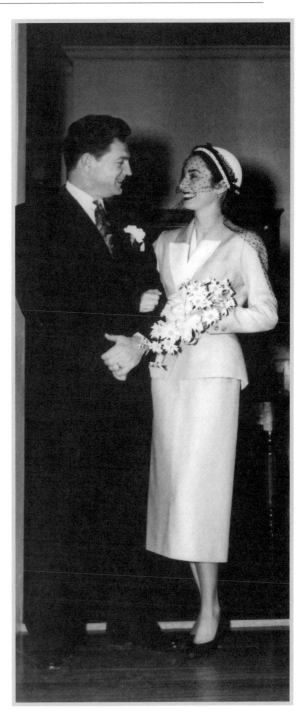

D. J. and I were married in Myrtle and Hood Mendel's home, one of three restored officers' homes on Fort Stockton's parade ground.

The travel agent repeated, "All I can do is get you a flight over there, but you will have to sleep on the beach."

I said, "That will be fine with me."

Then we got stubborn and made our own flight plans. We flew over to the Bahamas without a hotel reservation. I loved the trip over the Florida Strait with its beautiful, clear water. The travel agent had lied to us about the hotels in the Bahamas being full. He just wanted us to go to Cuba since he got a larger commission on hotels in Havana. This was nine years before Castro took power and Cuba was still a hot spot for tourists.

After landing in the Bahamas, we had no problem finding a lovely room in a small hotel. The social editor of the local magazine asked if we would be willing to have our picture published in the next issue. I have no idea how they found out we were there. Most likely, the hotel reported couples who were honeymooning. We were photographed for the *Bahamas Magazine,* along with the rich and famous who were wintering in the islands.

We had told no one where we going on our honeymoon, as we had endured enough flak over having a private family-only wedding. None of our friends in Texas knew we were in the Bahamas. One night, we were sitting on the terrace of a lovely hotel overlooking a vast array of yachts moored in the shimmering harbor.

I realized that even though we had all been through the same war, there was a lot of money left somewhere. Unfortunately for us, it had yet to reach Fort Stockton. All of the waiters were wearing red uniforms with white gloves, looking as if they were ready to fight for the Redcoats against us colonists in the Revolutionary War.

Behind us was a long table of Bahamians, along with a few Yankees, and several handsome British Royal Navy officers. There must have been fifteen or twenty people at their dinner table. I could hardly help overhearing some of their conversation. One man was sitting next to a lady with a New York accent. He said, "Those Texans. They are so ignorant and awful."

She replied, "They are not."

"What do you mean 'they are not'? They are all rambunctious and loud."

"They are not like that at all."

"How do you know?"

"I visit Texas regularly."

"Where?"

"It's a very small town."

He was almost rude to her, demanding, "Where?"

Finally, she said, "Fort Stockton."

I was eavesdropping intently and started to tell D. J. to listen to the conversation, but he was already terribly hard of hearing, especially when there was background noise. I could not yell in his ear in such a sophisticated place. He was sitting opposite me and I knew he had not heard a word they were saying at the next table.

The lady continued, "My friends in Fort Stockton are well-educated, send their children to college, and are interested in music and art."

The man beside her remained unconvinced. "That's amazing. I would like to meet Texans like them."

After his remark, that was my invitation to get up and introduced myself. It would also have been obvious to everyone that I had been listening in on their conversation. Since D. J. had heard nothing, he could not understand why I was acting so agitated. He thought I was going crazy.

Back home again in Fort Stockton, I happened to tell Bill Lawrence, the map-maker at the leasing office, about my overhearing that strange conversation in the Bahamas.

He said, "It's not strange at all. That woman is my aunt. Why didn't you tell me you were going to the Bahamas? She has a winter home there."

The woman who had been defending Texans was the aunt of my co-worker. Think of the good time we could have had with her in the Bahamas. Today, I would have known to send her a note with a waiter, but back then I did not realize I could do any such thing.

When we returned to the mainland, we drove up the coast of Florida while the orange trees were blooming. There were no car air conditioners then, so we had all the windows down to savor the fabulous aroma of orange blossoms as we drove along. We visited Savannah to see an old army friend of D. J.'s and we stayed at a hotel where ducks swam in a pond in the lobby.

Then we drove back through Natchez, Mississippi, visiting the

antebellum homes and gardens there. After a wonderful three weeks, we headed home. We went all out on our honeymoon, knowing that once D. J.'s practice began growing, there would be no time for a long vacation. When we returned in late March, we wasted no time starting a family. I was already pregnant when we arrived home.

Before re-opening his practice, D. J. decided to do a brief medical review, because it had been so long since he had worked in a hospital. He decided to go to El Paso to work with Doctors Wilcox and Deiter, two fine surgeons who were glad to have him assisting them. Closing his office in Fort Stockton temporarily, D. J. and I went off to El Paso for six months. While we were gone, his father's leukemia worsened and D. J. arranged for him to get the first cortisone shots ever given in Texas. The injections helped to raise Dr. Sibley's red blood count for a while, but then it dropped again.

I loved El Paso and while there I got my first glimpse of the world of medicine as well as what it was going to be like to be married to a doctor. The physicians' wives in El Paso had an auxiliary and invited me to join. I was surprised at how readily they accepted me into their group. They did not judge me by my husband's position or by our temporary stay in El Paso. They held teas, parties, and luncheons, and we were always going somewhere.

More important, I learned how these women coped with being doctors' wives and yet were still able to keep their husbands in line. Their men were always busy and some doctors do tend to be egotistical, jealous, and to act like big shots, so their wives worked quietly behind the scenes to defuse potential controversies among their husbands. I learned that if the wives got along well, their husbands could put aside petty jealousies—a very practical education for me. The practice of medicine was never the central topic at our gatherings. More important to the auxiliary members was forming lasting friendships.

D. J. and I often went across the border to Juarez, Mexico, for lunch or to shop. I still have clothes that I bought in Juarez fifty-plus years ago. One day, we were having lunch at the famous Hotel Del Norte in downtown El Paso, when a beautiful young woman walked in. As she was escorted to her table, everyone was staring at her. She was a knockout. At first, we could not decide who she was, until finally we realized

the glamorous young woman was Elizabeth Taylor. She was engaged to Nicky Hilton—destined to be the first of her seven marriages—and she was in El Paso to visit his mother. The Del Norte was one of the original Hilton hotels.

El Paso was a wonderful place to live, and after his refresher ended, D. J. was asked to begin work with one of the top physicians in El Paso, eventually taking over his practice. He thought about that offer long and hard, but knew in his heart we had to go home to Fort Stockton.

D. J.'s father was dying, and Jeff Lyle, the Sibley's ranch foreman, was getting older. D. J. realized he had too many family obligations and business interests not to continue living in Fort Stockton. Earlier in the summer, D. J.'s father was hospitalized in El Paso. By the time August arrived, he was failing rapidly. His worsening condition caused us to come home a month early. In September, Dr. Sibley died at home in Fort Stockton, not long after we returned.

By then, I was six months pregnant. When my doctor examined my X-rays, he thought he was looking at a paraplegic, because we learned then that I was missing a vertebra in my lower back. That condition most likely caused two of my children to arrive about a month premature. Ever since that diagnosis, I have been extremely careful to maintain proper posture and always to get plenty of exercise.

One of my personal characteristics is never to waste my time. While I was awaiting the birth of our first child, I decided to renovate an old house the Sibley family had owned for years. It was located above Comanche Springs, and during the war, the government had taken it over and converted it into three apartments. After the war, it was returned to the Sibleys. I took on its renovation as a personal challenge. I was eager to make that house our home.

D. J. was happy for me to take charge of work on the house, since he was busy with his practice. Other than my art studies in college, I had no background at all in architecture or construction, so I had to learn on the job. Did I ever have a lot to learn!

The house had adobe walls and its ceilings were twelve feet high. The inside walls were seventeen inches thick, the outside ones twenty-one inches thick. Ours was not a fancy house, but it was an unusual combination of Indian adobe and American Gothic, with hardwood floors and a steep-pitched roof.

We had to remove all the plaster from both the outside and inside walls and to re-plaster both. We redid the floors, wiring, and plumbing, and even installed air conditioning units in the windows. Home air conditioning was new to most Texans then and it made our lives much more comfortable.

We added a new roof, new porches, new steps, and enclosed one of the back porches to create a good-sized kitchen. This colossal effort was almost like starting from scratch, but gave me intense hands-on training in renovation as well as in the fine art of dealing with contractors.

We had one unforgettable contractor named George O'Neill, who was a devout Baptist. Redheaded and red-faced, he always arrived at dawn. While he was putting shingles on the roof, each and every time he hit a nail he would say "Goddamn." This man could not hammer without cursing. It was part of his routine. I could hear every one of those "Goddamns," so when I asked him to watch his language, he said he would. Despite his promise, the very next time that hammer landed, out came another "Goddamn."

The house we restored in Fort Stockton. When we left Fort Stockton for Austin, we donated the house to Pecos County for public use.

D. J. had made it clear to me that he did not want to deliver our baby himself. He said that if anything went wrong, he would suffer from that for the rest of his life. He felt it was better to ask another doctor deliver our children. He was right.

The Sibleys had donated the land for the county hospital, which was built in the late forties. D. J. had delivered the first baby to be born there. By the time our child was born in 1950, there were four doctors practicing in Fort Stockton. Dr. Oswalt, whose son Chip later became one of our neighbors in Austin, was the doctor who delivered our son Jake.

Before we had a county hospital, Fort Stockton's private hospital was owned by Dr. and Mrs. Walter Craddock. I did not learn until years later that when we were still dating, Blanche Craddock would often say quite firmly to my future spouse, "D. J., you have just got to marry Jane."

Of course, I mentioned earlier that he and I never talked about that subject. D. J.'s regular response to Mrs. Craddock was, "We will marry when the time is right." He never was one who liked to rush into anything.

The Craddocks came from Alpine, where they had been running another small hospital. When Walter and Blanche lived in Fort Stockton during the war, they could find no help, except for a maid or two. He looked after the patients, she was his nurse. Together, they cooked, cleaned, and washed all the hospital linens. They ran every aspect of the entire hospital, and they lived in the building as well.

Dr. Craddock had black hair and eyes, bushy eyebrows, and a stubbly beard. He had the stocky physique of a wrestler, and had actually wrestled in college to help pay for his tuition. Their hospital had a tiny patch of lawn, and one morning, Dr. Craddock was cutting the grass. A lady drove up in a big fancy car and honked her horn. He stopped mowing and walked over to her.

She said, "My good man, come here. My husband is the colonel at the air field and I want you to come mow our lawn."

He said, "Well, let me think about it."

She told him, "I will pay you well. What are you getting here?"

"I get pretty good pay and my meals are included."

"That's okay. I'll give you what you're getting here."

79

"One more thing, I get to sleep with the boss's wife."

She almost fainted, slammed her foot on the gas pedal, leaving a thick trail of exhaust as she roared away. Dr. Craddock had a great sense of humor and we hated to see them leave town. However, soon after the county hospital opened, the Craddocks closed their hospital and left.

Jake was born October 24, 1950, in the county hospital; he immediately got sick. He screamed and hollered without ceasing. Jake was exposed to an awful infant diarrhea infection in the hospital. All the babies who stayed overnight there got it, too, but the ones who went home did not.

As it turned out, the carrier was a nurse who worked in the hospital. The Craddocks may have had a small private hospital, but the county operation finished a poor second in health and sanitation.

I stayed in the hospital for two weeks. First, because of Jake's illness and, second, we were waiting for the workmen to paint our bedroom. There was no other room for me to move into at home. I found the color I wanted on the cover of *House Beautiful*, which had featured Alan Ladd's pale blue piano. I wanted our bedroom to be exactly that color.

The poor painter would mix the paint and put a few droplets on the cover of the magazine and send it to the hospital. After considering his suggestion, I would say, "Add this and add that," and send it back so he could try mixing it again.

You could not choose colors from a paint chart back then like you can today. They had basic colors in oil paints and there were none of those shake-and-mix machines we see now in every hardware store. After numerous failed attempts, the painter got the shade exactly right: a beautiful turquoise. However, oil paint back then contained lead— whose poisonous effect was already well known—so I could not return home until the paint had dried thoroughly, which took two weeks.

The strain of Jake's diarrhea was so virulent that we tried every medicine we could find on my poor baby, but none of them worked. He just kept on screaming. I came home to an unfinished house, a baby with horrible diarrhea in my arms, and a contractor on the roof yelling "Goddamn" every time he hit a nail.

D. J. was working night and day, so much he was almost never home. One morning, Mr. O'Neill was laying shingles and after his

fiftieth curse, I yelled, "George, one day my baby is going to start talking and I don't want his first word to be 'Goddamn.' You finish that roof and get on out of here!"

Motherhood had hit me with full force. I could not have made it without help from D. J.'s mother, who was now a widow with extra time on her hands. My mother also helped us in the evening after she finished work at the post office. Both grandmothers were glad to help and, fortunately, they got along well.

After we finished that renovation, the old house was now a lovely home. I had learned so much dealing with all the builders, construction workers, contractors, and painters, that I felt a real sense of accomplishment. I believe our new family was meant to live in that house because Mama Minnie had lived there around 1915. She was married in front of that very same fireplace.

As a young girl, she slept on the sleeping porch where she could catch the night breeze. At the time, Pancho Villa was on the loose, raiding ranchers on both sides of the border, so Mama slept with a sawed-off shotgun by her side. Only she and her sister, Bird, were at home. Her brother had joined the marines, another brother had died, her father had skipped town, and her mother was busy running the Riggs Hotel.

While I was having a baby and renovating the house, D. J. moved his practice to larger quarters. When his family bought the hotel, they had also bought a two-story stone building a block and a half down the street. The building, erected by the railroad, once housed apartments upstairs and a grocery downstairs, but it had been vacant for many years. It had a full-sized basement, which was still filled with windmill parts and old commodes from the hotel. I never could figure out which was the more useless, a broken windmill or a broken commode. And we had lots of both.

The basement was a great place to store D. J.'s medical journals. He always intended to read them, but rarely had time. Since he could not bear to throw them away, they went into the basement and piled up over the years. D. J. was working terribly long hours but must have had one night off since I was soon pregnant again. I remember standing in our kitchen saying, "Dear God. Send me a little girl."

During the twenties, D. J.'s family had bought the Coyonosa Ranch, north of Fort Stockton, which turned out to be the best investment they

ever made. We leased the minerals on the ranch to Humble Oil, later renamed Exxon, and were thinking about trading the surface land for a forty-section ranch north of Van Horn in Culberson County.

In early 1952, D. J. and I, along with our mothers, drove out to take a look at the Culberson County ranch to decide whether to buy it. We left Jake at home with the maid, as he was only two. After looking it over, D. J.'s mother, D. J., and I agreed to buy the ranch and to proceed with negotiations.

On the way back home, we crossed the salt flats between the Delaware Mountains and the Diablos, an area that had been the site of the Salt Wars between Indian tribes who made annual trips there for salt to preserve their meat. For years, the Indians fought among themselves for access to the salt, and later they battled the newly arriving ranchers, too.

Shortly before our trip across the salt flats, there was a pretty good rain, and the ruts in the road were about fourteen inches deep. That stretch across the salt flats was one of the roughest roads I had ever traveled, and I was eight months pregnant. As we headed home, I turned to the grandmothers sitting in the back seat.

"I have a feeling that I'm going to have a little girl and D. J. and I would like to name her for both of you."

My mother was named Minnie and D. J.'s mother was Effie.

I said, "I think Minnie Effie is a nice name." (I was joking.)

They both shrieked in unison. "Oh, no, don't put that name on a pretty little girl."

"Well, what would you suggest?"

Effie said, "I don't have a middle name, but my mother's name was Victoria."

My mother's middle name was Mahala, so I said, "We'll call her Mahala Victoria." That is how our daughter got her name.

We came home to Fort Stockton to learn of a horrible tragedy. One of our friends had a four-year-old daughter and five-year-old son. Valerie and her brother were playing while their mother had gone to get the maid. Their unmarried aunt was supposed to be watching them.

Unfortunately, she was not paying attention to the kids, who were playing with matches. Valerie's nylon gown caught fire and covered her in flames at once. With such terrible burns, the little girl had no chance at all to survive.

All of us felt terrible as we knew how easily it could have been one of our own children. Hastily, I helped put together an Episcopal service for the family with a reception following. In the midst of our preparations, I realized that Mahala Victoria was about to make her entrance into the world. Our beautiful daughter was born March 26, 1952. Just like her older brother, she arrived a month early.

I remember everything about those dramatic days: the rough road across the salt flats, the grandmothers' wise decision to veto the name "Minnie Effie," the tragedy of Valerie's death, and the joy of Mahala's birth. Everything had happened during one week in 1952.

D. J. and I decided two children were enough. A few years later, a pharmaceutical company was doing a study on birth control and asked doctors' wives to participate, so I volunteered.

None of us volunteers were reimbursed for our efforts, but were given free the new birth control gel. I said, "This is great because I'm not going to have any more babies." Well, nine months later, along came Hiram. That was one birth control product that never made it to market. Lots of unplanned babies were born that year.

Toward the end of my third and final pregnancy, I developed an edema called pre-eclampsia, a toxic infection that can kill the mother and her baby. I was hospitalized for a week, and released only two days before Christmas. I had no energy for all the things that needed doing. We had ordered bicycles for Jake and Mahala through the local drug store. They arrived right before Christmas, unassembled.

The four doctors then practicing in Fort Stockton rotated being on emergency call each week. They also rotated working on holidays, although D. J. always seemed to be the doctor who got Christmas. My infection kept me from doing anything about the children's bicycles. I was stuck in bed, tottering around, and eating soup.

I begged the poor pharmacist who sold us the bikes to come help us. He stayed up half the night putting those darn bicycles together. Today, bikes come already assembled, which must make plenty of parents and store owners happy on Christmas Eve.

My doctor was a friend, Alan Sherrod, who practiced in the small Texas oilfield town of Iraan. When my contractions began, I called him. Alan reassured me, "Don't worry. Don't worry. I'm only twenty-six minutes away in my Aston-Martin."

"I'm not worried."

He said, "You are right there next to the hospital. Don't worry."

"I'm not worried."

But I went into labor in the middle of the fireworks at a New Year's Eve party for the children. I started counting my pains and said, "D. J., I think I had better go to the hospital." I was wearing a pretty velvet maternity dress along with red high-heeled shoes and diamond earrings. As we headed straight to the hospital, I was pretty certain I was the best dressed patient of the night.

Before we zipped across town, D. J. had called Alan, but my doctor was not home. He was at a Marathon Oil camp attending a Christmas party. In those days, oil companies housed their employees in the field and there was no telephone at that camp. D. J. called the deputy sheriff nearby, who went out and informed the doctor. Unfortunately, Alan was not driving his Aston-Martin that night, but had his wife's Cadillac. It took him a good bit more than thirty minutes to drive those sixty-five miles.

While we were waiting for Alan, D. J. told me, "I am going to put you in the delivery room." I was concerned that he might to have to deliver the baby and knew he did not want to.

D. J. called Mama, who was at the country club party. She rounded up three other doctors and brought them all to the hospital.

About that time, Alan thundered in, sporting a sequined tie, all dressed up for New Year's. When I came to after giving birth, I remember that tie of his flapping in my face. Alan had no time to get into a scrub suit, although I saw D. J. wearing one with a New Year's cap on his head. Hiram arrived at 12:40 a.m. on New Year's Day, the first baby of 1957 to be born in Pecos County. Once they were certain the baby and I were in good shape, D. J. and Mama headed for the club and stayed up the rest of the night.

About the time they left, I had an unexpected visitor: a beautiful and elegant woman friend who was in the hospital for alcohol treatment. Since the hospital was packed, they had put her in a tiny room, hardly larger than a closet. In fact, it *was* a closet—one where they kept caged frogs that were used for fertility tests. Their cage held water and the frisky frogs were leaping around in it. That activity alone would have been bad enough if you were sober, but if you were

recovering from an alcoholic black-out, jumping frogs are not what you want see.

When my friend came to and saw those frogs, she went crazy. Ours was a small hospital in a small town, and somehow she had heard I was there. She came running down the hall screaming my name and waving her arms.

"Janie! Janie! Janie, are you awake?"

Of course I was awake. Hospitals are always crowded and noisy during the holidays and New Year's Eve is the worst night of all. That is when people stab their best friends, shoot their spouses, or have wrecks after drinking too much. Finally, we calmed her down, got her back in the closet and removed the frogs.

My doctor and his wife were partying with D. J. and Mama while I was all alone and hungry in the hospital. Pretty soon, the festive country club crowd descended on my room; they were feeling no pain and were eager to see Hiram. Luckily, our baby was in seclusion in the nursery, well fed, and asleep—unlike his mother. I was wide awake and no one had thought to bring me food or juice.

Right after the raucous country club gang departed, a distraught nurse arrived around four in the morning. Apparently, my room had become operations central for the entire hospital. The nurse was holding a lighted candle and she looked like a picture of Florence Nightingale from my high school history book.

"Mrs. Sibley, I have a problem and I don't know what to do."

She was the head nurse, so her statement was not encouraging.

"The electricity has gone off in town and we only have a few hours of auxiliary power in our generator for the operating room." She was frantic, almost in tears. She asked me, "Who do I call?"

Because of all the noisy visitors I had endured, I was wide awake but still had my wits about me. "You call Mr. Welker at home. He is the manager of West Texas Utilities and a nice man. Very slowly explain the situation and he will help you."

She phoned Mr. Welker and calmly described the problem. So many people had called and cussed him out whenever there was a power outage that he was impressed by her polite manner. She returned to my room minutes later, flashing a big smile.

"He told me the power would be back on in less than two hours. A bird hit the lines, but everything is going to be okay."

She was immensely relieved that the hospital had enough power for the operating room until the electricity in the building came back on.

That concluded my first night with Hiram, a child who definitely came in with a bang.

Jake, holding newborn baby Hiram, seated beside Mahala in 1957

8

Motherhood

THE YEAR AFTER Hiram was born, I contracted mononucleosis, which was terribly debilitating. All I could manage to do for months was to stay in bed. Before I became ill, D. J. and I had bought the Gray Mule Saloon in Fort Stockton, which we were restoring.

Built in 1896, the Gray Mule was in surprisingly good condition. Elodia Barron had rented the space for her Mexican café, but to meet city regulations, we needed to add another restroom. We were adding the facility to the outside of the building.

I told Magdalena, my yard man, that I would give him our old ranch pickup if he would make 200 adobe bricks from which we could build the restroom. He was so thrilled at the prospect of getting the truck that he eagerly agreed to make the adobes.

At the time, our home was located on the parade ground of old Fort Stockton, where, more than a hundred years earlier, adobe bricks helped to build the fort. Even though I had too little energy to supervise his project closely, I knew Magdalena could make adobe, because his own and most other Mexican families built their own houses from adobe. After Magdalena tested the clay soil, he told me it had just the right consistency for good adobe.

One morning a few days later, I pulled myself out of bed to check on his progress with the bricks. I had on my brand new Neiman-Marcus red brocade lounging pajamas, thinking I would feel better if I dressed up. In grand style, I strolled through the brush and mesquite onto the parade ground behind our house, where the men were making the adobe.

Magdalena and his son, with their pants rolled up, were tromping around in the shallow pit, mixing water with clay mud for the bricks. Magdalena spoke little English and my Spanish was no better. The adobe looked good to me, but I did not see any hay for the bricks. Hay helps bind the muddy clay and water. You do not need much hay, but I did not see *any,* so I said, "Magdalena, *donde está . . .*"

Oops, I realized at that moment that I did not know the Spanish word for "hay," so I used the word for "grass."

"*. . . secate para el adobe?*"

He scratched his head, then finally, he said, "Oh, Janie, I used a little bit of sheet." He motioned to the corral and then I got what he was talking about.

We had two Arabian horses. I did dressage on one and D. J. rode the other for relaxation whenever he had time. Magdalena had used pure Arabian "sheet" for the binder, and it worked just fine.

Once I understood what Magdalena was saying, I leaned against that old pickup truck I was giving to him, dying with laughter on the inside, but not daring to laugh out loud so as not to embarrass Magdalena.

Adobe bricks are made in a frame on the ground, divided into sections, one for each brick. A mix of mud, water, and hay is dumped into each section, a lot like baking mud pies. As the mixture dries, the wood absorbs some of the moisture, and so does the air and the ground underneath it. After a few days, the frame is removed and you can stack the adobes like bricks of gold. Only in our case, it was mud and *manure.*

Finally, we completed the restroom and the restaurant was opened. It had a charming Mexican décor, with murals and painted glass, and the food was excellent. Unfortunately, it was not successful financially, closing a few years later.

It took me months to recover from my mono. While I was sick, I did not feel like doing a single thing. Eating and sleeping were the most taxing activities I could manage. Mono was widespread in the fifties, when it was "the kissing disease." Maybe so, but I assure you I did not get it from kissing. In fact, I have no idea how I ever contracted it. All I wanted most was to rid myself of it. The local girl who helped me out during the day had her own family, so she went home every night. I was lucky to have our two grandmothers living close by to help take care of the children in the evenings.

In 1957, during summer solstice, I was weaning Hiram on the longest day of the year. In those days there was no pill available to stop my milk flow. Instead, I took something strong—D. J.'s tightly woven Guatemalan belt it was—and wrapped it around my breasts. After about a week, that compression gradually stopped the flow of my milk. Taking a pill sounds like a far more pleasant alternative.

I was so tired from the mono that, eventually, I called Miss Merle Broyles, who helped my mother when I was born, and later while I was an infant. She had received her "training" as a nurse by helping local doctors during the terrible influenza epidemic of 1918.

By the time I asked Miss Merle if she could stay with Hiram at night, I was so exhausted from caring for my two older children that I could not seem to get any sleep. She quickly agreed to come every evening, staying all night to tend our baby. We had a bedroom where Jake and Mahala each had a bed, but Hiram was still in his crib.

Miss Merle would sit in a rocking chair and watch Hiram, making certain he was covered and did not roll over. She took wonderful care of him, gave him his bottle, and brought him to me so he could nurse. Miss Merle was precisely the kind of nurse every mother needs. She might not have had formal training, but she certainly could have earned a PhD in common sense and kindness.

Miss Merle was an old maid who lived alone with her little bantam chickens. While watching Hiram, Miss Merle always got up and made herself a cup of coffee around four or five in the morning—and strong coffee it was! You could float a horseshoe in her cup.

One morning not long after the sun came up, Miss Merle was in the room with the baby. Jake and Mahala had gone outside to play in a big sand pit under the tree. She heard them in the yard, but paid no further attention to them. Everything sounded perfectly normal to her. Then, all of a sudden, Miss Merle could no longer hear them. They were gone, and must have left the yard around six o'clock.

When she realized they were not there, and Miss Merle came running into my room, I could see she was terribly upset.

"Jane, Jane. The children are gone! They were out there playing under the tree in the sand pit only a few minutes ago."

At once, I got up, threw on my robe, dragged myself out to the car, and drove across the street. I got out and looked over the railing to see

if they might have drowned in the public swimming pool. Mercifully, it was empty. Back in the car, I drove all around the neighborhood calling, "Has anyone seen Jake and Mahala?"

They were five and six at the time, plenty old enough to get into big trouble.

Jake had a little red tractor that he loved to ride. When we first found it at Western Auto, I asked, "How much does it cost?" It was $39.95, a good bit of money to us at the time.

"Jake, that is too expensive," I told him, "but I will let you help me paint the bathroom and, if you do a good job, I will pay you and then you can buy the tractor." That was his first paying job and he did his part well. Jake earned the money, I matched it, and we bought the tractor. Jake was so proud of his tractor and, of course, he had a little red wagon that he hitched to the back.

While Miss Merle was looking after Hiram and I was trying to sleep, Jake put his little sister in the wagon, attached it to the tractor, rode on out of our driveway, and headed up the street five blocks to Highway US 290, where all the big trucks roared through town.

While I was racing up and down the neighborhood streets calling out the car windows, Jake crossed that busy highway, pulling Mahala behind him. First they went to the filling station and visited with Jake's friend who owned it. Then they came back across that dangerous highway and went into a restaurant where many local men sat around every morning and drank coffee. We called it "gun row," because a lot of them were deputies with their pistols in their holsters.

Jake and Mahala sat in a booth and ordered their breakfast. Jake had no money, but that did not faze him one bit. When it was time to pay, he went up to gun row and found another of his friends, who owned a service station downtown. Jake was mighty big on service station owners.

He said, "Tommy, you're a good friend of mine."

Tommy beamed. "Yes, Jake, I'm a good friend of yours. What do you need?"

"I need some money for breakfast."

"All right, I'll take care of it."

Jake thanked Tommy, left the restaurant, and headed back home. By that time, I was back at the house. Frantic as I felt right then, I did not

want to call Mama, because she might have said, "Oh, Jane, you did the wrong thing. . . ." I definitely did not need to hear that.

As soon as the children finally showed up, I ran outside and hugged them with a delirious mixture of relief and exasperation.

"Where have you been, Jake?"

"Oh, we went to the restaurant for breakfast." He acted as if he ate out every morning.

"We had milk," Mahala piped up.

Jake always felt he could do anything. The summer he was nine he walked into the lumber yard and told the manager, Sam Lloyd, "I want to work for you all."

Sam turned to his wife, who did the books, and said, "I figure we can give him something to do." They both knew Jake well because he visited regularly.

Sure enough, Sam found some chores to keep Jake busy. It did not take Jake long to find where things were kept, and he would go get them for the owners when they needed them. He learned a lot about the lumber yard that summer. Sam told me, "Jane, we can't put him on the payroll because it's illegal. Heck, he's only nine years old."

I said, "Don't worry. I'll give him some money."

"No, I'll pay him. He's helping *us* out."

I think Sam gave him money out of his pocket. His wife told me, "Jake earned it. He's good help."

Jake had many interests. One day, he decided to make a cake, so he went over to see Willie Rowe, who was a fine artist. (I keep some of Willie's etchings in my powder room to this day.) Jake said, "Willie, I want to bake a cake." She was happy to oblige him, so they baked a cake together, and it was good, too. Jake liked to cook; he made several cakes that year.

He had an independent streak early on in life. It is a shame he was too young to run the Mexican restaurant we put in the Grey Mule Saloon. With Jake in charge, it might have been a success.

9

⤷

Preserving History and Moving a Church

B Y 1957, when Hiram arrived, I had been married for seven years, had three children, a busy husband, and the crowded social calendar of every doctor's wife. D. J.'s and mine was a good life and we were happy living and working in Fort Stockton.

Although I had always enjoyed dressing up, during the fifties, I was doing a lot of painting and renovating. There were even some years when I paid too little attention to how I looked than I used to. Fortunately for my self-esteem, I was not alone; my condition was all-too-typical of other mothers who were busy rearing small children.

So, all you ladies, here is a caution from Jane Sibley: unless you pay close attention to how you look to others, dressing down can become a habit; a very bad one. Sometimes back then, I might even go into town wearing jeans with paint on them from an art project, and with my hair tied up in a bandana.

Our local medical auxiliary members were all physicians' wives from five or six nearby West Texas counties. One morning, we four Fort Stockton wives had an epiphany: in a moment of extreme clarity, we decided to begin making an effort to dress appropriately in public. Of course, our husbands all wore suits to work, but we realized we were looking more like house-bound babysitters. We all agreed it would be better for our husbands' reputations as well as for our own self-esteem, if we ourselves maintained a more professional appearance.

Whether we liked it or not, even in a little town, people looked up

to doctors' wives. We were aware that they talked about us, telling each other how good we looked, or, sometimes, they might make unkind comments. That was why our group of four resolved not to give our critics any additional ammunition. We never discussed the subject again, but simply made the changes we needed to and became more conscious of our appearance. For one thing, we stopped wearing blue jeans to town. In fact, I dropped jeans altogether from my wardrobe for the next fifty years, right up until I started wearing them again in 2006.

Maintaining a stylish wardrobe was fairly complicated in our little town. There was not a single place in Fort Stockton where any of us could shop for beautiful clothes. True, through their amazing catalogs, Sears & Roebuck and Montgomery Ward had been supplying rural areas for decades, but the mid-fifties were long before the days of high-end fashion catalogs.

As a result, when I was really desperate to buy a nice outfit, I would call Neiman's in Dallas. They would send me whatever I needed, always with shoes to match. One time, I ordered a gorgeous maternity dress from them, made from a red silk Indian sari trimmed in gold thread. That beautiful dress was one of the few joys I ever experienced while pregnant.

Even though I did not have much money to spend on clothes at the time, I always shopped at Neiman's when I could. Everybody I knew shopped there. If they told you otherwise, they were lying. Neiman's was where you went when you wanted to invest some money in a good purse or some stylish shoes.

A hundred and fifty miles northeast of us in San Angelo were two good department stores: Hemphill-Wells and Cox-Rushing. Hemphill-Wells had a highly respected furrier who visited San Angelo and who sent out notices that he would be available to discuss furs. One time, I took the itinerant furrier some panther skins given to me by the government trapper who had caught and killed the big cats on our ranch.

At first, the furrier was horrified. He was insulted that I would assume he would work with predator pelts. However, I refused to allow myself to become angry at the furrier's rudeness, so I left the pelts with him until he could examine them more carefully. Those skins really were exquisite.

"Look," I told him, "I'll go out to lunch and come back later. Meantime, you can have a closer look at my legally acquired panther skins."

D. J. and I at the Symphony Jewel Ball

Once the furrier took his "closer look," he became quite excited about their quality. So much so that he had made for me a beautiful panther fur cape.

My career as a Fort Stockton cultural leader almost came to an untimely end when a community concert organization of which I was a member contracted with a ballet troupe to perform in our town. When the company arrived, we discovered their agent had neglected to inform us that, quite sensibly, they could not perform on a varnished floor because it would offer too little traction for ballet toe shoes.

Our only venue—the high school auditorium—was varnished, so we

received permission from the school board to sand its floor. Sadly, during that process, one of the sanders accidentally burned down that wing of the school. Undaunted, we put on our brave faces and asked permission to perform in the Latino school instead. Incredibly, that show *did* go on.

Back in the fifties, D. J. and I became involved in conserving and protecting the historic landmarks of our town. We tried to save the first building in Fort Stockton ever constructed by an Anglo. It had been built by a prominent merchant and was a fine old adobe building with a pitched tin roof.

When I sketched the building's interior, I was surprised to discover packing crates that came from San Antonio by wagon with provisions for the town. Those crates were broken down before becoming ceiling insulation. The crates covered the *vigas*, logs that ran across the ceiling from wall to wall. Trees for timber were so scarce in our desert, that those logs had to be brought to Fort Stockton by wagon from the Davis Mountains, a hundred miles to the west. Above the *vigas* the builders had placed the packing crates, covering them with adobe dirt mixed with water, which supposedly would seal the ceiling and keep water out. Despite our best efforts and the building's obvious historic value, the county judge and commissioner's court decided to tear down the structure, replacing it with a library. What they commissioned turned out to be one of the ugliest buildings in town. Unfortunately, it is still standing.

Not long after the fine old building was demolished, D. J. and I met an architect from the University of Texas, asked by local officials to create a city plan. When he saw all of our historic buildings that were still standing, he implored us to organize a historical society in order to preserve them.

At the architect's urging, D. J. and I organized the Fort Stockton Historical Society. We brought together a few friends and obtained from Internal Revenue a 501(c)(3) designation as a non-profit. We thus became "conservationists" long before that term ever became popular.

Fort Stockton's first outstanding local historian was my friend, Judge O. W. Williams, who died in the 1940s. A Harvard graduate, he lived in one of the old officer's homes in Fort Stockton.

Having contracted tuberculosis, he came to Texas during its frontier days for its good clean air and milder climate. After arriving in

Dallas, he was unable to find work as a lawyer, so he answered an ad in a newspaper for a job on a surveying crew. That off-beat job caused O. W. Williams to become one of the original land surveyors of the Texas panhandle.

That job also nearly cost my old friend his life when he found himself in the path of what must have been one of the last great buffalo stampedes on the Texas plains. There were five men in his surveying crew and they were out where the land was totally flat and empty for miles in every direction. There were no trees, not even a good-sized rock. The group had left their camp in an arroyo a considerable distance away, and the men were walking about mid-day.

Judge Oscar Waldo Williams (left), John Potts (middle), and George Sachse (right). Judge Williams, a Harvard-graduated lawyer, is my friend Claytie's grandfather; Mr. Potts, a merchant, is my husband D. J.'s grandfather; and Mr. Sachse, a rancher, is my friend Patsy Kelley's grandfather. They stand outside the Stockton Hotel, where they had just enjoyed a Sunday lunch.

Far away in the distance they heard a sound that resembled thunder. Because there was not a cloud in the sky, the crew realized the noise had nothing to do with weather. As the ominous sound grew louder and louder, minute by minute, eventually the men became aware it was the roar of a monster stampede. Back then, that sound could only mean buffalo. They also realized they had walked too far to reach even the relative safety of their arroyo campsite.

All the while, that thundering was growing louder. Then they began to see dust clouds to the north, stretching from one side of that horizon to the other.

They knew they were in terrible danger. Buffalo can run at a tremendous speed and there were thousands of them in that rushing herd. However, the only defense those men could muster came from their deep knowledge of buffalo habits. From experience, they knew that if two buffalo in the front line broke wide and went around them, the others would follow that lead.

That unique buffalo trait was absolutely their only possible chance to survive, and even then, their odds were none too good.

All they had with them were their surveying instruments. They set their transit in front of them on a tripod, then the men lined up single file behind that fragile contraption of wood and brass, which was certainly not much of a barrier, but was all they had.

I feel sure they did some serious praying as more than 200,000 tons of buffalo galloped straight at them. Sure enough, the two buffalo in the front line spotted their transit tripod, broke slightly to one side, followed by all the other buffalo, missing the surveyors by scant inches on either side.

The men felt the panting breaths of those enormous animals as they passed; the sound of their hooves was deafening. Fifteen minutes it took for that immense herd to pass those very lucky surveyors.

Even though they thought they were going to die, the worried surveyors lived to tell that tale, none receiving so much as a scratch. The men and women who settled West Texas had acquired real wisdom about the animals that lived in the lands they all shared. Those surveyors survived because they knew and understood the nature and the habits of the buffalo.

Their miraculous escape would make a great scene in a movie, but

the director would have to use special effects. Not even actors desperate for work would ever let a herd of buffalo come charging past them only six inches away.

It was Judge Williams who first got me interested in history. I was only a child when I first visited him. His stories always held me spellbound. He had moved to Fort Stockton in his younger days and was elected county judge while Judge Roy Bean was a justice of the peace in Langtry, Texas, where he became famous as the "Law West of the Pecos."

At that same time, Fort Stockton was going through a terrible situation with the local sheriff, Andy Royal. He had become a little dictator and was completely out of control. Royal would tell some poor cowboy to "dance" in the street and, as he hopped up and down, would empty his six-shooter at the victim's boots. He especially enjoyed killing Mexicans for no reason at all. The sheriff took the law into his own hands, murdered innocent people, and terrorized the community.

Fort Stockton's business leaders decided they had to get rid of him, but knew he would not go peaceably. They hated to kill him because Sheriff Royal had a good family, but he just had to go. The town leaders met secretly and put one black bean in a bowl with white beans. The man who drew the black bean had to carry out the group's decision and shoot the sheriff dead.

Meantime, Judge Williams had telegraphed the governor in Austin to send some Texas Rangers to deal with the situation legally. As things turned out, a Ranger was present in the courthouse when the executioner walked into the building, found the sheriff sitting at his desk, and killed him.

Officially, no one "saw anything," so there was never an attempt made to find the sheriff's killer. Frontier justice had worked its peculiar ways. Today, the sheriff's desk with its bloodstained drawer is one of the more macabre attractions of the Riggs Museum.

In 1956, sixty-two years after Andy Royal's murder, I received a commission to paint a sixty-foot historical mural on a restaurant wall. That work took a long time, and took even a longer time for me to receive pay for my work, but finally they gave me $200, which came to $3.22 a foot. I earned every penny of that commission and bought myself a bracelet with the proceeds.

The Riggs Hotel, due in part to D. J.'s diplomatic negotiations with each Riggs family member, became the "Annie Riggs Memorial Museum."

I painted that mural in two parts: half depicted the construction of the army fort, the making of adobe, and a mule-driven US Mail stagecoach coming through town. The other wall featured the old town and some of its historic buildings. Of course, a few years later, my mural was painted over, a major problem with all murals. It seems most murals are painted over at some point. If the "Mona Lisa" had first appeared on a restaurant wall, we would be unable today to see her mysterious smile.

The Fort Stockton Historical Society published a little pamphlet describing the buildings on the town's historic tour. There were two or three sentences about each one, including the Gray Mule Saloon. Mistakenly, the pamphlet referred to it as "the Red Eye Saloon owned by Sheriff Andy Royal," who had been assassinated

One day while I was painting, the man who wrote the pamphlet and the newspaper editor who published it showed up unexpectedly. The

99

editor had gotten a letter from one of Andy Royal's daughters who said she was going to wait for the three of us at the Pearly Gates. I was included because I had drawn the illustrations for the story. She was going to lay down the law that her father was innocent—but as it developed, what really caused her to threaten us with heavenly retribution sixty years after the event was that we used the wrong wording for the saloon. We had referred to it as the "Red Eye," which she thought was demeaning, instead of the "Gray Mule."

Once we took out those offensive words, the daughter was satisfied, and the three of us accused were relieved not to have such a scandalous scene waiting for us at the gateway to heaven. What would Saint Peter think?

In the nineteen fifties, Clayton Williams Sr., father of my friend Claytie, collected some local stories and wrote a history of our region. He was interested in the Historical Society and encouraged us to safeguard the old buildings by having official state plaques affixed to them. It is a lot more difficult to tear down an old building if it has been designated a "landmark" by the State of Texas.

His brother, J. C. Williams, had spent twenty years in China working with an oil company. He was a friend of General Claire Chennault of the "Flying Tigers." It was J. C. who opened my eyes to the world beyond West Texas as well as to the wonders of China—you will read a lot more about my interest in China in a later chapter.

Once we understood how to organize, support, and lobby our local authorities, we managed to save some of Fort Stockton's wonderful old buildings. By that time, a few more residents were becoming interested in preservation. Actually, a lot of our people were interested, but nobody in Fort Stockton would admit it until after we had organized the Historical Society, which, by the way, celebrated its fiftieth anniversary in 2006.

We devoted considerable effort into saving the venerable Riggs Hotel by turning it into a museum. As befit the descendants of the feisty Barney Riggs, there was a long history of family ups and downs, which led inevitably to squabbles over ownership of the hotel building.

Those Riggs just could not get along. D. J. was the only person around who never took sides locally, so he talked to each of the Riggs' heirs individually. After many conversations and some delicate

diplomacy on D. J.'s part, he got them all to agree to donate any of their interests in the Riggs Hotel to the Fort Stockton Historical Society so the hotel could become a museum.

That was good for Fort Stockton and wonderful for the Riggs family. Today, that historic old hotel lives on in their mother's name. The hotel is kept the way it looked more than a hundred years ago. The Annie Riggs Memorial Museum is the most popular tourist attraction in Fort Stockton.

Apart from the "judicial" murder of Sheriff Andy Royal, the Gray Mule Saloon was the scene of many other dramatic Fort Stockton moments. In the early nineteen hundreds, a local rancher had sold his cattle to a man in New Mexico. In our part of Texas in those days, no one ever did business with personal checks or money orders. You carried your money with you and your word was as good as a contract. Back then in West Texas, banking was almost unknown.

Since the rancher lived somewhere near Ozona, east of the Pecos River, he turned his cattle over to a young cowboy to drive them cross country, delivering them to the buyer in New Mexico.

The kid agreed, but before he even reached Fort Stockton with those cattle, a fellow came along and offered to buy them at a better price than the man in New Mexico was offering. The cowboy thought he was getting a good deal for his boss, so he sold the cattle and rode on into Fort Stockton, where he made his way to the Gray Mule Saloon to celebrate.

Pretty soon, in walked the original owner of the cattle. When he saw the

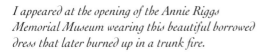

I appeared at the opening of the Annie Riggs Memorial Museum wearing this beautiful borrowed dress that later burned up in a trunk fire.

101

cowboy who was supposed to be delivering his herd in New Mexico, he said, "What are you doing here?"

The kid said, "I sold those cattle to a man I met and made you more money."

The rancher said, "I gave my word to that man in New Mexico that you would be there and we had agreed on the price of the cattle." He got so angry that he pulled his pistol and shot the young cowboy.

The other cowboy customers in the Gray Mule stretched out their friend in the back room. The young man knew he was dying, so he began to give away his few possessions. He gave away his belt, his boots, and his saddle. He even gave away his horse. All of his friends were waiting for him to give them something. Two of them, who wanted his hat, had an argument about it and decided to shoot it out. They pulled their pistols at the same moment and shot each other dead. Both cowboys were buried next to that troublesome hat.

After D. J. and I bought the Gray Mule Saloon, we thought we had found a long-term tenant in Elodia Barron, when she opened her Mexican restaurant in it. But Elodia went out of business within two years. Later, I learned that eight of ten new restaurants last less than three years.

This was about the same time we were going to have to re-do Mama's house. The plaster was cracked and it was going to cost a fortune to renovate. Besides, it was not in a good location for an elderly person, because she had no close neighbors.

When I asked her, "How would you like to move in to the Gray Mule?" she said, "I would love it."

So Mama moved into the former saloon and turned it into an attractive home. She adored living in the middle of town and could not have been happier. Across the side street was the abstract office where much of the petroleum business of Pecos County took place. She was also fairly close to the courthouse, which was always busy. Across from the courthouse was the jail, so if anybody ever broke out, that action would be right there for her to witness.

Tourists frequently read the Gray Mule historical marker on the wall and knocked on Mama's door asking to come in to see the saloon. She often showed them around.

I warned her not to, but she insisted, "I enjoy them." She sometimes

said that she could not let them in because she and Miss Kitty (from TV's *Gunsmoke*) were up late and were too tired. So that was that. Mama had an excellent memory. She lived to be nearly 91, when she died of old age.

As if he did not have enough to do, D. J. wanted to establish an Episcopal church in Fort Stockton. We were officially part of the Diocese of the Rio Grande, which ran from Santa Fe, New Mexico, to the Pecos River in Texas. When D. J. talked to the bishop in Santa Fe, the prelate was only lukewarm about establishing a new mission church in Fort Stockton, because he didn't want us to start one only to have it fail. The bishop thought it would be too difficult for us to keep a small church going in a community that already had strong Baptist, Methodist, Church of Christ, and Roman Catholic congregations.

Mama, Minnie Dunn, living at the Grey Mule. She was quite a pistol.

However, a number of new people had moved into our community who were reared Episcopalians. But once they moved to Fort Stockton, they had no choice but to join other denominations. When those one-time Episcopalians heard about our plan, they were enthusiastic about having an Episcopal church established in Fort Stockton.

We named our mission church "St. Stephen's." D. J. became a lay reader and, with the bishop's blessing, we began holding Sunday services in D. J.'s medical office. One Christmas Sunday, D. J. was reading the lesson when the husband of one of his patients arrived at the door.

His wife was in labor at the hospital and he whispered, "Please come, Dr. Sibley."

D. J. took off his vestments, handed them and the Bible to the acolyte, and said, "You finish." Off he went to the hospital, where he delivered a little baby boy on Christmas Day. The baby happened to be Jewish, which seemed appropriate for the season. A week later, on New Year's Day, D. J. circumcised the child.

We had to share a priest with Pecos, fifty-four miles away, and he came to Fort Stockton every other Sunday and once a month to give us communion. He told us the church in Pecos was going to tear down its original structure so they could build a larger church on the same lot. Tearing down the original struck both D. J. and me as a terrible idea. That too-small church in Pecos was a Victorian gem. I thought over the issue for about ten seconds, before saying to the priest, "Why don't you donate your building to St. Stephen's?"

The priest said, "I will talk to the vestry." They were facing the expense of moving the building or tearing it down, so they told us they would be happy to give us the building provided we moved it. D. J. and I donated an acre of land near our home for the new church site. That was a perfect location for our new church, right at the end of a major street, and overlooking Comanche Springs.

The Pecos church had only the interior dimensions of a fairly large room, about twenty by thirty feet. I will never forget that moving day. First, the roof was removed and placed in the open space inside the church. We had an Episcopalian friend who worked for West Texas Utilities. He arranged for his company to send a crane to remove the steeple and place it on another truck. The building itself arrived in Fort Stockton on a large flatbed trailer.

As they were driving slowly from Pecos to Fort Stockton, snow began to fall. In our area, snow was so rare that I took its arrival that day as a divine omen. When they reached Fort Stockton, the crane was waiting and it placed the steeple back on the church. We had successfully moved an architectural treasure.

The building was originally erected, so the story went, by people living in Pecos who were not accepted into the local Christian Church congregation. It was thought back then that some of the Episcopalians had "tainted reputations." We decided not to mention that on the plaque we put on the front of the building. It read:

> St. Stephen's Episcopal Church. Originally constructed at Pecos (54 mi. NW) in 1896, this building served the congregation of St. Mark's Episcopal Church. In 1958, it was sold to members of St. Stephen's Episcopal Church of Fort Stockton and moved to this site. Located on property donated by Dr. D. J. Sibley. . . .

I have added a second plaque to correct the mistakes on the first. It now reads the church was "given," not "sold," and my name appears along with my husband's as the donor of the land. The lower part of the church was built with square nails. Then the railroad came to Pecos and brought round nails, so you can tell when each part of the building was constructed. Fifty years after its relocation, St. Stephen's is still in use.

Although the exterior was lovely, the interior needed work. Three of us in the congregation had artistic backgrounds. Willie Rowe had studied art at Sophie Newcomb College in New Orleans, was an etcher, and owned her own press. I had trained in art, and another friend had excellent taste. Together, we agreed on the church color scheme. The outside color blended with the mesas in the distance; the inside walls are all white.

Willie did a trefoil design for the windows. We chose some antique paper for covering the glass, a faux stained-glass pattern we ordered from Brussels. We fixed up the church beautifully inside and out. We even arranged for new pews to be built.

Willie got in touch with Bill Spratling, a good friend from her days at Sophie Newcomb (a girls-only college that has since become part of Tulane University). Bill had designed for one of the major silver companies

in New York, before moving to Mexico and reviving the silver industry in Taxco (which helped the economy of that entire area).

Willie prevailed on Bill to design our cross, which is ebony and about two feet high. Mounted at its center is a small silver sun disc. Bill also handcrafted a silver chalice for us, embedded with Mexican amethysts.

While quite plain, inside our white church, that black cross looks stunning. We went for an artistic impression and it all turned out just beautifully—simple and exquisite. Oddly, the parishioners back in Pecos were terribly upset because of the changes we made. Once we had restored the church to its original beauty, they felt we had "stolen" their building. Instead, we all felt we had reclaimed a jewel.

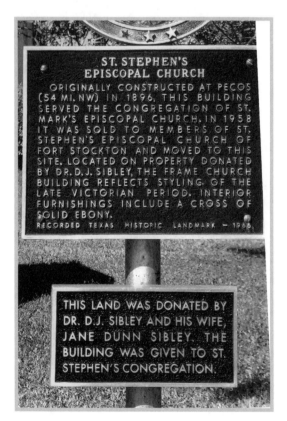

Historical marker outside St. Stephen's Church, Fort Stockton

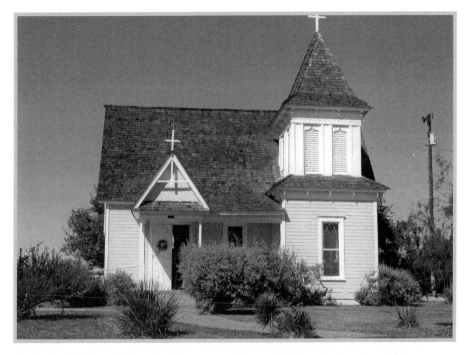

St. Stephen's Episcopal Church, which we moved by truck to Fort Stockton from Pecos, Texas, and renovated in 1958

D. J. remained as the St. Stephen's lay reader until we moved to Austin in 1962, at which point Sara Garnett took over from him. Sara had moved into the home of her grandfather, Judge Williams, which her mother had recently restored and made into a grand home. It was another one of the old fort officer's quarters.

Trained as an attorney, Sara had practiced law with her father and brother in Oklahoma City before joining the army and serving overseas in Germany and Japan. When she retired from the military, Sara came to Fort Stockton, where eventually she felt the calling to become an Episcopal priest.

She went through rigorous training, studied hard, and passed the ecclesiastical examinations for the priesthood. D. J. was her presenter. The day Sara was ordained at the cathedral in El Paso, she received an enormous bouquet of flowers from her nephew in New York, addressed to "Father Sara." Ever since her ordination day, she has been "Father Sara."

Sara is almost six feet tall, with an equally imposing sense of humor. Soon after the church arrived in Fort Stockton, some local yellow jacket wasps built their nests in the steeple. It seemed that our steeple had become a magnet for every yellow jacket in Pecos County. We screened it and did everything we could think of to keep them out, but they always found their way back.

One Sunday, just as Father Sara was elevating the host, suddenly she paused, looked down and said, "That bastard bit me!" The congregation died laughing, and she went right on with the service. She believed, as I do, that God sometimes needs a good laugh.

Sara Kathryn Garnett, our first permanent Episcopal priest in Fort Stockton, lived in one of the old fort officers' homes. "Father Sara" performed the marriage of Hiram and Liz. Sara also baptized each of my grandchildren.

10

*

Our World Explodes while I'm Washing Sheets

FOR ELEVEN YEARS, D. J. and I led an active life in Fort Stockton with our three growing children and lots of friends. Our only major problem was D. J.'s never-ending medical practice. That part of our life was difficult for our whole family.

His career as a small-town doctor who still made house calls required endless hours away from home. For D. J., there was no such thing as controlling his own time. Like most small town doctors, his life belonged to his patients, not his family.

Typically, in the middle of the night, he would get a call from a husband. "Oh, doctor, please come!" Some patients had no choice but to knock on our door, because they had no telephone. Many nights at three in the morning, D. J. would hear banging on our door, pull himself out of bed, to find a frantic man standing outside.

"Dr. Sibley, it's my wife, her lips are turning wrong side out!"

I always wanted to see that particular affliction, but D. J. never would let me come along. Usually, the man's wife was hysterical—or pretending to be—in order to win a family fight, a disturbingly common tactic. However, it was one that D. J. was unable to evaluate until he examined the woman. To do that, he would get dressed, and follow the husband to their house.

D. J. had developed a clever test to determine whether a woman actually was in distress. Usually, he found the man's wife lying on the

Our family visits the Rio Grande, 1959.

bed, looking like death, totally rigid. First thing D. J. did was grasp one of her ankles and gently pull that leg to one side.

If she reacted, then he knew she was faking. But, if she was truly hysterical and in an altered state, the woman would not move when he grabbed her ankle. If D. J. decided she had no significant medical issues, he said to the husband, "Don't worry. She'll be all right."

After that, he drove back home and tried to fall asleep for a few more hours. News of hysterical wives, car wrecks, and babies arriving in the middle of the night were common fare at our house.

Just when our life was becoming more and more unfair, possible absolution arrived for us. Dr. Ira Clark and his wife, who lived in Houston, vacationed every summer in our nearby Davis Mountains. He was charming and brilliant and had developed the Houston Medical Center. One of his patients was M. D. Anderson, owner of the Anderson Clayton Cotton Brokerage, the largest cotton finance source in America.

Anderson's generous gifts funded the medical center that bears his name, which has the reputation as one of the best cancer treatment and research centers in the world.

Dr. Clark suggested that D. J. come to Houston to become board certified in internal medicine. D. J. had taken that training years earlier during his residency, but he wanted to retrain before taking his medical board exams. He had begun to feel that the endless hours of his general practice were beginning to threaten his health. By practicing internal medicine, at least he would have more control over his time.

Why, if that were to happen, then D.J. might even be able to have more normal working hours, avoiding those middle-of-the-night phone calls. A schedule like that would let him marshal his strength more effectively.

D. J. then arranged for a young doctor to establish a general medical practice in D. J.'s Fort Stockton office, so D. J.'s staff could remain in place while we lived in Houston during his retraining.

We could afford to take off a year because of the money we were receiving from an oil and gas lease. Exxon had leased some acreage on our Coyonosa property. Our income from the lease was $25,000. In 1961, that money would support us for a year in Houston. Otherwise, we could not have made that move.

We rented our house in Fort Stockton and drove almost seven hundred miles east with our three children, ranging in age from three to ten. Also in our car was our maid, a dog, and a cat (fortunately, both animals got along). We had brought our own linens, but had rented furniture for a little house we leased in Willow Bend, a pleasant suburban neighborhood in Houston.

While D. J. was beginning his year of rotation at the Medical Center, I had my own opportunity to experience Houston. We were already acquainted with friends in Houston who were in the oil business. Bob Bybee, whose father had been chairman of the geology department at UT, had met a Fort Stockton girl, Elizabeth Rachal, when Bob was a freshman in college, and he later married her. By the time we arrived in Houston, Bob had become a vice-president of Humble Oil (now Exxon), overseeing all their drilling on the east coast.

We also enjoyed spending time with I. T. Pryor III, a childhood friend of ours from Fort Stockton. We called him "Tommy," and he and

I shared the same birthday, April 24. He was a graduate of Princeton, a charming man, who had married Kathleen, a lovely East Texas girl. Tommy's grandfather was one of the cattle barons of South Texas, who began his Texas experience as an orphan, but by 1885, had became one of the state's largest landowners.

Tommy's father managed their ranch in West Texas for a number of years but never really liked ranching. He preferred the oil business, so eventually that huge ranch was sold. We spent a lot of time with the Pryors and Bybees and with some of D. J.'s medical colleagues.

As for me, Houston felt fantastic to me back then. I could lay a map on the steering wheel of my car and drive anywhere in the city. I am not sure I ever locked the car door. I shopped for antiques and went to museums, took a ceramics course at the Fine Arts Museum, and I had a ball. D. J. could not have been happier either. He spent many hours working at the medical center with some of the finest doctors in our country.

Air conditioning was one of the few areas where D. J. and I did not see eye to eye. He was hot natured and set our home thermostat at sixty-five degrees. I would be shivering, but he was "The Man." According to the mores of that time, the husband decided what temperature our houses would have. Do not ask me where that "rule" came from, but I abided by it. He never once thought to ask me if I liked living in an ice house.

Perhaps oddly, I even left the thermostat set on "his" temperature setting after he left the house. For some reason, I did not have sense enough to turn it up after he drove away. Instead, I would gripe and complain about how cold I was.

Finally, one day I had enough. I told D. J., "I am going to Sakowitz's to buy a full-length fur coat if you do not turn up some warmth in this house." He could tell from my tone of voice that I meant it. He also knew we could not afford a mink coat. Ever since the thermostat setting was adjusted, I never again had to bring up that topic.

Every month or two, I would get in our Buick and drive home to Fort Stockton to check on the grandmothers. I thought nothing of making that trip without D. J. It was merely a long day's drive with the kids, our maid, our dog, and me. I do not recall what we did about the cat.

Back then, our car could hold everybody and still have plenty of

room in the front seat. Maybe those old cars were not as safe as to-day's—there were no seat belts, air bags, or car seats for the children—but they were wonderfully roomy.

My favorite route was to travel the back way around Eldorado and west to Iraan, a long, lonely stretch—eighty-five miles of nothing but good straight road. But on one trip, around midnight, I had a flat tire. The only nearby intersection was the road to Ozona. Everybody else in the car was asleep, so I just sat there. I did not consider trying to change the tire because the service stations had begun tightening the lug nuts with those powerful air-driven impact wrenches, so I knew I could never get them off. I simply sat there waiting for "divine intervention." As things turned out, I did not have to wait for long.

Pretty soon, a pickup came along, at first it kept right on going past me, but then it turned around, and stopped right next to us. In that pickup was crew working on a drilling rig that was changing shifts at midnight. Those fellows jumped out and changed my flat in five minutes.

Needless to say, I never expected my divine intervention to arrive in the form of oil field workers, but perhaps that is how the deity works. It seems to me that many of our miracles come to us in disguise. My oil field heroes were the nicest old boys.

When I tried to give them some money for beer, they said, "Oh, no."

They would not take a penny before heading on their way. It was wonderful to travel back then. Whenever something unexpected happened, it seemed someone would come along, stop, and help you out.

Traveling back then was also much safer. During the nineteen-fifties, even Houston was safer. We just loved that city's cultural diversity and its multiple attractions. We attended the symphony, visited museums, and took art tours.

The very wealthy de Menil family had started their immense art collection, and we visited their home while taking an art tour one Sunday afternoon. Although the de Menil's house was designed by Philip Johnson, the famous architect, their neighbors did not appreciate it. Some of them said the house looked more like a Texaco station. Whatever anyone thought about the architecture of the de Menil home, the family had collected some wonderful sculptures and displayed them in their garden.

I cherished every day we spent in Houston. We arrived in Houston at the beginning of 1961. From January to early September, we enjoyed

eight magical months. We never again had a time quite like it. But our happiness there was truly the calm before the storm we could never have seem coming. In September, as Hurricane Carla began gathering force in the Gulf of Mexico, D. J.'s and my life changed forever. After swirling around in the Gulf for days, that hurricane eventually took aim directly at Houston.

A dentist we knew from Fort Stockton had come to Baylor Medical School to take advanced training. His wife was a nurse. She told him, "I'm going to stay in town. If the hurricane strikes, I'll be needed here." Her husband had planned to take their children and leave town.

The city authorities were telling residents that they might have to evacuate the city. When we turned on the television, all the regular programs were already off the air. The stations just kept showing the eye of the hurricane spinning around, then pointed out the location and growing strength of the storm, which was not too helpful—remember, this was long before the days of weather satellites so the storm was represented by arrows of wind direction—but we needed something more to keep us better informed.

Weather forecasting in the early sixties was nowhere near as accurate as today's high tech version. The experts in the sixties were not really sure whether or not the storm was going to strike Houston, but neither did they want to take any chances about its course. Therefore, the city was preparing to evacuate its more than a million people.

I had lived most of my life in West Texas, seven hundred miles from the coast, so I had never personally experienced a hurricane. Consequently, I was unsure what to do and had no idea what hurricane procedures required. I called Bob Bybee's wife and asked her, "How do I get ready for a hurricane?"

"Wash all your clothes and linens while there is still power as you want everything to be clean," she said. "Buy candles and board up your windows. Stock up on flashlights, batteries, water, and canned food."

That was exactly what we did.

D. J. had just come back from the lumberyard with boards for the windows when we got a call from our lawyer, Maurice Bullock, in Fort Stockton.

"D. J., the Effie Potts Sibley #1 has blown and caught fire."

That well had not only blown, it was still burning. At the moment, no one could tell us the extent of the fire or if anyone was killed.

The first thing D. J. did after talking to Maurice, was to call Bob Bybee at Humble Oil, which had sub-leased our Coyonosa site to Mobil Oil. When Mobil decided to drill the well, they named it after D. J.'s mother, Effie Potts Sibley. After sub-leasing, Mobil became responsible for everything that happened at the site.

Bob had deep oil industry connections, so he called Midland to find out what was really going on with that well.

Even with Bob's assistance, it took hours for us to learn any reliable information. Finally, we received truly horrible news: five men were dead. Usually, when a well blows, the men on the derrick have a rope attached at their belts so they can swing out and drop safely off the derrick. This time, tragically, the well blew with so much force that there was no sound at all from the well to warn the men up on that rig. Furthermore, and even worse, the well caught fire instantly. All told, besides the dead at the well site, there were 103 badly burned victims.

I have heard two separate stories about what happened that day. One is that there was no blow-out preventer, a mechanism below the rig floor that automatically shuts down the well. The second theory was that the blow-out preventer they had in place was inadequate to control the force of that blast. Most likely, the second version is probably correct.

That well had been giving Mobil trouble for days. They were drilling an uncased open hole—a wildcat—because there was no proven petroleum in the area. Open holes are not cased with pipe linings and thus are much less expensive to drill. The company may or may not case it later if it produces. Oil companies are reluctant to invest in pipe for a wildcat unlikely to be successful. When our well blew, the drill bit was down deep, at nine or ten thousand feet.

To lessen the friction of the bit as it rotates at its head, a substance called drilling mud is injected under pressure into the hole. This "mud" is composed of clay called bentonite that eases the friction so the steel drilling tools will not melt. But because there was no pipe casing, when the pressurized natural gas from the hole began to rise, instead of protecting the well, that rising gas forced the drilling mud into side fissures in the rock into what is called a "thief formation."

That was why it became more difficult to hold down the pressure in the hole. As the gas rose, it lifted the mud and squeezed it laterally, "stolen" from the hole. The crew injected more and more mud, but the roughnecks ("oil rig" workers) on our well could not get enough mud into that well soon enough to save it.

The farmer raising cotton on the surface was a friend of ours, and earlier, Mobil asked him to go to town and reinsure his farm laborers for oil field work. They were *braceros* from Mexico, who were under legal

Effie Potts Sibley #1 — drilled by Mobil Oil on our Coyonosa Ranch, 22 miles north of Fort

contract to him and who were already insured for farm work. He rein-sured them and Mobil paid the premium, which was their obligation.

At the time of the accident, Mobil had hired a hundred Mexican workers to pass sacks of mud to the well, hand-to-hand, much as rescue workers passed sand bags to a levee trying to stop an oncoming flood. They kept handing the sacks of mud up to the hole, one after another, which is why there were so many men on the site when that well blew.

Schlumberger, an oil field service company, and Halliburton, were also there. Everybody was try-ing to find some way to con-trol the well when suddenly, *whooo.sshh!* . . . The well blew and caught fire simultane-ously. No one knows precisely what caused the fire. Maybe a rock on the way to the surface struck the rig, creating a spark that ignited the escaping gas.

The heat from the fire was so fierce it melted the huge drilling rig, owned by Parker Drilling Company. There were no cell phones in 1961, but a land line ran out to the high-way. Eventually, ambulances began to arrive from Pecos, Monahans, and Fort Stockton to transport the injured to area hospitals. It was a nightmare scene.

Suddenly, we saw reports on Houston's television sta-tions about our well exploding. There were no pictures, only verbal news reports. Hurricane Carla was coming and our well had exploded while we were

Stockton — on the day of its tragic explosion.

busy washing clothes, boarding windows, and trying to keep our three children calm. D. J. once again called our lawyer in Fort Stockton.

"Maurice, I'm supposed to be in Austin for a medical committee meeting tomorrow. We're going to that meeting. Get Jane's mother and my mother on a bus out of Fort Stockton right now and have them meet us at the Driskill Hotel in Austin."

We knew there would be terrible tension in Fort Stockton when they heard about the well explosion. Our mothers did not need to hear about the disaster from everyone in town. The newspapers would be full of it and the whole town would be talking.

With the hurricane coming and the fire raging at the well, we got into our car and left Houston, not knowing if we would ever see that house again. As usual, we had a full load: the three children, the maid, D. J., me, and the dog and cat. I had done my hurricane preparation as instructed and assure you that we left that house spotless. If Carla paid us a visit, she would find clean sheets. In heavy traffic, we headed to Austin, usually a three-hour drive, but it took much longer that day.

By the time we reached the Driskill, the grandmothers had arrived before us and were waiting calmly in the lobby. As we walked into the hotel, after all we had been through, Mahala—who was nine years old—ran to her grandmothers yelling, "Effie and Minnie, you won't believe it!" Wide-eyed, she exclaimed, "Jane's dyed her hair!"

Hurricanes and burning oil wells may come and go, but my hair color was all the news, according to our daughter. Mahala was right: I had started dyeing my hair and I still do. Our children always called us Jane and D. J., since that is what everyone else called us. Jake must have started it and the other children followed suit. They never called us "Mother and Daddy."

The Driskill did not permit dogs to stay there, but the clerk at the front desk kindly took our Weimaraner home with him. Considering the size of that dog, I am sure the clerk got a good tip. They sent a box up to our room for the cat. I still wonder why cats can enjoy the luxury of the Driskill and dogs are not welcomed. Some dog with a good trial lawyer might win a big settlement from a successful anti-canine discrimination suit.

The Driskill gave us the lovely old suite where we always stayed. We spent three or four days in Austin. From the television news, we

learned that at the last moment the hurricane veered away and merely sideswiped Houston. Our part of town was not affected at all.

Once we knew it was safe to go home, we headed back to Houston and the grandmothers returned to Fort Stockton. We remained in Houston until D. J. completed his program at the end of 1961.

About the well tragedy, D.J. told me, "Mobil is drilling another well, an offset close to the first well." So, now it looked as if we were going to have major production, an event that would change our lives dramatically.

Although up to that time our well disaster was the world's worst oil field catastrophe, we were grateful that the injuries to the workers on the ground were not terribly severe. Among the 103 injured *braceros*, there was no loss of life. Each of them received excellent medical care and financial compensation from the insurance policies taken out only days before the explosion. Mobil made generous settlements to the families of its five employees who were killed on the rig, though their loss was devastating to everyone involved.

Red Adair, the famous oilfield daredevil and well fire expert, was called in to contain the blaze. His crew drove red Ford Thunderbirds, wore red overalls, and drank Scotch whiskey. I never met Red, but he knew how to put out oilfield fires, and he understood exactly what he was doing. He extinguished the fire on our property in only a few days and even pulled away the melted rig, which was a total loss.

But then, before his crew could leave, the atmospheric pressure at the well head had increased, preventing the natural gas from rising safely into the air. Instead, the gas began to pool close to the ground.

Millions of cubic feet of gas soon covered the well head area. Not only was it impossible to do any work under those conditions, in case metal hit metal and sparked, another massive explosion would ignite a new fire that could spread across the entire area.

Under those circumstances, Mobil was afraid there would be another uncontainable disaster, so they ordered Red Adair to ignite the escaped gas. The resulting fire burned for several more days before Red extinguished it once more. Immediately, Mobil capped the first well and began to drill another nearby.

Later, Mobil went back to the original well and developed production

there as well. Since they had not identified accurately the well's geological formation, they called it the "Sibley formation." Eventually, petroleum geologists determined that our site was part of the Wolfcamp Formation, found throughout the Permian Basin of West Texas.

Mobil drilled a number of wells in order to determine the extent of the reservoir. It took them three years to get a realistic estimate of the amount of petroleum deposits. It turned out to be the largest natural gas reservoir ever found in West Texas.

Effie Potts Sibley #1, the original well, later became one of Mobil's most productive properties. In the oil business, as well as within my personal vocabulary, few words are sweeter than "productive." A second well was even more productive, followed by a number of others drilled on our land. Eventually, our production proved to be primarily natural gas, combined with high-grade oil, or distillate.

We never discussed the tragedy with anyone, nor did we visit the site of that horrific fire. D. J. felt that it would be better if we kept a low profile and created no publicity. We could not do anything about what had happened and there was no reason for us to make an appearance. Eventually, there were a number of lawsuits, but Mobil dealt with them.

Mama was happy for us, because she realized all the new opportunities we would have. However, many of our friends in Fort Stockton did not know how to respond to our good fortune. Some quit calling us altogether. Finally, I phoned one of our friends. "Have you dropped us completely?"

She said, "We didn't think you'd be interested in us."

"What do you mean?"

I was amazed that she felt we would no longer want to see them, but a lot of people felt that way. I did everything I could to keep things normal and told one group of long-time acquaintances, "Don't run away from us. We want to keep our friends."

Most people did not understand that we would not receive any income from the wells for at least three years. We had to wait until the oil company did more drilling to determine more accurately the size of the reservoir so that the Texas Railroad Commission could set the "allowable," the amount Mobil would be allowed by the state to produce from the field. The state did not want this vast new field to upset the amount

of natural gas already available to the market, thus lowering prices for everyone.

Since deregulation occurred, the rules have changed. Now, every well can produce to its full capacity. Back in the sixties, the Texas Railroad Commission had final say and the oil company could do no further drilling nor make any money until the commission made their decision on the allowable.

As a result, for three years, we lived on our savings and our income from the ranch and from our oil lease. We did not have anything like the money most people assumed had fallen into our laps. Our lifestyle was pretty much the same as it always had been, not at all like many of our Fort Stockton friends imagined.

When we realized there would be major production on our lease, D. J. felt we should leave Fort Stockton. He understood that whenever a family's financial circumstances changed dramatically, their children often suffered because of it. People treated the whole family differently and children are not equipped to handle well any sudden changes in how they are perceived by their playmates and their families. Because we did not want our kids to have to pay for our family's good fortune, we decided to move. That was the right decision for us.

The main question was: where should we go? I told D. J. that I did not want to leave Texas; he agreed. We considered San Antonio, Dallas, El Paso, and Houston. Finally, he said, "What about Austin?"

We knew no one there, which we decided was a great advantage. If you move to a community where you already have friends, they will of course invite you into their circle. However, if you do not care for some members of the group, what are your options? That is always an awkward situation to deal with diplomatically. Since we had no close friends in our state capital, that problem would not exist. For us Sibleys, Austin was our blank slate.

In 1962, we moved to Austin, beginning a new chapter in our lives. I wanted to be involved in the arts, D. J. wanted to do medical research, and there were good schools for the children. We could not have made a better choice. Both D. J. and I had attended the University and almost everyone who went there wants to come back someday to live in Austin. We had created our own opportunity to do just that.

During the eighties, I designed this wrought iron gate we installed outside our Austin home. The gate is West Texas-themed: symbolically, it features the Twin Sisters peaks (emblematic of the skyline seen from Alpine, Texas), a jackrabbit, a scissor-tail swallow swooping down to catch an insect, and quail running across the front. Cumulus cloud outlines curve above the top of the gate. Perry Lorenz did the forging. Later, I added hand-rails (not pictured) curving down toward the street, emblazoned with the opening notes of Beethoven's Fifth Symphony.

Our lovely home has appeared in many publications over the years, including Na-tional Geographic, which called the house "a remarkable Spanish Revival masterpiece."

Our children in the front yard of our Austin home, from left: Jake, Mahala (holding "Quito" her pet chihuahua), and Hiram. Jake broke his arm earlier that day when his bicycle skidded on wet pavement.

Effie and Mahala in the 60s

D. J. found us a lovely home above Shoal Creek, overlooking downtown. Mahala and I took one look and loved it immediately. We never even looked at another house. I have lived here since 1962.

D. J. knew exactly how he wanted to spend his time. He said, "I am going to do research, and now I'll have the time for it. Besides, I can no longer practice medicine, because if I do, someone will sue me and hope they can win a big settlement."

Medical malpractice lawsuits were just beginning to become a problem. At the time, not D. J. nor any doctor we knew had been sued for malpractice. Soon, however, trial lawyers began advertising and inciting people to file suits, almost as quickly, the insurance companies began settling them. The successful suits soon prompted a blizzard of frivolous malpractice suits, causing nearly astronomical premiums for medical malpractice insurance.

When we moved to Austin, in many ways it was still a small community, with a population of about 160,000. I enjoyed the city's art and music and D. J. was delighted with the university, its libraries, and its research facilities. We enrolled our children into St. Andrew's, a good private school.

Our lives changed forever that day Carla came to Houston—and for the better. D. J. never again had to worry about 3:00 a.m. emergency calls and now he could explore the world of research that he so loved. I was soon to discover skills and talents I did not yet know I possessed. Those discoveries would have an impact on a world far removed from the West Texas town where once I had planned to live for the rest of my life.

Unfortunately, D. J's mother never really enjoyed her wealth. She would not fly or get on a cruise ship. She was afraid to spend her money. In fact, Effie never really believed that she had any. She was co-owner of one of the largest producing wells in the country, but could never absorb the enormity of that fact.

Even after her great good fortune came her way, Effie often said, "I am going to end up on the poor farm." The early years of her marriage, with her husband so close to death from tuberculosis, followed by twenty-six years of daily struggle operating a hotel, had taken their toll.

The only thing Effie would allow herself to buy was a diamond. Accompanied by our lawyer's wife, she would take her diamond ring to El Paso and go to her favorite jewelry store. Each time she went, she

would change out her ring for one with a larger blue-white stone. That diamond ring was the one thing on which she would ever spend any money. I have the ring in the bank now and it *is* a beauty.

As the years passed, Effie became terribly forgetful. Eventually, we brought her to Austin, to live at Westminster Manor, where she had around-the-clock care. She was there for almost a decade, suffering from Alzheimer's disease long before we ever heard the name. Effie had no conscious memory of her final eight years, although she lived to be ninety.

II

🖎

Laguna Gloria

A FTER WE MOVED to Austin, I became involved with the Laguna Gloria Museum of Art, an institution founded to showcase Texas artists and their work. The museum was a bequest of heiress Clara Driscoll, who, at the age of nineteen, became famous for using her money to buy the Alamo in San Antonio, saving it from demolition.

The museum is located in the Driscoll mansion on 35th Street on the shores of Lake Austin. Ever since my days as a student at UT I had wanted to be involved in the art world. In 1950, as a bride in El Paso, I had joined the Austin chapter of the Texas Fine Arts Association. The active Austin members welcomed me warmly after we moved. They soon discovered that I would take jobs nobody else wanted, even jobs I had not volunteered to do. But I got those anyway.

In 1964, when the art gallery committee nominated me to become chairman of "Fiesta," Laguna Gloria's annual fundraiser—a difficult and demanding position—I said, "Yes, but I want to do it my way."

Once I accepted that job, I quoted J. Frank Dobie, the delightful Texas humorist and author, who said, "It always rains on *Cinco de Mayo.*" Naturally, that was always the day we held our Fiesta.

Alice Kleberg Reynolds was then president of the museum. "Alice," I asked, "do you mind if we really try to make some money this year?"

"Sure, Jane, go right ahead."

Our "Fiesta" was supposed to be a fund raiser, so I thought we ought to raise some funds, even though the museum had never made much money on the event. If they were lucky, in former years, they broke

even. But primarily, the event goal had formerly been mostly to promote local artists. I, too, was eager to support the artists, but I also wanted us to make a profit.

While it was always great fun, Fiesta was far too much work done by too few people. To spread the work, for the first time, I organized committees. I was determined that we were going to surprise everyone and make some serious money. The only way to do that was to organize early, monitor the work of the committees, and watch our expenses carefully.

I never imagined that this more or less unglamorous job would give me a reputation as someone who could get things done. Being Fiesta chairman was a long way from the world of Monet and Picasso, but it allowed me to hone my organizational skills. Every Monday morning for five months before the event, all my committee chairmen met with me in my dining room. We sat around our long table and drank coffee while each committee chairman gave her report.

As a result, at each step along the way, we knew where we were and what we had left to do. Fiesta was always held on the museum grounds and local artists rented booths where they showcased their work. We charged them ten dollars each to set up a booth.

Even back then, that was the best deal in town, because the artists sold what they displayed and they kept all the profits. The museum did not receive any commission. All we asked was that they each donate one work for the auctions we held on Saturday and Sunday.

We were pretty sure we would make money at the auction for the contributed art pieces, because we had a terrific auctioneer. Jack Darrouzet was a local attorney. If he was as persuasive in front of a jury as he was at selling art, he must have won a lot of cases.

I was also fairly certain we could increase our profits on food and beverage sales. One thing we learned well was that when your goal was to sell more beer, salt the popcorn heavily and locate the popcorn stand right next to the beer booth. We were more than generous with the salt and our beer sales soared.

We also introduced the tradition of selling *cascarones*, empty eggshells that are dyed, filled with confetti, then sealed with tissue paper. All of our committee folks ate scrambled eggs for months so we would have enough empty eggshells. We even appointed a chairman of *cascarones*,

which must look a bit strange on a resumé but was an important position because we made hundreds of them.

Cascarones were the devil to make, but were wildly popular. We sold them in egg cartons and the kids loved them because they could run around breaking egg shells over each other's heads without their parents yelling at them. *Cascarones* were messy, but otherwise harmless, and the kids, and even some grownups, had a ball with them. Those "children" are all middle-aged today, but they still talk fondly about the fun they had with those *cascarones* that first year.

In order to make a profit, I found that we had to consider every aspect of any operation. For years, the museum had asked a famous Austin eatery, "Matt's El Rancho," to cater Fiesta. At the end of the weekend, Matt would "contribute" $200. I was pretty certain that was not an accurate accounting.

After I talked to Monroe Lopez, who owned a different Mexican restaurant, he said, "I'll supply the food, you sell it. That way, I will not have to hire waiters and charge the museum for catering." By using our volunteer waiters, the food cost was low and our profit margin was high.

Making a few positive changes can have a major impact on the bottom line. The main reason we made more money that year was by using volunteer waiters—mostly our long-suffering husbands. Although they drank up some of our beer profits, that was fine with us.

The payoff for all our months of hard work came on Fiesta weekend: for once, there was not a drop of rain (We had moved the date already.). Everybody arrived in festive Mexican dress and Austin's mayor was there to cut the ribbon. For the first time, we used shuttle buses from Camp Mabry to make parking easier, with Boy Scouts there handling traffic.

The day's festivities began, with a general trying to enter Camp Mabry on National Guard business. But a Boy Scout stopped him, saying, "Sir, you can't come in today. This area is reserved."

The officer, bedecked with ribbons, replied, "But I'm the general here."

The Scout answered, "I don't care, sir. I have been told not to let anybody come through here."

The general told him, "I sure would like to have you in my corps."

The youngster kept him out, and the general thought that was priceless.

Fiesta made a net profit that year of $10,000. In 1964 dollars, that was like making $100,000 or more today. Before then, the museum had been happy to break even or maybe to raise around $500. Back then, making a profit of $10,000 was unheard of. All our committee meetings and those confetti-filled egg shells were well worth our effort.

In that one weekend, Fiesta established my reputation in Austin. I had become known as an organizer who took time to plan carefully and one willing to keep on top of the committees who did most of the work.

Those Monday morning meetings at our house made all the difference. Over the phone, no one can get eight or ten committee chairmen to agree to anything. But if everyone on a committee accepts you as "the boss," they have already agreed to be present in person. These days Fiesta raises hundreds of thousands of dollars each year, but that now tried and true tradition of fund-raising goes right back to our dining room table in 1964.

After my initial success with Fiesta, the museum board asked me to serve as president. I accepted, even though the term of office was for only one year, not nearly long enough to accomplish very much. No one can create a real impact in twelve months, because you need a year just to learn the ropes and to begin understanding what is going on in any organization. Otherwise, just as you get a grip on what you must do and how to do it, your term is up.

One of our main objectives was to add some classrooms and offices and to do some needed renovations to Laguna Gloria's property. However, the museum did not have title to the land on which it stood. Clara Driscoll, who built Laguna Gloria and lived there for years, had bequeathed the property to the Texas Fine Arts Association, stipulating that the association was obligated to maintain the property and to use it as a museum.

When I told the board it was not right for us to put member donations into a building program when we did not have title to the land, it raised considerable controversy. Nevertheless, it would have been irresponsible to build anything on property that was not legally ours. Everyone agreed that we should ask the state association to transfer title to our chapter, along with full authority as well as responsibility for its ownership.

The state association approved the transfer. They would no longer

have to pay utilities, be responsible for upkeep, or cover the salary of the museum director. The whole issue came down to a question of finances. At the time, the association could not afford to maintain Laguna Gloria but, according to the terms of Clara Driscoll's will, it was prohibited from selling it, either. Furthermore, if they failed to maintain the property and also to operate it as a museum, the property would revert to the State of Texas.

In the mid-sixties, those good old boys of the Texas legislature did not think the state needed to own an art museum. There was very little federal or state commitment to the arts back then, so the beautiful Laguna Gloria property would likely have been sold to developers.

Oh my, but the wheels of bureaucracy do move soooo slowly. Although I started the process of transferring the title when I was president, my successors, Vicki Smart and Sandy Leach, also worked on it during their terms.

Will Wilson, former attorney general of Texas, was president of the Texas Fine Arts Association. I said to everyone on our board, "Let's get started while Will is president as he will understand the legal implications of the transfer." He did see the logic of our proposal and, finally, the title was transferred. It took three presidents and a former state attorney general to get the job done.

From my experience with West Texas ranchers, I understood well the importance of having clear title to the land. Ranchers block out land for mutual convenience in crossing ravines, cliffs, and difficult terrain. "Blocking" involves an exchange of property but not of title. Your neighbor's land may be under your fence, but you do not own it. Your land is inside his fence, but it does not belong to him.

D. J.'s father had once drilled for water in the Glass Mountains and located the well on his side of the fence, except he forgot that the land was blocked with the adjoining ranch. After he realized that the water from his well rightfully belonged to his neighbor, Dr. Sibley was beside himself with worry, even though his neighbor never did anything about it. His anxiety over land rights made a lasting impression on me.

That was only one reason why I was so insistent that the museum have full title to the property on which it was planning to build. Making sure we got the title to its land was my most important contribution to Laguna Gloria.

12

↙

The Castle

D. J. AND I had never actually planned to build a castle on a mountaintop, forty-two miles from anywhere. The castle's true genesis was an exploding commode; a significant secondary element in its existence was a talented architect who owed D. J. $10,000.

Ever since 1924, D. J.'s parents had owned a large ranch in the Glass Mountains near Alpine, Texas. The Sibleys never spent a single night on their land. Only cowboys ever lived there, working the ranch and sleeping in two small houses on the property. One year in the late 60s, when no one, not even a cowboy, was living on the ranch, we invited Claytie and Modesta Williams, Johnny and Sue May, and several other friends to go hunting.

The ladies slept in the small house, the men roughed it outside. D. J. and I slept in the "honeymoon cottage," which had a dirt floor and was built from stalks of the ocotillo, a tall slender cactus, the stalks tied together with baling wire. If D. J. had taken me there on our own honeymoon, I doubt our marriage would have survived.

The weather was so brisk the men camping out woke up to frost on their beards, but they did not seem to mind that. They hunted all day, came back at dusk, ate a big supper by the campfire, fell asleep in their sleeping bags under the stars, and got up at dawn to hunt some more. I enjoyed the company but would not want to live that way for long.

After a few days, the weather turned much colder. When D. J. went into the old house one morning, he was unable to flush its commode. The

water had frozen in the tank. Someone had stuck a piece of cardboard in the bathroom window where the glass should have been, but it did not keep out the freezing air, and the water in the tank had turned to ice.

D. J. went into the kitchen, filled a bucket with hot water then poured it into the commode tank; not one of his wisest decisions. That tank went "KABOOM," cracked apart and spewed its contents all over the place. When I walked in, the linoleum floor was flooded.

"D. J., what happened?"

Sheepishly, he replied, "It just blew up."

Since one of D. J.'s ancestors was Sehoy, a Creek Indian princess of the Wind Clan, I could not help myself. "It looks to me like the Prince of the Wind just blew up the commode." That accident was actually a blessing in disguise, because it pushed us to make an overdue decision.

"This cannot happen again. D. J., we have to build a decent ranch house. How can we have guests out here and ask them to live like this? Roughing it is one thing, but a frozen commode is another."

I had picked the right moment to make my case. D. J. agreed.

Meantime, one of our friends, Jack Stehling, a talented architect, had persuaded D. J. to loan him $10,000. Against his better judgment — and without even a signed document stating the amount of the loan — D. J. lent Jack the money, allegedly so Jack could pay some overdue bills. However, instead, that cash went to buy a sapphire ring for Jack's current lady friend. Jack just did not seem capable of living within his means.

He had divorced his wife and he had four children to support. Despite his family obligations, Jack liked beautiful women and he gave them gifts he could not afford. The odd thing was that D. J. never loaned money to anyone.

He always told me, "If I start, I'll never stop."

Jack was his sole life-long exception. When we decided to build our house, D. J. called Jack and asked him to design it as repayment for the loan. Since Jack had no other way to repay D. J., he said he would love to do our house. Over the coming years, we got our money's worth from the brilliance of Jack's imagination, many times over.

D. J. and I agreed that we should think carefully about the design of our new house. We told Jack we did not want a dormitory arrangement, but a house that would be good for family hunts, since many

of our friends had children. When families were present, that would also cut down on excess drinking, typical behavior during many hunts.

Personally, I do not like mixing drinking and guns. I wanted our guests to drink and not shoot or to shoot and not drink.

We also wanted a house that we could leave, come back to in two or three months, and find the place in good condition. I was determined that the house would be easy to maintain. Too often, I had seen friends with ranch houses where the beleaguered wife was cook, laundress, and everything else. That role was not for me.

Then we threw Jack a monster curve: we told him we wanted a 360-degree view, a house from which we could look out in every direction. Well, Jack surprised us from the beginning. He showed us a sketch for a six-sided house, planning for a structure with six stone towers — each one itself hexagonal — each tower connected to the next by glass walls.

The whole basis of Jack's idea depended upon multiples of the triangle, the most stable form in nature. No doubt, his design was certainly startling, but it was elegant, too. No one we knew had ever seen anything like it.

D. J. suggested we include some smaller rooms for two people that he called "sleeping cells." On the palm of his hand, Jack sketched an arrangement of D. J.'s sleeping cells.

"I have another request, Jack," I said. "This house will be on a windy mountaintop and I do not want to be hauling groceries out of the car when that strong West Texas wind is roaring. Please give me a place where I can drive the car right up to our door."

Then D. J. piped up, "You are not going to cut down any of my piñon trees." He loved those pine trees that can only grow at higher elevations.

"That is not a problem, Jane," Jack said to me. "We will elevate the house. Then you can drive up to the front door, take in your groceries easily, and no, D. J., we won't have to cut down any piñon trees either."

Next, we had to pick the perfect site. D. J. and I had ridden horseback over many areas of the ranch and we finally decided on a spot in the Rincón pasture that had a beautiful view. We thought that location was all set until we had a visit from Stan Beard, a land man who was working on leases for Mobil Oil.

Stan told us Mobil wanted to drill in our "White Elephant" pasture,

aptly named because it had a stock tank that never would hold water, but let it slowly percolate into the ground. We had tried lining the bottom with drilling mud, but not even that helped. That tank could hold thousands of gallons of water, but every drop was gone a week after any rainfall.

In Texas, we call a "stock tank" any depression in a field that has some kind of dam at its lower end to capture run-off rain water. No matter what measures we tried, this one remained completely porous.

After a few more friendly visits, Stan said, "I understand you are planning to build a ranch house on top of that mountain down in the Rincón."

D. J. Sibley #1, a dry hole well, in the White Elephant Pasture at our Glass Mountain Ranch

When we told him that was our plan, he said, "I'd strongly advise against it. Your neighbor is strange and very difficult. Mobil has leased his ranch, but I can't deal with the man. I show up to see him and, even though I know he is in the house, he makes me wait outside for three hours before he shows his face.

"When he comes out, he says, 'Well, what do you want?' He has a high-powered rifle with a Weaver scope and could sight it on your house. I am afraid he does not have a good opinion of D. J., either, since he once told me, 'That D. J. Sibley is a nut. He has to have somebody else run his business. He has a trust.'"

We had never met the neighbor, but even so, he had decided we were little better than spoiled children simply because D. J. did not choose to spend his time dealing with finances. We thanked Stan for warning us and decided we could do without a crazy, gun-toting neighbor with his telescopic sight aimed at us. After absorbing Stan's warning, D. J. and I mounted our horses and began to look for a different and, we hoped, even better location for our ranch house.

That temporary setback turned out to be a great piece of luck, because we found the perfect spot for the house on a mountaintop with panoramic views, located in the center of our ranch. Best of all, there was no neighbor to eye us through the scope on his deer rifle.

In the meantime, our architect, Jack Stehling had prepared some preliminary drawings. We realized his design could be turned in any direction and placed anywhere, on top of a mountain or even in a valley. His plan showed the six towers he had first sketched, each six sided, with six glass floor-to-ceiling windows between each tower.

The entire structure was elevated eight feet above the ground. Its central tower was also hexagonal, with a spiral stairway that led to the roof. A plastic dome above the stairs would admit light and we could raise the dome so we could go out on the roof to enjoy our spectacular view of mountains, valley, and sky.

Although the house was not going to be constructed on the highest mountain in our area, when you were standing on its roof you would still be a mile high. Isn't that high enough for anybody?

We asked Jack to come out and visit the site we had selected. As things turned out, his design could not have been more perfect for the location we chose. Jack, by applying his imagination and coming

up with his excellent design concepts more than repaid his debt to D. J. Just when we were getting ready to begin building, D. J. became terribly ill. Over the previous five years he had begun drinking too much alcohol. Whether that urge was a result of the depression that ran in his family or from some terrible memories from the war—what they now

The Castle towers' stonework is patterned after these intricate limestone outcroppings in Gilliland Canyon. The canyon walls have cacti growing right out of these almost vertical cliffs. Manuel, our house man, is standing on top.

136

call "Post-Traumatic Stress Disorder"—I did not know. Whatever the cause, I certainly knew he was sick. It is almost always difficult to figure out what is really wrong with someone when they have been drinking too much.

When I took D. J. to his doctor in Austin, I told him D. J.'s health was already deteriorating. Although all my husband's medical records were right there in the doctor's office, he never thought to test D. J. for a recurrence of his tuberculosis. His doctor decided my husband's problem was alcoholism.

"We will put him in an alcohol treatment facility here in Austin."

I said, "No. I would like him to go to the hospital in Galveston first, where he went to med school, so he can get a thorough physical examination."

Driver, a young black man who worked for us at the time and who was a wonderful driver, helped me take D. J. to Galveston. After we checked D. J. into the hospital, Forris drove me back to Austin—a round trip of almost 500 miles. Just as we arrived home, exhausted from the long drive, I received a call from the hospital in Galveston.

"Come and get your husband. He has active tuberculosis and we don't want him here in this hospital another day."

I could not believe it. Twenty years after recovering from TB, my husband had a relapse that almost killed him. The next day, Forris and I got back in our car and drove down to Galveston to pick up D. J. In the meantime, I had made arrangements for a pulmonologist to examine him in Austin.

D. J. told me, "I've broken my health because I have been drinking."

During our first fifteen years of marriage, D. J. drank very little, usually not at all. That changed gradually in the sixties for reasons I never fully understood. I had lived with the progression of his alcoholism for at least five years and felt it was connected to the severe depression that had plagued him since childhood. D. J. had a genetic predisposition to that condition. His father suffered from debilitating depressions so severe that Dr. Sibley often went to bed and stayed there for two or three days, canceling all his dental appointments.

Despite her many wonderful qualities, D. J.'s mother, Effie, dealt with her own chronic anxiety that began when her husband contracted tuberculosis. She left the security of their home in central Texas to go with him to El Paso while he was in the sanitarium.

She and D. J. lived in a small apartment in El Paso. D. J. was only four years old at the time, while his father was hospitalized, fighting for his life. To make matters worse, Mrs. Sibley was terrified of Mexicans, not a good thing if you are living in El Paso with the Mexico border right across the Rio Grande. While they were there, America entered World War I, and that frightened Effie, too.

Her fears never left her. Even after they owned a hotel and ranches and her husband had a successful dental practice, she never felt secure. Despite their prosperity, she always felt insecure.

Apparently, D. J.'s father's depression as well as his mother's anxiety had been passed on to my husband. He hid those issues well, and on the outside, always seemed charming and successful, but his underlying problems were always present.

After spending six months in isolated bed rest at a sanitarium in Austin, D. J. was able to move to our ranch to recuperate. We spent most of the following year living in the trailer we had set up at the ranch while The Castle was under construction. D. J. rested and gradually regained his health—owing largely to the wonders of streptomycin, considered a miracle drug at the time. However, that powerful antibiotic had a crushing side effect: it damaged his weak hearing even more.

While D. J. was recovering, we finished The Castle. The construction crew worked for almost a year, from February until November 1969, also a busy time in the life of the Sibley family. We were dealing with D. J.'s health, building a hexagonal ranch house in the middle of nowhere, and Mobil Oil was drilling in our White Elephant pasture.

Since D. J. was so sick, I thought the best place for our kids to be was in good private schools. Hiram went to Allen Academy in Bryan, Texas, Jake was in Oxford Academy in New Jersey, and Mahala was attending St. Mary's in the Mountains in New Hampshire.

Mobil began drilling the D. J. Sibley #1 in our White Elephant pasture, the first well ever to be drilled in the Glass Mountains. However, not even that was the biggest event in our lives. When the drilling crew arrived, it was a red letter day for us, because they brought with them a working telephone line that ran along the ground four miles before connecting to the nearest pole.

For some reason, the workers had chosen a pink phone to hang from a pole in the desert, a surprising color choice for a drilling crew, but we

could not have cared less what color it was as long as it connected us to the outside world.

Mobil pulled in five trailers to house their people and their lab equipment. There was a geologist for the lab and two drilling superintendents who alternated weeks at the site. The roughnecks worked eight-hour shifts and commuted daily to Fort Stockton. Oil field supply people, mostly salesmen, came and went throughout the day. One day, I counted fifty-six cars around that rig. Unfortunately, Mobil never did get production, so our White Elephant continued to live up to its name, but anyway, we had a marvelous time, except for a single exception.

A few weeks before Christmas, Jake, who was home for the holidays, had started back to town when he noticed another pickup just ahead of him. On a mountain ridge, the driver stopped, got out, and cut the top off a piñon, helping himself to a small Christmas tree. Jake followed him down the mountain road, but the man drove so fast Jake could not keep up.

We were livid over the mutilation of the tree, because now the rest of the tree would die. I decided to do what I could to put a stop to the theft. I created a hastily assembled burial cairn of rocks, located near the cattle guard everyone used. I placed an old pair of boots on sticks so they projected out of the rocks. At the head of the "grave," I made a sign in the shape of a tombstone and wrote an inscription aimed at would-be piñon thieves: "Here lies the last man who helped himself to a Christmas tree." We never lost another.

During The Castle's construction, we lived in our trailer, parked a short distance down the mountain from our home site, so we could be near the work. Our physical presence made a major difference. There is nothing like having owners hovering nearby to answer questions and to help keep things moving right along and on schedule.

Living on a construction site also caused quite a change in our lifestyle. We bought a tent with mesh screen walls that became our *al fresco* dining room, where we took nearly every meal. We spread a thirty-dollar oriental rug on the ground, draped a cloth over the tabletop, hung a Moorish lantern from the ceiling, and felt like Arab sheiks!

To run our household, even in a trailer, I had help from Mexican migrants. In the years before political correctness, Mexican nationals

who crossed the Rio Grande illegally were usually called "wetbacks." I recognize that the word is a hot-button for Tejanos today, but as far as I am concerned, "wetback" is no pejorative.

Instead, I consider it an honorable term that demands respect, because it describes brave men so desperate and eager to find work to support their families they were willing to cross a river into a strange country, walk 150 miles or more across rugged, dangerous desert terrain, and after they arrived, to risk arrest.

I respect their desire to have a better life, the very same motive by which my own ancestors were inspired when they decided to leave everything behind in Georgia and move to an unsettled land we now call "Texas."

The Mexicans we met found their way to our ranch by word-of-mouth. We were located on the old Comanche Trail that had been used for hundreds of years as a transit route. In the eighteen hundreds, after the fall rains greened the grass and the first full autumn moon rose in the sky, the Comanches and Apaches left the plains and rode their horses south through the Glass Mountains toward Mexico. They were seeking plunder: cattle, horses, and Mexican slaves. Once there, the Indians would kill the men, rape the women, and slowly retrace the trail back north with the survivors—mostly children and any women whose hair they did not fancy for scalp locks—on foot as slaves.

Those convoys followed traditional trails that ran past the infrequent water holes, past the best grazing, and through the safest terrain. These numerous trails—the highways of the Comanche moon—fanned out over West Texas. Thus it was that the Comanche trail, revived in the 1970s by Mexican migrant workers, was already laid out and waiting for them.

The Mexican workers who came north found places where they could cross the Rio Grande safely before hiking up the old trail to search for work. Occasionally, I would look out a window of The Castle and there would be two or three men, sometimes even five or ten, standing outside waiting for someone to notice them. Many of our Mexican workers, coming for the first time, wore woven leather sandals called *huaraches,* which were the length of their feet, the sandal soles made from Firestone tire treads held on their feet by thin cotton rope.

These travelers often arrived exhausted, having walked 100 miles or more over a rough trail. Carrying little to eat—maybe only some dried meat and some tortillas—they stuck to the trail and found drinking water in stock tanks along the way. When they reached our place, they almost always spent two or three days just resting from their journey.

If they wanted to work for a few days, or even longer, that would be fine with us. After their work for us was completed, then they might move on. We asked few questions of them, mainly because we did not want to know too much. We were well aware we were walking a fine line between helping our uninvited guests and the Border Patrol, whose job it was to send them back across the border.

The Mexicans slept in the piñon trees, their bedding linens card-board boxes, flattened and laid on the lower branches of the trees so the migrants could hit the ground running. By sleeping in the trees, they could jump down and make a quick escape if they heard a car driving up our ranch road, because it might be bringing the *Chotas*—the Border Patrol.

Sometimes I wondered how they could sleep without falling out of the trees, but they managed it. I never remember anyone being injured. Most of the men were small, and that may have helped them survive. They always had their hats with them, even while sleeping, since the *sombreros* offered some protection from the sun during the day and from the cold at night. No matter the weather, those broad-brimmed hats were vital to their survival.

Rarely could any of the men who worked for us speak much English, but I know they were literate because they wrote so many letters home. They were polite, had good manners, and were never foul-mouthed. Of course, even if they had used bad language, I would not have understood a word. They were happy to have any job we offered them, and seemed to be dedicated to their families. On payday, they always saved most of their money to send home.

Provided we did not hide the migrant workers, the Border Patrol did not hold us ranchers responsible for hiring them. But after 1980, that stand-off was changed. At that time, Congress passed legislation that held ranchers liable for hiring undocumented Mexican workers. Today, that law states that ranchers who knowingly employ illegal aliens can be fined if convicted.

During most of The Castle's construction, D. J. was too weak from his TB episode to lift anything or even to drive. For help in the trailer, he would choose a migrant laborer he thought was especially well groomed and eager to learn. D. J.'s Spanish was excellent and that made all the difference for us.

Since our illegal aliens could not risk going into town for fear of being arrested and deported, whenever they needed something, they wrote out a list and D. J. or I were expected to get exactly what they asked for. If we got buttons when they wanted snaps on their shirts, they would ask us to return that purchase. It was usually I who drove the forty-two miles into town. D. J. did most of their shopping.

Looking back, I am amazed at how well we communicated with the migrant workers in the trailer and, later on, in The Castle. My Mexican housemen had never worked in any kitchen. In Mexico, that was because their wives presided there. None had never cooked a meal or seen a washing machine, dishwasher, or dryer.

Most had never driven an automobile, but almost at once, there they were, soon driving our ranch vehicles. Those workers of ours all got a do-it-yourself driver's education course and were not required to pass a driving test. It was amazing how fast they learned. Naturally, there were a few minor accidents from time to time, and soon there were no mirrors or door handles left on most of our ranch vehicles, with many of their doors wired shut!

For more than ten years, we provided a temporary home to illegal aliens who came and left at will. One morning, Hiram was home from school, sleeping late in his bunk in his tiny room between mine and D. J.'s in the trailer. Our home on wheels had three bedrooms and two bathrooms but was definitely not one of those fancy "mobile homes." It was just a plain old trailer, eight feet wide and forty feet long.

A young man named Lourdes was working for us that day. I am afraid he was not the most handsome kid in the world. In fact, Lourdes looked a lot like a squirrel. But he was a good boy and a great worker. He was also different from the others, who all had families back in Mexico; Lourdes was a bachelor. We were all inside the trailer when I heard the Chotas coming.

The Border Patrol was heading up our road and they were already close to the trailer. It was too late for Lourdes to run, so we were all

trapped. We were not supposed to be harboring an alien and we knew that was a federal crime. D. J. was in bed, so ill and exhausted he did not know what was going on. Quickly, I pushed Lourdes into Hiram's room, put him in the upper bunk, covered him, and said, "Keep your head down." Then I jiggled Hiram awake. "Don't say anything. Lourdes is up above you." Hiram mumbled something, turned over and went back to sleep.

About this time I heard a knock on the trailer door. After trying my best to compose myself, I greeted the Chotas with a smile. "How are y'all? Would you like a cup of coffee?"

"Yes, thank you, ma'am. We would enjoy some coffee."

We sat there and visited for what seemed like hours while inwardly I quaked. I was already envisioning myself stuck in the federal pen for harboring an illegal alien. Something told me I would not like the accommodations there. Finally, after coffee, cookies, and much conversation, the Chotas left.

We built fences and we built pipelines with our Mexican labor. They all wanted to work for "El Patrón," as they called D. J., since he was so good to them, paid them more than other ranchers, and fed them well, which made a big difference to them. The Mexican workers who helped me in the trailer and in The Castle also learned valuable practical skills that they took home with them. I taught them how to serve a meal when we had guests. They could pour the tea and coffee, serve the plates, and help me in the kitchen.

For outdoor work on the ranch, D. J. designated one of ablest men to be his "Caporál," to serve as boss of the other men. D. J. would talk to his corporal in Spanish, telling him what chores he wanted done, and the corporal would make sure it happened. This almost military chain of command, with Major D. J. commanding the corporal, worked perfectly. The other workers were responsible to the corporal and respected his authority.

When one of the workers wanted to go back to Mexico, we would get him a money order for his wages. It was far too dangerous for any of them to carry cash during their journey back down the "wetback trail." After packing some food, our helper would walk all the way back to the border, then take a bus home to his family.

All of our workers always knew that if they came back to us, they

would always have a job. Over the years, we had a consistent group of workers we came to know well and to trust.

My houseman always wore his hat in the house. I remember one of my guests complaining, "Why don't you tell him to take off his hat?"

"That is his most precious possession," I said. "If a Chota drives up and it is cold outside, at least he will get out of here with his hat on to keep his head warm. And in the summer, if it is as hot as usual, he will have protection from the sun. So I am not going to be the one to tell him to take off his hat."

In November 1969, we finished building The Castle, moving in just in time to celebrate our first Thanksgiving there. But our first social event was a deer hunt. We invited Mary and Asher McComb from San Antonio, and the Griffins from Shiner, and, sure enough, we had a twelve-inch snow fall! Since it rarely snows at The Castle, I believe Mother Nature was trying to tell us something.

I think she was saying, "Congratulations on building your castle. It may be cold outside, but now you don't have to worry about your commode freezing!"

When it was completed, the ranch house had two stories. Soon everyone was referring to it as "The Castle," because it looked just like one. I have no idea who first called it that, but the name stuck. There is no question it made a powerful architectural statement—almost a declaration—sitting on top of its mountain forty-two miles from the nearest town and eighteen from a paved road.

All that The Castle lacked was a moat and a drawbridge. There are six bedrooms on the main (upper) floor and six more rooms below. Nobody can figure out the exact square footage, since all the rooms are hexagonal. None of the bedrooms are large, about one hundred square feet each, including their built-in bunk beds.

We built another structure down the hill called the "Wetback Country Club," or WBCC, for short. It had bunk beds, a kitchen, a dining area, and a bathroom. Now our workers never again had to cook, eat, and sleep outside. Instead, they could enjoy living in their comfortable new lodgings.

Once The Castle was completed, we began to invite lots of guests. All our friends were eager to see what we had been working on for so long. Having people visit The Castle was always great fun for D. J. and me, and for our children. No visitor had ever seen anything quite like it.

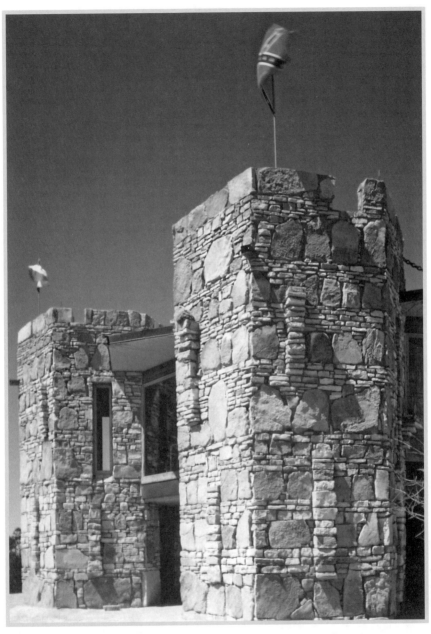

D. J. and I, with our architect, decided The Castle would incorporate the colors, textures, and shapes of its surrounding Chihuahua Desert region.

We had so much room we could sleep twelve upstairs and four downstairs. Everyone seemed stunned by its design, too, but what really impressed guests most were the vistas from every window. I have seen beautiful views in many countries, but nothing surpasses ours anywhere in the world. Almost forty years later, I never tire of looking at the mountains and the stars.

Since The Castle had every convenience, it was easy to forget it was located in the middle of a wilderness. In the early seventies, the government and local ranchers got together and hired a trapper to control predators: wolves, panthers, and coyotes. The panthers come out of the Big Bend National Park and spread north in an extended circle, feeding on calves, lambs, and fawns. After the females hole up to have their kittens in a small cave, they return to their "safe place" in Big Bend National Park. The panther roaming lands reach out almost 150 miles.

All the predators have been terribly damaging to sheep ranching in our area. The wild killers are hard to control, since they are primarily

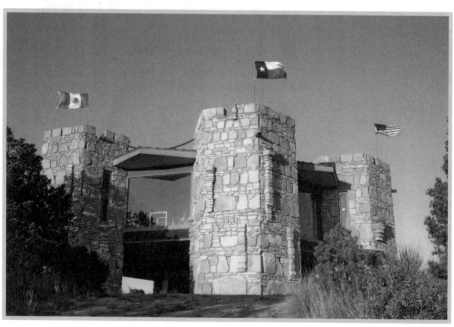

We fly above each of The Castle towers the six flags of Texas: Spain, France, Mexico, the Confederacy, the United States, and the Republic of Texas.

nocturnal and sleep in hidden places during the day. Hunting a panther is not simple at all. You can set traps for them, but they are hard to shoot, easily going from standstill to forty miles an hour in a few seconds. You have to be a darn quick and accurate shot to get your gun out and aim without shooting off your own foot instead of the cat.

Our only uninvited guests at The Castle are mice and rats. Mice love The Castle because they consider it upscale living. No matter what we do, the little devils find some way to get inside. I have never been sure how the rats get in. I think they just open the door. We also have to deal with miller moths, those insects you see flapping around light bulbs at night and indoors. They spit, make a mess, and incinerate them-

selves in the process, just like insect suicide bombers. Sometimes, after we have been away from The Castle for several months, we arrive to discover the millers have invaded and died inside by the thousands. Cleaning up after them comes with the territory, I'm afraid.

As word of The Castle spread, we played host to a wide range of interesting people. One of our most famous guests was Lady Bird Johnson. She learned of our ranch from a botanist friend of ours, Barton Warnock, who worked with her on the Texas volume of *Wild Flowers of the United States*.

When Lady Bird called to ask me if she could come to see the

Mahala (right), D. J., and I at The Castle for deer season, 1978

Keeping myself warm beside a fireplace at The Castle — hunting season, 1980

bluebonnets in the Big Bend one March, I said, "Of course, why don't you come for Easter?"

Lady Bird was charming, gracious, and the best houseguest in the world, but I had no idea what hosting a former First Lady entailed. She was required to have two cars, one to ride in and the other as a getaway car in case of an emergency. Then there were the cars for the rest of her party and her Secret Service contingent. Federal agents commandeered

most of the rental vehicles in Alpine and El Paso. That fairly modest weekend visit had turned into a four-county production. I had never seen anything quite like it, and it all began because Lady Bird Johnson asked me to show her the bluebonnets of the Big Bend.

H. C. Carter, a local businessman, had a twin-engine plane and he and a co-pilot flew Lady Bird and her entourage to Lajitas, our closest functioning airport. The local officials asked for additional officers, as they were concerned about Lady Bird's presence so close to the border.

Liz Carpenter, Lady Bird's close friend and former press secretary, came with her, along with Grace Jones. Liz had grown up in Salado, a tiny town about fifty miles north of Austin, and Grace owned the up-scale dress shop there I have already mentioned. Liz also brought Ray

Lady Bird Johnson and D. J. examining a madrona tree during her Easter visit to our Glass Mountain Ranch

Daum from the Humanities Research Center, the primary cultural repository at the University of Texas.

When their plane landed in Lajitas, I was already busy at The Castle making sure everything was just right for dinner. I had asked Barton Warnock to greet them in my stead. He and Lady Bird had become friends while working together on that Texas wildflower book. As a highly respected botanist, Barton was the obvious choice to guide Lady Bird through Big Bend National Park.

Thank goodness the bluebonnets were in full bloom and had covered the Chisos Mountains that year. I also called Gil Phelps, a good friend who owned La Kiva, a subterranean bar and restaurant located on the banks of Terlingua Creek. The atmosphere at La Kiva featured art nouveau with a decidedly rustic southwestern tinge, totally different from any restaurant I had ever seen. Lady Bird loved it.

A pencil sketch I made at the Glass Mountain Ranch of Old Blue Mountain, named for its color when viewed from a distance through the desert atmosphere

As it was Easter and Lady Bird was an Episcopalian, I called Father Sara, our dear friend and priest from Fort Stockton. "Please come out to The Castle, Sara, and bring the small cross, your travel host, and a communion chalice, and we will have our Easter service down by the pool. If the weather is bad, we will have it in front of the window that centers on Mitre Peak." Mitre is one of the most beautiful mountains in the Davis Range at any time of day or in any weather.

On Saturday, the weather was lovely while Lady Bird was touring our ranch. Naturally, that night a "norther" blew in. Its arrival was not exactly a surprise. Easter at The Castle always seemed to attract bad weather.

When Sara arrived to conduct her service, she announced, "I need somebody to read the lesson and someone to read the scripture."

I asked the two Secret Service men to help her with the liturgy. At the service, we invited all our Mexican workers—legal or not. What a truly eclectic congregation we had created: a former First Lady and her press secretary, a one-time New York fashion model, the Secret Service agents, our own family, and a number of illegal aliens, all worshiping in the same room, led in prayer by a six-foot woman priest. I think the Lord must have been pleased.

13

The Symphony

NETTIE JONES, a neighbor of ours, invited me in 1967 to join the board of the Austin Symphony Orchestra (ASO). Believe it or not, for the first few years I served, I kept relatively quiet. The men on that board ran things, but did not seem to have any real enthusiasm for the work. For lack of a regular meeting place, we gathered from time to time in the board rooms of various Austin banks.

The ASO was the city's oldest performing arts group, founded in 1911. However, classical music in Texas has always had a rather select following. By 1972, the symphony was considering bankruptcy. At one board meeting, there were only ten or twelve directors present when we went around the table and took a voice vote on whether to declare bankruptcy. Everyone before me had voted "yes."

I was sitting half way around the table and when my turn came I said, "The Sibleys don't take bankruptcy. They never have and they never will. I vote no."

Following my firm declaration, the men were too embarrassed to vote for bankruptcy after a lady said she did not believe in it. Although I did not realize it until years later, my three short sentences on the bankruptcy vote had changed my life.

After my bold statement at the board meeting, I could hardly say "No, thank you," when the board asked me to take on the symphony presidency. At that time, leading the symphony was the last thing in the world I would ever have asked for—or been expected to do.

True, I had studied piano for fifteen years, but classical music was never my major interest. Art was. On a more practical note, the Austin Symphony was a mess. The orchestra was unable to pay its debts; could not even meet the payment on its loan at the bank. The ASO was a well-known loser, and when I took over, its reputation was at an all-time low. Clearly, no one in her right mind would have chosen to take on the considerable task of guiding the symphony out of its financial swamp.

Here is how my tenure began: I was on a committee with Jim Leach to appoint a new president, but we had no luck finding anyone willing to take the job. "Jane, I have been president," Jim said to me one day. "So now, it's your turn."

"Jim, I can't possibly do it. It's just too much." Right after that, some of the men on the board took me to lunch at the Headliner's Club. They brought me gorgeous roses and asked me, "Won't you please consider it?"

"Roses and desperate men are hard for me to turn down," I told them. However, I said I would consider becoming president, provided I could run things my way *and* serve longer than one year.

Nettie Jones, my neighbor and a great friend. She provided strong support for me during my early days as president of the symphony.

"Oh, yes. Do anything you want," they said. Those men on the symphony board reminded me of the former Dallas mayor reputed to have said about the Dallas orchestra, "Tell them I will give them money as long as I don't have to go to the damned concerts." With the other board members' promise, I had permission to do things my way. That is exactly what I did.

Of course, I realized full well why they chose me: they could find no one else to serve as president. Once I agreed to accept the job, I had to decide what to tackle first. When I became president in 1972, the symphony had a part-time business manager, a secretary, and a debt of $40,000. In today's dollars, that would be equal to more than $200,000.

The bank was gritting its teeth over us because we had no major

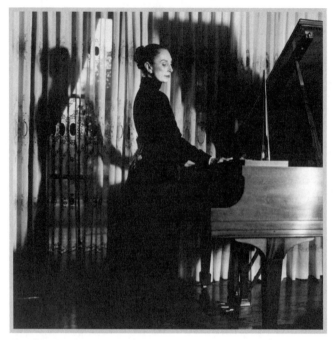

Standing at my piano.

financial donors. A typical contribution to the symphony was $25. A "generous" one was $100. That level of donation was why the symphony was broke, even though it began its existence in 1911, and had been performing in Austin for more than sixty years.

Our debt disturbed me most. I took no comfort at all that many other symphonies were in our condition, too. I refused to believe things had to stay that way. I was determined to change that mindset in Austin. Along with the finance problems, the orchestra was performing in an inappropriate venue. The multi-purpose, concrete-floored Palmer Auditorium attracted sparse audiences for ASO's concerts. Everywhere I looked, more challenges popped up.

The orchestra's contract with the musicians union was another major issue. Nobody in the office knew where to find the union contract. Everyone told me we had one, but no one could lay hands on it. Eventually, the contract turned up in a lawyer's desk drawer. The symphony had received a 501(c)(3) tax benefit from the IRS. Good lord, I thought,

how would their auditors respond to a non-profit that handled its business so shabbily? I was appalled.

Because I was desperate for more productive and continuing legal advice, I did something that no arts organization in Austin had ever done. I recruited one of our board members, attorney Bill Kemp, to be our legal counsel.

When I asked Bill to serve, he told me, "I'd love to. I'm already chairman of the subscriptions committee and I hate that job." Thirty-four years later, he is still on the board as vice-president and legal counsel. Bill handles all negotiations with the union and the writing of the musicians' contract.

The symphony musicians elect a representative to bargain for them during our contract negotiations. Those meetings extend over several weeks and often last many long hours. Whenever we have our meetings with the union, it is always give and take. Within a year or two we had begun an annual audit by an outside accounting firm. These days, all Austin arts organizations have retained legal counsel.

Unfortunately, I had inherited an executive director who was a charming man who had a problem with alcohol. At the time, I was not aware how much or how often he imbibed. His position was part-time and we paid him next to nothing. I would have drunk too much as well if I had tried to get by on his salary. Every time he made a note of something he was supposed to do, he would put the note into his jacket pocket. He wore seersucker jackets that went to the laundromat, so that was where his notes often washed away.

To put it kindly, he did not accomplish very much. We had no bookkeeping system. We had no CPA. We were unable to pay our rent. We did not even *have* a bookkeeper. What we had was a secretary and a manager who was supposed to be keeping the books himself.

The man's title was "Executive Director," but he was actually our business manager. He was a pleasant man and loved the arts, but he knew nothing at all about business. I kept on insisting that we hire an outside bookkeeper to check our accounts. When I finally lost all patience, I told him, "I need to see our books."

He would not produce them.

Finally, I said, "I am coming down to get the books."

Before I picked them up, I asked the woman who was running the

Heritage Society, a group dedicated to preserving Austin's architectural past, if she would examine our books in her spare time. I offered to pay her for her effort, but asked her to remember the symphony was a non-profit organization. Little did she know just how non-profit.

When I arrived to get the books, I had assumed we had an actual ledger. Instead our executive director handed me a shoebox full of check stubs.

After I delivered the box to the woman at the Heritage Association, she said, "Jane, I wouldn't touch this." That was my red flag. Actually, it was more of a neon sign that was flashing this message: "Help!" At which point, I told myself, I simply cannot possibly accomplish what I will need to accomplish all at once, so I am going to bite off one problem at a time.

First, we began to draw some strong people to the board, especially men. Women were limited in their clout in the business world thirty-five years ago. Men, especially if they loved serious music, could get more things done. That reaction may sound odd coming from a woman, but that is how things really were back then.

In 1972 and 1973, during my first year, most women were house-wives. Today, I am glad to say, women make up almost sixty per cent of college students and half of medical school and law school students. Texas has a woman senator. The US House of Representatives has had a woman speaker. We may have a woman president in the next few years—whether we like it or not. But that was not the case when I took over the symphony. In the beginning, I had no choice but to depend on the men who were willing to serve on our board.

After I became president, I learned a lot by calling other people who managed symphony organizations all over our country, asking them searching questions. You can get plenty of honest information if you are just willing to ask for it. By talking with so many symphony managers of whom I asked, "How do you ever manage to survive? Why are so many orchestras broke?" I found out how, and why.

Very soon, I discovered we were not the only orchestra having financial problems. Too many of them had dysfunctional boards, even as ours was growing stronger month by month. Our vision for the Austin Symphony was for it to be a professional orchestra, one that was also being *run* professionally.

Consequently, I devised my own philosophy of how to manage our orchestra. I pictured it as a milking stool, one with the standard three legs. The first leg was our board. The second leg was our manager and staff. The third was our conductor and his musicians. Finally, the seat of the stool represented our concert productions. As a result, if one leg wobbles, the music suffers. The three legs of the stool can sometimes get into squabbles, particularly when they stray from their areas of expertise. However, if everyone agrees to stick to doing their own jobs as best they can, things will usually work out just fine.

Even as we continued to fine tune the board's membership, we tried very hard to avoid changing our committee chairmen. Ray Hall, who ran his own advertising firm, was the vice-president. He told me, "Jane, we need to find a bank that will give us a line of credit."

At the time, I did not know what a "line of credit" was, but it sounded pretty good to me anyway. As soon as I understood how a line could help us, off we went to visit with Ben Morgan, president of Austin's relatively new Community National Bank.

Bankers like Ben, who were rooted deeply in their communities, have become rare in today's world of financial takeovers and mergers by impersonal multinational conglomerates. It is a harsh fact of modern life to realize that banks which remained more conservative and locally focused held onto their fiscal independence when the risk-inclined multinationals almost all leapt off the financial cliff in 2008.

When we first approached Ben, Community National Bank was just getting started. In fact, its first office was in the back of a filling station on Airport Boulevard. Ben wanted his new bank to live up to its name and to become well known in the community, so he agreed to give us a line of credit. Our first line was modest, but it did provided the symphony with something of a cushion we could depend on.

Our most significant financial problem was cash flow. Our fund drive for the current year had raised barely enough to cover expenses for the past season. There was no money that we could use to plan the budget for our next season. That new line of credit helped us bridge that perilous gap.

Within a few years, we were no longer merely paying for the previous season, but putting money into next season's budget. In those days, our fund drive only raised about $10,000. D. J. and I and the Potts/

Sibley Foundation donated half of that. Nettie Jones put in $1,000, Ellen Garwood contributed another thousand, and Southwestern Bell gave us a thousand. Do the math: that totals all of $8,000. Many people donated $25, and felt good about their contribution.

Our most pressing task was to change the attitude about what appropriate giving was, and we desperately needed more—and more generous—corporate sponsors. At the time, not one of the city's banks donated to us. But after he gave us our line of credit, eventually we persuaded Ben Morgan to join our board. In my opinion, Ben personally saved the Austin Symphony. We could not have made it without his deep devotion to our cause.

Finally, as soon as we paid off our debt at the Austin National Bank, we invited bankers and some prominent businessmen to join our board. One or two of the candidates said, "We want this run like a man would run a business."

Hmm, I thought to myself, you have no idea what you are talking about. It was not easy for me to keep my mouth shut at such effrontery, but I managed. Somehow. Nevertheless, I kept trying to get across to new board members this primary concept: the symphony is not a business. Right up front, we are not-for-profit. And, of course, we are not a charity either.

We hire professional musicians and they produce marvelous music. I kept trying to make it clear to board candidates that it was not possible to run the symphony completely like a business. One important element is that we work with many volunteers and we cannot easily dismiss them. Therefore, quite unbusiness-like, we had to achieve a delicate balance, one that too many orchestras do not manage at all well.

Until recently, our symphony had not been run "at all well" either and certainly not efficiently. I was doing my best to move us ahead, with my ultimate goal of the orchestra becoming a thoroughly professional not-for-profit organization. We needed a long-range strategy so we could develop some long-term solutions.

When time came to elect a new president at the end of the year, the nominating committee suggested we make no changes. Because they were true to their word, I stayed on. Little did I know when that first reappointment occurred that I would remain connected to the symphony for a quarter century.

In 1980, I found the perfect business manager right in my own back-yard—Ken Caswell, a descendant of one of Austin's most prominent families through the preceding years. His mother lived around the corner from D. J. and me. Ken stopped in to see us once in a while when he was in town.

At the time, he was managing the opera in Memphis, and before that had been manager of the San Antonio Symphony and Opera, where he had learned his arts spurs under a real pro, a brilliant conductor named Victor Alessandro.

One day, when I called Ken, I asked him, "Would you be interested in moving to Austin?"

He said, "Yes."

When I asked, "Would you be interested in becoming our symphony's business manager?"

He replied instantly, "I'd love it!" Ken was happy to take the job, staying with us for eighteen years and becoming one of my most trusted friends. Ours could not have been a better arrangement. Ken must

Ken Caswell next to the Historical Marker at his grandfather's home in Austin

have called me from two to five times a day, or more, every day, for all of those eighteen years, while we discussed every nuance of the symphony's operations.

One of our main challenges was building an inclusive, enthusiastic, talented, and committed board that would represent all segments of Austin's diverse population.

I told the board, "We are accepting city funds and we must be an institution that reflects our entire community." The sixties Civil Rights Act may have been the law of the land, but when it came to the arts, Austin was very much an all-white world. I wanted at least one black person and a Mexican American on our board. My desire was somewhat shocking at the time, but the board went along. We were the first arts group in our area to have an integrated board.

To recruit a strong member from Austin's African American community, I called on Exalton Delco, whose wife, Wilhelmina, was a Texas legislator, a state representative. An educator and head of student affairs at Huston Tillotson College, Exalton is a quiet and dignified man. I told him I was trying to expand our board to make it more inclusive.

Betty Himmelblau (left), member of the Austin City Council, and Joan "Jo Jo" Holtzman, who wrote children's songs, two wonderful friends from the Symphony board

He responded, "Do you know that I play the violin?"

I said, "I had no idea."

He was happy to join us and he is still on our board.

That was pure luck, but you need lots of it when you start out to make some serious changes. Then I met Aaron Kruger and his wife, Edythe. (He was the son of the prominent poet Fania Kruger.) We sat across from each other at a dinner and found we had lots of old friends in common. Aaron explained to me why the Jewish community—part of a population with centuries of history supporting the arts—was no longer supporting the symphony.

Aaron told me it was because of a previous conductor, Ezra Rachlin, who was a brilliant pianist and a contemporary of Leonard Bernstein's. Unfortunately, Ezra had an extremely high opinion of himself and he expressed it frequently. His arrogance overshadowed his talent. Even

D. J. and I (I am to his right on "Pecoso") representing on horseback the Symphony in an Austin parade.

worse, he was slow to meet his personal financial obligations. In other words, he did not pay his bills.

Since Ezra was Jewish, his error was considered a poor reflection on the rest of the Jewish community. As a result, that community had stopped supporting the symphony, embarrassed by Ezra Rachlin's personal failings.

"Jane, we'll just work at it and get them back," Aaron told me. True to his word, Aaron worked wonders. He was so highly regarded by the Austin Jewish community that when he told them how things had changed at the symphony, folks followed his lead and began supporting us again. A natural-born music lover, Aaron Kruger was one of the first board members I learned to depend upon. I might call him at ten o'clock at night with a problem to which I could see no solution. Aaron almost always helped me resolve it.

Another creative problem solver for the symphony was Sander Shapiro, an attorney. I asked him to be chairman of our finance committee, because I did not want a CPA as chairman. Accountants tend to deal with immediate issues, but I preferred someone who could think long-term.

Ezra Rachlin also managed to sever the symphony's relationship with the University of Texas. He got angry when anybody on campus used his practice room. Because of one undiplomatic and cranky conductor, we had lost the backing of both UT and of the Jewish community, two very significant supporters of the arts, both as to performers and benefactors. Mercifully, Ezra was gone before I took over.

Because I was a member of the advisory council at UT's College of Fine Arts, I was acquainted with Bob Bays, chairman at the time of the music department.

During my first year as president, he called me. "I'd like to visit with you. I think we can work something out to help both our music department and the symphony. I can budget half the salary for someone to teach conducting. If the symphony can come up with the rest, we can get a fairly good conductor."

We found the money and it was an excellent investment. Together, we hired Maurice Perez, who had charisma but was a borderline egomaniac. Of course, many conductors are, and despite his grandiosity, Maurice was a major step up from Ezra. Maurice lived in Corpus Christi

and led both the Corpus Christi Symphony and the Austin Symphony during the early seventies.

Once Bob Bays and I had collaborated successfully on getting money for a conductor, he helped me solve another major problem. He was familiar with the ongoing struggle the symphony had with UT. After I became president, no professors from UT were playing in the orchestra. Not one. Until Bob said the words I had been hoping to hear: "I want to encourage my faculty to perform with the Austin Symphony."

To make that happen, Bob had to go to the administration of the university and ask them to waive a rule. At the time, professors could not moonlight, and amazingly, playing with the symphony the UT rules considered as moonlighting. Bob's argument with the university was that it improves a professor's teaching skills to perform regularly in a symphony orchestra. He must have been persuasive, because we

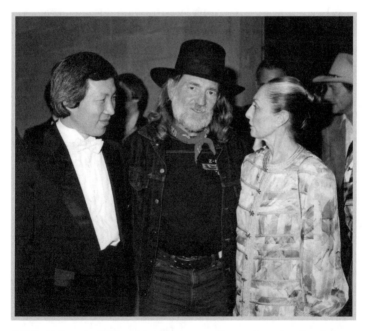

Willie Nelson (middle), with Symphony conductor Sung Kwak and me during an Austin visit by Prince Charles, who we entertained with a Symphony Musical Evening. As the program began, Willie Nelson and his band rose up on the lift playing "Whiskey River" to Prince Charles's considerable delight.

got both our concert master and our principal cellist from UT's music department faculty.

Before long, all our principals were also teaching at the university. By including those faculty musicians, we had begun to develop another base of support that helped us to become a more successful and more respected orchestra.

Next, I had to improve our fund-raising. I told the board members that part of their job was to raise money. Previously, that had not been a requirement. I also said they had to buy tickets to all our concerts. If board members were not attending our concerts, what kind of message was that sending to the public?

Our staff prepares a list of potential individual donors and corporate sponsors, but board members do the canvassing. As a result, ever since we expanded board responsibilities, both our budget and our list of supporters continue to expand. Today, our annual budget is almost $3.5 million. When I first became president, the budget was barely $10,000.

Recently, as I looked over our records from 1977, I noticed we had improved our budget to $70,000, producing our first-ever surplus at the end of that year: a whopping $12,000! In 2007, we raised more than $1,000,000 during our fund drive, not including corporate contributions (our corporate donors bring in at least a half-million dollars a year). Currently, ticket sales cover about half the budget, considered high among other symphony orchestras. Best of all, we have ZERO debt.

Some people like to sit on a board, but prefer somebody else to do the work. They would rather depend on the executive director or the conductor to raise money for the orchestra. I never thought it was morally correct for the business manager to have to raise money to pay his own salary. The conductor should not have to do that either. They should be free to concentrate on their full-time jobs.

The board's responsibility is to raise money and to set policy. If a manager does not do his job, you can fire him. You can even replace the conductor. There is no need to fire board members. They almost always resign from the board voluntarily if they are not doing anything. You can always weed them out diplomatically.

Some orchestras have much larger budgets than Austin's, because they have such high labor costs. We operate differently from those

symphonies and that is one of our assets. We do not contract for a thirty-five or forty-week season, but for individual performances. All our musicians have other jobs and are not dependent on the symphony for their entire livelihood. That procedure of ours takes tremendous pressure off them and off our management. Every time our musicians rehearse or perform, they are paid. That is how we keep our budget reined in.

Houston's orchestra is paid the year round, by the month. That arrangement can cause difficulties between management and the musician's union. The musicians always want more money, because the symphony is their full-time and only job; the symphony may not be able to meet their demands, even if they have a large annual budget.

We hold open auditions every fall, but the first chairs, our principals, do not audition since they have already earned their places. We have first chair, second chair, and third chair. They are our core.

We carry over each season from fifteen to twenty principal players year-to-year who are usually not required to audition. If our conductor feels someone has not been practicing enough, he might ask that person to repeat an audition. By using the talented musicians who teach at UT, we have been able to employ excellent musicians part-time. We can stage a larger or a smaller orchestra depending on the compositions played in a concert. We do Mozart with a smaller ensemble, while Rachmaninoff requires a much bigger orchestra. We once had ninety musicians for a Mahler symphony. Mahler liked a lot of sound and we provided it.

For six years, from 1984 to 1990, I was a member of the American Symphony Orchestra League's board of directors. The organization includes orchestras as varied as the New York Philharmonic, the St. Louis and Chicago symphonies as well as medium-sized and smaller orchestras. I enjoyed meeting other symphony leaders from all over the country, some of whom were presidents of symphonies, others were professional executive directors. There were no musicians on that board. ASOL was primarily a lobbying organization that worked to increase federal spending on the arts, mainly symphonies. We always met in Washington, DC.

When President Lyndon Johnson set up the National Endowment for the Arts in the sixties, for the first time the federal government began offering grants to orchestras. I was appointed to NEA's board when

Ronald Reagan was president and legislation was pending to continue funding NEA. The board members lobbied Congress to extend the life of the Endowment and we were successful.

I knew Senator John Tower from Texas personally, and as I began to lobby him, he said, "You don't have to talk to me about that. My wife has already told me how I have to vote." It also worked in our favor that concerts are far less controversial than some of the fairly shocking art exhibitions that got the Endowment into unpleasant controversies at the time.

One of my strengths as a board member was having good contacts, but never being afraid to initiate new ones. I was not shy about asking for information, whether I had met a person or not. All I needed was a phone. I wanted to learn from people who had experience. That same quality has helped my work in building the symphony board and in fund raising over the years. I have never hesitated to call anyone who might assist us, and they usually took my call and told me what I needed to do or to whom I should talk.

I did not always go along with the leadership of the American Symphony Orchestra League. At one meeting, the president of the league proposed that every orchestra should include a music committee.

I piped up, "What for?"

"To tell the conductor what to play."

"When we don't like what our conductor plays, we fire him," I said. After all, I feel it is insulting to tell your music director what to program. That is his job, not management's.

The Austin Symphony has done quite well with our three-legged, but cooperative, separation of powers. We believe strongly in private funding and never rely on public grants. Arts organizations can easily get hooked on public grants, causing them to slack off on their own fund-raising, and thus to lose their independence. If a change of administration occurs or there is a tightening of federal, state, or city budgets, those grants can disappear. If changes like them do occur, an organization can be stuck with a huge hole in its budget. We would not allow that to happen in Austin.

Symphonies, like all arts organizations, need money to operate. Most of them hire an executive director and a staff. Many also have costly union contracts or they conduct capital campaigns for which they hire professional fundraisers. Every arts organization has travel expenses

and some are paying off previous debt. Thank goodness our orchestra has no debt and no professional fundraisers to pay. I am proud to say we are way ahead of many others.

My life changed quite a lot when I began working with the symphony, but it has been a great joy as well as an occasional headache. In many ways, mine was a full-time job. Very soon, I realized I could not deal with everything personally, so I delegated as much of the day-to-day operations as I could to our staff. I chose to concentrate on the big picture, to learn how to put all the parts together, and slowly to chip away at our problems, one at a time.

As the years went by, ours became an organization that attracted plenty of volunteers. Today, the Austin Women's Symphony League has seven hundred members. Altogether, more than a thousand people are involved with the symphony. We have enlarged the board a number of times.

Aaron Kruger told me, "Jane, each time we increase the size of the board, we get more money." He was right, which is why our board now has a hundred members. Its size means we have a hundred people thinking about the symphony. Since nobody ever wants to leave our board, we must be doing something right.

I never planned to remain president for so long. Things just kept coming up and we were all working together so well that we never saw any need for a change at the top. I must say that I loved my work. After a few years, being president was not a burden but a manageable challenge. I did that work for a quarter of a century.

Before I stepped down, I selected Joe Long as our next president, mostly because he could run a meeting better than anyone I ever saw. It was not exactly a democratic election, more like that of a banana republic, but we got Joe to lead us.

When people ask me where I learned my executive skills, I really do not have a good answer. Maybe they were always part of me. Of course, I did have some previous executive experience: I had been president of the Fort Stockton Garden Club.

Whenever I had a knotty symphony problem to consider, and hopefully to resolve, I often went to our ranch in West Texas, to sit on our mountain top, to just think amid that vast solitude, and sometimes just to watch the buzzards. They may even have helped me the most.

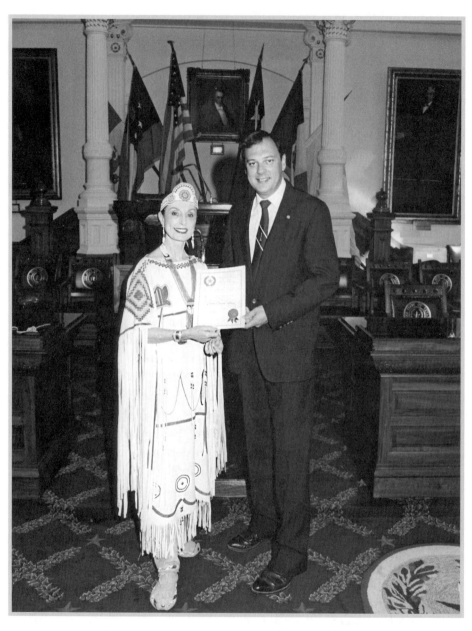

I walked up to the Capitol in my Sioux Indian outfit to receive an award, after attending the Symphony Halloween concert at the Paramount Theater.

I always tried to learn from the mistakes of other symphonies and arts institutions and to make sure we did not duplicate theirs. For example, in one city, a conductor had received a large grant. The orchestra management assumed the grant belonged to them. The conductor assumed it was his. When he moved on to another orchestra, he took the grant money with him. Often, an organization can avoid a mistake by having good legal counsel, and by always putting everything in writing.

D. J. was pleased for me to be involved in the symphony. He knew I was good at it, and that it made me happy. While he was involved in a number of organizations over the years, he was more the analytical type. He was a thinker who did research at UT, where he worked with the school of pharmacy. I never discussed symphony affairs with D. J. because that was *my* work, not *ours*.

One of the things that can bring down symphonies is family gossip: "My husband said this and you shouldn't do that." I insisted that our board members attend meetings, to understand what was going on, and not to go home and second-guess decisions with their spouses or ever to discuss symphony business with outsiders.

At this writing, our current conductor, Peter Bay, is in his second five-year contract. He has greatly enhanced the symphony through his leadership and style. He continues to program music of the great composers, is sensitive to his musicians, and is highly respected in the community. He and his beautiful wife, Sara Jane, an operatic soprano, display a rare combination of talent and charm.

From 1972 to 1997, I was president of the Austin Symphony. One thing I feel most proud of is getting so many diverse groups from throughout our community involved in the symphony. During my tenure, Austin more than doubled in population and that growth brought in many people who loved the arts and who wanted their children to grow up listening to good music. We have made tremendous strides that have elevated our orchestra into the top echelon for its size.

I served during an unusual period in American classical music, when Asian and Asian American musicians began displaying their extraordinary abilities. Seiji Ozawa was conducting in Boston; the great cellist Yo-Yo Ma was beginning to make his reputation. Austin was in the forefront, with tenures from our two extraordinary symphony conductors, Akira Endo from Japan and Sung Kwak from Korea.

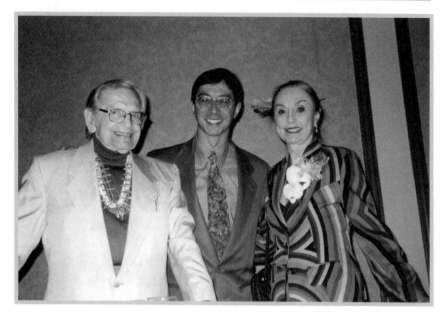

D. J. (left) and I with Peter Bay (center), current conductor of the Austin Symphony, at the Most Worthy Citizen luncheon

Today, people who hear my name often associate me with the Austin Symphony Orchestra. Some even think I started it. That opinion makes me feel certain I have gotten a lot more credit than I deserve. No one person can possibly build any institution alone. Such an effort requires hundreds of people working tirelessly for years. That kind of help is what I experienced during my entire tenure. I was blessed with the assistance of very talented people, some of whom I selected personally, a few I inherited.

I am equally certain more than a few of those folks arrived through the intercession of a Higher Power. One vital key to the Austin Symphony's growth and quality was having our board initiate such strong leadership while we were busy accomplishing our most important innovations.

In fall of 1996, the board appointed me its chairman. I have served in that role for more than a decade. My main job is functioning when our president, Joe Long, is away. This arrangement has worked well. Joe

and his wife, Terry, like to travel. Whenever he is away, I can provide answers to any issues that arise.

In 1985, the Austin Symphony Orchestra established the Jane Dunn Sibley Award for Outstanding Cultural Arts Leadership, presented by the Austin Symphony Orchestra Society. The society presented their first award to me on the night of the Symphony Ball in 1985, a wonderful and lovely surprise. We do not present the award every year, only when we feel someone deserves it. Other honorees have been Jerry Smith, John Bustin, Joe Long, and Bobby Crenshaw.

Shortly after D. J. died in 2005, I received a letter from John, my first symphony business manager. I had not heard from him in more than thirty years. He apologized for his previous behavior and said, "I am sorry that I caused you such problems." He told me he was no longer drinking and that his life was entirely different. I was happy for him and thought back on how far we had come in the thirty-three years since he handed me our "books" in their shoebox.

14

Symphony Square

BY 1974, the symphony was already beginning to gain in popularity and to succeed financially, so we needed more office space. Through good fortune and the initiative of Peggy Brown, a board member, we able to expand our physical location and to develop the wholly new concept we call today, "Symphony Square."

Peggy was a major force in the Heritage Society of Austin, and she was absolutely passionate about preservation. She told me the symphony could acquire an historic building at 11th and Red River Street as our symphony office. US Urban Renewal had offered the building free to the Heritage Society. UR's mission was to demolish the entire rundown area along Red River by tearing down many of the older buildings that had fallen into disrepair. Early Austin settlers had built some of the structures, a few before the Civil War. Others were modest homes constructed of fieldstone held together by a mortar made from lime mixed with sand.

"I think we can do the move for $20,000," Peggy informed me.

Because I had restored some buildings in Fort Stockton, I knew it would cost a lot more but did not mention that to Peggy because I did not want to dampen her enthusiasm. After I asked her to look into the possibilities, she began working with Urban Renewal, a federal agency that had never worked with any arts groups.

Fortunately for our group, Leon Lurie, the director of Urban Renewal in Austin, attended Dallas Symphony concerts with his grandmother on

Sunday afternoons when he was a little boy. Even though Leon was not himself inspired to attend any more concerts for the rest of his life, he understood that many people loved them. Recalling somewhat fondly his own concert excursions with his grandmother, Leon told us he would gladly work with us. Once again, our good luck was very much with us.

The Austin Urban Renewal Agency was extremely powerful and had almost unbridled authority to bulldoze just about every older building in our city. To counteract the agency's willfulness, and to preserve as many of Austin's historic sites as possible, the Heritage Society was raising a fuss. The society's more passionate members were unafraid to speak out, but the group had little funding with which to counter Urban Renewal (UR). Leon Lurie's federal agency not only had broad powers—it had access to lots and lots of federal funding.

Urban Renewal had set up regional offices throughout our country and its mandate was clear: to raze rundown city areas in order to create new developments. While UR did add greatly to Austin's downtown property development, some of its results were heart-wrenching for property owners who had lost their buildings.

The agency's rules and regulations allowed only one non-profit project in the downtown Austin area. The area under renovation began at Fifteenth Street and went south to Tenth. To the west the renewal area was bordered by I-35 and to the east, by the State Capitol complex. Whatever buildings within that zone UR had scheduled to be demolished one could purchase at UR's appraisal price, before moving it to its new location. UR even had a modest budget for relocating buildings, but the purchasers were liable for any excess costs.

We began by trying to renovate one building as it stood. Eventually, we preserved four buildings that were a hundred years old or older, all originally scheduled for demolition. Three of the four we had to relocate and all of them required extensive renovation.

As soon as we had met federal requirements that allowed us to receive funding to relocate them, Urban Renewal was so eager to clear the land, that we had to move fast in order to meet their deadlines. Early in our work, Peggy and I named our planned target site "Symphony Square," even though we all agreed the land was actually a trapezoid. Sometimes accuracy must give way to poetry, so Symphony Square it was.

The buildings we selected, we planned to relocate to land along Waller Creek, which lies in a 100-year flood plain. That factor required us to obtain a number of variances from the Austin city council. On behalf of the symphony, all thirteen of those variances passed unanimously after Peggy and I presented them before the city council.

Knowing how important creating Symphony Square could be to the Austin Symphony's image and visibility, we continued our lobbying efforts with enthusiasm. We were still struggling to build our board and to establish a sounder financial footing, but the opportunity posed by Symphony Square was too good to pass up.

Peggy and I chose to appreciate the opportunity we had with Symphony Square rather than bemoaning its possible bureaucratic challenges or worrying about the fund-raising issues we were taking on.

That opportunity inspired Peggy and me both during our frequent appearances before the Austin city council while we lobbied for Symphony Square. We often slipped in the back door of the council chambers so we could visit with the members individually.

One day, someone announced from the podium in the council chambers, "If Peggy and Jane will let go of the council members, we'll start our meeting." We did and they did. We are the only organization I know that has gone to the council so many times and never been turned down once. While creating Symphony Square, we worked under three different mayors, and they always supported us. In Austin, I believe that is a record, one to be proud of. We are!

Peggy and I contacted foundations and private individuals in order to make up the difference between what we needed to renovate each building and the available funds Urban Renewal could allocate.

Remember, this was the mid-seventies, so our renewal plans were coinciding with the US bicentennial celebrations. Once again, our good fortune was working for us. We took shameless advantage of the patriotic spirit abroad in our land to raise money for our own Texas historical restoration. We were quite successful. Although I am sure we could complete a similar project today, the bicentennial spirit back then helped us tremendously.

Our renovation budget for all four buildings was about $250,000. Today, the same project would cost millions. We kept our funds in a separate bank account, because we did not want the symphony to

assume any added fiscal obligations. The money we raised for the build-
ing project we spent very well: the combined efforts of Urban Renewal
and Symphony Square helped create a model of historic renovation that
contributed to our achieving an attractive and highly desirable business
environment.

The location of Symphony Square comprises two acres, pretty tight
when you're squeezing three buildings inside that area. Fortunately,
some additional land across the street became available as a site for our
fourth building.

To move all of those buildings, we hired a Navajo contractor named
Jack Logan, who unfortunately could not obtain insurance, because
Jack was not a licensed engineer. Furthermore, he seemed to plan even
complex moves like ours in the Navajo language, inside his head.

I do not recall how we ended up with him, but Jack was one of the
few people in Texas who knew how to move a stone building that was
not square. Jack set up a little trailer house close to our site where he
drank coffee, sat, and thought about how best to complete our move. He
was a marvel at moving older, fragile buildings; a true natural genius.

We could not deal with just any contractor, but needed one who spe-
cialized in restoration. Luckily, we found Tyrus Cox, from Fredericks-
burg. Tyrus had restored a number of old houses as well as a few Texas
historical properties. Our stonemason, James King, was a true artisan
who had worked at his profession since he was six years old, learning to
lay stone beside his daddy. James built our ranch house in the late six-
ties and I insisted that we use him on Symphony Square.

The first structure we worked on was the Jeremiah Hamilton Build-
ing, located on the corner of Eleventh and Red River, the first of our
Symphony Square quartet. The building's name was that of a former
slave who had served on the Texas legislature during Reconstruction.
Hamilton could read and write when most slaves were illiterate.

By the mid-nineteen seventies, the building had fallen on hard times,
becoming a hippie dive beer hall. It may even have been one of the many
Austin venues where Janis Joplin sang during the sixties. Luckily for
our purposes, we did not have to move that building. We were able to
restore it on site, and today, it houses the symphony's season subscrip-
tion office and our music archives.

The second building we saved was the New Orleans Mercantile,

The Jeremiah Hamilton House, located at 11th Street and Red River Street, houses the Symphony's music archives.

which we had to move only one block from its location at the corner of Twelfth and Red River. We restored it to its original appearance as a country store. Moving any stone building is a work of art and one with which I was totally unfamiliar. Nothing in my background had prepared me for the logistics required.

A rotten wooden floor was pulled out so two trenches could be dug in the ground. Into those trenches, Jack Logan laid steel I-beams that extended beyond the length of the structure. After that, he poured a new concrete floor and let it cure, which created a substantial floor strong enough that the moving crew to lift the entire structure and place it on a flat bed trailer. The Mercantile rode its one-block journey in elevated grandeur. At Eleventh and Red River a crane lifted the old building from the trailer and lowered gently onto its new foundation. Once safely in place, workers severed those protruding I-beams.

Now the hard task of its total restoration began. Artisans returned the exterior to its pre-Civil war look, while the inside was being adapted

The Mercantile, once the New Orleans Club, where blues queen Ernie Mae Miller sang for years

to the needs of the twentieth century. Our dedicated workers granted the New Orleans Mercantile a new lease on life. The symphony now uses it for summer children's programs and rents it for special events and private parties.

The D'Orsay Doyle House was our third building. We had to move it across the street on a flat bed. Because it was square-shaped and because we had already transported the Mercantile successfully, the second move was fairly simple. Once renovated, this building became the office for the Women's Symphony League. We arranged for its surrounding gardens to be landscaped in an authentic early-Texas design.

Our greatest challenge turned out to be moving the Hardeman House, originally located at San Jacinto and Seventeenth Street, six

The Doyle House, now integrated into Symphony Square, houses offices for the Symphony Summer Art Park and the Women's Symphony League.

blocks away. This building was large and L-shaped, which made its center of gravity difficult to locate. Because it was not square, it was also far more difficult to transport. To add to those hazards, the city had built a median across Fifteenth Street that the Hardeman house would have to cross without tipping over.

What was Jack's solution? Take off the porch and wrap the building with steel cables, like a great big Christmas package. After that procedure was completed, workers moved the house onto a supporting frame, then lifted it onto a flat-bed trailer and moved it down the street.

The day of that move, Jack came walking down the street ahead of the building, cool and calm as he could be. The movers stopped the house next to the old Brackenridge Hospital. As Jack and the trailer arrived at Symphony Square, the Austin police had already stopped traffic. Jack was ready to pull the building into place when he reached

for an oil spray can. He intended to spray oil on the street to get better traction for the truck tires.

Noticing Jack's oil can, a policeman said, "You can't spray that oil on the street."

Jack did not say a word. Instead, he turned around and sprayed oil on the tires. The policeman just shrugged. Jack's solution did not break any ordinances. Apparently, you could put oil on the tires, but not on the street. How is that for classic bureaucratic thinking?

The Hardeman relocation took only one day, but I cannot describe precisely how it went because I left town. I was far too nervous to watch that move. Wayne Bell, a restoration architect at the University of Texas, had seated his students on a hill overlooking our move like hovering buzzards, eager to witness our building falling apart.

Even though I was not there, I heard every detail from those who were. I only showed up after everything was in place, vastly relieved that the house had remained in one piece. My greatest fear was that I would find a giant pile of rocks on the street. As soon as the Hardeman House was safely in place, my pulse rate returned to normal.

The Hardeman House was scheduled to become a restaurant, so it needed a basement as the site for its bar. Well before we moved that building, we excavated a basement at the site, waterproofed the walls, installed concrete pillars to support the structure, then put all the excavated dirt back inside to keep the walls from crumbling when the building was lowered onto it. As soon as the building was safely on its foundation, we removed all the dirt from the basement. That dirt certainly did a heap of moving.

Throughout the planning and restoration of Symphony Square, our close advisors were the ladies of the San Antonio Conservation Society. They knew well all the ins and outs of preservation work from their many years of experience; they were more than generous with us, to offer us their sage counsel. Their president worked very much as I did. She had active committees, knew what was going on, and had the authority to make decisions herself.

Whenever we hit a snag, we would call the Conservation Society in San Antonio. They always replied "Come on down." By the time we arrived, their experts were already on hand to help us.

For example, they advised us on the spacing of seats for our

amphitheater, since they had built one in San Antonio on the River Walk. Their theater is city-owned and anyone can put a program on that stage, which has led to a few awkward moments. They have even had nude weddings on the River Walk, which may be good for tourism but was not the kind of programming we had in mind. Because the City of Austin was not involved in our development, our lease with Urban Renewal was crucially important. The symphony lease with Urban Renewal states specifically that there will be no political or religious affairs on the stage of our amphitheater. Over the years, that clause has allowed us to avoid a lot of potential problems.

The entire Urban Renewal Waller Creek project included the development of Waterloo Park, which covers 10.74 acres, the relocation of three blocks of Red River, and a hike and bike trail from Tenth to Fifteenth Street. As bulldozers were moving down Red River, wreckers

The Hardeman House, for many years leased to General Hardeman, was remodeled after the Civil War in Greek Revival style, an architectural influence evident in the porch

were already razing Brackenridge Hospital, and our historic houses moving along on flat-bed trailers like so many bulky chessmen.

Frank Erwin, the powerful chairman of the UT Board of Regents, asked Peggy and me, "What in the hell are you girls doing?"

Later, after all the renovations were in place, no one enjoyed our posh Quorum Restaurant, located in one of our restored buildings, more than Frank Erwin.

We all felt Symphony Square would provide increased public awareness of our symphony orchestra, since its buildings were located at one of the busiest intersections in the city. While there's no way I can prove this opinion, I believe the police train their cadets on our corner. Provided they survive that hazardous traffic assignment, only then does the department accept them onto the force.

The contrast in the immediate area has been amazing. When we

columns, topped by Corinthian capitals. The Hardeman House is leased by Serrano's, a popular restaurant serving Mexican cuisine.

began our renovation efforts, there were no buildings around us because Urban Renewal had razed all the old ones. It was a blank canvas on which we were the first to make our mark.

During the intervening years, developers erected a number of new multi-storey buildings nearby, including the Teacher Retirement Headquarters, the Marriott Hotel as well as a government building, and a credit union building whose design matches our architectural style.

In 2007, the city announced a new plan for developing the Waller Creek neighborhood into a tourist attraction like the River Walk in San Antonio. Austin's civic officials have been "planning" to clean up that creek for thirty years, so if I can possibly live to celebrate my hundredth birthday, maybe I can also witness that project's dedication.

Without Peggy Brown's vision and her devoted participation, neither I nor our city would be admiring Symphony Square today, splendid in its restored glory. Peggy's inspired vision helped save and renovate those venerable buildings by converting them into space the symphony needed as well as garnering all the positive publicity we received.

As symphony president, I was always trying to shore up and enhance the symphony's finances and its reputation, so it was a pleasure for me to imagine how the Symphony Square renewal project could become such a perfect fit for the Austin Symphony Orchestra. In much the same way, Peggy and I became the perfect pair willing to take on that monumental but oh-so-beneficial project for our city.

Peggy worked her way, I worked mine, and after our four years of collaboration everything came together perfectly. Today, a plaque on site honors both of us for helping to create Symphony Square.

We opened Symphony Square with fandango appropriate to our nation's bicentennial anniversary. The Square appeared in newspaper articles from all over the United States. Even the Christian Science Monitor, printed around the world in fifteen languages, covered our project. Symphony Square gave our orchestra a focus and an image that other symphonies did not have.

Once our buildings were saved and restored, we worked even harder and more effectively to involve more people from our community in the symphony's programs. We inaugurated an extensive children's program that continues to this day. Throughout the summer, we scheduled programs for younger audiences in the amphitheater. We enlisted the ladies

auxiliary of a neighboring African American church to bake cookies we served at young people's events.

Our board members are always alert to even more opportunities. For example, this incident occurred a few years later, after the owner of the building next to Symphony Square placed a "For Sale" sign on the front lawn.

Eddie Safady, who today is vice-president of the symphony board, was passing by that location on the way to his bank when he noticed the sign. Immediately, he was on the phone to our manager. "We've got to buy that building before noon," Eddie declared. We did.

Andrew Heller made a large donation toward the purchase of that very building to honor his wife: consequently, it became the Mary Ann Heller Building. When constructed in the seventies, the building's architect had created a facade that matched the look of Symphony Square, so it was a perfect fit. The Heller Building houses the symphony's business offices.

One day while I was working in the Jeremiah Hamilton Building, the first one whose renovation we completed to use for our office, we had yet another piece of good luck. We found ourselves an extraordinary volunteer who was absolutely perfect for us: a retired three-star general who had been a high-ranking officer in the air force for so many years he had to relearn how to drive after he retired at sixty. He knew nothing at all about life as a civilian.

This military gentleman was walking alongside the creek one day when our manager, John Tabor, who had been assigned in Germany to handle the general's unit community relations program, recognized him.

"Jane, General Blood is walking around outside without an apparent destination. I'll bet he doesn't have anything to do." Before he retired, the general commanded the Strategic Air Command unit at Bergstrom Air Force Base, right outside of Austin.

When we got in touch, we asked him if he would come in and visit with Peggy and me. After turning on our considerable persuasion, we discovered the general was not only charming but willing and eager to do something worthwhile with his new-found spare time. He agreed to take charge of handling our bills and bookkeeping. General Blood was instantly a marvelous addition to Symphony Square.

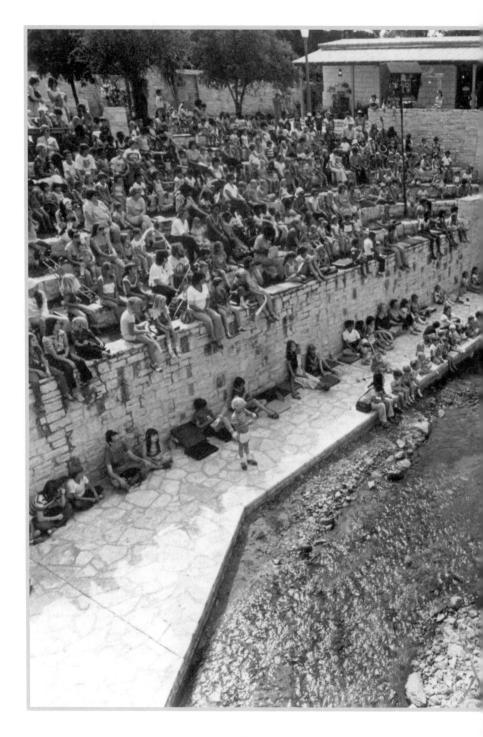

184

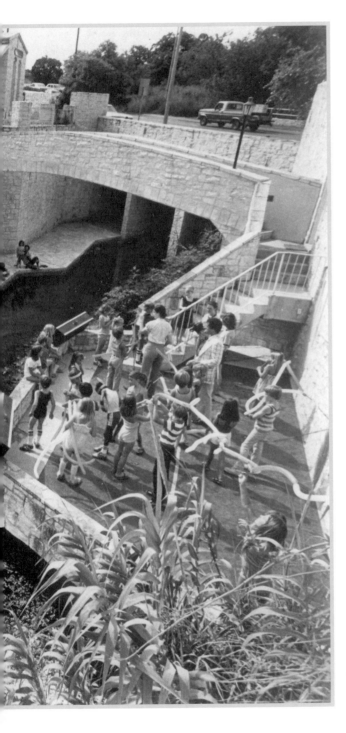

Family crowd seated beside Waller Creek for Children's Day at Symphony Square

185

He needed us and we certainly needed him. Soon, he was working with us every day. One of his strengths was his imposing presence. One day, a city inspector — much like the policeman who had objected to spraying oil on the street — was harassing us about the doorknob on our front door. He insisted that we had to have a modern doorknob. We had an old one with a square lock on the back. We first tried arguing with him. "The one we've got works fine."

"No, it's not up to current standards. You can't keep this door knob."

That dispute had one on for some months, until one day, we looked out the window and we spotted the inspector. Fortunately, General Blood was in the office and he told us it was his turn to talk to the officious man.

Although the general was a kind, gentle man, he could also put on his "General" image. In that guise, he was impressive and very much in charge. He went out into the hall and said to the busy-body inspector, "I'm General Blood. What can I do for you?"

In response, the inspector almost saluted.

Then the general told him about all the things we were doing for the community. That inspector departed quickly, his tail tucked tightly between his legs. He never came back. The general won our skirmish without firing a shot, and we kept our doorknob.

Another time, General Blood was in the office with Peggy and me. "You know, girls, I'd be perfectly happy if one of you was flying my right wing and the other was flying my left wing." That was one of the loveliest compliments I have ever received, especially as it came from a three-star general who had flown everything from Stinson trainers to supersonic jets. Compliments do not get any better than that one. Eventually, we added the general to our board so he would have some official status with the symphony.

General Blood passed away in the fall of 2009 and can never be replaced.

15

People I have Been Privileged to Meet and to Know

D. J. AND I were fortunate to own two beautiful places to live—first, our home in Austin, designed by Hal B. Thompson in the Spanish Revival style that later swept the southwest including California, and the other, The Castle, the contemporary house we erected on a mountaintop in the Glass Mountains of West Texas. At both homes, we enriched our lives by inviting the fascinating guests who shared their lives with ours.

Before we built The Castle, we hosted hunts each fall deer season seeking our cagey West Texas mule deer. Our men friends really like to get outdoors then and be "macho." However, our hunts were different from most. We invited only couples—a policy that really cut down on drinking. The women mostly stayed together to visit while the men went out to hunt from a pickup with a ranch hand to guide them. Deer follow common trails to water or to green feeding areas, and our guides knew where those best hunting grounds were.

Frank Borman was one of our fascinating guests.

Frank Borman

Frank Borman, the Apollo astronaut, knew our friends Johnny and Sue May from Fort Stockton. They all went to school together at the University of Arizona in Tucson. When Johnny asked D. J. if he could invite Frank to hunt on our ranch, we were happy to have them join us.

Frank brought his son and we brought our older son, Jake, who was seventeen at the time. Then we all went out and spent a night or two hunting. Frank was wonderfully down-to-earth, although I think we can agree that may be an odd phrase to describe an astronaut. D. J. enjoyed being with Johnny, Frank, and the boys, but said he had enough camping out during World War II to last him several lifetimes. We kept cots and bedrolls in the "honeymoon casita."

Frank told us he was going to be on one of the upcoming missions but was not sure which it would be. He thought he might be on the crew of Apollo 8, which was scheduled to circle the moon. He was right.

In late December 1968, Frank Borman commanded the crew that first circled the moon before returning safely to earth.

Sometime during that deer season visit, Frank learned about Jake's interest in flying. Jake had earned his pilot's license a few years earlier. A pretty impressive feat for a boy of Jake's tender age. When the date of Frank's Apollo moon flight approached, he invited Jake to be his guest at NASA's Kennedy Space Center in Florida.

Frank was unable to greet Jake himself before the launch, because he was wired and suited up, but Frank had invited our son to be a guest at to an exclusive dinner hosted by the president of King Energy the night before Apollo 8 took off.

Jake was thrilled to be included, and when he called home to tell us about the invitation, I said, "For heaven's sakes, don't order a drink. You look older than you are and they will probably serve you. Please don't do it, because the hotel could lose its liquor license if they are caught and they'll go broke without that license."

Jake said, "Yes, Jane. Yes, Jane." As far as I know, he did not have a drink, but I would not swear to it.

Jake was at a table with several prominent people, including Buzz Aldrin, the astronaut who later walked on the moon. It was a large group, filled with celebrities and high-ranking space officials. Mr. King introduced the first astronaut to go into space, Alan Shepard, the master of ceremonies for the evening.

"There is someone in our midst who knows about the space program from its very beginning, going all the way back to Goddard and his experiments in the desert in New Mexico," Alan Shepard said to the

guests. "That man is Colonel Charles Lindbergh. Colonel, would you be kind enough to say a few words?"

Lindbergh spoke for forty-five minutes, giving an overview of flight from the twenties to the sixties. The audience was thrilled. Rarely, did Lindbergh ever speak more than a few sentences in public. He seldom gave interviews, and it was most unusual for him to speak as long as he did on that occasion.

Jake called us at midnight to tell us all about his evening. As a licensed pilot himself, Jake was thrilled to hear Lindbergh's speech and to have been present on such a momentous occasion.

Immediately after Frank Borman's Apollo 8 launch, the guests headed home to celebrate Christmas. Mr. King told Jake, "I'll be happy drop you in Austin," so Jake got to ride in a private plane that held thirty passengers. That boy always seemed to luck into things.

I told my friend, Wayne Bell, the restoration architect, about Jake's experience and he said, "I sure had a dull puberty."

At home, Jake was still elated over his once-in-a-lifetime experience. He was seldom talkative, but he could express himself well when he chose to. Jake spoke at length with us about his experience at NASA and about hearing Colonel Lindbergh's talk, which was one of the great experiences of Jake's life. He had two cameras with him, so he clicked away as much as he could, capturing some wonderful photographs of Frank Borman's Apollo lift-off.

Miss Ima Hogg

A few days after Jake returned from Florida, Nettie and Albert Jones, who lived near us in Austin at the corner of Niles and Pease, invited us to Christmas dinner. People were still talking about how, while Borman was guiding the Apollo spacecraft around the moon, he had read this passage from Genesis: "In the beginning God created the heavens and the earth. . . ."

That Christmas, Miss Ima Hogg was also a guest of Albert and Nettie. Albert had been an attorney in Houston with Jim Baker's elite law firm, Baker & Botts. When Albert retired, he wanted to share his knowledge and experience with students, so he and Nettie moved to

Austin. He began teaching at the UT Law School, which I thought was a wise and wholly admirable thing for Albert to do.

Nettie, who had majored in music, loved to play their piano and often sponsored scholarships for promising students. When she and Albert were living in Houston, Nettie and Miss Ima had worked together on the Houston Symphony, and had become close friends.

Sometime during that Christmas dinner, we three ladies were seated on the settee and visiting. Miss Ima was in her mid-eighties, but was still pretty feisty and, as usual, eternally independent and quite out-spoken. Some time earlier, she had broken her ankle during a visit to London, so she apologized to us for her need to use a cane.

I was seated on one side of her, Nettie on the other. Miss Ima was a woman of impeccable taste, as everyone who ever met her quickly discovered. She admired my gold necklace, which had a sprinkling of diamonds and was designed for me by John Lednicky, who taught jewelry at UT. John was one of the most creative people I ever met.

After she complimented my necklace, Miss Ima boldly asked, "What did you pay for it?"

Well, I thought, what nerve! I was shocked that she had asked me the price. However, when Miss Ima wanted to find out something, she never hesitated. Even so, her query so startled Nettie that her eyes popped wide open. I could tell that she was as stunned as I by Miss Ima's cheeky question.

Hmm, I thought to myself, if she really wants to know so badly, I'll just go right ahead and tell her.

"It cost $15,000."

Miss Ima almost snorted, but she recovered quickly. "I could have bought a painting for that amount."

Nettie, this extraordinarily grand lady's dear friend, smiled sweetly. "But you couldn't hang one around your neck."

We all had a good laugh, once Nettie had put Miss Ima's comment in perspective for her. Then Nettie announced, "Miss Ima, I'm going to move off this sofa because I want you to hear Jake Sibley tell you about his experience at NASA. He's just back from Kennedy Space Center where he saw the Apollo lift off."

Jake regaled Miss Ima with his reactions to the dinner hosted by Alan Shepard as well as recounting Lindbergh's speech for her.

In response, she told Jake, "I was on the reviewing stand in New York City when Lindbergh returned from Paris in 1927." The intrepid young aviator's solo, non-stop flight across the Atlantic created a world-wide sensation. His return to New York generated the largest ticker-tape parade ever seen in the city before that time. Lindbergh's flight was forty-one years earlier and now another American had just circled the moon! And Miss Ima had witnessed it all!

Knowing Miss Ima was a great experience for me. We had so many interests in common. She was a talented musician, who had played the piano since the age of three, and who had studied music in New York, Berlin, and Vienna. In 1913, she helped found the Houston Symphony, serving as its president in 1917. She remained active with the symphony and was president again from 1946 to 1956. She died in 1975 at ninety-three, only a few years after I became president of the Austin Symphony.

Miss Ima was a leader in historical preservation, who had a major impact across Texas. In the fifties, she renovated the Hogg family home at Varner Plantation near West Columbia, Texas, built by one of our state's earliest settlers. In the sixties, she restored the Winedale Inn, a nineteenth-century stagecoach stop at Round Top, Texas, which she do-nated to the University of Texas.

Miss Ima made a lasting mark on Texas history when, in 1953, she was appointed to the Texas State Historical Survey Committee by Gov-ernor Alan Shivers. This group later became the Texas Historical Com-mission, which gave her an award in 1967 for "meritorious service in historic preservation."

Miss Ima Hogg used her influence and resources to persuade Texas to create official markers for historical sites, and for its rarest, most memorable buildings. She bequeathed most of her estate to the Hogg Foundation in support of mental health. She was a great, great lady. Her Houston home, Bayou Bend, is now a premier museum of American decorative art.

Mary Moody Northen

Mary Moody Northen was one of my favorite people. I got to know her when we served together on the Texas Historical Commission. She was quiet, but her flashing brown eyes seemed always to see just about

everything. She had a mind for business like her daddy, William Lewis Moody Jr., who founded the American Life Insurance Company in their hometown of Galveston.

Their home was one of the few that withstood the horrible 1900 hurricane and flood that devastated Galveston. The history books have recorded that the storm killed between six and eight thousand people—far more than were lost when Katrina hit New Orleans. That storm remains the worst natural disaster in American history. Before it came ashore, Galveston was the leading city in Texas, but it never fully recovered from that catastrophic tragedy.

Mary's father bought his house after the flood, so he knew exactly what he was getting. Their big brick house Mary later bequeathed to the city. Eventually their home became an excellent museum.

To me, Mary often spoke of her upbringing. Clearly, she worshiped her father, much as Ima Hogg had adored hers. Their main difference was that Miss Ima's father, Jim Hogg was Texas' governor. It was he who actively instilled philanthropy in each of his children.

On the other hand, Mary's father was very tight with money—even with his wife and daughter. Mr. Moody was the very devil when it came to hanging onto his money. When Mary was preparing to make her debut, her mother brought her to New York to find the proper gown. They found a dress that her mother and Mary both liked. Mrs. Moody wrote her husband, told him the price, and asked him, "Should I pay this much for it?"

He wrote back and said, "No." It took more than a few attempts for them to find a satisfactory gown at a price Mr. Moody was willing to pay for. Mary finally made her debut in the ballroom on the second floor of their Galveston home. Not a huge room, but quite a beautiful one. To this day it still is decorated with the ribbons and dried flowers left over from Mary's debutante ball, an event still recalled as a high mark in the history of Galveston society.

After Mary married Edwin Clyde Northen, a man twenty years her senior, they moved into a house two blocks from her father's mansion. Mr. Moody had opened his successful insurance company in 1913. Mr. Northen worked at his father-in-law's company. Even though Mary had two brothers, she was her father's favorite and he was grooming her to take over his business. After her mother's death, Mary had dinner with

her father every night, discussing his business interests until midnight or later. She was a complete night owl, stayed up until all hours, and usually got up around ten or eleven in the morning.

Mary never had children, devoting much of her time to her father and her husband. One of her great interests was American Indian jewelry, which both of us collected. We loved to buy authentic necklaces and bracelets, and we both had a wonderful time wearing them.

She loved yellow roses and never tired of them. I was standing beside her on several occasions when she received bouquets of yellow roses, and she could not have been happier. She would get two or three dozen roses for every philanthropic gift she made from the Moody Foundation. Those flowers were a good investment, considering the magnitude of her philanthropy.

Among its many other gifts, the Moody Foundation donated the planetarium at Texas Tech University, and also the Mary Moody Northen Theater at St. Edwards University in Austin. Mary wanted all of her gifts recognized as coming from the Moody family. She was supportive of historical preservation and donated money toward our restoration of Symphony Square.

Her husband died of a heart attack in 1954; seven weeks later, her father passed away at eighty-nine, leaving Mary the bulk of his fortune as well as responsibility for the total management of his business and financial affairs. At an age when most people are considering retirement, Mary was running her family's insurance companies, newspapers, banks, and hotels as well as chairing a number of boards.

Although she was brilliant in business, Mary was devoted to the arts. She became interested in the prehistoric paintings that she had heard me talk about so often. During our Texas State Historical Commission meetings, I kept talking about what Rosemary and I had done near the Pecos River. One day Mary said, "I want to see that site for myself."

Although she was nearing eighty and would have to climb the side of a mountain to see the murals, she wanted to go. We told her it would be a difficult and dangerous climb. Undeterred, she said, "I want to go."

When Truett Latimer, executive director of the Texas Historical Commission, asked her, "Mrs. Northen, can't we just tell you all about it?"

She looked him in the eyes and repeated, "*I want to go.*" And that was that. Like Miss Ima, Mary Northen was firm and she was determined.

Together, we went off to view the murals. As we climbed the side of that mountain, I noticed she was not even wearing walking shoes, but had on her little-old-lady shoes with their three-quarter-inch heels and laces up the front. Nevertheless, Mary made it up and back just fine.

Her stern upbringing meant Mary never appeared in public wearing pants. Mary always wore skirts. For the entire climb we took to view the prehistoric pictographs, I was on one side of her and Truett was on the other. I am pretty sure somebody else was right behind us. She made it safely to the top where she saw the 3,000-year-old paintings on the walls of Fate Bell Shelter. Mary told Truett and me that the event was one of the thrills of her life. It was also just about a three-hundred-foot climb for her. Poor Truett was scared to death for Mary, both on the way up and back.

D. J. and I went to Mary's ninetieth birthday party in Galveston on a night so cold, windy, and rain-soaked that the terrible weather almost ruined the whole affair. Her friends from all over Texas were present despite the terrible weather, and we all managed to have a good time anyway. Mary died in 1986 at the age of 94 in the mansion she had inherited from her father. She was such a wonderful character, which we are fortunate to have a quite a few of here in Texas. Our state has never known a shortage of colorful individuals.

Claytie Williams

My old friend, Claytie Williams, is one of the finest people I know. On March 4, 2006, the Texas State Historical Association honored him as an Outstanding Texan. At eighty-one, Claytie is going strong, running his businesses, being charitable as well as serving as the subject of a recent biography.

Claytie suffered unfairly from negative publicity when he ran for governor in 1990 against Ann Richards—most of it was dead wrong. I have known him since we were children, playing together in the ruins of old Fort Stockton. Claytie and I always had a great time together, even though I was six years older, an unimportant difference that never mattered at all to us.

Claytie is smart, hard-working, and totally honest. In his business and personal dealings, he is straightforward. While running for governor, his

West Texas candor was no help to him. The press twisted everything Claytie said, and he ended up losing that election. In my opinion, the State of Texas was the real loser.

Claytie's first job as a young man was selling insurance, where he soon learned that the insurance company was somebody else's business. If you are an entrepreneur at heart, as he is, you need to work for yourself. Before he went off on his own, Claytie started out in the oil business with Johnny May, Frank Borman's friend. They bought up some leases, eventually getting into drilling. They were reasonably successful, but eventually they split up because Claytie had a grander vision than Johnny.

Chicora "Chic" Williams and Clayton Williams Sr., celebrating their 50th wedding anniversary in Fort Stockton, with their children, Claytie (far left) and Janet (far right)

Claytie Williams and his wife, Modesta at his parents' 50th wedding anniversary. Claytie and I have been friends since childhood, when we grew up as neighbors near Comanche Springs and played "Cowboys and Indians" in the old fort ruins.

Choosing to expand the business, Claytie put a lot of effort into drilling, but then he kept right on building and growing. How many people do you know who have borrowed half a billion dollars from a large eastern bank and paid it back in full and on time? Claytie's integrity is impeccable.

Claytie Williams is a proud graduate of Texas A&M. For years, he taught a class in entrepreneurship at A&M. When he ran for governor, no one ever publicized Claytie's many acts of generosity.

He lost that election because of a joke he told at his Alpine ranch. D. J. and I had gone to Houston that day for Albert Jones's funeral. That particular September was hotter than the devil. I remember standing in the shade of a grand oak tree at Albert's burial noticing how much perspiration was running off every mourner's face.

After the service, we flew to Midland to pick up our car so we could drive on to the ranch for Claytie's event. When we stopped in Dallas to change planes, I saw a girl wearing a fur jacket even though it was over a hundred degrees outside.

I thought to myself, "I'll bet she's wearing it because it's brand new." What I did not realize was that she heard that a norther was blowing into West Texas just about then. So she was prepared and I most certainly was not.

By the time we landed in Midland, it was about as cold there as Houston had been hot. We had blithely traveled from summer to winter in an hour, which, as all Texans know so well, is not unusual there. As soon as we got into our car in the airport lot, I climbed in the back and put on my windbreaker and my leggings.

Claytie had scheduled a big round-up at his ranch and he had invited the press. When he saw that the rain, cold, and wind were going to ruin the day's festivities, he announced, "Well, there's not a thing we can do about it. It's just like rape. You might as well relax and enjoy it."

That line cost my old friend Claytie the election. The press repeated it over and over and tried to make his remark sound like a dirty joke.

I felt especially terrible after he lost, because I was one of those who had encouraged him to run. To help persuade him, I said, "You are the only person I know who does not have any bad things in your past. Usually, somebody has a dark spot somewhere. You don't. Everybody who knows you admires you."

Claytie and I have been through thick and thin together. It means so much to me to have friends I can count on, no matter what, folks you may not see all that much, but who you know that you can pick up the phone and call night or day. Claytie is that kind of friend.

His wife, Modesta, is adorable. She is also an excellent hunter who can shoot as well as Claytie can. We all laughed when they married, because we knew he had met his match.

Today, although they live in Midland, they have traveled the world

from the Himalayas to Azerbaijan, hunting Big Horn sheep. To become a member of the Big Horn Sheep Hunter's Club, a hunter must kill six bucks of different species. As I write this story in 2011, Modesta has bagged twenty-one Big Horn bucks of different species, with many duplicates. Despite all his land, wealth, and achievements, Claytie remains a good, decent person.

The Lopez-Portillo Sisters

Curtis Weeks was on my symphony board. His wife, Christina, reared in Mexico, was close friends with the powerful Lopez-Portillo family, so she had kept in close touch with Alicia and Margarita Lopez-Portillo. In Mexico, perhaps even more deeply than in the US, family is everything. When Mexico elected the brother of her friends president in the seventies, Christina felt that was a perfect opportunity for the Austin Symphony to perform in Mexico City.

The new president's sisters were prominent, although unelected, members of his government. As personal secretary for President Lopez-Portillo, Alicia became the power behind the throne. She ran the president's office with such an iron hand that no one got anywhere close to the president unless Alicia said so.

Margarita, the president's other sister, wore long, fake eyelashes and lots of lipstick. She was very artsy and was in charge of RTC, the powerful commission overseeing Mexico's radio, television, and cinema.

Christina invited them both to Austin for a gala weekend, which was actually an audition for the symphony and for those of us connected with the orchestra. Alicia and Margarita were honored guests at the symphony concert where the governor of Texas and one of our US senators were present. After the performance, we introduced our honored guests from Mexico at a reception in the Headliner's Club.

The evening before the concert, D. J. and I had invited the sisters from Mexico to a black tie candlelight dinner in their honor at our home. We had votive candles lining the dining room, on the beams above the living room, and outside on the portal. There were Spanish shawls on the dinner tables and mariachis playing and singing on the stairway.

Before anyone arrived, D. J. was on a ladder, taking his time lighting all those votive candles. Despite my urging, no matter how many times

I kept warning him, "Hurry! Hurry up! Everyone will be here any second." D. J. was still on the ladder when the sisters arrived.

The Lopez-Portillo sisters were elegant, charming, and impeccably dressed. During their conversation with Peter Flawn, president of the University of Texas, they asked him to give back a flag Texans had captured in a battle with Mexico that was on display at the university.

After they made their case eloquently, Peter smiled sweetly, but said, "You are not going to have it."

Despite that skirmish, we got through the rest of the evening with flying colors. During the entire weekend, we went all-out to make the Lopez-Portillo sisters feel special. We must have succeeded. The Mexico government soon invited our orchestra to perform in Mexico.

After Alicia told us Braniff Airlines owed them a favor, the airline agreed to fly the symphony to Mexico City free of charge. Braniff was glad to donate our trip. Those sisters had tremendous influence and were hardly shy about using it. I wanted our symphony trip to be non-stop, so I called Jake Pickle, our Austin congressman.

"We need Austin's airport to be named a temporary international airport so we do not have to go through customs at the border." I knew it would cause a lot of extra work to unload the airplane with its eighty bulky and invaluable instruments. Jake used his connections to make that happen, so we were able to fly non-stop from Austin to Mexico City.

The orchestra played its first concert at Montezuma's favorite summer retreat near Cuernavaca, which is now a social security resort where Mexican workers can take their families on vacations. The setting is beautiful and the Mexican government provided rooms and meals while we were there.

After Cuernavaca, we went on to Mexico City, performing at the Palacio de Bellas Artes, an elegant concert hall built in the eighteen hundreds. Louis Comfort Tiffany created the hall's curtain, which is all glass. At least a hundred years old, it is a breathtaking work of art.

When I tell people about it, they always ask the same question: "How do you make a glass curtain?"

I usually answer, "Ask Tiffany, not me."

We had a large audience for our concert and the orchestra played its best. It was a great moment for the symphony and for our conductor, Akira Endo. After a triumphant evening in Mexico City, the following

day we performed on the terrace at Chapultepec Palace. As a gesture of hospitality, the famous Ballet Folklórico de Mexico performed for us to embellish the festivity.

Christina Weeks did the Austin Symphony a wonderful favor. Our week in Mexico not only gave our orchestra some excellent publicity, but instilled in us a sense of pride and self-confidence as well. As we boarded the plane that would bring us home, I thought back a few years to the darker days I experienced during the early seventies, savoring just how far we had come. Soon after we returned, D. J. and the symphony presented me with a portrait medallion commemorating the symphony's trip to Mexico.

> To Jane Dunn Sibley
> Because we know that it can never be possible to acknowledge all that you have done for and all that you have been to the Austin Symphony Orchestra, we can only offer this simple tribute, and hope that it conveys to you our thanks, our deep affection, and our great admiration.
> *La Inigualable*
> She who has no equal

James Michener

Sometime in the early eighties, Texas Governor Bill Clements invited James Michener to write a book about Texas commemorating the state's sesquicentennial in 1986. The governor made Michener such an extremely generous offer that Jim was soon occupying an office at the University of Texas, his home base for researching our state. While the author was exploring West Texas, Claytie Williams invited him to a Brangus cattle sale at Claytie's ranch near Fort Davis.

D. J. and I invited Jim to stay with us at The Castle, so we could be his guides to the cattle sale at Claytie's. We had met James Michener when he first came to Austin, and had liked him immediately. He was an easy guest, as are so many distinguished people. He loved The Castle and our idea of flying the six flags that had flown over Texas, one from each tower.

James Michener (left) and D. J., with his dog, "Priscilla" on his lap, both celebrating D. J.'s eightieth birthday. James is one of the most cordial people I have ever met.

Although a celebrated author, Jim Michener was a sweet, kind gentleman who was always thoughtful of others. He never exhibited any hints of prejudice or self-importance. I remember him saying that he owed his success to Rodgers and Hammerstein. They turned his first book, *Tales of the South Pacific*, which won a Pulitzer Prize in 1948, into the major hit musical, *South Pacific*, which has been performed the world over. While the book gained him literary acclaim, Broadway made James Michener so famous that for the next forty years all his books were international best-sellers.

After finishing the thousand-page *Texas*, Jim and his wife Mari settled in Austin, donating more than $30 million to the University of Texas, including their personal collection of modern art, and an endowment establishing the Michener Center for Writers at UT.

Aldous Huxley

After moving with the family to Austin, D. J. became associated with Roger Williams, the nutritionist at UT who sent him on a trip. After my husband ate breakfast with Aldous Huxley in New York, D. J. invited the author to come to Texas.

"I would love to come," he told D. J.

He was our guest at a dinner in our home, but it was Hiram's Weimaraner who would not leave Huxley's side. They were "muy simpatico."

Lady Bird Johnson

A special guest at our ranch was Lady Bird Johnson and her entourage. Mrs. Johnson and D. J. were in complete agreement about the environment. She wanted to visit West Texas especially to see the bluebonnets blooming on the mountain sides in Big Bend National Park. Easter morning was cold, so Father Sara conducted her service in the living room with Mitre Peak in the background. The attending secret service agents each read the epistle and collect, and everyone participated in communion, even our wetbacks who worked on the ranch. There is no place on earth more beautiful than spring in Texas.

Steven Weinberg

Steven Weinberg grew up in Manhattan—a city boy all the way. In 1982, the University of Texas offered him a distinguished professorship in the department of physics. His wife, Louise, was offered a professorship in the School of Law. Steven had won the Nobel Prize in Physics in 1979, and he came to UT from Harvard.

Before that, he had taught and researched at all the best places—Cal Berkeley, MIT—and had done his doctoral work at Princeton. Everyone thought Steven was smart and he agreed with them. However, not everyone took to his personality. One evening, at an after-concert reception, D. J. told me he had complimented Steven on his work, before inviting him and his wife to visit our ranch.

"What did he say?"

"He would love to come."

When I called Louise to issue a more proper invitation, Steven got on the phone. "I don't know if we can come. I am waiting for the proofs of my new book and will have to sit down and go over every word."

"Well then, Professor," I told him, "Our ranch is the ideal place for you to do that work. There is a great big table you can use and I guarantee in advance that no one will bother you. The phone will not ring. If it does, no one will admit you are there. You can have absolute quiet and privacy."

"How do I get there?"

"You'll take a plane to Midland, where you'll change to a smaller plane that lands at Alpine, about forty miles from the ranch."

"I won't fly in a little plane."

"You can always drive, but it's a long way."

He thought about it and changed his mind. A few days later, we picked them up at the Alpine airport. He had never been west of Fredericksburg, which is not at all like our West Texas. When he arrived in Alpine, he discovered a part of the world he had never visited and he loved it.

One night after dinner, we were sitting down the hill next to the pool. As Steven looked up at the black sky filled with billions of stars, he said, "I have never really seen the stars before."

"Steven," I said, "you must have seen the stars."

"Remember, I grew up in Manhattan. I've spent my whole life in cities filled with lights."

This brilliant physicist had never had a chance to observe the Milky Way outside the glare of city lights. About that time, we saw a satellite pass overhead and were able to track it all the way across the sky. Steven said, "I'll have to call in and find out which one it was."

I told him, "I have already made plans for us to visit McDonald Observatory and have asked Harlan Smith to give us a private tour."

Dr. Harlan Smith was director of the observatory, a world-renowned astronomer who had helped persuade NASA to use ground-based telescopes to support their space missions. The observatory is a branch of the University of Texas.

Steven said, "I have talked to him many times, but had no idea I would ever be out here." Seeing those two gentlemen—both giants in their field—touring the observatory together was a joy. Steven was

awed by the observatory's 107-inch telescope and thoroughly enjoyed his time with Harlan Smith.

When we got back to The Castle, he said, "There is one more thing I'd like to do while I'm here. I'd like to ride a horse." I asked Arturo, our house man, to saddle two horses and Steven gamely got up on one of them.

"Now, Steven, you just hold onto these reins and give your horse a little nudge with your heels and he'll move. I'll go first, so your horse will follow mine."

I started off and a few seconds later Steven announced, "He won't go." I looked back and saw he had let his reins drop onto his horse's neck.

"Steven, don't move."

I got off my horse, walked back, picked up the reins, and handed them to him. "The reins are like the steering wheel of a car. Don't let go of them."

After we rode about twenty-five feet, he said, "Okay, I've had enough." We had barely gotten started, but I turned us around and we walked slowly back to the corral. The Nobel Laureate could now say he had ridden a horse.

While he was at the ranch he got a phone call. When he finished the conversation he told us, "I did something you probably won't like."

"What?"

"I accepted a position on President Clinton's Science Commission."

I surprised him by saying, "That's wonderful. He can use your good sense."

Unfortunately, after he became president, Clinton bowed to pressure from congressional leaders and canceled construction of the supercollider then under construction at Waxahachie, Texas. Steven was heartsick about the shortsightedness of that decision. The government had invested billions of dollars in a project that offered great possibilities for scientific research, but Clinton caved in and left it unfinished.

Robert Tishman and the Black and White Dinner

Following the 1992 riots in the south-central Watts area of Los Angeles, a lot of people were anxious to calm that volatile situation. One

such person was Robert Tishman, the largest real estate developer in New York City.

He had collected African art and wanted to be a conduit for young African Americans to learn about their African roots and to be proud of their origins. Robert Tishman had contacted Donald Goodall, chairman of the University of Texas art department, with that proposal. UT welcomed his idea.

Dr. Goodall called D. J. and me and asked if we would have a dinner party to honor the Tishmans and would we include some influential African Americans on our guest list. We drew our guest list from UT professors, from the Texas legislature, and from Huston-Tillotson, the historically black college in Austin. We balanced our invitation list with business and political friends, who enthusiastically supported the idea. Fred Moore was a major help. He was the recently retired president of Mobil Oil International, and was now living in Austin.

I decided to serve curry, historically from India, thence to Africa, before becoming popular in the US. When a friend called who had heard about our "Black and White" party, he announced "I'm coming." Besides my formal invitation, I called each guest to offer a personal invitation and to describe the Tishman African Art Exhibit.

We served that that black tie dinner on our front portal, illumined by lots of candles. There were about thirty guests, about equally divided by color. I knew my house man, Forris, would disappear if I told him in advance what was taking place. Sure enough, my son Hiram and Forris were in the dining room looking out the big picture window as the guests began to arrive. Bug-eyed, Forris said "What those people doin' comin' up the front walk?"

Hiram calmly said, "Jane's having a black and white party tonight." By then, the black waiters had arrived, and they were sure and skilled in a situation none had ever experienced. However, when I later went to the kitchen to check on things, one of them, named Theodore, said, "I'm an elder in the church, and these black men won't take any beer from me."

Nevertheless, the evening went quite smoothly. The event was truly one recalled fondly by everyone who was present. The Tishmans felt honored. And later, all of Austin's African American school children

attended the African art show. That exhibit set an attendance record at the museum.

Here's another story on integration in Texas. There was a fine look-ing black man who worked at the Driskill Hotel for years. He reigned over the waiters and doormen, and he wore a white jacket with epaulets on the shoulders. When he was asked, "Youngblood, how do you feel about integration?" Youngblood replied, "Well, I just don't know, I got relatives on both sides."

16

⤸

Buzzard Feathers and Movie Stars

MY FRIEND GRACE JONES has led a fascinating life. People of a certain age will understand that I do not mean the movie star of the same name but the former leading fashion model. She attended the University of Texas at the same time I did, and I am surprised our paths did not cross there.

When the war came along, Grace told herself, "I'm not doing the right thing by staying in school. I want to join the Women's Air Force Service Pilots." The WASPs were just being organized at the time. With great reluctance, Grace's daddy finally relented and approved her flying lessons. She was his only daughter, so that was not an easy decision for him. Grace went to Bobby Ragsdale, who ran a private airport in Austin, and he taught her to fly. After Grace became a WASP pilot, she ferried military airplanes all around the US, but never flew overseas, much to Grace's dismay, but doubtless to her father's great relief.

During the war, Grace met Jack Jones, another aviator, who later became a fighter pilot ace in the South Pacific. After the war, they married, living in Germany and Japan while Jack completed his air force career. When they got back to the states, Grace went to New York, where she became a top fashion model, meeting and working with many of the great designers of the fashion world. Grace not only had a keen eye for fashion, but a deep fascination with the business side of the "rag trade," as the fashion industry is known by its insiders.

After Jack retired from the air force as a colonel, they returned to Texas, where Grace owned property. Doubtless, her pilot husband was

surprised when she announced, "I want to open a couture dress shop in Salado, Texas." Since the population of Salado was less than five hundred souls, everyone who heard Grace's plan thought she had lost her mind. The naysayers all said there was no way she could possibly succeed owning a high fashion shop in a tiny town in Central Texas. Grace knew better. Soon, she persuaded a banker to back her.

Because of Grace's connections as a model, she began to stock all the best names in fashion: Christian Dior, Geoffrey Beene, and Pauline Trigere, to name a few. Her shop carried only the finest couture fashions. In my own closet are clothes from many world-famous designers, and I bought them all at Grace's little shop in Salado.

When I use the term "couture," I do not mean its former usage: true couture clothes are designed and custom made for you and you alone. The true couture lines are almost finished today, because they are so expensive. Few customers are willing or able to pay twenty to thirty thousand dollars for one dress. In fact, there was not much difference

Grace Jones (right) and I sharing gossip at a fashion show in Salado at Christmastime

between true haute couture and the designer couture fashions Grace carried.

From the moment she opened its doors, Grace's shop was a great success. Its location was about a half mile off I-35, the main north-south interstate highway connecting Dallas, Fort Worth, Temple, Austin, and San Antonio as well as all the little towns and the wealthy ranchers who lived nearby. Whenever I drove to Salado to see Grace or to shop, I would meet women at Grace's shop from all over Texas. Almost ironically, as things turned out, it seemed that her small-town, out-of-the-way site was one of Grace's strongest assets. She consistently drew customers from as far away as 250 miles or even farther.

Grace grew up in Smithville, a town of 3,300 Central Texans, about forty miles east of Austin. She knew all about small Texas towns and she really enjoyed them. She and Jack owned some ranch land near Salado that had been in her family for years. They never had children, so their house was a modest-sized one. But Grace, with her flair for design, had lovely furniture and some beautiful art that she and Jack had acquired in Europe and Japan.

Grace opened her shop doors in the mid-sixties and for its thirty-five years of existence, her boutique was a magnet for style in Texas. Grace closed her store around 2000; by then, she was approaching eighty! Along with Stanley Marcus in Dallas, Grace Jones was one of the leaders of fashion in Texas. Her shop had four dressing rooms, each with a sitting room.

Eventually, I bought almost all my clothes from Grace, except shoes. Each time I went, I would call her and say I was coming. By the time I arrived, Grace would be ready for me. Suddenly, all these marvelous creations would appear before me. Along with dresses and coats, she stocked exquisite scarves and purses.

Once or twice each year, Grace went to New York; she went to Paris every other year. She brought us the best and the latest in world fashion: established names as well as gifted new designers. Grace had wonderful taste and a serious sense of calculation for her customers that many other buyers seemed to lack.

Because of her experience on the runway, Grace always treated designers as colleagues, while other buyers were often too unctuous when they introduced their ritzy clients. From time to time, Grace produced

fashion shows to benefit mental health, or for Scott and White Clinic, the famous treatment center near Temple, Texas.

To model for the benefits, she would call on some of her best customers. Whenever Grace called on me, she always knew I would be there to help. By opening a successful couture shop in such a small Texas town, Grace managed to get extensive national publicity. We had seen her written up in *The New York Times* and she once had a two-page spread in *People*.

Personally, I believe fashion is art that people wear. Just as in a gallery, there is good art and bad art. The same is true with fashion. Some women make poor choices with their clothes and look like hell, when, with some guidance and some knowledge, they could look wonderful.

If one of her clients lacked the ability to put things together for herself, then Grace was at her very best. She would and she could give any customer a total look: hat, scarf, dress, and coat. When she had achieved the look she was aiming for, then Grace would say, "That's a great outfit. It works."

Forever and ever, I have loved hats, wearing them consistently until sadly, they went out of style in the late sixties. One of my cutest hats was one that Grace carried in her lap on the plane home, all the way from Paris. Talk about customer service! In my opinion, hats were driven right out of fashion by those silly beehive hair-dos.

No woman alive could possibly wear a hat on top of a beehive. Unfortunately, once hats went out of style, they stayed out. Today, there are no longer hat racks in restaurants or hotels for

A Grace Jones Fashion Show. I am modeling a cocktail dress by Bernard Perris, a French designer.

men who wear wide-brimmed western hats; so they have to keep them on when dining or dancing.

My dear friend Grace also had a sharp eye for sophisticated, sleek design. The simplicity of any garment is what reveals its inherent beauty. Simplicity highlights craftsmanship and purity of the lines. Quality tailoring is best defined by superior fabric.

Personally, I have always preferred strong colors. If an outfit is all black, I want it *really* black. For the most part, I favor vivid colors over pastels. Furthermore, I have never been someone who bought anything merely because it was "fashionable." Who is to say what is "fashionable"? I have never followed the trends of the moment, always preferring to trust my personal taste.

It won't surprise you to hear I feel the same way about my hair. I have worn a chignon since 1950. I have no desire ever to change. During my college years, my hair was fairly long, but I wore it in a "page boy" like most everybody else. I kept that hair style until Jake was born, when I realized that with a husband and a new baby, I had no extra time to fix my hair.

Living in West Texas, where the wind is constant, I got tired of my hair blowing in my face and having to comb it all the time. Because it would never stay in place, I devised my own look that allowed me to go outside and stand in the wind without being bothered. I have had the same hairstyle for almost sixty years. I figure if I wear it this way long enough, one day it may even become fashionable.

Now I am going to tell you about my feather.

In 1968, a second round of TB put D. J. in the hospital. After he spent six months in the sanitarium, we went to live on the ranch for a year. I could not ride alone because it is very unwise to ride solo out there: too many unexpected events can occur, and most often do so just when you are least expecting them. Even if you are familiar with the country, you can be disoriented, or maybe even be thrown from your horse, or be bitten by a snake.

Since I could not ride without company, I began to walk or just to go outside and sit on a rock and watch the buzzards hovering in the sky above my head. It was perfectly beautiful to watch them soar. If I was high enough on a mountain top, I could even look down to observe them. After I began admiring the buzzards, I began to tuck a buzzard

D. J. and I, side by side, posing on our front walk, for a National Geographic *photographer. The magazine's story on Austin included us.*

feather in my hair. In the late sixties, I must say, that habit of mine really caught other folks' attention. Even when I went to Paris or New York, I wore my feather. Most people seemed to love it.

Of course, my feather got a lot more attention than it deserved. I even began getting write-ups about it in the press. I think the reason I've been written about and photographed so often is that I have an individual style. Most people follow other people's styles;

212

DYNAMIC
Doyennes

The perfect evening in the vital life of Austin original Jane Sibley is dinner at Jeffrey's or Aquarelle, followed by an Austin Symphony Orchestra performance at the Long Center.

A portrait of me in my later years from a magazine interview

I have always tried to find my own: Strong colors — hair pulled back — feather.

I have been displaying my feather for almost forty years. Nevertheless, most people do not seem to understand why, since I seldom share with them my fascination with the birds. They say, "Why would you want to have anything to do with those ugly birds?"

"Maybe because I also know a lot of ugly people. And I don't avoid them."

213

"But buzzards are so nasty."

"I disagree. They clean our highways. Think what our taxes would be if we had to pay humans to deal with that messy buzzard road work."

To give the bird its due, I started a Buzzard Society. Of course, there was a lot of tongue in cheek about that. In the late sixties, America seemed to be moving away from elitism. Everyone had to be equal, whether they actually were or not. Newspapers cut back on their society pages. Sororities and fraternities went out of style. Kids from wealthy families ran away from home, declaring that they hated the "Establishment." They even joined communes, but went right on cashing their trust fund checks.

Amid all that social turmoil, I decided there should be at least one thing left in America that remained elite: the Buzzard Society. That is why I am Founder, President, and its only Member. Naturally, a lot of people wanted to join. But I told them all, "I'm sorry. You can't join. It's the last remaining vestige of the elite."

I keep a fistful of feathers to choose from each day. Frank McBee, former CEO of Tracor, whose wife, Sue, was a columnist for the Austin newspaper for many years, loved buzzards too, and Sue brought me buzzard feathers from their ranch. Frank tried to get a bill through the Texas legislature about a Buzzard Society that he wanted to organize. As soon as I found out about it, I renamed mine the *International* Buzzard Society.

One time I was driving a little too fast between San Angelo and Midland. That is mighty dull country, but a few little hills do help to break the monotony. As I went over one, a highway patrolman came after me for speeding. He pulled me over and wanted to know my occupation.

"I'm president of the International Buzzard Society."

When D. J. heard my statement, he pulled the newspaper he was reading over his head and did not say a single word.

The patrolman replied, "I've heard about a lot of occupations, but I've never heard that one before, so I am going to let you go."

Then I told him why I was speeding: a truck in front of me would not let me by. The patrolman took off and stopped the truck.

I have been fortunate to be around people like Grace Jones, who have incredible taste. Through her I have been able to wear clothes from some of the greatest designers of the late twentieth century. Pauline

Trigere was one of the very best. Her designs were classic. Although she started out making gloves, Pauline got into fashion design and had the guts to keep at it and succeed.

Geoffrey Beene was my favorite American designer, although I met him only on rare occasions. It was always fun to go to fashion week in New York with Grace. She received invitations to all the major shows and almost always invited me to come along.

One year we were in Paris and Grace and I went to the first fashion show for the trade given by a new designer, Christian La Croix. I was in absolute awe of what I saw and Grace nudged me to quit moving my head as I followed every move of the models. I had never seen any designer handle fabric and design so well. La Croix has a gift for finding the true character of a fabric and for exploring its infinite possibilities. He is fearless in his choice of color and texture combinations.

Fortunately for me, D. J. liked Grace. He told me, "You support her." I took him at his word.

In 1970, Preston Smith was governor of Texas, and his wife, Ima, was honorary chairman of a mental health benefit. When she asked Grace Jones to produce a fashion show for the benefit, Grace said she would be delighted.

She called her friend, Jean Louis, a marvelous Frenchman dedicated to fashion, who designed elegant gowns for motion pictures. He did all of Loretta Young's costumes and created beautiful clothes for many of Hollywood's top stars.

Grace decided to use professional models and to mix in some of her loyal customers. I was fortunate to be one of them, and we all got a crash course in runway modeling. Grace wanted us to look our best, so we learned how to walk, twist, turn, and smile with the best of them. The professional models could not have been nicer to us amateurs, going out of their way to help us with our makeup.

The evening before the fashion show at the Austin Country Club, D. J. and I hosted a candlelight dinner for thirty guests on our front portal to honor Jean Louis. It was a lovely evening, but Grace's husband, Jack, worried because Jean Louis' clothes had not arrived. Jack kept coming inside, calling the airport, and asking, "Have the clothes gotten here?"

They were coming by plane to Austin in huge cartons of fifty dresses each. Now, it was only twenty-four hours before the show, and the

dresses had not arrived. Finally, D. J. got on the line to trace them. They were coming on Continental Airlines, so we asked ourselves, "Who do we know at Continental?" Almost in unison we all said, "Jerry Ponton!"

We called our young friend, Jerry Ponton, who worked in Midland as a manager for Continental, and told him, "The clothes haven't come and the show is tomorrow night. What can we do?"

He said, "Don't worry. I'll trace them for you. If they are still in California, I'll get on a plane and go out there and get them myself."

The reason Jerry was so good to us went back a few years to when we were building The Castle and D. J. was so sick. Mahala and I were flying to Arizona to consider her possible attendance at the Orme School, north of Phoenix.

The Midland airport was a three-and-a-half hour drive from the ranch, which had no telephone, so there was no way in advance to check on our flight. When we got to the airport a young ticket clerk gave us the bad news: they did not have room for us on the plane, because it was overbooked. His name tag read "JERRY PONTON."

After we got his bad news, I said, "Jerry, can you come over here for a moment? I am going to tell you a story. There was a Ponton family that ranched on Plum Creek near Austin when some Indians raided the ranch. They proceeded to peel the soles off the Ponton men's feet. I just want you to know that my daughter here is part Indian."

He said, "I'll get you on the plane." And he did.

We had scared the wits out of poor Jerry, but I had actually told him a true story. It's still called the Great Comanche Indian Raid, one during which the warriors raided all the way to the Gulf coast. In fact, after they skinned the Ponton men's feet, they forced them to run behind the Indian horses for a few miles before they killed the Ponton men. Despite our scary story, Jerry became our good friend.

He certainly never forgot us and he came to our rescue several times. Once, Jake flew into Midland from New York and left his portable typewriter in the overhead compartment. When we realized what happened, we called Jerry. He got in touch with Continental's luggage department in Phoenix.

"When that plane lands, you go out there, get that typewriter off the plane, and send it back here."

The man in Phoenix said, "I can't. I don't have time."

Jerry said, "You do have time and you'll do it!" We got Jake's type-writer back.

Jerry was a good guy to know. As soon as he started tracing the Jean Louis clothes shipment, Jerry learned that the plane was hijacked on its way to Austin and was heading for Cuba.

Fortunately, somebody on board had subdued the hijacker and the plane had landed in New Orleans. Except in New Orleans, no one was in any rush to return our fashions to us in Austin.

While Jerry lit a fire under Continental's airport staff in New Or-leans, Jean Louis called his good friend, Loretta Young, in California. "Loretta, get all your clothes together—hats, shoes, everything—and bring them to Austin. Then call Kathy Crosby and get her to do the same thing."

Gene Tierney was already attending our party that night with her hus-band, an oil man from Houston. Jean Louis said to Gene, "Call home and get all your things together." She made a quick call to her maid, who im-mediately dispatched Gene's most elegant gowns from Houston to Austin.

The authorities at Los Angeles Airport allowed Loretta to be driven in her limo directly out to the plane for Dallas. She had hat boxes, suit-cases, everything you can imagine. Since there was no easy connecting flight to Austin, Grace and Jack got a friend with a private plane to fly to Dallas and pick up Loretta. She came all the way to Austin as a favor to Jean Louis. Kathy Crosby, who grew up in Robstown, Texas, could not come in person, but she sent her clothes.

The next night the hijacked clothes arrived late, but just in time, as we would not start until they arrived. By the time the show began, everybody in the audience had drunk quite a bit, but the show was well worth the wait. The crowd was treated to Gene Tierney and Loretta Young modeling their own clothes, and I got to model with them. We had professional models, Grace's customers, and two movie stars. That was one of our finest hours.

The day after the fashion show, the governor's wife invited Loretta to come for tea.

I drove Loretta over to the Governor's Mansion, and when we got there I remember Loretta remarked, "Oh, what a lovely needlepoint

chair." Loretta could not see well from her days as a child actress, when the klieg lights had damaged her eyesight. Maybe that was one reason she always looked so dreamy on screen.

I had to tell her, "I'm afraid it's not what you think it is. It's only chintz."

At the time, the governor's mansion hardly lived up to its impressive name. The interior was ragged and needed lots of work. However, once Gov. Bill Clements and his wife, Rita, raised money for an interior renovation and hired professionals to decorate it properly, it looked lovely. Jackie Kennedy's tasteful re-decoration of the White House, which had garnered so much praise, also inspired Rita Clements. Then, in 2008, the mansion was fire-bombed and nearly destroyed, so the mansion had to be re-done all over again.

Jean Louis's wife died of cancer a few years after our splendid fund raiser, and he and Loretta married. They were both Catholic, their homes were reasonably close to each other, and they loved to garden. They thought it was silly to keep two houses, so they got married and had some good years together.

17

Rock Art

NOT ALL MASTERPICES
ARE IN MUSEUMS

D. J. and I had been interested in historic preservation ever since we helped organize the Fort Stockton Historical Society back in the mid-fifties. We learned that you do not need to hold public office to make a big difference while trying to save historic structures and natural treasures. What you need most is an ability to influence those in power.

We applied our experience from what we managed to achieve in Fort Stockton to help save an important and priceless site of prehistoric Texas art, to help create a state park to showcase those ancient wall paintings, and to establish the Rock Art Foundation.

In 1968, the US Corps of Engineers were supervising the building of Amistad Dam across the Rio Grande near Del Rio, Texas. The dam would control floodwaters and also create Lake Amistad, a seventy-mile-long reservoir.

Although the National Park Service had already removed more than a million artifacts that would be submerged beneath the new lake's waters, many rare prehistoric wall paintings would be under water once the dam was completed.

Our goal was to preserve the rock art found beneath overhanging bluffs, at the confluence of the Rio Pecos and the Rio Grande. D. J. and I were both deeply concerned because so much ancient history would be underneath waters created by the dam.

After Texas State Archeologist Curtis Tunnel joined us in Del Rio, we went into the Rio Pecos canyons to visit many of the doomed sites.

Admiring rock art at Painted Canyon in the Lake Amistad area. Today, both the entire expanse of Painted Canyon and these spectacular figures are underwater.

On their walls, we could still distinguish along the river banks layers of sediment delineating periods of drought and flood. In 1968, just when we were becoming more involved with saving the Rio Pecos rock art, D. J.'s TB was back, with a vengeance. He spent the next six months recuperating in a sanitarium and we focused all of our family's attention on getting him well.

By the time he left the hospital, Amistad Dam was completed and had created a new lake. This recreation area in the midst of the arid Texas countryside attracts thousands of visitors each year, including fishermen and boating enthusiasts. The US National Park Service supervises Lake Amistad; its rangers patrol the water and the banks on the US side of the lake. However, the invaluable rock art treasures along the Pecos River, which empties into the lake, were still at serious risk of destruction, unprotected and virtually unknown to the general public.

In 1970, I attended a concert of American Indian dancers with my friend Solveig Turpin, an archeologist who had researched for her doctorate the Lower Pecos area and its rock art drawings.

During intermission, I asked Solveig, "What's happening down on the river?"

"Oh, Jane, the vandalism is just awful. Some people have used spray cans and painted over some of our 4,000-year-old wall paintings."

"Well, what are we going to do about it?"

"I don't know, but it's just terrible. We are not going to have anything left."

"As much as I hate the idea, I think we need to form an organization."

"We probably do."

"Let me call Rosie Jones."

Rosemary Jones's family, the Whiteheads, had ranched in that area for many generations and I knew she would want to work with us.

Rosemary, Solveig, and I began working together to protect and save the prehistoric rock art located on private ranch land, but left unprotected by the ranchers. At the time, if someone wanted to go to a ranch near the Pecos River and dig for arrowheads or pots, the local landowners would usually say, "Sure, go on." They did not care if people built campfires, even though the wood smoke damaged the wall paintings.

Solveig Turpin, an archeologist specializing in the Lower Pecos Region, was instrumental in helping us establish the Seminole Canyon State Park.

Rosemary Jones is a rancher, and my dear friend. For a hundred years, her family's ranch has remained in their possession.

Most ranchers were completely oblivious to the value of rock art on their own property. They were like the Egyptians who, for centuries, showed little interest in the pyramids or other 4,000-year-old artifacts right in their midst. They had always been there in the background, so the Egyptians did not appreciate their historical value.

The same opinions prevailed among our Texas ranchers. They let people come onto their property and walk off with prehistoric artifacts without a thought to what was being lost. To the untrained eye, rock art does not look at all like the priceless ornaments displayed in a museum. Often, some of the best pieces are found down in the dirt.

At that point, I got in touch with Fred Moore, a friend who had been president of Mobil International. Originally from Comanche, Texas, Fred was a highly educated gentleman who had retired in Austin, where he was appointed chairman of the Coordinating Board of the University of Texas. He also became president of the Texas Historical Foundation and had invited D. J. to become a member.

In 1971, Fred suggested that we take Governor Preston Smith to tour the rock art sites and to visit Panther Cave. Much of his visit to the area took us around Lake Amistad in a National Park Service boat that visited some of the most seriously endangered sites.

The governor did not know a damn thing about rock art, but had the good sense to understand its value as well as the necessity of preserving it. As a result of that trip, he appointed me to the Texas Historical Commission, a six-year term. He said to me, "Now, you take this on and let's see what you can do."

I persuaded Texas Governor Preston Smith to visit the Rio Grande to see the prehistoric pictographs, in response, he sent me this personally autographed photograph. "My warmest personal regards and best wishes to Jane Sibley!! Preston Smith, Governor of Texas."

Rosemary Jones was a member of the Texas Historical Society while I was on the Historical Commission. Both of us were trying to get the state interested in preserving the early shelter paintings. Our Texas sites are quite different from European cave paintings that were already well protected because they were located deep within caves. Texas shelter paintings are found under the windswept caprock of the mesas along the Rio Pecos where it joins the Rio Grande.

It took millions of years of erosion to create the overhangs, which vary in length from fifty to three hundred feet. One of the shelters is the length of two football fields. Many of the wall paintings are ten to twelve feet high, and some murals are sixty feet long. How many sixty-foot paintings have you ever seen? That is not something you will find in the Louvre.

For centuries, those overhangs protected nomadic hunters from heat and cold, and provided a location for their religious ceremonies. Some paintings go back three to four thousand years,. A few could have been painted as recently as the eighteen hundreds. Some of the paintings depict Spaniards on horseback, along with churches and crosses. You can even tell when the bow and arrow replaced the *atlatl*, an ancient throwing stick used for hunting. The paintings are a priceless record of nomadic life spanning thousands of years.

The migratory tribes that created the paintings camped along the banks of the Rio Grande and Pecos rivers for several months each year. There they established relationships, arranged marriages, and held religious ceremonies. During their rituals, a shaman went into a deep trance. When he regained consciousness, he painted what he had seen while in an altered state. The drawings depict many examples of shamans leaving this world disguised as panthers or deer, going to the next world, and returning.

Around the time of the Texas Centennial in 1936, when there was a surge of interest in Texas history, the Witte Museum in San Antonio retrieved many artifacts. Archeologists uncovered animal skeletons as well as remnants from the nomads who had camped at the Pecos River site.

They also found projectile points of flint made to kill game. Besides the paintings, there were remains from the nomads' daily lives, including woven baskets, mats, sandals made of yucca fiber, and stone tools. The

Witte has carefully preserved and catalogued thousands of prehistoric artifacts. Even so, many paintings and potential archeological sites in the lower areas of the river have been lost to the rising waters of Lake Amistad.

In 1968, Governor John Connolly wanted to cut out some of the wall paintings in order to transport them to Hemisfair, San Antonio's international exposition that helped create the city's booming tourist and convention industry.

Engineers from Brown & Root who examined the site, reported to the governor. "It won't work. You can't move the paintings because you'll destroy them in the process."

The obvious solution to protecting the rock art and shelter paintings was to create a state park. That is precisely what we set out to do. We soon discovered that can take years of patient persuasion to get the legislature to create a new park, even one containing works of art found nowhere else in the world.

To speed up that laborious prospect, Rosie worked on the ranchers, and I worked on the politicians. Solveig provided us with scientific and archeological backup. Somehow, it all came together. Between 1973 and 1977, the State of Texas bought 2,172.5 acres along Seminole Canyon. That land is now a state park and historical site operated by the Texas Parks and Wildlife Department. The floodwaters still collect in the canyon, running about five miles into Lake Amistad, from US 90 to the Mexican border. The park itself is a narrow strip, four to five miles long, running along each side of Seminole Canyon, which flows into Lake Amistad. The park entrance is on US 90, nine miles west of Comstock. In 2006, the park served more than 41,000 visitors.

After the park's completion in February 1980, Rosie called the Parks and Wildlife Department in Austin, asking them, "When are you going to dedicate the park?" They told her they had no money available to fund a dedication.

"That's all right," Rosie said. "Jane and I will take care of that part."

That was what we did. We agreed to split the cost, planned an official dedication, set the date, and hosted a big barbecue.

When Rosie suggested to me, "I'll get Chino, and if you get Hobby, we'll be able to dedicate the park in style."

Wendell Chino was chief of the Mescalero Apache Indians, whose

Rosemary Jones and I flashing self-congratulatory grins in Fate Bell before a prehistoric pictograph, part of Seminole Canyon State Park.

reservation was in Ruidoso, New Mexico. Bill Hobby was then lieutenant governor of Texas. On dedication day, D. J. and I went to the airport in Del Rio to meet our state's second-highest elected official, who arrived in a little single-propeller, flippetty-floppetty state plane that hopped across the field as it landed.

A few minutes later, Chino descended from the sky in his own Learjet.

He had been awarded generous retroactive compensation by the federal government when he complained that his tribe's land had been taken away by the Americans. LBJ could not argue the point, since the chief was right.

Our impressive event included ceremonial Indian dancers from the Huichol tribe in Mexico, whose ancestors had once lived in the area. By calling every well-connected person we knew in the Texas and the national media, we got some excellent press coverage. Within days, the whole world knew about Seminole Canyon State Park.

The Rock Art Foundation headquarters are in San Antonio, but the foundation owns and maintains the White Shaman Preserve near Seminole Canyon State Park and Historic Site, just outside the Lake Amistad National Recreation Area. The goals of the foundation are public education, research, and preservation. Since its founding in our living room in 1991, its membership roll now has more than 900 participants.

The foundation provides organized tours of Seminole Canyon State Park with trained volunteers as guides. It has an informative website that summarizes our efforts in one paragraph:

> Until recently, few people knew that Texas harbored one of the largest and most diverse bodies of rock art in the New World. Dr. and Mrs. D. J. Sibley, with their friend and local rancher, Rosemary Jones, convinced the State of Texas to purchase Seminole Canyon State Park and Historic Site as a refuge for prehistoric pictograph styles.

That description may make the lengthy and arduous process we endured sound easy, but I know better. From those first trips D. J. and I took down the Pecos in 1968, it took twelve years for us to dedicate this state park, getting it funded, developed, and dedicated.

After the Rock Art Foundation was established, we were joined by a number of people who had a deep interest in preserving this irreplaceable gift from the past. In 1994, Bill Worrell, a noted sculptor and dear friend, created an eighteen-foot-tall bronze shaman overlooking the canyon.

The young man who commissioned that shaman sculpture was called "Froggie" by almost everyone who knew him. His actual first name is

Jeffrey and he went to Choate with my son Hiram. Froggie is from the Bronfman family of Canada. He donated Bill Worrell's shaman sculpture in memory of his father, who had died the year before. They had been estranged until his dad became ill, but reconciled before his death. After Jeffrey commissioned this beautiful work, his mother flew in from Montreal to attend its dedication.

Parks never happen in a hurry. Big Bend took fifty years; the Big Thicket took seventy. If you ever feel inspired to accomplish something worthwhile, do not expect instant gratification. You must have patience, determination, and considerable perseverance.

Chronology
Amazing What You Can Accomplish, when Your Good Cause Attracts Concerned People, Willing to Take Part in a Forty-Year Campaign

1968	Jane and D. J. photograph rock art on the Rio Grande before the drawings were covered by the rising waters of Lake Amistad
1968–9	D. J. has recurrence of TB
1969	Dam is completed, creating seventy-mile-long Lake Amistad
1971	Jane and D. J. invite Governor Preston Smith on river trip to Panther Cave to view prehistoric drawings.
1971	Governor Smith appoints Jane to Texas State Historical Commission.
1971	Jane, Dr. Solveig Turpin, and Rosemary Jones work together to protect rock art, by gaining support for a new state park at the site.
1973	Potts/Sibley Foundation builds a security fence around Panther Cave art to protect it from vandals.
1973–7	State of Texas purchases land from private owners to create state park
1980	Seminole Canyon State Park opens to the public
1980	Jane and Rosemary organize a dedication ceremony for the park
1991	Rock Art Foundation is formally established
1994	Bill Worrell's bronze shaman statue is installed in park.
1994	Rock Art Foundation acquires the White Shaman Shelter and acreage across the highway from the park, funded by the Gale Galloway family, Texas ranchers who appreciate rock art.
2006	41,000 visitors tour Seminole State Park
2008	Rock Art Foundation attracts 900 members

Texas Historical Commission

In the mid-seventies, while I was on the Texas Historical Commission, a curious thing occurred. A hot potato was tossed our way from the legislature. Teachers moving into the state had always been required to take a course in Texas history in order to obtain a teaching certificate. Some teachers had questioned the need for that course and our commission had to decide whether to retain the requirement.

A powerful member of the commission, a federal judge who was a brother-in-law of Ed Clark, Lyndon Johnson's fund-raiser and confidant, made a motion to do away with the requirement to study Texas history. The commission was ready to accept his proposal without question until the chairman asked, "Are there any questions?"

"I have a question," I said. "What is wrong with studying Texas history?"

There was a long, pregnant pause, while everyone present gave the motion a second thought. Then, I added, "We have the most exciting history of any state in the country. What harm would it do for a teacher to learn it?"

Suddenly, the other members of the commission were asking themselves, "What were we thinking?" Within moments, they all changed their tune. That motion could have slid through easily since the most prominent man on the board had proposed it. However, I knew it was not right. If they wanted to say that Texas history was not important, they could have voted me down, but I did not even have to make a motion.

Immediately, the judge said, "I withdraw my motion."

Because I was willing to take a stand and express my opinion, all Texas teachers must have some knowledge of the state's history in order to teach in our public schools.

Another time, the Historical Commission was called together for an emergency meeting. Those of us who could get there met in one of the state offices. Someone had discovered a serious loophole in our charter from the legislature. The Texas Historical Commission had started out as the "Texas Historical Survey Committee" and the legislature had only recently changed it to a "commission."

Therefore, all historical markers created up to that time were technically invalid. That meant the Alamo could have been torn down if some

developer went after it. Immediately, we grandfathered all markers and historical designations and made sure they were legal. The saying "the devil is in the details" is so true. This example proved the point. Although seemingly a minor technicality, that oversight could have had major repercussions.

D. J. Sibley Family Centennial Faculty Fellowship in Prehistoric Art

The University of Texas celebrated the 100th anniversary of its founding by releasing money from the permanent fund to match gifts to the UT academic program, thus doubling the size of the original gift. D. J. and I, and our three children, chose the art department and nominated a study of prehistoric art as the recipient of our collective gift.

Following the establishment of the Sibley Family Lectureship, the university engaged several outstanding speakers who came to the campus, gave a single lecture, and left. While the lectures were excellent, they happened infrequently and had no continuity.

When Linda Schele, an outstanding art professor at UT asked us if she could collect the money over a period of several years, then present a seminar of experts from around the world, all expenses paid, who would come to the university and discuss one topic that she selected. The seminar would take place over several days and the final meeting would be open to the public, followed by publication of all the topics presented during the convocation.

Her plan was what we had been envisioning all along. D. J. and I both wanted to sponsor international scholars in order for them to interact and share their knowledge. Except for the final session, these meetings were closed to the public so that the participants could concentrate on scholarship instead of performing before an audience.

Starting in 1991, the seminar was sponsored by the art department at the University of Texas at Austin. On the first evening, we always hosted the group for dinner at our home. We usually had about thirty people, many of whom spoke different languages. Sometimes our dinners resembled a UN session, only without the translators.

The university gave the seminar a new title that is long, accurate, and almost impossible to repeat, but the quality of the seminars more than

makes up for it. The topics have varied widely since the first seminar was organized by Linda Schele in 1991.

1991: Kingship: How the Concept Developed in World Civilization
1993: Cosmology and Natural Modeling among Aboriginal American Peoples
2000: The Representation of Altered States of Consciousness in the Art of Indigenous Americans
2003: The Art and Archeology of the Moche

We were planning the third conference in 1998 when we lost Linda Schele to cancer. She was a gifted scholar, writer, and speaker. She was also a highly respected art historian who had a major impact on the study of the Maya. Linda was multi-talented: she wrote books, appeared on a PBS special, and was one of the first scholars to interpret Mayan glyphs.

The University of Texas art department, along with her husband, endowed a chair in her memory held today by David Stuart, an archeologist who grew up playing in the ruins of the Yucatán. His father was head of the research division of *National Geographic*. David is continuing Linda's work. He is one of the most knowledgeable people in his field. He told my son, Hiram and me, that our seminar is a "valuable resource for scholars and has gained great prestige in the archeological community."

The Sibley Family involvement with the lectureship has continued and has developed over the last two decades. In 2006, a group of us went to Antigua, Guatemala, on a scouting expedition for the university. The group included David Stuart, John Yancey, chairman of the UT art department; Caroline Porter, a professor at the university; Bridgette Beinecke, a restoration architect, and Rachel Sibley, my granddaughter, who celebrated her twentieth birthday at a candlelight dinner in Antigua.

We went to Antigua to evaluate restoring a hundred-year-old historic warehouse owned by a prominent Guatemalan family. Located in the center of Antigua, the building had fallen into disrepair and the Herrera family decided to completely restore it and lease it to the University of Texas as a Center for Mesoamerican Studies. Casa Herrera, the restored building, was completed in 2008. It was officially opened with the D. J. Sibley Family Centennial Faculty Fellowship in Prehistoric Art conference in March 2010.

18

Lifetime Friendships

I AM SO grateful for the enduring friendships I have maintained. There are a few of us who grew up in Fort Stockton in the twenties and thirties who still call each other regularly. Sometimes, we phone each other at least every three months or so, but often we connect once a week. Whenever we talk or see each other, we still have our good and strong connections.

We attended various colleges, we married, and even ended up living in different parts of the country, and yet we manage to remain close. Generally, our husbands got along with each other, which made things a lot easier. Most of us are within two or three years in age and, fortunately, we have been a pretty healthy group.

One of the great advantages of having old friends is our ability to employ candor with each other. Not so long ago, my cousin, Kathleen Crosby St. Claire, was ailing when she called me. She lives on a somewhat isolated ranch, and I was trying to get her to see a specialist in Austin who might be able to help her.

"Kathleen, can you get to Austin?"

"I can get to Austin, but I don't know if I can get to my car. I'm using two walkers."

When it rains, her arthritis gets worse, but she still holds on to that typically Texan oh-so-wry sense of humor. She told me, "It's rained two inches and we really needed it, Jane. So I can stand a two-inch *pain*." To a real rancher like Kathleen, whose family has ranched their land for more than a hundred years, her pain is a lot less important than what a good rain can do for her grazing land.

232

Having time-tested friendships is both a comfort and it is also, *comfortable*. We each share common ground and we know each other deep down, sharing a foundation of mutual experiences that can only be result from time's passage. My old friends are my true treasures and I do my best to treat them as such.

Mary McComb

Mary McComb has been my friend since childhood. Her family settled in West Texas before the turn of the last century. Her grandfather was a successful rancher, who established the "Diamond Y" brand. The "Y" was for his last name, Young, and the brand was simpler in design than the old Spanish brands, which were pretty to look at, but not too successful on cattle. They were very elaborate and burned so much flesh that screwworms were able to infect the brand wound, invade the brains of the cattle, and kill them. Those fancy brands looked pretty, but they also killed lots of cattle.

Mary is six years older than I, but our parents were close friends, so we spent a lot of time together when growing up. Later, we both married physicians. As couples, we four traveled together and shared similar likes and dislikes. D. J. and I enjoyed attending meetings of the American College of Surgeons as guests of Dr. and Mrs. Asher McComb.

Mary's daughters, Margaret and Molly, and our children, Jake and Mahala, were good friends, too. Mary's kids used to come to Fort Stockton in the summers and Jake was always pulling one of them around in his little red wagon.

Mary was a good actress, who won a screen test when she was eighteen. Although Paramount Pictures offered her a contract, her father would not let her sign it.

"No daughter of mine is going to be an actress," he stated firmly. And that was how Mary missed being in the movies. But later, Mary found a perfect venue for her talents at the San Antonio Little Theater, which cast her in leading roles for more than twenty years.

When Mary played in comedies, she displayed a witty, sophisticated character that proved to be her true calling. She should have been cast as Auntie Mame, and would have gotten the part except for an article that appeared in a local newspaper. Before the director auditioned the

Mary Winfield McComb, born the same night my baby brother was born. Mary lived, but he died after two weeks. My mother was always very fond of Mary and we became friends.

actors, a theater critic wrote in his column, "The only person to play Auntie Mame is Mary McComb."

That comment made the director so furious and so jealous that he announced, "I'm not going to have anybody cast my play for me." To get even with the critic, childishly, he would not cast Mary, even though she was perfect for the part. The girl he chose to play Mame was pregnant, which merely added insult to injury.

Whenever Mary was playing the lead in a Little Theater production, her husband, Asher, always hosted a dinner party at one of San

Antonio's downtown clubs. D. J. and I always attended. Asher was a lovely Southern gentleman who had quite a sense of humor. He needed one to be happily married to Mary, as she was famous for her often biting wit.

While he enjoyed Mary's lively conversation, Asher was genteel and courtly. He was a graduate of Virginia Military Institute (VMI) and thought it was the finest military school in the world. D. J. always enjoyed telling him that New Mexico Military Institute graduated more army officers.

Mary lived in San Antonio during the war, while I was at the university. Because of gas rationing, there was not much traveling back and forth. During my school year, I often saw her parents more often than I did Mary. Her father, Heine Winfield, was a state senator for almost twenty years, and when he came to Austin for the legislative sessions, he and his wife, Theo, took an apartment at the Stephen F. Austin Hotel.

From his years in business and politics, Heine had a great repertoire of stories, and he told them well. It was obvious where Mary got her humor and her acting ability. Heine was a successful politician who had a special knack that allowed him to connect with all kinds of people. His senatorial district was the largest in the state, running all the way from El Paso to the Pecos River. He was a highly respected legislator.

Senator Winfield's major achievement was persuading the state to appropriate money to establish Big Bend State Park, which was a Texas state park before it became a national park. Obtaining funding to acquire the park land from a conservative legislature was not easy. It took Mary's father many hard years of lobbying and arm-twisting to convince his colleagues to fund the Big Bend Park acquisition.

Finally, he got a group of legislators to agree to take a look at the proposed park site. Sen. Winfield arranged a special train to transport them from Austin to the small town of Alpine, way out in West Texas. Upon arrival, the state legislators would be greeted by local dignitaries and then taken by automobile to tour Big Bend.

However, on their long train ride west, the legislators started drinking. They also became seriously involved playing a serious poker game. When they arrived in Alpine, the game was still going strong, so they moved it directly into the Holland Hotel. They were not about to leave that game until it was over, so local officials were left waiting outside with empty cars.

Heine could not persuade a single one of them to leave that game. Finally, the legislators all agreed. "Hell, Heine, we'll pass your bill if you'll just leave us alone!" He did and they did. So that's how Texas got Big Bend State Park, which was later transferred to the Department of the Interior under the supervision of the National Park Service.

Mignon Rachal

Mignon is descended from Texas pioneers on both sides of her family. Her mother's ancestors arrived in Texas in the eighteen thirties and her father was a descendant of the Peters Colony, which came to Texas under a contract from Stephen F. Austin, the charismatic entrepreneur from Missouri, who helped colonize Texas.

In 1821, after Mexico broke away from Spain, they gave Austin permission to invite American settlers to Texas, thus creating a buffer between the North American Indian tribes and the people of northern Mexico. The Texans became the first line of defense against the Indians, who had frustrated two hundred years of Spanish efforts to conquer them and convert them to Catholicism.

Mignon's father, Guy Rachal, was a successful sheep rancher. He and his wife, Bess, had four children. Unfortunately, their only son died very young of scarlet fever.

Guy's business partner was Moise Cerf, from Ennis, Texas, which was a center of the cotton trade south of Dallas, dating back to pre-Civil War days. Moise's family came from Russia seeking a better life. They found one in Texas. Moise, whose name meant Moses in Hebrew, was a bachelor and he had a strong attachment to the Rachal family.

Years later, he presented to D. J. and me some rare books, including first editions, in gratitude to D. J., who took such beautiful care of Guy after he suffered a heart attack.

Mignon was with her father at the ranch when he was stricken, got him into the car, and rushed him thirty miles to town. D. J. commended Mignon for her quick thinking. He said if she had let her father stay at the ranch, he would have died. Because she got him to the hospital so promptly, D. J. was able to treat him, enabling Guy to survive and eventually to regain his health.

During World War II, Mignon fell in love with a pilot, Paul Hall,

whose nickname was "Woody." After he finished his flight training at the air field in Fort Stockton, eventually he was sent overseas. His plane was shot down in Europe, but luckily, he was not wounded and was able to return to active duty.

When he came back to the states on leave, they were married, and I was one of Mignon's bridesmaids. Because her wedding took place in the middle of the war, it was impossible to get good fabric for our dresses, so we made do with what we had. We realized having nice dresses was unimportant in the grand scheme of things, but could not help missing pretty clothes.

After the war, Woody remained in the air force and they started their family. They already had two boys, when Mignon became pregnant for the third time. Although Woody had received orders sending him to Japan, he received special permission to stay in the states to await their third child's birth. D. J. delivered their youngest, another boy.

Woody returned to Japan, where he served during the Korean conflict. Within a year of his third son's birth, Woody was killed in a freak accident. As he was coming in to land, another plane in his squadron approached too close to Woody, clipped his wing and both planes crashed, killing their pilots. How ironic that Woody lived through World War II, surviving being shot down then, only to be killed in 1951, landing at his own base.

Suddenly, in her late twenties, Mignon was a widow with three small boys to rear. She did not allow herself to wallow in grief, but went back to school at Sul Ross College in Alpine. After earning her degree, she taught history at Fort Stockton High School. A few years later, she married Lennis Gilbert, who was with the Odessa, Texas, Chamber of Commerce.

At least once a year, several members of his organization flew to Austin to lobby the legislators. On one of those trips, their small plane crashed while landing at the Austin Airport. Everyone on board was killed. Within just a few years, Mignon had lost two husbands to plane crashes.

Lennis's death was caused by a too-short runway at Austin's airport. All the pilots knew of the problem, and talked about it, but the runway could not be extended because of the surrounding terrain. I had strongly favored moving the airport out of the middle of town, but most voters

fought to keep it there because it was "convenient." It was convenient, all right, and deadly, too.

The day Lennis died, I had taken Mama to Mason, Texas, to visit her sister, Bird, who was dying of cancer. On our way home, I stopped in San Angelo to call D. J. and tell him we would be home that evening.

"Lennis has been killed in a plane crash and I'm at the hospital," he told me. "Plus, they are about to operate on Jake for acute appendicitis." Well! First, I called Mignon, then as fast as I could, I drove the 165 miles to Fort Stockton.

As soon as I pulled up in front of the hospital, I rushed inside in time to see Jake lying on a gurney and being wheeled back to his room. He had gotten through his operation just fine and I breathed a sigh of relief. I will never forget my mixed feelings that day: gratitude for Jake's successful surgery and stunned sadness over Mignon's loss of Lennis.

Whatever happens to her, Mignon is not someone who ever lets life keep her down. She married again some years later to a wonderful man named Bruce Pearson, a geologist. As they were flying off in his plane on their honeymoon, I said, "Mignon, I don't even want to know about your flying."

She said, "I didn't think you'd want to."

A few years later, they had a little girl, Rachal, who was their pride and joy. They were quite a compatible couple and had a good marriage. I believe Mignon had more in common with Bruce than with either of her previous husbands. Altogether, she had four children: three boys by her first husband and a girl by her third.

Mignon's youngest son, Peter, the one D. J. delivered, was a handsome boy, but had a difficult time in school. He became deeply involved in the counterculture of the late sixties. Peter died when he was in his twenties, which was terribly hard on Mignon. Her other boys did well. Blain is a geologist now teaching at Sul Ross University; Guy Jr., is running the family's oil business. Rachal teaches French at a private school in Midland.

Jean Nunn

Jean is responsible for my appreciation of fine jewelry. She came from a family much like mine, but had the great good fortune of having

two aunts, Dorothy and Ann, who married local geologists. In Fort Stockton, you either married geologists or cowboys, so her aunts made wise choices. Both couples settled in San Antonio, and their husbands made fortunes in the East Texas oil fields.

Ann and Dick had no children, and Dorothy and Don had only one son, so they were very close to Jean and, luckily, so was I. Whenever we visited them in San Antonio, we entered a world we had seen only in the movies. The aunts had beautiful homes with cooks, maids, and limousines driven by chauffeurs. Mignon, Jean, and I sometimes visited for weeks at a time. The chauffeurs would drive us wherever we wanted to go.

Since I had always appreciated fashion, I was utterly fascinated by the aunts' furs and jewelry, feeling as if I had stepped straight into the Wizard of Oz's Emerald City. Dorothy's husband, Don, was a hard rock geologist, who loved gem stones. He bought his wife fabulous jewels, including some of the crown jewels of Russia, which had been taken out of the country following the Bolshevik Revolution. The ones he had acquired were not state pieces like tiaras, of course, but he had acquired some breathtaking rings, necklaces, and bracelets.

Choosing not to bury them in safes, Dorothy wore them often. She believed gorgeous jewelry was intended to be seen and appreciated, not stored. Ann preferred furs and she had a closet full. I am sure that today she would be picketed by animal rights activists. I am equally certain she would pay not one bit of attention to any of them.

During our visits to San Antonio, Jean, Mignon, and I learned about the good life and we liked what we saw. Many years later, when D. J. and I were visiting the McCombs, Asher turned to D. J., "Where did these girls learn so much about emeralds?"

"I have never thought about it," D. J. shrugged.

But then I decided to pipe up. "We learned right there in Fort Stockton from Jean's aunts. They taught us all about emeralds, rubies, pearls, and even about jade. And you have been paying for those lessons ever since."

Jean married Mercer Ivey, a tall, handsome young man. He was six foot-six and his family owned cotton farms in South Texas as well as having some petroleum interests. Mercer's older brother, Ben, was one of the handsomest men I have ever seen. Sadly, while Jean and

Mercer were on their honeymoon in Asheville, NC, Ben was killed in a car wreck. He had movie star looks, and many girls had crushes on him, when suddenly, he was gone.

Unlike some of my friends, Jean's life has been relatively calm. She and Mercer did well farming around Taft, near Corpus Christi, and did some ranching at Carrizo Springs. They have four children, two boys and two girls, all married with children. Mercer died in 1998, and Jean continues living in her home on the farm.

Patsy Kelley

Patsy is my wonderful friend who was so good to me when I worked in Dallas. Back then, I lived in a rented room while working at Sanger's department store. Patsy attended Southern Methodist University, but decided academic life was not for her, so she dropped out of school. This decision upset her mother, who was my first grade teacher in Fort Stockton.

Patsy's mother earned her masters degree in education, later becoming a counselor at Highland Park High School in Dallas, one of the top schools in Texas. Patsy's mother was terribly disappointed when her daughter decided not to finish college.

Patsy had other ideas. She went to work at Texas Instruments in the early days of that enormously successful company. She loved it there, working closely with many of their top executives. Patsy especially enjoyed Jack Kilby, one of the co-creators of the computer chip. She became a top purchasing agent at TI and her stock bonuses became quite valuable. Before too long, her mother realized that Patsy had made the right decision after all.

She said "I don't know why I complained that Patsy didn't get a degree. In her first year on the job, she was making more than I did after thirty years in education."

Patsy's grandfather had been a rancher in West Texas and she was the only heir to his 26,000-acre ranch near Fort Stockton. The ranch was on Six Shooter Draw, a wide depression in the land that channels water to the Pecos River after a big rain. According to local lore, the creek was called "Six Shooter" because there had once been a famous gunfight there. Of course, that name could also have been applied to

Patsy Kelley (left), Guy Hall, Mignon's older son (middle), and Peggy Brown at D. J.'s eightieth birthday party in Austin

many locations in West Texas. Patsy is a city girl, so she sold the ranch and now leads a full life in Dallas.

At her retirement dinner, Patsy received a beautiful charm with rubies and sapphires to commemorate her outstanding career. She stays active in retirement, takes courses at SMU, enjoys the arts, and collects rare books by English writers. While she never married, Patsy is adored by her friends and is my son Hiram's godmother as well as godmother to one of Mignon's boys. Patsy has battled cancer successfully and, as long as she can drive her Cadillac, is happy.

It amazes me how many of my closest friends are only children. Patsy was an only child, as was Jean Nunn. Mary McComb, another only child, was born after her mother had survived five miscarriages. D. J. was an only child, as am I, and it has never bothered any of us. I think we liked all the extra attention lavished on us growing up.

Polly and Joe McWhorter

Polly's family moved from Fort Stockton to the Fort Davis area, where her father bought a spectacular ranch not far from the famous

Bloys Camp Meeting. Mr. Bloys was a preacher in the early nineteen hundreds, who thought everybody should get together one week in early August, go camping and hold revival meetings outdoors. After Mr. Bloys started the meeting with his family and close friends, it was named for him.

Soon other ranchers set up camps nearby so they and their families could attend the annual camp meeting. In the early days, they brought chuck wagons, their own beef, and cooked over open fires. As word about the camp meeting spread, hundreds of people from all over West Texas came to spend a week there. Some folks went on to build cabins in the area. A hundred years later, the camp meeting continues and now it even has a web site. There's still plenty of good preaching and the meeting invites a variety of Protestant denominations to participate.

Polly and I used to ride horseback to the camp meetings, where we had fun seeing our friends. Camp meetings gave rural people, who often lived in some isolation, a chance to get together. Those meetings were as much social events as they were religious gatherings.

Most people today, who have never heard of a camp meeting, let alone ever been to one, are missing out on a lot of fun. If you are ever near Fort Davis during the second week in August, you should go. Bloys Camp Meeting is open to the public, if you are a Christian. If not, they will do their best to make you one!

Polly's daddy was known as "Skinny"—surely you can guess why—and he regularly warned us not to ride too far into the mountains away from their ranch headquarters. Dangerous black bears lived up in those mountains, which Skinny knew well from personal experience. One of his cowboys, Red, was out riding when he came across a bear caught in a trap, writhing between two iron jaws chained to a stake in the ground.

When that furious bear lunged at Red, his horse shied, throwing Red to the ground. He was badly injured and he could not move. Red had to lie there immobilized, as the bear lunged and lunged, yanking hard on the trap chain, getting closer to Red with each lunge. If that bear ever got to Red, his certain fate was bear lunch.

In the absolute nick of time, Skinny arrived on horseback, shot the bear, and saved Red's life. That was such a close call that Skinny never let Polly or me forget it. For years, I kept a photograph of that enormous

bear with Skinny and Red standing beside it. Both men were six feet tall, but that bear was huge, towering over both of their heads.

Polly fell in love and married a cowboy, Joe McWhorter, who worked for Skinny. They started their married life during the terrible drought of the nineteen fifties. Joe was then manager of the Henderson Ranch near Fort Davis, leased by Jim Espy from Mr. Henderson, who was residing at the time in the state penitentiary. How Mr. Henderson got there is a story worthy of a TV soap opera.

Living on a ranch in West Texas can be lonely and some people often drank too much. Occasionally, they did things under the influence of alcohol that had tragic consequences. Mr. Henderson was away on a business trip for a few days. While he was gone, his wife and her mother decided to party at the Henderson ranch with some officers from the pilot training base in nearby Marfa.

Mr. Henderson decided to return home a day early and, as there was no telephone at the ranch, was unable to call his wife to let her know he was on his way back.

Obviously, she was not expecting him. When Henderson arrived in the middle of their party and saw what was going on, he went berserk. In a blind rage, he pulled out a pistol and shot his wife, mother-in-law, and both airmen, killing all four.

After he shot them, he called Dr. Malone Hill. "Doc, I have just done an awful thing. There are a lot of bodies out here."

Of course, no West Texas jury would sentence Henderson to the death penalty since they figured his wife and mother-in-law got what they deserved. However, they sentenced Henderson to prison for life. He never got out. But he was known as the wealthiest man in the penitentiary.

Now, there's a story that sounds like one you might read about in a supermarket tabloid, except it happens to be true. When Polly and Joe were living in Henderson's house, I actually saw the knotty pine walls with bullet holes still in them.

The drought got so bad Polly and Joe could not make a living on the ranch. They also realized that working for day wages was no way for them to get ahead. The drought did them a favor, providing the push they needed to make a major change. "At last," Joe told Polly. "Let's get out of here."

After Joe quit his cowboying, they moved to New Mexico, where he studied and earned a degree in aeronautical engineering at the university. Polly taught school to put him through college, and Joe was well aware how lucky he was to have such a supportive wife.

Although they had some lean days financially, Joe's and Polly's decision paid off. Joe's degree led him into an exciting career with the largest aircraft company in the world. He became the liaison between Boeing and the United States government, helping to develop the stealth bomber and other major projects.

Years later, Skinny was driving too fast, as usual, and was killed in a car wreck. Polly's mother, Bernice, lived on into her nineties and eventually, her granddaughter inherited the ranch. Polly and Joe lived in Washington State for many years where Boeing headquarters were located near Seattle.

After they lost one baby, they adopted a little girl, then had a boy of their own. Their daughter once worked as my secretary, not the easiest position in the world, and she did a good job. Their son made a big name for himself in the contracting business in the northwest. Polly and Joe prospered in Washington, ran a few cattle, retired and bought a beautiful place in New Mexico between Taos and Santa Fe.

Gloster and Ruth Harral

Gloster's great uncle was Arthur Anderson, not the accounting man, but the West Texas rancher. Uncle Arthur brought the first sheep to West Texas and branded the open A for Anderson with a hat above the A. He said, "It's so hot out here even a brand needs a hat."

Gloster Harral was another only child. He was a good friend of D. J.'s, though he was a few years younger and lived on the Hat A Ranch. Gloster's mother, Caroline, was an unusual woman, who always told everyone she was from Boston. After she died, we learned she was born in Baird, Texas, a little town on the railroad between Fort Worth and Abilene.

Baird was not quite Boston, but at least its name began with B. She wanted so badly to be from New England, but her obituary spoiled her myth. I am sure delusions of grandeur must have caused her to name her

only son Gloster, not exactly an easy name for a boy to grow up with on a ranch in West Texas.

Caroline was reared in the east, went to art school there, and was quite talented. She and her husband, Arthur, or "Artur," as she called him to make his name sound more exotic, were actually cousins. In those days, cousins often married, as Franklin and Eleanor Roosevelt did in 1905. Certainly, their union made financial sense; Uncle Arthur, who had no children, divided his ranch among his nephews and nieces. Each was to get twenty sections of land. By marrying, Arthur and Caroline got forty sections, doubling their holdings.

Gloster went to Culver Military Academy in Indiana, returned home, and had begun sheep ranching when the war broke out. He joined the infantry as a private and was stationed at Fort Leonard Wood in Missouri, where he met Ruth, who was attending Lindenwood College. She was only seventeen when they married in the early days of the war.

When D. J. and I were dating in the late forties, we saw a lot of Gloster and Ruth, and she became one of my closest friends. We would often visit them at the Harral Ranch. Gloster and D. J. each had small airplanes, so we hosted fly-in breakfasts at the Hat A.

We got up before dawn, started cooking pounds of bacon, eggs, and biscuits. We had all the cowboys helping, there was so much food to prepare. Everybody we knew who had a private plane would fly in and we would all have breakfast together. Sometimes, there would be fifty people arriving in twenty or thirty airplanes.

No one was ever officially invited. The news was spread through the local newspaper and the *San Angelo Standard-Times*. The editors there were always eager for a good story and a fly-in breakfast did not happen in most places. Gloster had cleared the brush to create something of a landing strip, but in West Texas in the forties, you could land almost anywhere. I must admit not all the landings were done according to strict FAA standards.

D. J. often brought his plane down on US 290, the trans-continental highway that ran from Florida to California before I-10, part of the Interstate Highway System, was created. Landing on 290 was not legal, but it certainly was handy, and there was never much traffic in our neighborhood. However, not a few drivers must have gotten a surprise

as they stared down the road to see a plane gliding to the pavement in front of them.

Gloster and Ruth enjoyed a long and happy marriage. They had a lovely daughter named Linda, and they also adopted a little boy called Turo, who now lives in California. Gloster had a good life ranching, then retired and sold the ranch in his later years. He died in his eighties and Ruth died in 2012, near Linda, in San Antonio.

Long after most of us left Fort Stockton and our worlds were all changed, my old friends and I have all stayed close. No matter our ups and downs, our triumphs and tragedies, these friendships have never wavered. When oil was discovered on our land, some of our friends in Fort Stockton began treating us differently, but not this core group. Our lifelong friends have never changed. They stuck with us. And we with them.

19

Ｅ

Around the World

EARLY IN 1983, I received a phone call from Mary Neely in Houston, who wanted to know if the Austin Symphony would like to sponsor the Youth Orchestra from China. An Oscar-winning documentary, *From Mao to Mozart: Isaac Stern in China,* featured the Chinese orchestra. When Isaac Stern, the great violinist, visited China in 1979, he discovered a group of talented young musicians who had emerged from years of censorship under the burden of communism.

They were performing classical music that their parents had taught them at home. Only a few years earlier, China itself had emerged from the disastrous Cultural Revolution. During those dark and dangerous years, the Communist government in China banned all western music performances and destroyed countless musical instruments.

After the Youth Orchestra arrived in America, they had to find sponsors to underwrite their performances. Unfortunately, I had to tell Mary that the Austin Symphony could only spend our donors' money on our own concerts. Despite that restriction, I personally loved the idea of the Chinese Youth Orchestra coming to Austin. I told Mary, "Let me think about it."

When I let D. J. know about the group, he was enthusiastic. "This sounds like something we should support, Jane. Go ahead and see what you can do."

When I called Mary back, I told her I would do my best to work out an appearance for the orchestra in Austin. The symphony could be its

presenters, for sure, but we would have to find outside funding for the concert.

Picking up my well-thumbed Rolodex, I got on the phone and began calling some people I knew who love the arts. Very quickly, we found the sponsorship money we needed.

From the donors, I never asked for large amounts, just enough to fund a venue for the concert and to help cover the players' basic expenses. I had no difficulty at all raising the few thousand dollars we needed.

Once funded, we had to figure out where the Chinese musicians would stay. The orchestra members did not speak English, nor did their chaperones, and none of the sponsors in Austin spoke Chinese. It was at that moment of clarity that I realized we needed help from our Chinese community in Austin.

The daughter of a Chinese friend played violin in our symphony, so I contacted her mother. Even before I finished explaining what we were looking for, she told me how thrilled she would be to help. She called me back in a few hours to report that the Austin Chinese community would love to host all the orchestra members in their homes.

Our Chinese families were overjoyed to have the young musicians staying with them. One woman told me, "Grandma is so excited. She can hardly wait to speak Chinese with the students." My Chinese friend had saved the day. By having the Chinese Youth orchestra players staying with Chinese families, the young people would feel at home, and the families would have the pleasure of hosting them.

Next, we needed a venue for their performance, so I called Ruben Johnson, who had just built a beautiful bank in Austin. When I asked Ruben if we could use his auditorium for the concert, he could not have been more gracious in his acceptance. Ruben told me he would be delighted to have the orchestra performing in his bank. Their auditorium had a stage just the right size for an orchestra of twenty musicians. With a few well-placed phone calls to the likeliest prospects, we achieved a venue for the concert and lodging for the players. Two of my major problems were solved.

Of course, I invited all the principals of our Austin Symphony to attend the concert. Many of them came, and Paul Olefsky, our great

cellist, was charmed to hear the young musicians from China. He was aware that few western musical instruments had survived Mao's Cultural Revolution. Some of the surviving instruments they were playing had been hidden away for years.

Consequently, they were in pretty miserable condition. The musical scores the Chinese players brought with them dated from before Japan's invasion of China in the thirties. However, what those young musicians lacked in instruments and scores, they made up for with their sheer talent.

Their principal cellist was only sixteen. After the concert, I introduced him to Paul Olefsky. Paul owned several Stradivarius cellos and a number of others that were almost as good. He had brought one of his spare cellos with him to the concert.

Paul asked the young cellist if he would like to play his spare cello and to use his bow. The youngster had never seen such a magnificent instrument or a bow that cost several hundred dollars. He picked up Paul's cello with reverence, sat down, and began to play. As he continued, tears were rolling down his cheeks.

As he finished, Paul said quietly, "You may keep the bow." The young cellist was speechless. Paul had made a beautiful gesture. More important, he had made an investment in the growth of a gifted young artist. Paul knew talent and he heard it aplenty that evening in the bank auditorium.

The Chinese are strong believers in social reciprocity, so they were eager to repay our hospitality. That fall, Paul Olefsky and Bill Race, a pianist from UT who had also attended the Youth Orchestra concert, were invited to teach at the Shanghai Conservatory during the Christmas holidays.

The pair went to China, taught there, and the Chinese invited them to return the following year. While in China, Paul met Hai Zheng, a student who was an outstanding cellist. Paul wanted her to continue her studies in the United States. Eventually, he received permission from the State Department to sponsor this gifted cellist so she could study at UT.

After several years of intensive study, Hai was invited to appear at the world-famous Tchaikovsky Competition in St. Petersburg, Russia,

where Texan Van Cliburn had won first place in 1958, and became internationally famous, personally creating a cultural breakthrough during the depths of the Cold War.

Before she went to Russia for the competition, I invited Hai to our home. I asked her, "What are you going to wear when you perform?"

"I am not sure what to do. I have nothing to wear, Mrs. Sibley."

I told her we could do something about that in no time at all, and, within a few hours, we created her wardrobe for the performance. We decked her out in a gorgeous Pauline Trigere black pants suit with a white satin blouse, and a black vest. She looked stunning with her coal black hair and luminous complexion.

Not long after that, the widow of Pablo Casals was visiting Austin to raise money for the Kennedy Center. I invited Paul Olefsky to join us for lunch, since Paul had known the great cellist many years before. Seeing his young widow must have started Paul thinking that Casals had married her when he was in his later years and she was quite young. Something must have clicked.

Lo and behold, not too much later, Paul asked Hai to marry him. He was in his mid-sixties and she was in her twenties, but Hai happily married him, converted to his religion, Judaism, and they now have a beautiful daughter. Paul may be much older than Hai, but being married and a father has kept him young.

When I went to his seventieth birthday party, I could see they were a happy family. Hai takes care of Paul and keeps him in line; he blooms when he is with her. She teaches at St. Stephen's School in Austin and, naturally, their daughter plays the cello.

The film about the Chinese Youth Orchestra was screened all over the world and had a powerful impact on audiences. A Chinese man from New Jersey, who had immigrated to America and made his fortune here, saw the film and decided that he would pay for the education of the young cellist to whom Paul Olefsky had given the bow.

The donor contacted the cellist and his parents in China and offered to finance his studies in the states. They accepted his generous offer and the young man came to America and studied at one of our top conservatories.

A few years ago, a guest Chinese cellist was playing with our orchestra. During a pre-concert luncheon, our conductor, Peter Bay, asked our soloist, "Have you ever been to Austin before?"

He said, "I may have been."

I raised my hand and told the story of the young Chinese cellist who appeared in *From Mao to Mozart,* who had come to Austin with the Chinese Youth Orchestra, receiving a bow from Paul Olefsky.

"I am that cellist," our guest said quietly.

That cellist is Jian Wang. Today, he manages a brilliant career, traveling the world performing at concerts with great symphony orchestras. His career proves that no one succeeds alone. Without Isaac Stern's film and the generous financial support of a Chinese-American businessman, Jian would never have had the opportunity to develop his talent fully, and thus to launch his successful international career.

In 1983, because of our work helping the Youth Orchestra, D. J. and I, as part of a Texas cultural delegation sponsored by the US State Department and the Chinese government, were invited to visit China. We were to attend the Peking Opera and other musical performances around the country. Traveling to China in the early nineteen eighties offered us a fascinating glimpse into a country that had only just begun to open its doors to the outside world.

First Trip to China

The day we arrived after an eighteen-hour flight, our hosts took us straight to the Peking Opera. All of us had terrible jet lag and what we needed most desperately was a good night's sleep. However, the Peking Opera was doing a special performance just for us, so we had to go.

Backstage, before the performance, we watched the cast putting on their ornate costumes, and applying their intricate makeup, which alone took almost two hours. I could not get over their headdresses. The women had elaborate hair-dos of which almost every element was artificial. They placed a tight band around their heads to lift the corners of their eyes, providing a more exotic and theatrical effect. Then, the

hairdresser pasted artificial curls around their faces and added wigs, jewels, and flowers.

A small orchestra was seated to the right of the stage, including drums, marimbas, and lots of other percussion. Despite the unusual sounds, it was not the atonal music that caught my attention, but the amazing sword duels taking place on stage. The actors were not using plastic weapons, but real ones. The performers were singing, dancing, and performing acrobatics, all the while brandishing swords that could have sliced off an opponent's limb or killed a fellow performer.

Quickly, I realized they had been training for this performance since they were small children, so they had all the routines memorized in detail, but occasionally, someone was bound to make a mistake. The sword fighters certainly kept me awake—only partly because I kept anticipating an unplanned decapitation any moment. To make things even more dramatic, the lights were turned off while the actors were sword fighting. Seconds later, when the lights came back up, the actors were still in the midst of their duel. All this vivid action was taking place only a few feet in front of us, much more than a little too close for comfort.

Our group of ten Texans was the entire audience and throughout the whole performance, we were all teetering on the verge of passing out from sleep deprivation. We tried pinching ourselves, doing our best to stay awake, and to be an appreciative audience. Fortunately, none of us began to snore and we made it through that magnificent opera without causing an international incident.

We arrived in China only eight years after Mao's death, six years before the Tiananmen Square massacre. That was a time of transition for the Chinese people after more than three decades of living in a tightly closed society. Everyone we met in China was extremely friendly, although many had never seen Caucasians before.

When our group walked through the streets, the local people stopped and stared at us, focusing on our eyes, so different from theirs. For the first time, I understood how it might feel to be an animal in a zoo. Except for one element, as the Chinese we saw were observing us, their expressions never changed. They stared at us as if we were from a different planet. In many ways, we were.

I did my personal best to give the Chinese something special by which to remember us. Almost everywhere we went, I wore my western hat made by Manny Gammage, and the Chinese loved it. I even brought my Texas boots and wore them sometimes.

The contrast in our styles of dress was stark. The Chinese were still wearing drab Mao uniforms. There was almost no color anywhere we looked. When we saw one little girl about two years old wearing red shoes, it was startling. We went to many schools, but spotted no more red shoes. Only the political ideology was that color. Their communist doctrine was drilled into the students from morning till night.

Many of the schools we visited had no heat, even though it was bitterly cold. I remember shivering through one concert in a freezing school auditorium. They had a piano in the school, rare at the time. A young woman had played it quite well, despite her thin dress, while I was wrapped in my fur coat and still shivering.

We went to the elite Shanghai Conservatory and there was no heat there, either. The conservatory had the grim look of Soviet architecture with concrete walls and steps. Because of all that concrete, the sound traveled from top to bottom down the steps, and the acoustics were impossible.

The Chinese are big on gifts and I presented them with a number of classical music scores that I hoped would be put to good use. They accepted them from me graciously, opened a glass cabinet, placed the scores inside, and locked the door. I am afraid they are still in there today, gathering dust.

In Beijing, we spent several nights in Chiang Kai-shek's guest house, finding it surprisingly plain. Madame Chiang was the descendant of old Chinese wealth and power, but her husband was not. He was a soldier. She was an aristocrat, from the Soong family, with great genes, who lived to be 106. While their history was fascinating, I was glad when we left the guest house and checked into a large, well-heated hotel.

The main thing I recall about that hotel is that all the "bell boys" were girls. It was the first time I had seen bell girls, though we do have them today in America, too. The officials told us quite proudly, "Chinese girls strong." These young women proved it by picking up our heavy suitcases and running with them up the stairs.

The hotel accommodations were fine, much like a big old-fashioned US hotel. During our free time, our host guides cautioned us not to get lost. We always brought with us a book of matches from the hotel, which we could show to a policeman so he could help us to get back to our hotel.

It seemed to me the Chinese were very elaborate planners who just loved to entertain. Every dinner was a multi-course banquet. We dined in special dining rooms with two or three large round tables. At every dinner or other meal, I sat beside a Chinese official, although we remained separated by that insurmountable language barrier. My dinner partners spoke no English and I spoke no Chinese.

In our mutual attempts to be cordial, we would smile, nod, and be extra polite, but that was the extent of any communication. What we could do without any linguistic difficulty was to eat, and the food was delicious. We used chopsticks at every meal and fortunately, I had practiced using them before the trip. I got to be quite good at using them, and did not miss our western utensils at all.

Our dinner companions were all officials from the Chinese government. Each table seated ten or twelve, but there were never any Chinese couples. A male official never brought his wife and a woman official never brought her husband. None of them spoke English except for our interpreter and, fortunately, she never left us.

There were many courses and all of them were tasty. We ate and ate and thought we had finished the meal—then they would bring on the main course. After a while, we learned to gauge our intake and ate only a small portion of the first few courses to save room for the later ones.

We never knew exactly what we were eating, which was probably a good thing, as I rarely recognized anything on my plate. Nevertheless, I was determined to sample every dish, no matter how strange it looked to me. I feel sure I had my share of octopus, shark, and eel, and I enjoyed them all. Whenever they brought out a large bowl of apples and placed it in the center of the table, it was our signal the meal was finally over. I never saw anyone eat an apple, but within three minutes everyone always got up and left the table.

There was no escaping a visit to Mao's tomb. A long line of Chinese

was waiting to pass in front of Mao's body, but the officials let tourists and foreigners go ahead of them. Even though I had no desire to stand in line to see a dead dictator, I could not help thinking it was unfair to the waiting Chinese. After all, he was their hero, not ours.

The mausoleum where his body is on display is elaborate and there are many steps leading up to its entrance. The Chinese seem to love steps. Maybe this helps them keep in shape as we rarely saw overweight Chinese in any age group. When we finished climbing the stairs to the mausoleum entrance, we entered a large room where Mao lay in a coffin carved of one large piece of rock crystal. As I looked at his perfectly preserved body, I wondered if it was really Mao or perhaps a wax version. Appropriately, his body lies in Tiananmen Square, which became infamous in 1989, when the Chinese army killed hundreds of students during formerly peaceful pro-democracy demonstrations.

A Chinese professor in line with us spoke good English. It was our first opportunity to speak to a Chinese citizen other than to our interpreter, so we got the professor off to one side.

"Are you facing any kind of persecution now?"

"No, we are not." He said that with such sincerity that I believed him. Things had changed dramatically since millions of intellectuals and professionals were sent from the cities to work the land during the Cultural Revolution. This professor lived through those terrible days, but many of his contemporaries did not survive. Between 1966 and 1976, millions of their best minds were lost forever.

The Peking Opera performances often depict female generals. They are not fictional creations. China had many female generals and a few empresses in its history and they were tough and mean, not unlike Madame Mao.

She was a modern throwback to ancient Chinese history. Clearly, Mao did not marry her for her beauty, but for her political abilities. He kept many mistresses and, after seeing his wife's picture, I understood why. She was the "hit woman" for Mao in his old age, and was widely feared and hated. After Mao died she fell from grace very quickly. As a devout member of the "Gang of Four" responsible for the Cultural

Revolution, she was put on trial, convicted, and imprisoned. In 1981, Madame Mao committed suicide in prison.

Chinese calligraphy fascinates me. When we went to an exhibit in Beijing, I bought some excellent examples of different styles of lettering, including ones that look like hieroglyphics and others that resemble the flourishes of Arabic. At one hotel where we stayed, an elderly man sat cross-legged on the floor of the lobby holding two large brushes, each four inches in diameter. He did calligraphy with both hands at once. Try that some time. Granted, the Chinese have had a long time to practice their art. After all, they invented paper. They were also the first to create fireworks, but unfortunately, we did not get to see a pyrotechnic exhibition. Instead, we saw the city skies alive with kites.

The Temple of Heaven in Beijing is one of the world's most exquisitely proportioned buildings and its acoustics are perfect. I was thrilled to see it and equally pleased to find that rare antiques were for sale in the nearby shop. I bought two jade disc earrings. I was so impressed by their quality that I paid the asking price.

One of the people in our group inquired about their cost and when I told her, she said, "You paid too much."

"No, I did not. I will never see anything like them again." I was right and have never come across jade of that quality in all the years since then.

In Asia and the Middle East, customers are expected to bargain with sellers over the price of everything. In some countries that includes wives. The art of negotiation can be great fun if you enjoy bargaining. However, in the seventies, China needed hard currency so badly that I did not have the heart to bargain. How times have changed now. If I went back today, I would bargain for everything, since China now owns so much of the US debt.

The people working behind the counters in the antiques stores were old and they looked as if they had been through the wringer. At the same time, I could tell they were experts who knew the value of what they were selling. These were not clerks placed there at random by the government. These were real old-time antiques dealers. I bought a couple of gold and coral hair ornaments, remembering that when Mao ordered all the women in China to cut their hair they had no choice but to obey.

Because of his ridiculous edict, millions of beautiful hair picks went to waste.

In one antiques store, the clerks spoke some English, which was extremely rare. When they found out we were from Texas, one of the wrinkled old men asked me, "You know Trammell Crow?"

I could hardly believe my ears. I told him "I certainly do," and was amazed that this ancient Chinese man knew my friend from Texas.

He told me Trammell Crow had bought many fine antiques from this store.

Hearing Trammell's name so far from home brought back a happy memory from my college days. He was serving in the Navy during World War II when I saw him for the first time. He had come to see his girlfriend, Margaret, who lived in our boarding house. All the girls were hanging out the window staring, he was so handsome in his uniform. Of course, most men in a white Navy uniform look their best, but Trammell was a seriously good-looking officer.

Second Trip to China

In 1984, when we hosted a delegation of the Chinese People's Republic Association for Friendship, we were asked to sponsor a performance of the Peking Opera at the University of Texas.

D. J. and I asked Claytie and Modesta Williams to co-sponsor it with us and we held a sold-out gala at Bates Hall. After the performance, we hosted a reception at our home. A number of Chinese families who helped us board the young musicians attended our party. I remember that all the performers dressed up for the supper and the young women wore long gloves and looked as if they had walked out of a movie from the thirties.

There was only one problem, but no one but me was worried about it. During that entire evening, I was terrified that one of the performers would try to defect. When Sol Hurok brought the Bolshoi Ballet to America, every year, it seemed, one or two dancers would seek asylum in order to stay in the west. That was how Nureyev and Baryshnikov became our most famous ballet stars. Eventually, the Soviets forbade Hurok from bringing any more performing groups to America.

I had nothing against defection as a practice, and would have been first in line to defect if I had to live under communism. However, I did not want anyone to defect from my house. I could just see the headline: "PEKING OPERA SINGER FOUND UNDER COUCH AT SIBLEY SOIREE." After the group left that evening, I looked in all the closets and under the beds to make sure no one was hiding.

The Chinese government must have been pleased with their reception in Austin. They invited us to come back to China in 1984. On our second trip, we sailed down the Yangtze River and saw the famous carvings on the cliffs that have now been inundated after the construction of the Three Gorges Dam. The thought of losing those irreplaceable historic carvings made me so angry I would not even look at the power plant they were building. I was furious with the Chinese government.

When Thanksgiving came, we were on the river boat. The Chinese knew it was a big American holiday that featured a turkey dinner. They were determined to be good hosts, but there was only one problem: there are no turkeys in China. In the spirit of Chinese ingenuity, they improvised.

Using unidentifiable mystery meat, they created a Phoenix, the mythical bird that rises from the ashes, so we would have a "bird" for Thanksgiving. They created such elaborate decorations with cut up meats, breads, and cake that we almost forgot the beast was no turkey. The Chinese understand the power of creative presentation. Their table service was always excellent, and when we snapped our fingers, everybody jumped. We had the finest of whatever was available. Looking back, it was one of the best Turkey Days ever, despite the fact there was no turkey.

After our trip down the Yangtze, we stayed at official Chinese guest houses, which were lavish, but cold. We had plush red velvet draperies, but too few blankets on the bed. I was tempted to take down the draperies and use them for covers. I remembered how in "Gone With the Wind," Scarlett O'Hara used her fine draperies to make a fancy dress. I thought about using those Chinese draperies more than once as we lay in bed freezing. As much as I enjoyed the scenery and all the cultural experiences, shivering from cold is one of my main impressions of China.

Later in the trip, we were traveling on a train, seated in what the Chinese called "first class." If that was first class, I would hate to experience coach. To put it kindly, the Chinese idea of first class is not the same as on Cunard Lines ships. It felt more like steerage.

We were traveling with a former Louisiana governor and his wife and the four of us were sharing one small compartment. It was a good thing we enjoyed each other's company. The men slept in the upper bunks and we ladies occupied the lowers.

I distinctly recall that there were only the four of us in the cabin when we turned out the lights and went to bed. A few hours later, I woke up in the middle of the night and discovered someone in bed with me and it was *not* D. J. I am an adventuresome traveler, only not *that* adventuresome.

A Chinese passenger had come into our compartment, got into my bunk and lay down beside me. He never said a word, just rolled over, and went sound asleep. That event was so unprecedented, one I had no idea how to handle. Finally, I realized that the strange man's intention was simply to find a place to sleep, so I had nothing to worry about. Gradually, I calmed down, never saying one word. I decided it was a lot like those cowboys who shared a bed at the Riggs Hotel in Fort Stockton. Somehow, I managed to go back to sleep.

I never saw my bedmate's face, or spoke to him, or knew when he arrived or left. I do know he was there for much of the night. Fortunately, it was winter, so everybody had their clothes on. I would rather not think what would have happened if our trip had taken place during a summer heat wave.

The next morning, I found out that the governor's wife had the same experience. Somebody climbed in with her, too. Our husbands did not know a thing about our bedmates until the next day. Later, we learned that what we had experienced was normal. During the night, Chinese trains made many stops and the local custom was for people to get on and search for a place to sleep. When they found one, they climbed into the bunk.

It has been almost twenty-five years since our trips to China. One of the things, I remember clearly. The Chinese guides told us we could leave our money or jewelry in our hotel rooms in plain sight. There was

no fear of theft whatsoever, because in China, the penalty for stealing was death, speedy and certain.

On the other hand, sanitation in China was—and still is, so far as I know today—a far cry from ours. I remember having an excellent lunch at a restaurant along the Yangtze. As we were walking to our boat, I looked into the kitchen and saw that they had stone sinks, which looked as if the water had not been changed since they washed their first dish. Clearly, the Chinese people have built up a powerful immunity to a wide range of bacteria or they would not be the world's most populous nation; they would all be dead.

My greatest regret about our trips to China is that we were unable to spend more time with regular people. In the mid-eighties, almost none of them spoke English, but it would have been wonderful to have gotten their point of view and heard about their experiences. When a few people came up to us in the streets and tried practicing their English, we did our best to talk with them, but there was really no way to converse. At least we knew they were interested in communicating with us, because they were learning our language. How many Americans do you know who are learning Chinese?

Instead of typical Chinese people, we met only their higher ups. Later, one of them came to New York when I was in the city and got in touch with me. He spoke English well and had an official position much like an ambassador. He invited me to have dinner at the Chinese consulate then located in the building that had housed the once-famous New York restaurant, *Le Carousel*.

I sat there with a Chinese consul and his aide, whom we had met on our recent trip, and had a lovely meal. At one point, I had a fleeting thought: "Nobody knows where I am. I could be whooshed off into white slavery." Then I remembered that I was past the prime of my white slavery days. My host treated me royally and asked if there was anything special I would like to do. I told him that I would love to see the new panda from China that was currently visiting the Bronx Zoo. We jumped into a limousine with red flags flying and headed off to see the panda. The only Chinese star I ever saw wore black and white fur.

Australia and New Guinea: 1990

Hiram, D. J. and I went to the South Pacific to visit some of the places where D. J. had served during World War II. First, we toured the north peninsula of Australia, which almost touches New Guinea, to see its prehistoric rock art. We climbed up and down mountains and canyons and stopped at a spring.

The rancher who leased the surface land was our guide. He made us tea as only the British can. Imagine being served hot tea in the middle of the bush. A couple who were traveling with us, who were riding in the back of the pickup, acted standoffish and aloof. It is hard to be snobbish in the wild, but they managed. Finally, Hiram started talking to them since he talks to everybody.

He said, "We are from Austin. Where are y'all from?"

They replied, "We are involved in a nuclear power plant south of Austin."

It turned out that they were scientists who where testifying in a prolonged lawsuit concerning a nuclear power plant near Fayetteville, Texas, about eighty miles from Austin.

Once Hiram broke the ice, they became much friendlier and from then on we had a good time. We climbed near the top of a mountain to see bluffs with paintings that are more than 40,000 years old. They did not look quite right to me until I learned that every year, a religious ceremony is held there during which the aborigines repaint the ancient symbols.

After that, we headed for Port Moresby, New Guinea, which was being threatened by "rascals"—the local term for bandits—who were giving the authorities trouble around the gold mines and causing unrest all over the island.

On our way to Port Moresby, we landed in Popendetta, near Buna, a major battle site where D. J. had served during the war. Popendetta was just a village with a barn for a hangar.

Having heard about the rascals, Hiram was not too enthusiastic about visiting there. He said, "Let's get back on the plane and get out of here. There are banditos everywhere and we may be in danger."

I said, "No, Hiram. We've come this far and we are not going to get back on the plane and leave."

There was an air-conditioned pickup waiting for us, which improved our spirits, and we headed off to see Buna, a mission operated by Roman Catholic nuns. During the war, all the nuns were evacuated from Buna, but over the years the missionaries had a positive impact on the native population, developed a bond of trust, and converted many of them to Christianity.

D. J. recalled that he had been in Manila in 1945 when they evacuated American civilians who had been held in Japanese prisons. We had old friends from Fort Stockton, John Lawrence, his wife, Marie, and their two children, who had lived in the Philippines for many years before the war. John was an executive with Lever Brothers and they had the terrible misfortune to be stuck in Manila when the war broke out.

After the Japanese conquered the city, the Lawrences were captives for three years. The whole family managed to survive more than a thousand days of captivity in the infamous San Tomás prison camp. They were among the lucky ones. John and Marie survived the war, but their marriage did not.

Once we had seen the battlefield and Hiram realized we were relatively safe, his mind turned to golf. He got out his golf clubs, found a taxi and drove out to the Popendetta Country Club. When the cab got there, he found a huge padlock on the gate, so Hiram did not play golf in New Guinea.

After seeing Buna, we went up to the highlands and joined a tour. New Guinea is not only beautiful, but extremely dangerous. One of Nelson Rockefeller's sons disappeared there almost fifty years ago, and they never found any trace of him. He could have fallen, been bitten by a snake, or drowned. No one knows what happened to him, and if they do, they are not talking.

We enjoyed our tour, although the sanitation was primitive. Life there is very precious, as the mortality rate is high for both infants and mothers. In many ways, the people still lived in a Stone Age culture. They rarely washed their hands and did not use toilet tissue. When they were hired to work in a hotel, the managers had to remove age-old habits and replace them with new customs of cleanliness.

We had marvelous drivers and spotters who looked for interesting birds and animals and who spoke excellent English. They told us they still had tribal warfare in New Guinea. There is constant conflict among the many tribes and they are always talking about fighting.

We were driving along one day and had to stop when our guide said, "They are going to have a war." One tribe was upset because someone from another tribe had killed one of their members. While everyone stood around talking, I bought a necklace from a fellow about to head into battle. I figured that if he was going to war he would not need it. Fortunately, as with many local disputes, the war was averted. But I still have his necklace.

One of the drivers showed us his greenhouse filled with various orchids. He transplanted, grew his plants, and was in contact with some of the leading orchid breeders in the world.

After visiting several primitive villages in the highlands, we boarded a luxurious catamaran that slept twenty-one. It was about half passengers and half crew and we met some lovely people on that tour. One of the passengers was among the wealthiest men in the United States and was with his second wife, "Babs."

The last day we were on the catamaran, I was sunning on the roof, talking to a fellow passenger from Arizona. Recently, *Town & Country* had photographed The Castle for their Chihuahuan desert feature, and I knew they were looking for other desert-dwellers. I told my companion, "I have a friend who writes for *Town & Country* who is doing a series on the great American deserts. Who might be interesting for her to interview in Arizona?"

About that time, Babs came up and said, "I can't contain myself any longer. I have to tell you. My husband and I are going to be in *Town & Country*."

The woman from Arizona and I looked at each other and said, "When?"

She said, "I'm not sure when, but soon. The magazine may be out when we get back." The MacMillans had been photographed in their Palm Springs home soon after D. J. and I were interviewed in Texas.

Babs and I found our husbands and said, "Sit down. We have something to tell you."

There had been no news aboard ship for any of us from the States. Almost in unison, they said, "What is it?"

"We are all going to be in the same issue of *Town & Country.*"

Sure enough, when we returned to Los Angeles, the magazine was out and there we were. D. J. and I had a two-page spread, which thrilled me. The MacMillans' story featured the extensive collection of modern art in their desert home.

20

The Long Center

FRANK ERWIN was the legendary chairman of the University of Texas board of regents and a confidant of governors and of presidents. One day, Mr. Erwin called and invited me to lunch at the Headliner's Club.

Of course, I said yes. Although I had no idea what he had up his sleeve, my curiosity was aroused. Besides, I did not want to miss an opportunity to meet with him.

Frank was an attorney and lobbyist who lived in our neighborhood on Woodlawn, across the street from Joe Long. He was a Democrat and close to the Lyndon Johnson family. Today, he is remembered as well as the bane of 60s liberals, but especially of hippies—"dirty nothings" and "tree huggers," he called them.

Frank's legendary intransigence usually meant that no one could ever negotiate with Frank. For him, it was his way or no way at all. You also had to watch every word you said to him, because he had a sharp mind and could and would trip you up and make you look like a fool. Whenever I was around him, I was extremely cautious, weighing carefully every word I uttered.

This will come as a shock to those who remember him for his colorful newspaper quotes, but for years, Frank had pushed for a first class performance space for the university. He liked opera, but the administration of the university had never prioritized cultural activities.

Theater, dance, music, and art had always struggled for money and space at UT. But Frank had been steadily promoting his project for a

concert hall. At one meeting, he even showed me a mock-up of what he envisioned as the "University of Texas Performing Arts Center." Without Frank Erwin's intercession, the university would never have had such a facility on the campus. That view of mine is not widely known. Somehow, Frank Erwin found a way around the university's ban on renting space to outside organizations, and began to move ahead on a performing arts center at UT.

When we met for lunch at the Headliner's Club, he and I met in a small private room overlooking the city. Frank had also invited a vice-president of the university and the new director of the Performing Arts Center. The director was business manager of the San Antonio Symphony, until UT hired him to oversee the final planning and construction of the university's new Performing Arts Center.

Of the five people who accompanied Frank to that meeting, not one knew a thing in the world about music, except for the man from San Antonio and me. Because of the seclusion of our luncheon, I suspected our main topic was a serious one. Frank Erwin was legendary for what he could accomplish in small rooms, and whenever he had business to discuss, he wasted no time on pleasantries.

These were Frank Erwin's first words at that meeting: "I want the Austin Symphony Orchestra to perform in the new Performing Arts Center at UT."

When I heard Frank Erwin's bold statement, I nearly fell off my chair. We were having a terrible time at the old Palmer Auditorium. The symphony had been playing there for years and we had to use uncomfortable temporary seats that the city put on an elevated platform so our patrons could see the orchestra.

Those seats rattled and squeaked throughout every concert. We had to spend expensive union hours putting them up and taking them down for each performance. I think someone finally threw them in the lake, since they disappeared and we never found out what happened to them. Truly, I actually believe those awful seats were deliberately destroyed. Even though I did not do it, I certainly wanted to. Palmer was an absolutely miserable place for the symphony to play. The floor was concrete and the acoustics were God-awful.

Cactus Pryor, a popular Texas humorist, actor, and radio personality

said, "The acoustics were designed by an underwater acoustician. If you filled Palmer with water you could hear perfectly."

He was not exaggerating. That is the way it had been for years and we had learned to live with it. We had no idea things would ever change. When Frank Erwin suddenly invited the symphony to move into a permanent home in the university's brand new concert hall, I was bewildered, shocked, and thrilled. Even so, I tried hard not to show it, because knowing Frank as I did, there was a trap hidden somewhere within his generous and unexpected offer.

With some caution in my tone, I said, "That's absolutely wonderful."

Frank's philosophy in sharing the space with us was that a good concert hall would benefit the university students. "I want UT students to hear the symphony. If we have you there, it is going to work," he boldly declared.

Then he sprang his trap. "Of course, we'll have to charge you."

"Of course you will. There's no other way. We'll lease the space."

The other men, who actually knew nothing about symphonies or orchestra finances, said, "We know the symphony has money, so you can pay a lot of rent."

Thank goodness, the new director of the Performing Arts Center, who had been managing the symphony in San Antonio, spoke up, "That's not true. Symphonies never have any money. We will have to set a fee that will be workable."

That is how our symphony moved into the new Nancy and Perry Bass Concert Hall, named for the Fort Worth couple who had given $12 million to the university's general fund. Most people think the Basses made their donation specifically for a concert venue, but the money was simply a gift to the school. To show its appreciation, the university named the Performing Arts Center in their honor.

For years, even before the Palmer Auditorium venue, the symphony had played in Gregory Gymnasium on the UT campus. In the early forties, while I was a student, that is where I first heard the Austin Symphony. The university gym was the largest facility in town back then, but it smelled vaguely of sweat and Lysol and its acoustics were abominable.

When one legendary conductor—it might have been George Szell of the Cleveland Orchestra or Fritz Reiner of Chicago—conducted

a concert there, he swore an oath that he would never come back to Austin.

However, aside from Gregory, there was no other performance space available to the Austin Symphony until the city built Palmer Auditorium in 1959. Even with all its problems, Palmer was a lot better and more serviceable a concert venue than the basketball floor with its bleachers.

When Bass Hall opened at UT in 1981, for the first five years, the symphony was the only local performing arts group to appear there. Then the ballet got on its feet financially, hired professional dancers, and reorganized as "Ballet Austin." In the mid eighties, the ballet requested space at Bass and began to perform there. In 1987, Austin Lyric Opera presented its first performance in the hall.

Within a few years, all three of Austin's civic arts groups were using the university space. Naturally, the opera needed the stage well in advance of their performance dates, just to install their sets. The symphony did not have to worry about sets or a curtain, which made our transitions easier.

We had worked well with the first two managing directors of the Performing Arts Center. That cordiality disappeared after UT hired a new one from a California university. When she arrived, our former relationship changed immediately.

This new director informed her staff: "The first thing I'm going to do is get rid of the locals." She meant us. She did not want the ballet, symphony, or opera performing at Bass Hall. Fortunately for all of us, that brash goal took fifteen years for her to achieve. In fact, when she announced her retirement in spring 2007 — that was about the same time we performed our last concert there, just before Bass Hall closed for renovation.

The new director booked more Broadway touring companies and major-name recitals. "The Phantom of the Opera" tied up the hall for two months. While the production brought in record ticket sales for UT, its presence harmed our local groups financially.

The university is an event presenter. They book a production to perform at Bass Concert Hall. The company shows up and the hall is theirs for a set period. We local arts groups are producers, who create our own programs. The symphony usually holds five rehearsals before every concert, but only our dress rehearsal takes place on stage. We are also not

a full-time orchestra, playing about thirty nights at Bass and presenting our pops* program downtown at Palmer, where we offer table seating and encourage the audience to bring picnic suppers.

By the nineties, the ballet, symphony, and opera were having increasing difficulty booking programs at the UT Performing Arts Center. We often had to book our guests, especially the more prominent artists, as much as two years in advance, so we all needed to know precisely when we could access the Bass facility.

Furthermore, the university's rental fees increased yearly and UT never submitted our new lease to the symphony until well after our next season was already underway. Our annual rent was set by the university at a price they alone determined. We could not renegotiate it with UT at all. To sort things out, I talked with Peter Flawn, president of the University of Texas at the time, and told him, "We don't want to contract from year to year."

He said, "Don't worry. The university is not going to kick you out."

"Peter, I don't care what you say. I am not comfortable contracting year to year." I wanted a five- or ten-year lease. That would be typical, but the university would not extend our contract. We could not even get from them a set fee so we could plan accurately for our annual budget.

On top of scheduling around the two other Austin performing arts groups, plus an increasing number of Broadway road shows, we had another conflict that occurred every fall: UT football games. We never worried about losing our audience, because we draw a different crowd than the Longhorns football games. Our problem was parking, not audience competition. On football weekends, fans took over parking lots for miles around the campus, bringing their trailers, and holding tailgate parties.

Fortunately, our symphony never scheduled matinees. We performed in the evening on Fridays and Saturdays. When UT played early afternoon games, we had no problem. However, when a game was set for a late afternoon kickoff, then we were in trouble. Everything depended on when the game began, and since that is usually determined by a network

* "Pops" is short for popular, like the Boston Pops. They play popular music, such as swing or jazz, or Broadway show scores orchestrated for the symphony. The events are informal, and patrons generally bring a picnic supper.

television schedule, game time can and does change from week to week. We always know the dates of UT's games, but not always their starting times.

Since we could not plan ahead with any certainty, we learned to avoid home game weekends altogether. Instead of having a Saturday night concert we scheduled a Sunday night concert or a Thursday night concert, although those nights never drew as many people and we lost some revenue as a result.

The only other good-sized performing venue in Austin is the Paramount Theater. The symphony uses the Paramount for chamber concerts and for our Halloween children's program, but it is far too small for our regular concerts. There are only two dressing rooms, located under the stage, and almost no space in the wings. Behind the back curtain is a brick wall and a door leading to an alley.

Once, when I appeared at the Paramount in a satirical production of "The Austin Follies," I had the dubious privilege of changing my clothes out in that alley. As a result, I found out what is meant by the "glamour" of the theater.

Because, finally, our symphony's leadership had enough of dealing with so many factors beyond our control, in 1991, we began looking seriously for a permanent concert site. We wanted to regain control of our own schedule. Ever since the UT arts center opening in 1981, we had performed at Bass. Over time, the climate there was no longer as comfortable for us, and our symphony business manager, Ken Caswell, was even more concerned about that effect than I.

When we began considering another option, we soon realized that creating a home of our own would make an enormous difference to the future of the symphony. Most important, we would regain total control over our performance schedule.

First, we considered the old Palmer Auditorium, where we were holding our pops concerts. It was fine for pops, with table seating, and people eating and drinking, but not so appropriate for classical concerts.

However, Palmer had 250,000 square feet of space, which was plenty with which to work. We wondered if we could get a more or less permanent lease from the city, then renovate Palmer entirely in order to perform all of our concerts there. We intended our new center to be available to all three Austin performing arts organizations—symphony,

ballet, and opera—not just for the symphony. That approach made good sense logistically, because we all knew there was more strength in numbers.

To consider our options, I invited Jare Smith, president of Ballet Austin, and Jo Anne Christian, president of the Austin Lyric Opera, to lunch with me at the Headliners Club. In a few hours, we decided we would do everything we could to work together, and then jointly propose to the city that we lease Palmer Auditorium and convert it into a first class concert hall.

"The 3 Js": Jare Smith (left), president of Ballet Austin, Joanne Christian (right), president of the Austin Lyric Opera, and I (seated), president of the Austin Symphony

We enlisted the help of David Graeber, an outstanding Austin architect, largely responsible for the revival of Sixth Street, who was vitally concerned with developing downtown Austin. He thought our idea of renovating Palmer was wonderful and he offered us the services of two young architects in his firm, Stan Haas and Michael Guarino.

We all liked Palmer's excellent location and its ample space. However, at its inauguration, the auditorium complex was to be a combined performing arts center and convention center, an inefficient arrangement that did not work well for either function. While the three of us had a reasonable idea of the changes we would need to make to adapt Palmer to our needs, we also now had two talented young architects to assist us. We had no budget to pay them, but David Graeber agreed to keep them on his payroll.

Our architects first measured the building. Meantime, I managed to locate the complete set of building plans prepared by the original architects, Jessen and Jessen. Locating those blueprints was surprisingly easy. I simply went to the Austin History Center and asked if they had the plans. They did and the History Center let me make copies. Those plans were a big help because now our architects had all of the original construction data, including the electrical and plumbing layouts and locations.

Through the years, I have learned that if you just ask nicely for things you want and need, you will often be amazed what you will accomplish.

The more we investigated restoration, the more practical it appeared to be. Early in 1997, I arranged a meeting with Dr. Robert Berdahl, president of the University of Texas. The symphony business manager, Ken Caswell, and I had gone there on many occasions to talk to a vice president and bring up problems we were having with the Performing Arts Center. This was our most important meeting since the one where Frank Erwin had first invited us to perform at Bass Hall. While we certainly did not want to appear ungrateful, we needed President Berdahl to understand that all three local arts organizations were facing crucial logistical difficulties.

At our meeting, I told him, "We have to do something about our future needs and we must start thinking about it now."

He understood our situation and wrote us a letter, "To whom it may concern," stating that the university needed its theater space for UT

programs exclusively, consequently, we three Austin arts groups would be asked to leave Bass.

Several years later, we received a strong supporting argument for our renovation case. The City of Austin announced that UT's Bass Concert Hall no longer met city codes for handling fires and emergencies. From 2007 to 2008, Bass would close for renovation.

Immediately, we took President Berdahl's letter to the Austin city council. Armed with our statement from the president of the University of Texas, we could now prove to the city that our move to Palmer was necessary, so they must consider our request as legal.

At first, we received little support on the council. They were lukewarm about our plan and had other more pressing issues to consider. However, they did agree Palmer was costing the city about a million dollars a year for upkeep and salaries, while bringing in less than $750,000. Over time, that loss represented substantial missing revenue for the city. With some effort, we enlisted the support of Jesus Garza, the Austin city manager, who became a vital ally.

We proceeded to organize our ad hoc group as "Arts Center Stage," and began searching for a president, but could find no one willing to lead our combined effort. We realized none of us should lead the group because the symphony, ballet, and opera were equal participants in the new center. For months, we struggled in our quest, trying to choose the right person. Every time the three of us met around my dining room table, my houseman, Raul, made lemonade for us, which we sipped while discussing who we might enlist as our leader.

In August 1997, we formed the Greater Austin Performing Arts Center, later to be renamed "The Long Center," organized a board, and established ourselves as a legal non-profit organization. We had our name, but very little else. We had yet to raise any money, but soon, Jare, Jo Anne, and I had agreed on a concept for reaching out to the Austin community for our needed funds.

We began having lunch with editors, businessmen, and heads of boards and agencies, one at a time. We always reserved a prime table at the Headliner's Club, one where other diners could see us, but not overhear what we were discussing. Other guests had to pass our regular table as they left the club.

That strategy worked beautifully. We would sit there at Table 52

with some poor devil in full view of the movers and shakers of Austin. There he was, seated with three women who were explaining, ever-so-graciously of course, why we needed his support. We always walked our guests over to the window, pointing out the current building, while painting a rosy picture of what Palmer could become and what that future would mean for Austin.

It did not hurt our overall effort that the Headliner's location was the best property in Austin for our fund raising purposes, with its panoramic view of the city skyline and Lady Bird Lake. With no money, no board president, and no design as yet: we were totally dedicated to selling the grandest view we could muster of our dream venue.

We had a memorable lunch with Austin's newspaper arts critic, Michael Barnes. His initial reaction was, "The symphony needs to pay the musicians more."

I thought, "This man does not know one damn thing about financing a symphony."

He added his personal obituary, "The Palmer renovation will never work and the city doesn't need it."

After Barnes's rude put down, we asked for a meeting with the editorial board of the *Austin American-Statesman*. When they said, "We

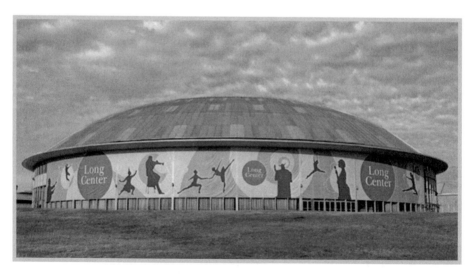

Palmer Auditorium at the beginning of its transformation to the Long Center

would like to ask Michael to attend," we responded, "That would be wonderful."

That was the day Mr. Barnes learned which way the wind was blowing. And that new knowledge caused him to change his mind about our plan.

In 2005, the Austin Critics Table Awards Committee voted me into the Austin Arts Hall of Fame. Michael Barnes made the introductory speech. "I have frequently disagreed with Jane Sibley, but now I know she was right. Other symphonies are folding and this one is not."

As I thanked him for his remarks later, I told him, "Michael, I would like to have a copy of your speech as I never thought I'd hear those words from your lips."

Soon, we encountered a new obstacle. In order to lease the Palmer property for our Greater Austin Performing Arts Center, the city council needed approval from the voters through a city-wide referendum. The council was legally required to put our plan to a vote, even though our group would pay to construct our non-profit performing arts center entirely with private funds.

From the very beginning, we decided we wanted no public money involved. We meant to avoid all the problems a bureaucracy can create. After the referendum was scheduled, we worked hard to get out the vote. Our proposal carried by a solid two-thirds majority.

One of our most valuable additions to the new board was Wayne Bell, whom we pursued over lunch. Wayne, as I have mentioned, is a restoration architect who knows construction, acoustics, and theatrical design. He taught at UT in the department of architecture and had worked with Miss Ima Hogg for years on her restoration projects.

Now retired from the university, Wayne was working with the state historical commission. He is a friend, an authority, who could advise us on what we should and should not do to adapt our old building to its new purpose.

Finally, in our lengthy search to find a president to head our new board, we visited with Ben Bentzin, an executive at Dell Computer, who was new to the board of Ballet Austin. Ben is six-foot-five, imposing in person and very smart. When we three women met with Ben in his office, he impressed all of us immediately. He seemed genuinely

excited about our project. As we left his office, we knew we had found our leader.

As soon as Ben accepted our invitation to become president, we got serious about building the rest of our board. Joe Long and Rusty Talley came on and brought a wide network of contacts. Jare, Jo Anne, and I were on the board from its beginning.

Getting Joe Long involved made all the difference. He was on the symphony board already and was my choice to succeed me as president in 1997. Twenty-five years was long enough for me, and I wanted to free up my time to concentrate on the new performing arts center. Joe is not only knowledgeable about music, he knows a broad range of useful people.

Joe Long began his career as a schoolteacher in South Texas, where he met his wife, Terry, who was also a teacher. They married and returned to the University of Texas, where Joe earned his law degree, while Terry completed her doctorate in education. After passing the bar, Joe practiced in the Texas attorney general's office, focusing on banking regulation.

After leaving the AG, Joe went into private practice and began buying banks, especially small ones that were struggling. One of the banks Joe acquired was Community National of Austin, whose president, Ben Morgan, gave the symphony our first line of credit in the beginning, when we needed one so badly. Over several decades, Joe ended up with a large number of banks, eventually selling all his holdings to Norwest.

In 2002, Joe became a Distinguished Alumnus of the University of Texas. His wife, Terry, received that honor herself in 2004. They give generously to the university's programs in Latin American studies and in the arts. Now Joe had joined the board of our struggling performing arts center. One day, we were sitting around the conference table talking about our dire financial situation. We had great plans, but no money. We wanted to move forward but needed the funds to do it.

I whispered to him, "Joe, you've got to give the center some money."

"I'm going to give some, *tomorrow.*"

I went home elated, wondering how much he would give. I said to D. J. "Do you think he might give a million? Or two million? Do you think there is a chance he might give five?"

The Longs gave twenty million dollars!

Teresa "Terry" Long and Joe Long, my special neighbors and good friends, shared my surprise eightieth birthday party, hosted by Hiram, Liz, and my grandchildren.

Theirs was one of the largest private gifts ever made in the state of Texas. Naturally, we wanted to name the center after the Longs, but Joe demurred. "I don't want that. . . ."

"It's going to be named something," I told him. "And it had better be named for you and Terry, since you are the ones who have made it possible. Having your names on it will help us raise even more money."

"But there are people who don't like me."

"That's true with everybody, Joe. Let us go ahead and do this."

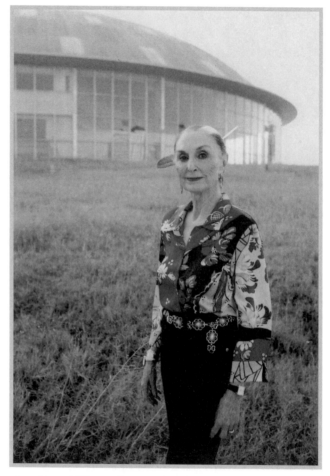

Jane Dunn Sibley at the Long Center

Eventually, we convinced him by naming the redesigned building the "Joe R. and Teresa Lozano Long Center for the Performing Arts." Wisely, Terry decided to include her maiden name, out of respect for her own heritage and in homage to the Mexican American community.

The Longs' gift made headlines. When the concept for the Long Center was made public, everybody started talking about it, pro and con. Sammy Allred, who co-hosted a morning radio show with Bob Cole, began attacking me on the air. I knew Bob Cole, who had been master of ceremonies for our Symphony Pops Concerts, and had emceed the

summer concerts at the Capitol. Sammy, his sidekick, was famous for his sarcasm and decided I made a good target.

He was championing a woman, coincidentally named Sammi, who held monthly craft shows at Palmer Auditorium. Among the many barbs he aimed my way, Sammy said I was an elitist snob who cared nothing for the common man and that it was immoral for us to dispossess his friend Sammi's craft show. I refused to listen to their radio show, because I realized such trivial talk could only have a minor impact on our efforts.

When some of my friends, Chuck Kalteyer, Debbie Kitchen, and one from Alpine, Lisa Pollard, felt Sammy was damaging our effort, they each called me. "Jane, you have to call Sammy and get him to stop."

To each of them, I always said, "I'm not going to put my head in the wolf's mouth. Let's just bide our time."

Sammy talked about me for months until he pretty much wore out the subject. Then opportunity knocked. I was attending the opening of "Red, White and Tuna," a new installment of the famous "Greater Tuna" plays of Joe Sears and Jaston Williams. A reception at the Driskill Hotel followed the opening. At the party, I spotted Bob Cole, a tall, nice-looking fellow.

"Is Sammy here?" I asked him casually.

When Bob said, "Yes. . . ." I detected more than a little apprehension in his tone.

"I want to meet him."

"You do? Uhhh, okay." Bob's eyes had that look of a deer in the headlights, and it was clear to me that he did not think my request was such a good idea.

After Bob called Sammy over, I smiled and extended my hand, "Hi, Sammy, I'm Jane Sibley."

For once, Sammy was speechless. I swear he was quaking; he managed to stutter a response, obviously embarrassed.

In my sweetest and most exaggerated Southern belle tone, I said, "I'm not mad at you. Now don't you say even one word. Your show is your business, so I know you have to make a living. I just want you to know that I do not hold any grudge against you: none whatsoever."

About that time, Robert Godwin, a photographer for the *West Austin News* came by.

"Robert, would you mind taking our picture, please?" That was when Robert captured Sammy and me standing together, cheek to cheek, grinning like we were the best of friends.

Later, I told Robert, "I want an eight by ten of that photo, in color." He sent it to me and I mailed it to Sammy inscribed "To my new best friend, Sammy. . . . Jane Sibley." That stopped his negative comments, once and for all.

On November 1, 2007, four months before the Long Center was scheduled to open, Sammy was fired by the radio station where he had worked for thirty-five years for cursing on his show. But not at me.

There was one sticky issue about naming the center after the Longs. The building already had a name: Palmer Auditorium. The city council had named it in honor of Lester Palmer, who served on the council in the fifties and was mayor from 1961 to 1967. We were concerned that he would want us to retain his name.

The Symphony left Bass Concert Hall at UT in April 2007, performing for a year at River Bend Church as an interim venue. On March 28, 2008, the Long Center held its grand opening, and the Symphony settled into its new home.

At the time, Lester Palmer was already into his nineties. Someone, but not I, from our group, spoke to Mr. Palmer's daughter. When she asked her daddy if we could transfer his name to the new exhibition hall that adjoined the performing arts center, he said he would be happy with that honor.

The architectural firms interested in working with us were amazed that our board knew so clearly what we wanted. Most boards begin a project of this scope having had no prior building experience. Not us. Our concept was as precise as mathematics. We knew what size stage we wanted, what size seats, and how many.

By the time we chose an architectural firm, there had been changes in leadership at all three member groups. Ken Caswell, the symphony business manager, had retired. We replaced Ken with Jim Reagan. Cookie Ruiz was the new executive director of Ballet Austin and Joe McCain was now executive director of the Austin Lyric Opera. Even

though there were new leaders in the arts organizations, we had retained a group of high caliber professionals who shared the same vision.

We invited fourteen architectural firms from across the country to make presentations. Ultimately, we picked Skidmore Owings Merrill from Chicago, because we liked what they had done in other cities. We were impressed with their background and by the depth of their experience.

Wayne Bell suggested we contract separately for an acoustician and theater designer, which kept control of those vital elements from resting solely with the architectural firm. That decision on our part turned out to be both extremely wise as well as far-sighted.

Ben Bentzin was a marvelous leader. He and Rusty Talley raised more than forty million dollars for the Long Center. They brought in major gifts one after another. *Bing. Bing. Bing.* Through Ben's fund-raising, the foundation of Michael (he founded Dell Computers) and Susan Dell, two of Austin's leading philanthropists, gave $10 million. The $20 million Joe Long has pledged will arrive in increments during the next few years.

By now, Jo Anne, Jare, and I had come to be known as "the 3 Js." In 1999, we three received the President Emeritus Award from the Downtown Austin Alliance for having the greatest impact on downtown Austin. I believe they gave it to us because we sat through all those lunches at the Headliner's Club, but more likely because we never ever gave up.

Things were going beautifully until 2001, when we hit a major snag. The stock market tumbled, the high tech industry took a terrible hit, and our local economy lost 20,000 jobs. On the one hand, I'm glad we cashed the Dell's checks when we did, but in truth, we had zero no-pays from our fund drive. Through that downturn, everyone who made a commitment paid up.

However, after the September 11 attack on the World Trade Center, charitable giving slowed to a trickle all across the country. We understood the financial situation, and we postponed asking for more money. The enthusiasm that fueled our early efforts had come to an abrupt halt. Instead of wasting our time and everybody else's, we put our fund raising on hold. We already had deposited almost $60 million, as well as holding a number of substantial pledges. For the next four years, that huge deposit would be drawing interest.

While we waited for economic conditions to improve, gradually they

did. In 2005, we hired a new executive director for the Long Center, Cliff Redd. Cliff helped us regain our fund raising momentum. Austin's economy picked up, the price of oil was rising, and we were able to raise money again.

When we were ready to move forward, we asked Skidmore Owings Merrill to revise their design, since it was now clear that we could no longer afford a $120-million complex. We postponed constructing a 750-seat theater and rehearsal hall that were part of the original design, and reduced the size of the center in response to our revised economic realities.

After Skidmore delivered their revised presentation, we saw they had made only a few changes, so it was obvious they were no longer interested in a project less grandiose than their original vision—a position not unknown among brilliant and strong-minded architects.

Next, we presented our newly trimmed-down concept to Stan Haas, who was working with us from the beginning. Stan had since formed his own architectural firm, Team Haas, headquartered in Austin. He made an excellent new presentation to the board.

We were so enthusiastic about his plan that we contracted directly with him instead of a large firm. In 2006, Team Haas was acquired by Nelson Partners of Austin, but Stan Haas remained our principal architect. We stayed with our original acoustician, Jaffe Holden & Associates from Connecticut, and with Fisher Dachs, our theatre design group from New York. We had followed Wayne Bell's sensible advice, making sure neither eastern sub-contractor was tied contractually to Skidmore, so we were able to retain their services after changing architects.

Our budget ended up at $67 million for the building; the city of Austin required us to set aside a $10-million endowment. The building cost $278 a square foot, about a third of most performing arts centers. We cut where we could and tightened our belt without sacrificing the quality or beauty of our building.

We even recycled many elements of the old auditorium, including 500 tons of steel, which otherwise we would have had to buy at great expense. We also reused much of the wood. We even recycled the dirt. In terms of environmental construction, we were ahead of our time, but we did not do any of those things only to be "green," we did them to save money, which proves to be one of the great benefits of "green" building.

By keeping the original stage house and elevating it from two to four

stories (fortunately, the original engineering was adequate to support that decision), we saved $4 million. We began construction in 2005, while continuing our fund-raising. Joe Long really did not want to start building until we had all the money, but ours was beginning to become an "old project."

Some people were even saying, "They will never build it."

We responded, "Yes, we will."

By late 2007, we had surpassed our financial goals. The construction budget was now paid for completely. Further, the endowment had exceeded $10 million and was growing. If we ever want to expand the center, we can add a theater and a rehearsal hall, which I think will happen eventually, as our city itself continues to grow.

From the very beginning, Jare, Jo Anne, and I had only two requirements: the best possible acoustics and plenty of ladies rooms so women would never have to stand in line. I am pleased to say both requirements have been met. We also wanted the seats to have plenty of legroom for our tall Texans. Ben Bentzin, with his large frame, actually tried out the seats to make sure they were comfortable enough for him.

People have no idea how much time and persistence it takes to bring a project like the Long Center from concept to reality. It has been a long road, with a number of detours, from our first conversation at the Headliner's Club in 1993 to opening night in 2008.

Our entire effort took no less than fifteen years: planning, pleading, cajoling, creating a board, working with the city, raising funds, and working with architects and builders. The best result of all our intense efforts is that Jare, Jo Anne, and I are still friends. Isn't that incredible? JoAnne lost her husband and I have lost mine as well as my daughter, so there have been many changes in our lives, but through it all? We three have remained friends.

On March 28, 2008, we took our seats on opening night in a magnificent concert hall designed specifically for symphony, ballet, and opera. The hall was christened with a piece of music that was specially commissioned, and modern, which was ironic for a mostly conservative audience that clings to old chestnuts, but of course they had to applaud. And applaud they did, at least for the venue—for at long last, we have a home of our own.

21

🦅

Jake

1950–1991

OUR FIRSTBORN SON had a name as expansive as his personality: Dunn Jacobi Sibley. Dunn was my family name and Jacobi was his grandfather Sibley's middle name. "Jake" was his nickname and it stuck.

If ever I was stranded on a desert island, I often told friends, I would want to be stuck there with Jake. He was competent in so many different areas: he thought things through logically and he demonstrated that quality from when he was a small child. At twelve, Jake called his grandmother long-distance—back when long distance was an extravagance—and asked for her ice cream recipe. She gave it to him over the phone. Once he had it, Jake went out and bought an old hand-crank ice cream freezer and made some of the best ice cream I have ever tasted.

When it came to taking the initiative, trying new things, and getting them done, Jake was amazing. He would think up all kinds of original projects and follow through with them. As a teenager, he got a ham radio and began talking with people all over the world, making friends on every continent but Antarctica.

He was also a natural marksman who hunted a good bit when he was young. One time he was shooting with a friend and he fired into the sky at a red-tailed hawk. At that exact moment, another hawk

Jake Sibley sees Jake Sibley, 1950.

flew directly above Jake's first target and Jake's bullet went through both birds. When they fell to the ground, Jake was astonished. At that moment, "two for the price of one" held a brand-new meaning to him.

Jake's interest in deer hunting gradually waned, but like many Texans do, he always kept a rifle on the gun rack of his pickup. At sixteen, he learned to fly, got his own plane, and flew back and forth to prep school in Arizona in his little putt-putt. He loved flying; I never worried about him because he was a cautious pilot—unfortunately, a trait that did not apply to the way he drove cars and motorcycles.

Jake was a true individualist who inherited his father's ability to look at the world dispassionately. Despite his intelligence, curiosity, and ingenuity, Jake was never able to fit himself into a structured academic environment. He attended some of the best private schools in Texas, including St. Thomas's in Houston as well as St. Andrew's and St. Stephen's in Austin. He became famous at St. Stephen's when he spotted a baby rattlesnake in the chapel and dispatched it swiftly with his boot heel. The poor little rattler was probably just trying to get converted.

After Jake ran out of "saints" schools, we enrolled him in Oxford Academy in New Jersey. That school promised to provide lots of individual attention to their students. The faculty was supposed to teach Jake how to study, but that never happened. His teachers pegged him as an underachiever and neglected to work with him individually. However, the faculty took the boys into New York City, where they ate lovely dinners, and went to the theater.

From that experience, Jake acquired beautiful manners, and he could discuss Broadway plays, but he never could manage to write a paper to fulfill his class assignment.

At Oxford, Jake had a roommate who regularly announced he was going to kill himself. Jake was happy to come home after a year there. Jake's next stop was the Orme School in Arizona, where our daughter Mahala had spent two years.

For his spring project, Jake rafted down the Colorado River through the gorges of the Grand Canyon into Lake Powell. Shortly before Jake's "river cruise," I had read an article in *National Geographic* showing in great detail the dangers of a raft trip through the white waters of the canyon.

I was sorry to have read about that, because I worried the whole time

he was on the river. Finally, he called me from a pay phone to announce that he had lived through the rapids. I wish cell phones had been around during Jake's adolescence. It would have saved me many a sleepless night.

Jake spoke eloquently, had excellent analytical skills, and could accomplish well almost anything he ever attempted. His Achilles heel remained his seeming inability to write. He was a voracious reader, but had difficulty expressing his thoughts on paper. He was terribly embarrassed about that.

He never discovered how to deal with his problem and neither did

Jake, a senior at Orme School, Humboldt, Arizona

we. Taking written tests was next to impossible for him. Sometimes, he would get up and walk out of class when they passed out the test papers. It is well nigh impossible to pass any course when you skip out on the exam.

In retrospect, I believe Jake may have had dyslexia or some other learning disability. During the sixties, teachers and psychologists too often failed to detect dyslexia and attention deficit disorder, which caused thousands of otherwise bright students to be mislabeled underachievers.

Leonardo da Vinci, Thomas Edison, and Pablo Picasso were all dyslexic and considered slow students by their traditionally trained teachers. I believe Jake would have done well in a Montessori school, but we did not have any in Austin when he was growing up. In the eighties, he helped start a Montessori school in Alpine, Texas, but never had an opportunity to attend one.

During his twenties, Jake went to a number of colleges. He attended St. Edwards University in Austin for a semester before transferring to Texas Western, now the University of Texas at El Paso. He earned a few credits at UTEP, but never stuck with his studies, eventually dropping out. After that, he moved to Alpine and worked on our ranch.

Later, Jake became interested in law enforcement and joined the Alpine police force. He took an EMS course to learn the life-saving skills he needed during his police work.

In June 1980, Jake married Mary Ann De Barbarie, who came from a prominent family that ranched south of Alpine at Cathedral Mountain, one of the most beautiful spots in Texas. Lawrence Haley, its original owner, never married. Instead, he left the ranch to his foreman, George Brown, who married and fathered seven children.

Mary Ann's mother was a Brown. Her name was Margaret, but everyone called her "T. D." She attended the University of Texas when I did. At UT, she was a Kappa, one of the best sororities on campus.

T. D. married Charles De Barbarie, a geologist. They were Roman Catholics who wanted a family desperately, but who were not able to have children. Through the church's adoption program, they went to New York and met two nuns who had come from Ireland with a beautiful little girl, not quite two years old.

Her name was Mary Ann and she was the answer to their prayers. They adopted her and brought her back to Texas, where she grew up

Jake at The Castle telling a tale during hunting season, 1978

on their Cathedral Mountain ranch with loving parents in the midst of scenic beauty to the horizon in every direction.

Jake and Mary Ann had known each other almost all their lives. They started dating in their mid-twenties and, after a few years, decided to marry. D. J. and I were crazy about Mary Ann and her family. She had gotten her degree at the University of Texas and was a bright, charming girl. She taught school for two years in Pecos, before moving to Alpine, where Jake was living.

Mary Ann and Jake planned their own wedding. They decided to have a small, private family wedding at her parent's ranch, to take place beneath a beautiful, ancient oak tree.

After I announced we would provide their rehearsal dinner at our ranch the night before the wedding, what started out to be a small affair, soon ended up with an invitation list of 110, because T. D. and I invited so many out-of-town guests. That dinner turned out to be one of the most famous, infamous, and unforgettable parties ever held at the ranch.

We invited everyone from both families to a gathering honoring Jake and Mary Ann on the day of the rehearsal dinner. Jane White, owner of the Bright Ranch, adjacent to where they filmed *Giant*, and her sister, Nancy, gave a lovely party for them. It took place in Marfa, at their grandmother's historic old home, decorated in 1920's style with original furniture, decorations, china, and silver.

One of the couples at our party was Judge Wilbur Hunt and his wife, Eugenia. Wilbur was a retired federal judge from Houston, who loved West Texas. His wife was an artist and they had a son, Granger, who suffered from asthma. Every summer, they went to the Cathedral Mountain Ranch, where Eugenia would paint and Granger could breathe good fresh air. They were driving back to Alpine from that luncheon in Marfa, when the judge got pulled over for speeding. When he looked out the window at the young highway patrol officer, the judge began laughing.

The patrolman did not know he was talking to a federal judge and had considerable trouble understanding what was so funny. He barked at Judge Hunt, "Stop laughing!"

The judge did. Although federal magistrates rarely get traffic tickets, Judge Hunt got one that day.

As we were heading back to our ranch after the Marfa luncheon, D. J. and I stopped in Alpine to pick up some lettuce I had ordered for our rehearsal dinner salad, since I was doing the cooking for the party. I had placed the order well ahead of time, because I wanted the lettuce to be fresh.

Our ranch is forty-two miles from the nearest grocery, so I always had to plan ahead.

When I got to the store they said, "We have the ninety-six heads of lettuce you ordered."

"I didn't order ninety-six heads of lettuce. I'm only having 110 people. Why would I want ninety-six heads of lettuce?"

"But you ordered them."

"I did not!"

Obviously, someone wrote down my order incorrectly. We nearly had a fight in the back room of the store, but I prevailed and we left with the number of lettuce heads I had ordered. I did not realize it then, but that confrontation was an omen of what lay ahead.

Why I decided to cook I will never know. I should have had the dinner catered, but for some inexplicable reason chose to do it myself. I relied on my maid from Fort Stockton, Sara Rosas, who had worked with me since my children were small. Sara had eleven surviving children from her nineteen pregnancies, so she was used to cooking for a crowd.

When D. J. and I arrived at the ranch, Sara came running down to meet me.

"Janie, Janie, we no got more rice!"

"What do you mean?"

"I cooked the rice. The Spanish rice."

"Sara, we are not having Spanish rice. We are having venison stroganoff with white rice."

That had been my intention, but Sara added spices and chili pepper and made five pounds of Spanish rice. Unintentionally, we served a new dish that night: Spanish rice stroganoff. I told myself not to worry about the rice. There were too many other things to do.

I had decorated the roof of The Castle so our guests could go up and share our spectacular view of mountains, sky, and stars. People also mingled around the pool where mariachis played all evening. I thought I had planned for every contingency, but was I sadly mistaken.

One of Jake's friends was a mathematical genius working at the Los Alamos NM atomic laboratory. He was a whiz at numbers but lacked more than a few social skills. Without informing us, he decided to bring his accordion.

If there is anything I cannot stand, it is accordion music. Needless to say, Jake's friend did not consult me about his addition to the evening's entertainment. He perched himself at the top of the stairs and played his accordion as guests arrived. Next, he began sashaying in and out of the

house and down to the pool. People must have thought we had flown in someone from the *Lawrence Welk Show*. Wherever I turned, there was that damnable accordion.

We had invited the conductor of the Austin Symphony, Akira Endo, who was Japanese. Since he did not know anyone, he offered to help me serve drinks.

Someone remarked to our lawyer, "Does Jane have a new houseman?"

He answered with a malicious grin, "Yes, and he's very expensive."

We entertained an eclectic mix of friends that night. Joe Henry Barton and his wife from Pecos were there. As a young African American, Joe Henry, had come to Fort Stockton from Liberty Hill to work for D. J.'s mother at the hotel, and we had always enjoyed his company. His wife's blonde wig was a fascinating and bold fashion statement.

I had chartered two buses from Monahans, to pick up our guests at their motel in Alpine. The buses were supposed to bring everyone to the ranch, returning them to the motel after the party ended. Each bus could carry forty-five passengers.

George and Margaret Griffin

Mary and Asher McComb had driven out from San Antonio, with their friends, Margaret and George Griffin, and the Griffins' son and daughter-in-law, Greg and Joan.

When Mary noticed one of the bus drivers looking at his fan belt with a worried expression, she said to Asher, "We are driving to the ranch in our own car." Mary could sense there was going to be trouble with the buses. Her intuition was right on target. Riding in their own automobile that night was one of the best decisions Mary ever made.

One bus broke down on the way to the ranch, causing everyone to pile into the second one. The refugees were packed like New York subway riders during rush hour.

Finally, everyone made it to the party, listened to accordion music and mariachis, drank many margaritas, ate Spanish rice and venison, and had a good time, despite their wretched bus ride.

Ours was such a lively group no one was going to let a little transportation difficulty bother us. Just as the party got going, our notorious West Texas wind came up with unusual force. That night, I swear it blew horizontally. Later, I told people, "All that lettuce I fought over in the afternoon headed south, dangling from every mesquite tree and cactus from our ranch to the border."

That was the damnedest wind I had ever experienced. Women were yelling, "Oh, my hair!" and dashing for the nearest mirror. I thought, "Honey, be grateful it stays on your head."

When it was time for everyone to go back to town, all the guests piled into the one functioning bus. Claytie Williams was there in a Scout SUV, so he volunteered to take Mary Ann's eighty-year-old aunt with him. Then he crammed as many others into his vehicle as he could. I think there were ten in there by the time Claytie left. He might have had to tie Mary Ann's elderly aunt to the Scout's roof rack.

We waved good-bye to our guests as they headed back to town. D. J and I realized that we had hosted a far more dramatic evening than we had planned. Little did we yet realize just how dramatic.

The surviving bus broke down after midnight on the highway twenty miles from Alpine, with the wind still blowing a gale. Everyone aboard was stranded in their finery on a pitch black West Texas highway that carried very little traffic that hour of the night. Finally, a pickup truck

stopped. It was towing an empty trailer, one that would usually be full of hay bales.

When the driver opened the pickup's passenger door, the wife of the federal judge said, "My husband *has* to ride," shoved him onto the front seat, before hopping onto his lap. They had grabbed the only seat in the cab, so the trailer was the only choice for the rest of the survivors.

When our lawyer's wife said, "I just don't know if I can do it."

Her husband said firmly, "Get in," and she did.

Off went a load of our elegant guests, riding in an open-air, hay-studded trailer.

The second bus was already double-loaded, so not all the bus folks could be accommodated in the trailer; a number had to stay behind, stranded beside the highway. Eventually, another pickup stopped and took them into town.

The Griffins' son, Greg, and his wife, Joan, were in that final load. By then, it was four o'clock in the morning. The Samaritan driving the truck was chewing tobacco. Every so often he spit out his window and a damp wad would fly past his passengers in the truck bed.

No one aboard ever said a single word. They were too grateful for the ride to complain about a little airborne tobacco spray. The last pickup reached Alpine about an hour before sun-up. When the young Griffins got back to the motel, they went to their parents' room, stretched across the bed, and the whole family died laughing at their travail.

D. J. and I went to bed knowing nothing about the awful time our guests were having. That was one time when not having a phone at the ranch was a real blessing. We would not have slept a wink if we had realized what they were going through. At the wedding the next night, all anyone could talk about was their adventure getting to and leaving from our ranch.

Dinner parties resounded with that tale for years to come.

Despite a memorable rehearsal dinner, a beautiful wedding, and a honeymoon trip to Europe on the QE II, Jake's marriage got off to a rocky start. After a year or two of working in Alpine, Jake got a better job with the Pecos, Texas, police force. Pecos is not the most exciting place in the world under the best of circumstances.

Jake's schedule was far from ideal, so Mary Ann was alone several

D.T. and Jane Sibley
honoring
Jake and Mary Ann Sibley
with
A West Texas Christmas

Thursday, December 25
The Driskill 1980

Supper and Dancing
Eight o'clock

Black tie and Boots

Invitation to the first Black Tie & Boots party, designed by Mahala Sibley

nights a week when he was on duty. Years later, Mary Ann said, "I'll never go to hell because I've lived in Pecos twice!" After three years, they drifted apart and their marriage was dissolved.

They had no children and parted amicably. Her mother and I discussed the situation and decided we would not let their divorce make any difference in our long friendship. Despite the divorce, our families have remained close and we are still very fond of Mary Ann.

Jake eventually went back to Alpine, continuing his work as a policeman and loving his job. After Jake decided to make a career of law enforcement, he became serious about finishing his education. He went to Sul Ross College in Alpine and earned his degree.

Jake was thirty-seven, but at last he had his diploma. By then, he was serving as deputy sheriff of Brewster County. Later that year, he married Jan Ponton—same name but unrelated to our useful friend at Continental Airlines. Jan was brought up in Alpine. Her mother, Beryl, and I also went to UT at the same time. Jan's father, Arvel, was a physician, and our families had been friends for years.

I had known Jan all her life. Jake and Jan were married on Christmas Eve, 1986. Mahala and her husband, Roger, were in Austin for the birth of their second child, who arrived on the 20th of December. Mahala and her baby had just arrived home from the hospital, so they were unable to attend Jake's ceremony.

The wedding took place at the First Presbyterian Church in San Antonio, where Jan's mother and father had married. It was a small service with only family members present, including Hiram and his new wife, Liz.

I thought Jan had made a mistake by holding their wedding in such a big church that would require a lot of decoration, but I was wrong. She knew what she was doing; the church was already decorated beautifully for Christmas and Jan did not have to buy one single flower. The church members had packed with poinsettias and it looked perfectly gorgeous.

I had told Jake and Jan that we would arrange their reception. I invited our old Fort Stockton gang, many of whom had moved to San Antonio, some of whom were survivors of the Great First Rehearsal Dinner Hay Ride.

The survivors were probably wondering what I had in store for them this time. I called the Argyle Club, talked with the manager, and let him

know what we wanted. One phone call and everything was set. The reception was beautiful, we saw old friends, and everyone had lots of fun.

Our grandchildren, Rachel and Shiloh, each about a year old, threw rose petals with abandon. A year later, Jake and Jan had a daughter, Sarah Elaine. Jake was absolutely wild about his child. Two years after that, they had another beautiful daughter, Elizabeth Victoria.

Jake enjoyed his work in Alpine. But, when some local businessmen asked him to run for sheriff, Jake turned them down. He was well aware of the tremendous increase in drug smuggling from across the border as well as the growing power and violence of the Mexican drug cartels. As much as he liked law enforcement, Jake felt that continuing his career might put his family at grave risk.

He told me, "As an officer, you only have an instant to make a choice about whether to use your weapon. That second can mean your life or death." The constant danger of his job began to bother him and he realized it was time to quit.

"Now that I have a wife and two children," he told me, "I don't want to stay in police work." Jake did not need to be in law enforcement. He had chosen the career because he liked the challenge and the opportunities he had to help people. During the months before his fatal accident, Jake was trying hard to decide what to do about his future.

The day Jake was killed he played golf with Hiram in the afternoon, then headed to a friend's ranch near Fort Davis for supper. Many law enforcement officers mistakenly believe the laws of physics do not apply to them. I am afraid that was true of Jake.

That evening, he was driving too fast, the highway was slick, and his pickup went off the road. His truck rolled over, ejecting Jake. He was not wearing his seatbelt. There is no way to know for certain what the outcome might have been if he had it fastened. Jake was killed almost instantly and never regained consciousness. He was forty-one.

At the time of Jake's accident, D. J. was recovering from serious surgery on his neck. He wore a device called a "halo," attached to four rigid steel rods that fit around his head and were screwed into D. J.'s skull to immobilize his neck and head. D. J. could not travel, and was confined to a hospital bed at home for several months.

The night of Jake's accident D. J. and I were having dinner in the bedroom. Hiram called to tell us Jake had been in an accident.

I said, "He'll be fine."

Hiram replied, "I'm afraid he won't be."

After a long pause, my first question was whether Sarah Elaine was with him. I knew he took that child everywhere and was afraid she had been in the truck. Elizabeth, his second daughter, was still a baby in her crib.

Hiram assured me the child was not with Jake. Hiram and Mahala had just left the hospital after closing Jake's beautiful blue eyes. As Mahala left Hiram's house that night, she paused to snap a photograph of Alpine at sunset. Later, she made a lovely tile plaque from the photo that hangs today in my dining room.

Someone called Sara Garnett, the Episcopal priest in Fort Stockton, and she called her cousin, Claytie Williams. Claytie called me immediately. "Jane, I can have a plane at your disposal. If you need to take Jake somewhere. . . ."

"It's too late for that."

"Then use the plane for whatever you need." Claytie's kindness made it possible for D. J. to attend Jake's service. We would never have gotten him to the ranch without that plane.

Hiram asked me, "Where do you want Jake buried?"

"At our ranch. Of course."

"I thought you'd say that."

After we talked about the location of Jake's gravesite, I said, "I want to be able to look out the east window that faces Sierra Madera and see Jake's grave. There's a beautiful little hill behind it."

"I know just where it is," Hiram said.

The spot was just below "Hiram's Heights," a group of hills we named for him since he loved them so much. He shares an affinity for that spot with some local panthers that regularly sleep among those rocks. Hiram headed to the ranch to begin the burial preparations.

Thanks to Claytie, we were able to bring D. J. to Alpine. Once there, the next question became how to get him to the ranch after leaving the state highway, over our unpaved, bumpy road to the ranch.

I called our neighbors in Alpine and asked them, "Can you persuade the county commissioner to grade that road in the next few days? D. J. cannot stand any jolting whatsoever."

When you have taken care of someone as long as I had taken care of

D. J., you just know what he can and cannot bear. That was how I knew D. J.'s neck and back could not withstand any bouncing or jostling. The halo was there to keep his neck rigid, but it was not meant to withstand a dirt road full of bumps and deep potholes.

I had no idea if our neighbors would be able to get our road graded, but instead fell back on what I have learned to do in all emergencies: I asked for what I needed.

I am still not sure how they managed it, or who did it, but someone must have been good friends with the county commissioner. That road was graded smooth, from the highway to the ranch, all accomplished during the next two days. The last stretch leading up to the ranch had been in such terrible shape that it took a blader to work that road so we could ride over it without injuring D. J.

Once we reached the ranch, I had a call from a young man who lived in the area. When Jake was deputy sheriff, he had responded to an accident in which one of this man's relatives was killed. He told me Jake had handled that situation so beautifully that it made all the difference in the world to his family. He said, "I'll do anything in the world for Jake. I have a welding business. Is there something we can do to help?"

He was exactly what we needed. "You can help us prepare Jake's gravesite."

He brought his jackhammer to the ranch and drilled through that limestone for hours. Because it is solid rock, he had to blast with dynamite to excavate a location for the grave.

Claytie then sent in his crew and they lined the cavity of this beautiful rock, the *"tomba"* as the Mexican workers called it. Twelve years later, Mahala was interred right above Jake. We could do no more blasting or we might have cracked The Castle walls.

Jake's headstone is a *tinaja,* a limestone rock with an oval shaped cavity about four inches deep that holds water after a rain. We found a perfect tinaja that we moved from a mesa to our Glass Mountain Ranch. I made a bronze plaque to fit into its cavity. After lying on that mesa for centuries, Jake's tinaja stands upright at the head of his grave.

In the years since Jake's death, we have had two more burials in that beautiful spot.

During the days following Jake's accident, I learned that we cannot undo anything. Life will not wait for us to adjust. We have to accept

Sarah (left) and Elizabeth (right) at the cairn of their father, my son Jake. The cairn is beside the Alpine-Fort Davis Highway, across from Mitre peak.

what is and move on. There were so many urgent matters we had to deal with immediately. Jake had two little girls who had lost their father and D. J.'s recovery from surgery was anything but assured.

I did not grieve in the usual sense of that word. Grieving seems to be an emotion I lack. During my early twenties, I had learned to deal with the realities of sickness and death when D. J. was in and out of the hospital. During three of the four years when we dating, I never knew for certain whether he would survive.

When my own father died suddenly, right in front of me, I was twenty-four. I realized early that life is unpredictable; that happiness and tragedy are mere seconds apart. No matter how secure you may think you are, there is no insulation from pain, sickness, and the loss of those you love.

In my more than fifty years of marriage, I had to remain strong to handle D. J.'s many accidents and his perilous health. I conditioned

myself to deal with whatever life handed me. It also occurs to me that I am descended from strong women. After my great-great-grandmother pulled a Comanche lance from her husband's body, she kept its point.

She, her daughter Mary Jane, granddaughter Alice Jane, and great-granddaughter Minnie Mahala, my own mother, endured hardships I can only imagine. Whether because I inherited some flinty gene from them, or whether at some level I feel bound to honor their heritage, I always face everything straight on.

I am aware of other couples who have lost a child, then given up on life altogether. I could never do that. Giving up is not in my nature, nor is it my way to honor the memory of a beloved child. I believe the best way to remember my children and my husband is to invest my time wisely. So I stay close to family and friends and I work on projects that make a difference to my community. If I occupy myself in a meaningful way, then I have little time to indulge in regrets or self-pity.

22

Mahala

1952-2003

MAHALA STARTED high school at St. Mary's in the Mountains in New Hampshire. The day we moved her into the dorm, her roommate informed us that she did not believe in God and she hated her mother. Those were just about her first words to us.

Well, that was also the moment when I thought to myself, "Oh, brother! We've sent Mahala a thousand miles from home to be with someone like that girl." We tried to get her a more compatible roommate, but the school authorities would not consider making a change for Mahala.

A family friend, who was a graduate of the school, had been very happy there. We had not considered that she came from the northeast and was ready-made to fit in with a student body made up of girls from that part of the country. Mahala was a Texas girl with different values and interests. She had traveled extensively, enjoyed wearing pretty clothes, and was more sophisticated socially than many of her schoolmates. Nevertheless, she did well academically and never let the Yankees intimidate her.

That fall, when D. J. came down with TB again, Mahala wanted to come home. She was not happy at the school, but she finished both semesters successfully, although we agreed she did not have to return the following year. I flew up to Boston to bring her home and rented a car to pick her up at the school. When we drove back to catch our plane, we had some time to kill. I noticed in the Boston paper that *Gone with the*

Wind was playing in town. I was in high school myself when the movie premiered in December 1939.

Watching *Gone with the Wind* in Boston was an odd experience. We were the only ones in the audience who laughed at the conversations between Scarlett and Prissy. The Bostonians completely missed the humor; it was just too Southern for them. As the Civil War dragged on, Atlanta burned, and there were so many deaths, that audience just sat there, dry-eyed. Mahala and I were crying our eyes out at the end of the movie, but we were the only ones shedding tears in that theater. Things may have changed somewhat in the last forty years, but in 1969, there was still an enormous cultural divide between Boston and Austin.

The following year, D. J. gradually regained his strength and Mahala was attending the Orme School in Arizona. A ranching family had established the school, because they wanted to educate their own children. At first, it was a one-room school north of Phoenix near the little town of Humboldt. Over time, Orme expanded into a highly respected private school. Mahala liked its western atmosphere much better than St. Mary's in the Mountains.

Orme wanted all its students to be a part of the world around them. For her spring project, Mahala lived on the Navajo reservation with an Indian family. Their house—a traditional Navajo house is called a *hogan*—had a dirt floor and the family water supply was from a hydrant outside.

The mother had TB and lived there with three generations of her family. Her husband had become a drunk and wandered off, leaving her and his children. At meal time, the family put a piece of unwashed oil cloth over the dirt floor and set a bowl of stew in the middle of it. Then, everyone dipped into the stew with tortillas. Mahala discovered she had to dip fast if she wanted to eat.

She ate with the family and drank water from the hydrant. She was very lucky not to contract tuberculosis. At night, she slept in a bedroll, waking every morning with curious Indians sitting on the sofa, staring at her strawberry blonde hair. They had never seen anything like it, but that did not keep them from giving her a hard time.

The Navajo children did their best to annoy, intimidate, and tease her. She held her own, telling them, "I'm part Indian, too. You can't bother me." Thank goodness she *was* part Indian, as she could easily

have been miserable. I wonder if she knew when she went out there how much Indians respect the ability to absorb a humorous barb and tease right back. Instead of being miserable, Mahala learned how some Indian families had to live, and she had a chance to experience personally what their daily lives were like.

Mahala spent two years at Orme and she did well academically, but decided to spend her senior year at home in Austin High School.

After she graduated from high school, Mahala attended the University of Texas and majored in art.

I told her, "If you study art you will learn to look more closely at everything around you and then you can enjoy life more fully." That had been my experience. When you consider the history of any civilization, what lasts through the ages is their art. Temples and palaces crumble. Political parties rise and fall. Philosophy can be distorted. Even history is revised. Only art is constant.

As a barometer of culture, I believe art is even more accurate than works of history. A lot of so-called histories should be re-classified as fiction. What we call "history" depends primarily on who wrote it. Too many authors reshape history to suit their own conceits. What is fact to one generation may not be true at all a few decades later. Art cannot be revised. *It simply is.*

In 1971, Mahala was invited to make her debut at the International Debutante Ball in New York. There are several organizations that present young ladies to society, and this was a favorite of many old New York families. The money raised by the ball went to support army and navy charities.

Mahala was invited through a friend of Grace Jones's who had many prominent connections in New York. Since Grace had no children, she always took delight in Mahala and the feeling was mutual. A few days before Mahala's debut, Grace and Jack Jones had a party for her at an east side restaurant called The Sign of the Dove. The management closed the restaurant to the public at ten o'clock when her guests began to arrive. All the debutantes and their parents were invited and a number of our friends from Austin came for the party and stayed for the ball.

When Mahala was going to her prep school in Arizona, one of her good friends was a charming young man named Lynn Brown. They

had not seen each other in at least five years and both were now in their twenties. As she was standing in line at the restaurant greeting her guests, along came Lynn. His maternal grandfather was a former president of Conoco Oil, who kept a penthouse on the top floor of the Waldorf, where the debutantes' families were staying. Those kids had the best time enjoying that penthouse.

"Communication is the best gift of all," a Christmas card designed and executed by Mahala in 1969. She loved West Texas telephone poles.

Mahala (right) seated at the Plaza Hotel dinner in New York City, appearing for her international debut. With Hal Bromm, her escort.

Lynn's other grandfather was an oil man in Oklahoma. He had moved his family to Texas to avoid state income taxes. They later moved to Montevideo, Uruguay, but their timing was unfortunate. Soon after they arrived, there was a revolution and the new government went after everybody with money, especially foreigners. So Lynn's father was stuck in Montevideo wearing a bulletproof vest, while we attended the ball.

Twenty debutantes were presented a few days after Christmas in the grand ballroom of the Waldorf-Astoria. One of the girls had been Bluebonnet Queen of Texas that year and later married a boy from a ranching family in Kerrville. She and Mahala were the only debutantes from Texas. Most of the girls were from the New York area.

In my opinion, which no doubt is a bit prejudiced, while the New York contingent was lovely, they could not compare to our Texas debs. When they were presented, our girls performed the "Texas dip," a deep bow at the end of which the girl's forehead touches the floor. It took months of practice, but made quite an impression on the audience.

Mahala's escort was Hal Bromm, who lived in New York, although his mother, Honey Bee Rooney, grew up with me in Fort Stockton. Hal was one of the best looking boys I ever saw. He owned an art gallery in New York City, and a few years later, Hal was unintentionally responsible for introducing Mahala to her future husband.

Although being a debutante in New York was a wonderful experience, it does not begin to compare with San Antonio's Fiesta. To become a visiting duchess, a young woman had to receive a special invitation from the Order of the Alamo, a prestigious men's organization in San Antonio. I had always hoped Mahala would be invited to Fiesta. This was one of the times when having a friend with influence made all the difference.

Governor Preston Smith had told me, "I need some good names for the Historical Commission."

I told him, "Jack Barretta is an obvious choice."

The governor promptly asked him to become a member.

Jack said, "Governor, I didn't vote for you."

Governor Smith replied, "That doesn't matter. I'm looking for good people who can do the job."

Jack was a perfect choice. He came from an old San Antonio family that had long been part of Texas history. His mother had donated money for the library at the Alamo and his wife, Mary Austin, was a descendant of Emily Austin Perry, sister of the founder of Anglo Texas, Stephen F. Austin. Mary had a remarkable Texana collection, including some of Austin's letters and personal effects. .

Jack was thrilled to be a member of the commission. Later, after D. J. and I hosted the commission at our ranch for a weekend, we drove Jack and Mary to Midland to catch their plane home. D. J. was driving and the Barrettas were sitting in back.

Out of the blue, Jack said, "I can't thank you enough for getting me on this commission, Jane. What can I do for you?"

Without missing a beat, I said, "Get our Mahala into Fiesta."

Mahala Sibley in her Bluebonnet Queen dress, which she wore when crowned by Governor Preston Smith at the Governor's Mansion in Austin

308

He said, "I will."

All right, I admit I was a bit pushy, but Jack did ask, and he was actually thrilled to be able to help. Jack's daughter had been Fiesta queen the year before, so he had considerable influence. A few months later, Mahala received her invitation.

Mahala was in Fiesta during the mid-seventies, and her experience was great fun for our whole family. Grace and Jack Jones came down to San Antonio to be with us for all the festivities, an entire week of parties, parades, and balls.

Fiesta is a Texas original and we were all thrilled for Mahala and our boys to be part of it. For Fiesta, Jake and Hiram traded in their blue jeans for tuxedos, and they both looked unusually elegant for an entire week. They could easily have been mistaken for British aristocracy until you heard their Texas accents.

Jake was Mahala's escort and by the time it was over, he said, "I've never been as tired in my life." Each princess wore a beautiful gown with an enormous, heavy train. Her job was to be charming, to walk gracefully, and never to trip over her dress. As a result, a duchess's poor, long-suffering escort had to fold up her train and carry it wherever they went. By the end of Fiesta Week, Jake was exhausted, but he told me it was well worth it to have been part of Fiesta.

After Mahala graduated from UT, she bought a little house in Austin, did some painting and began working in ceramics. Then Hal Bromm came back into our lives through one of the artists whose work was shown in his gallery.

An Englishman named Roger Cutforth did excellent work, including photographs, paintings, and drawings. Roger had a reputation as an outstanding fine arts photographer and one of his photos was the cover of *Art News*, considered a real coup.

Roger's work was so impressive that Roger received a grant from the National Endowment for the Arts to photograph the southwestern United States.

Before Roger left New York, Hal told him, "Be sure to look up the Sibleys when you go through Austin. When he and Mahala met, they were instantly attracted to each other. They went out together several times during the few days Roger was in Austin. Mahala fell for him as she never had for anyone else.

Mahala modeled her Fiesta presentation gown in 1974. Its design represented wandering minstrels. Many years ago, Fiesta began when Texas women wanted to forgive and to forget the Texan war for independence from Mexico. They decided to portray that wish symbolically by hosting a Battle of Flowers, which today has grown into a major celebration. Fiesta takes place annually in San Antonio around April 21, the day Texas declared its independence and became a republic. Today, Fiesta encompasses week long festivities.

310

Indian jewelry was introduced to Austin, and Mahala and I are wearing some of the finer pieces.

Roger was equally attracted to her, which was apparent to everyone who saw them together. After Roger headed west, Mahala soon joined him. Together, they traveled throughout West Texas, New Mexico, and Arizona. They camped, hiked, and really enjoyed being together. Roger took photographs, and fell in love simultaneously with West Texas and with our daughter.

Despite their obvious mutual attraction, Mahala could not have chosen a man whose values were more markedly different from those of her family. Roger is an English socialist who believes nobody should have a lot of money.

"Roger, who will buy your paintings if they cannot pay you for them?" I asked him that question once, after listening to one of his "poverty is better" sermons.

He shrugged, and replied, "I paint for art's sake."

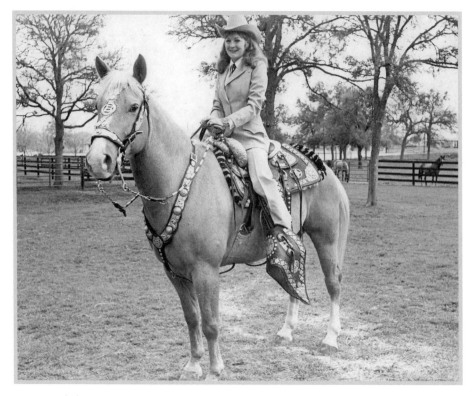

Mahala rode "Oro" down Congress Avenue, seated on a beautiful silver-mounted saddle. She was parade queen for the Austin Livestock Show and Rodeo.

He was the polar opposite of Mahala, who was practical, who understood financial matters, and who appreciated the opportunities that her family's resources had provided for her. She could "rough" it well enough, but she also enjoyed the finer things of life. I never quite understood how their particular chemistry worked. Maybe the old saying is true: opposites *do* attract. That was certainly the case with Roger and Mahala.

Eventually, Roger settled in Terlingua, a tiny village in an isolated area right on the Mexican border, seventy miles south of Alpine. If you ever wish to get as far away from civilization as possible, Terlingua is just the destination for you.

Mahala joined him there and within a few years, they had two little

girls. Shiloh was born in 1985, Kiowa in 1986. They had lived together for almost four years, and soon after Kiowa was born, they decided to marry. Shiloh was their flower girl.

Mahala and Roger were married quietly in the Episcopal Church we had helped found in Fort Stockton. Roger had been married before, but he had never bothered to acquire the necessary documents that would have allowed the bishop to permit him as a divorced person to be married by a priest of the Episcopal Church. Because of Roger's oversight, our dear friend, Father Sara, could not perform the ceremony without the bishop's permission. She could bless them and support them, but was unable to officiate at their ceremony.

They needed a minister to marry them, so Mahala engaged a Methodist preacher. They were at the church at the appointed time, but the minister did not show.

They waited for an hour, but he never appeared. Father Sara was determined that a wedding would take place that day so she took matters into her own hands. She pulled off her vestments, got into her car drove up and down Main Street in Fort Stockton, searching for an ordained minister, not caring at all whether he was Baptist or a Jehovah's Witness. If he was ordained and licensed, he could do the job.

At last, she spotted a local preacher who was just returning home from a vacation with his family.

She told him, "Follow me. You have some of the Lord's work to do." She took him to the church, he performed the ceremony, and Mahala and Roger were married at last. Thank goodness Father Sara was there to see them through their wedding. She is now in her nineties, retired, and living in Wisconsin, close to her niece.

The rest of the family could not be at the wedding because Mahala and Roger did not want any fuss made about their marriage. Mahala was afraid if she invited even a few people, it would turn into a big affair. Roger disliked any kind of ceremony so they only had two witnesses.

Because of his strong socialist political philosophy as well as his utter disdain for wealth, Roger prefers everything to be down to earth. That is why living in Terlingua suits him so well. Mahala and Roger bought twenty acres out in the country near Study Butte and had their trailer homes parked next to each other so they each could have a studio and some privacy.

Things went well for a while, but when Shiloh began to have convulsions in addition to the usual childhood illnesses. Mahala told her husband, "I can't live an hour's drive from the nearest doctor. My baby's health is too important."

Roger did not choose to leave, but Mahala moved to Alpine, where there was decent medical care. She bought a little house and Roger remained in his trailer in Study Butte.

One day, Roger was baking some bread in his gas stove. He lit the pilot and threw away the match, but it landed in a wastebasket, re-ignited, and burned down his entire trailer. He lost almost everything he owned, including paintings, photographs, slides, cameras, and clothes. In minutes, most of Roger's life's work was destroyed.

Somehow, the fire did not spread to Mahala's trailer, but it dealt a deep psychological blow to Roger. Within a few years after the fire, he stopped painting and doing photography. His personality became increasingly negative. Roger is extremely talented, as Mahala was, and I am sorry he stopped painting. He seems to have lost all his creative impulse.

Three generations at home in West Texas. Left to right, Jane, Minnie, and Mahala, seated on the sofa at the Grey Mule.

When Mahala decided to get a divorce, the judge asked her, "Do you want Roger to pay child support?"

She said, "No. He doesn't have the money and why should I burden him with it?" She gave him her half of the property, and I believe she felt free for the first time in a number of years.

Roger stayed on in Study Butte, living in Mahala's trailer until he built his own home. He did all the work himself and it turned out beautifully. Roger's home has a unique look and the colors are lovely. He is a typical Englishman, who loves gardening. Over time, he created the only English garden I have ever seen on the banks of the Rio Grande. Roger is quite thrifty and he enjoys the simple life and solitude he has found in Study Butte. The world does not touch him there, and he does not touch the world.

Mahala loved living in Alpine. She thought it was good place for the

Left to right, Mahala, Minnie, and Jane, in Fort Stockton, 1984.

Kiowa (left) and Shiloh playing dress-up

children to grow up. From pre-school through the fifth grade, they went to the Alpine Montessori elementary school. That school did not offer classes above fifth grade, so beginning in sixth grade her girls went to Alpine public schools. In 2000, Mahala moved to Austin, where Shiloh and Kiowa could have better academic opportunities.

The following year, Kiowa went off to Loomis Chaffey, a prep school in Connecticut, where her first day of high school was September 11, 2001, which must have been difficult. However, she liked the school and did well academically. Shiloh went to Austin High, the same school the Bush twins attended, although not at the same time. A large city high school with at least 2,000 students, it was a far cry from Alpine.

When Mahala came back to Austin, she moved back into her own house on Woodlawn, a few blocks from us. Unfortunately, she never got back into her own art work. An artist needs a studio, and although she had her kiln in Austin, she needed more space to do tile work.

Mahala had plans drawn to re-do her house and to add a studio, but had not started working on it. She also told me she was not interested

in marrying again. I think she was thoroughly fed up with marriage. Mahala wanted no one to interfere with her life and no one did. She had always liked spending time alone. Even as a child, she would sometimes sit in her closet and read for hours.

One morning, very early, Shiloh banged on our door, screaming and hysterical. "Mom's dead! Mom's dead!"

Mahala had died during the night. That morning, when Shiloh arrived for breakfast, she found her mother lying on the floor. There was no way to determine the exact time of Mahala's death. The police came, and I called a physician friend to come over.

The medical examiner told me, "There will have to be an autopsy."

I said, "I want one."

The autopsy showed that Mahala had died from a spontaneous hemorrhage of her brain stem.

Mahala's doctor explained to me, "That is not unusual for women her age."

There is no way to predict that event and anyone who survives often spends the rest of their life in bed, totally unaware of their surroundings. There are some things that are worse than death, and at least the Lord spared Mahala that fate. She was gone in a second. Mahala was fifty-two; she had been back in Austin for three years when she died.

One of Mahala's favorite plants was the maguey. Its bloom stalk can reach ten feet high and it displays yellow blossoms on the tips of its branches. We commissioned a copper maguey grave marker for Mahala. Designed and crafted by Gary Thompson, her marker has been mounted on Bisset Rocks, from the same geological formation that forms Paisley Hills, close by the same beautiful spot where Jake rests.

My daughter lived in Alpine for almost fifteen years. Across from her house, she owned a building where she had established a studio. She did a lot of work while living in Alpine. After she died, her trust moved all her possessions, including her art work, to the Bank of America in Austin. The bank looks after her property as well as her assets. Besides her own work, Mahala owned an extensive art collection.

When people ask me how I was able to handle Mahala's death so soon after Jake's, I do not have a good answer, except that I do believe I can accept the realities of life. Simply put, I really had no time to feel sorry for myself, because I had to concentrate on helping Mahala's girls.

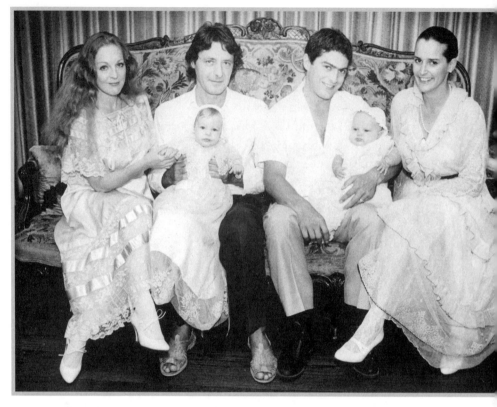

(Left to right) Mahala, Roger (holding Shiloh), Hiram (holding Rachel), and Liz in Jane and D. J.'s living room in Austin at the Ice Cream Social honoring our first two granddaughters

Kiowa was not yet sixteen when her mother died, so she went to live with her father for her junior year, attending school in Terlingua. When she turned sixteen, she went back to Loomis Chaffey in Connecticut for her senior year. She did quite well there.

When Kiowa studied Spanish before spending a semester in Barcelona, Shiloh went to Spain, too, and spent time with her. After graduating from prep school, Kiowa went to Sul Ross for her first year of college, posting a 4.0 average. In spring 2007, she transferred to Texas Tech in Lubbock to study architecture. In December 2010, she was graduated from Tech, moving on to begin graduate school at Houston's Rice University in fall 2011.

Shiloh, after conquering some difficulties, displays her diploma.

Because Shiloh was only a junior in high school when her mother died, Mahala's death was terribly hard on her. Afterward, Shiloh had trouble concentrating in school, so her principal suggested she take some time off. After a few tough years, but with time, counseling, and her own will power, Shiloh has since come a long way.

In 2006, she passed her GED, and began her first semester of college. Shiloh inherited a long bloodline of survivors, so I am convinced she will be fine. She plans to move to Houston with Kiowa and will be attending art school there.

23

Hiram

1957–

WHEN HIRAM WAS only six months old, D. J. became chair of a committee of the Texas Medical Society. They had a big meeting in Dallas and he wanted me to go with him. I was still nursing Hiram, so we took him and our maid with us, leaving Jake and Mahala in the care of their grandmothers back home in Fort Stockton.

Hiram was a stunning baby. I realize every mother thinks her baby is beautiful, but Hiram stopped traffic in the aisles of Neiman-Marcus. That weekend in Dallas, he was wearing a white piqué double-breasted coat, a matching cap with a tiny bill, white shoes, and socks. I wanted to go to Neiman's, so I brought along Eudelia, our maid, who was overwhelmed by the store.

She had never seen anything like Neiman-Marcus. Her eyes widened and she said, "Oh, Janie!" I noticed a definite Christmas morning expression on Eudelia's face.

The clerks at Neiman's thought Hiram was a little prince. As we were leaving the store, Charles Laughton, the well-known British actor who often played villains in the movies, walked all the way across the lobby to see my handsome baby. He admired Hiram extravagantly and talked to him for several minutes.

I was shocked at how charming Laughton was. This distinguished actor was such a far cry from the characters he often played. He was warm and pleasant in person and could not get over Hiram. Our youngest son had that effect on people.

When we returned to our room at the Baker Hotel and took off

Hiram's white cap, there was a big red bump—a pox. He had come down with chicken pox, which destroyed the myth that a nursing baby will carry its mother's immunity to the disease. I had chicken pox as a child, but that did not stop Hiram from getting it. He was unable to appear in public for several weeks while covered with chicken pox, but he did have that single moment of perfect glory at Neiman-Marcus, fawned over by Charles Laughton.

Hiram appreciated elegance at an early age. When we were living in Houston, he was only four, but loved to go to lunch with me at Sakowitz on the day of their weekly fashion show. He was smitten by a beautiful model and made his feelings clear to her and everyone else. When she walked out on the runway, his eyes lit up.

Hiram had a taste for beauty very early. The model he admired was sweet and she smiled and waved to him as she passed. We went to the fashion show almost every week, and there and then, Hiram became a four-year-old stage door Johnny.

When we moved to Austin a year later, Hiram went to St. Andrew's, a private school with an excellent reputation. He had a hard time there because every day after lunch he developed a terrible headache. His teachers were completely unsympathetic. They thought he was faking, as some students have been known to do.

Since Hiram got a headache every day at exactly the same time, right after he had eaten lunch, the faculty should have taken his problem more seriously. Instead of trying to find the cause of Hiram's headaches, they told us he was going to fail third grade and would have to repeat the class the following year. He should also visit a psychiatrist.

At that time, D. J. and I had planned a trip to England. Since Hiram was getting no support from his school, we told him he could come with us, but under certain conditions. We told him there would be no hamburgers or Cokes on the trip and warned him we would be spending a lot of time in castles and museums.

Surprising us, he said, "I'd love to go to castles and museums."

I think he would have been happy to go anywhere to get out of that school. We took Hiram with us and he lived up to his promises. He had a wonderful time, displayed a natural curiosity, and turned out to be a great traveler.

In London, Hiram was in his element. He wore a beautiful camel's

Hiram (left) and Socorro (right), the caporal of our workers, taking care of a young deer trapped by accident in a wire fence in the Glass Mountains

hair overcoat, and when we walked into a restaurant for lunch or dinner, the waiter would always say to Hiram, "Your coat, m'lord." As you might imagine, Hiram loved the attention, but he handled it graciously.

When Hiram looked at the large restaurant menus, he saw a lot of words he could not read. Sometimes, the menu was larger then he was. Even so, it took him no time at all to become accustomed to the joys of posh restaurants.

To help him read the menu, he would motion for a waiter to come over to our table. The waiter went through each item and explained the various selections. Only after the instruction ended would Hiram order his meal. He loved everything about hotels, restaurants, and the rituals of travel. Even at his youthful age, he was open to new experiences, learning more on that trip than he had in a year at school.

We had a driver who took Hiram to the zoo in Regent's Park on several occasions when we thought he needed some respite from us. But

at no time during our trip to England did Hiram ever complain about anything. That trip turned him into a great traveler.

Even now, I love to go places with him, only partly because he always seems to know how to get things done. Even as a child, he could catch a taxi in New York City. At airports, he got our luggage off the carousel when nobody else could. He would slide between the legs of the travelers in front of us if he had to.

Before we left London, we met Lord Bromley-Davenport, who invited us to spend a weekend at his family's manor. We drove to Capesthorne, near Manchester, and stayed at our host's magnificent country home, which was hundreds of years old. For generations, members of that family had been art collectors, and they had acquired an array of magnificent Italian paintings.

Until World War II, they also owned a Giotto altarpiece, but as the family finances fell on hard times, they had to sell paintings and etchings from their reserve collection. They sold the Giotto during the war, when they were desperate for funds to pay the higher war taxes.

Their home was filled with treasures of every imaginable sort. In their living room was an oriental rug twenty-five feet long. The dining room table seated twenty. They even had a bedroom set aside for Her Majesty, with her monogram on the headboard, and linens embroidered "ER II."

The family also had a 4,000-piece set of china. No, that is not a misprint: *four thousand pieces.* That china had a long-distance history. Produced originally in England, the family dishes were shipped to China to be hand-painted. After decoration, the china went back to England. After four centuries of nearly constant use, the family had broken only a few hundred pieces. I am pleased to say that neither Hiram nor his parents added any pieces to that breakage history.

While D. J. and I admired the art collection, Hiram accompanied the Italian houseman, toured the entire house, and had the time of his life. He particularly liked the basement since it contained a full collection of armor that had been worn by knights when they rode into battle.

On that trip, Hiram also learned about the charms of room service, a delightful amenity he appreciates to this day. If heaven does not have room service, Hiram may check out. After his trip to England, my youngest son had become a confirmed globetrotter, and no one does it with more style than he demonstrates.

After we returned home, Hiram went back to school, where he once again began suffering from post-lunch headaches again. When some doctors thought he was experiencing an emotional issue and wanted him to see a psychiatrist, I took him to see an allergist.

"Hiram, tell me," the allergist asked him, "Has there ever been a time when you did not have headaches after you ate something?"

"I didn't have any in England."

That moment of insight came when we realized his diet was causing Hiram's problem headaches. He drank milk on our trip without a problem. But it turned out he was allergic to the milk served at his school. Most likely, some chemicals in the feed of the dairy cows that supplied his school's milk had caused Hiram's headaches.

Once Hiram stopped drinking that milk, he was fine. Nevertheless, St. Andrew's failed him, so we sent him to Matthews Elementary School. Unlike some children, Hiram left private school, went to a public school, and he did just fine.

In 1967, when D. J. was president of the English Speaking Union in Austin, the US State Department asked us to entertain the Lord Mayor of London, who was arriving in Austin with his wife and his batman. Of course, the Lord Mayor's batman had nothing at all to do with the comic book character. Instead, he took care of details, making certain that life ran smoothly for the Lord Mayor.

We were getting ready to go to the airport to meet the Lord Mayor when Hiram announced he wanted to go with us, bringing his friend, Brian.

I said, "All right, Brian, you hurry on home and put on your best suit, then get back here as quick as you can." In half an hour, Brian walked in looking as if he was going to a wedding. Both boys were about ten then, and they were all slicked up.

Before we went out on the tarmac to greet our guests from London, we met the mayor of Austin and his wife, Harry and Leila Jane Aiken. Harry had begun the Night Hawk restaurants, which were popular for many years. I introduced the boys to the mayor, first Hiram and then Brian. As Brian shook his hand, I saw the mayor suddenly change expression. Brian had been chewing gum. He did not want to greet the mayor with chewing gum in his mouth so he had put it into his hand. Unfortunately, he chose his right hand and that got him into a sticky situation.

I was grateful the chewing gum incident happened with our own mayor and not the fancy Lord Mayor of London. When he got off the plane, he had his ceremonial gold chains around his neck. He looked every bit as elegant as you would expect, and his arrival caused quite a scene at the Austin Airport. Hiram loved all that pomp and circumstance.

When D. J. came down with TB again in 1968, we sent Hiram to Allen Academy, a boarding school near College Station, with a long history

I love this poem, "The Fall of the Alamo." Our son Hiram wrote it around his tenth birthday.

in Texas. Sam Houston had sent his son there. Hiram was eleven, and that was the first time he ever played on a school athletic team.

A natural athlete, Hiram was especially good at playing football, and he also excelled on the racquetball court. What distinguished him from most other boys with his level of athletic ability was his personal motivation for playing sports. He was athletic, but not competitive. Hiram liked sports for the pure joy of playing, but he never had the intense competitive streak drilled into most American boys by the time they leave grade school.

Hiram never had that obsession to win at all costs, and I admire him for that. He also came away from Allen Academy with a medal for neatness, which, knowing him as I did, I found rather stunning.

In the summer before his ninth grade, we were in Connecticut, looking at prep schools for Hiram, when we toured the Choate campus one morning. We planned to visit another school in the afternoon, but a friend of Mahala's had invited the children to go swimming in the pool at the Greenwich Country Club. They had such a terrific time swimming that Hiram informed me he would be happy to go to Choate. That is how he decided to attend one of the top schools in America.

After tenth grade, Hiram went to Spain for the summer to make up a Spanish credit he lacked. Franco was still alive, and it was a fascinating time to be living in Madrid with a Spanish family. Hiram learned a lot of Spanish and had a great experience there, but never followed up to get credit for the missing course.

Two of his best friends from Choate, Johnny Collett and Jesse Steindler, were leaving Connecticut to go to the Colorado Rocky Mountain School in Carbondale, Colorado. As a result, Hiram chose not to return to Choate, but first, he attended Austin High School for about two weeks. However, soon he felt the academics at AHS were "a joke," so he bought himself a purple MG, drove to Colorado Rocky Mountain School, and lived in a dorm there without enrolling.

After a few weeks, he asked the school administration if he could enroll, but by then, he was too late. His experience there made such a positive impression on him that, years later, both of his children attended the school.

The following summer, Hiram went to Cholula, Mexico, with Mahala.

There, he attended the University of the Americas, because they allowed him to enroll without a high school diploma.

After that, he came back to Texas, got his GED, and attended St. Edward's University, the University of Texas, and Sul Ross. While he never formally graduated from college, Hiram remains a "student of life," with a sharp intellect and an eclectic taste in literature.

For a while, I worried about Hiram's not finishing college, but when I talked to D. J. about that, he said, "Just let him feel his way along."

D. J. always had a hands-off attitude about our children's education,

Jake (left) and Hiram at our Glass Mountain Ranch

and did not offer them much direction. "They will work things out, and everything will be all right."

I believe that attitude of his may have been shaped by the heavy-handed control his own parents exercised over D. J. as a child. After he became a parent, he chose exactly the opposite approach. I am sure Hiram feels that he never had much guidance about his academic life, and he is right. But once he became a parent himself, the pendulum swung in the opposite direction, and he and Liz took an active role in their children's education.

Hiram's life changed dramatically when he met Liz Fahey. Her father had been killed in Vietnam in the early days of the war. Her mother, Anne, is English, so the family went back to England, eventually moving on to Capetown, South Africa.

There were four Fahey children: three girls and a boy. It was difficult for Anne to work and all on her own rear at the same time her four children. When Liz was thirteen, she came to Houston to live with her father's sister, so Liz could get to know her deceased father's family, as she and her siblings are the only grandchildren.

A year later, the rest of her family followed her to Texas. Liz attended St. John's, an outstanding Houston private school, and she liked Texas immediately. Furthermore, the girls at St. John's liked her, too, and soon Liz was meeting some of the wealthiest kids in River Oaks.

Many years later, I asked her, "Liz, how did you do that?"

She told me, "I think their mothers liked my English accent." Liz did well in Houston, got good grades, and made life-long friends. After graduating from high school, she went on to the University of Texas.

Liz met Hiram at the Symphony Ball, a gala that raises money for the symphony and is one of the highlights of Austin's social season. Even though Hiram was escorting Curry Glassell, one of Liz's friends from Houston, he and Liz hit it off immediately.

As soon as I met Liz, I knew Hiram had found someone with depth and grace. For a while, they dated pretty steadily, but to my considerable dismay, they broke up. However, I never said a word about that, because I well knew that a mother's approval of a girlfriend can be the kiss of death.

Hiram moved back to Alpine, living at our ranch, and commuting to Alpine to attend Sul Ross, until he moved into a little trailer house on the south side of town.

A few years later, I picked up the Austin paper and saw Liz's picture on the front page. She and Pam Lewis, a friend from Houston, had gone to the Paramount Theater and parked their car on the hill near St. David's Church. As they left the Paramount and walked up Ninth Street, a young man jumped them and held a knife to Pam's throat.

Liz's instant reaction was to swing her purse at him. She swung it with so much force that both her friend and her attacker both hit the ground. The girls started yelling "Police! Help! Help!" and, for once, by great good fortune, an officer was nearby and heard them.

The attacker took off, but the police cornered him at the Brazos Street entrance to the Driskill Hotel.

With amazing gall, the mugger declared, "Officers, stop those girls. They are trying to kill me!" Fortunately, the police were not fooled. Liz's courageous instinct just may have saved her friend's life.

After I called Hiram and read him the article. I could almost see the smile on his face as he said, "That's my Lizzie."

Not long after that, he called Liz and they got back together. Shortly after Liz received her degree in French and international business from UT she moved to Alpine and joined Hiram. About a year later, they had decided to marry.

In the meantime, Liz's mother had finished rearing her other children and moved to the Virgin Islands. While living there, she met Roger Currier, who had worked for the US State Department. Anne and Roger married not long before Hiram and Liz said their own vows. As a result, the wedding invitation read: *Mr. and Mrs. Roger Currier cordially invite you to the wedding of her daughter Elizabeth Jane Fahey to Hiram Andrew Sibley.* Hiram's middle name, Andrew, honored D. J.'s uncle, whose own generosity had made it possible for his younger brother, D. J.'s father, to go to college.

Liz and Hiram's wedding was to take place at St. David's, the large Episcopal church in downtown Austin, near where Liz and her friend were attacked.

I told Anne, "Since the wedding will be in Austin and most of the guests will be our friends, please let us play the role of the bride's parents and you play the role of the groom's parents. If you will handle the rehearsal dinner, we will take care of the wedding." That arrangement worked out well for both families.

The church was filled to capacity with family and friends from all over Texas. Mahala was a bridesmaid and Jake was best man. The service was lovely, and the reception followed in the elegant ballroom of the Driskill Hotel. It was black tie and boots, like Jake's first wedding reception. Several hundred guests joined a grand march to the music of "Yellow Rose of Texas," enjoyed Mexican food, and danced to the music of Beto y Los Fairlanes.

There were ice carvings on the mezzanine and hundreds of *papeles picados* hanging across the ceiling. Almost thirty years later, people are still talking about that party. Not long ago, a friend told me she thought it was one of the most spectacular weddings she had ever attended.

For their honeymoon, Hiram and Liz took a first class, three-month "East-West" trip around the world on Pan American, one of the great old airlines that no longer exist. Hiram had ninety days to demonstrate his skills as a sophisticated traveler to his new wife. After circling the globe, Liz and Hiram came back to create a full life for themselves in Alpine.

They built a passive solar adobe home on a hilltop right outside Alpine, doing much of the work themselves. Hiram's talented architect friend, Logan Wagner, helped design their house. They brought in Alfredo Avila from Mexico, a well-known *bovadero*—dome builder—to construct six domes forming the roof. A *bovada* is a circular dome above a square room, a detail often seen in churches in Mexico.

In 2006, Hiram added a mile-and-a-half-long concrete driveway from the road to his house. If you had ever driven it unpaved, you would realize at once why he had it paved. Despite the length of that road-building project, Hiram did not hire a crew, but paved it himself with a single helper.

He can build almost anything. Hiram also has a great love for the outdoors and is an avid hiker and camper. Besides his other activities, Hiram keeps a watchful eye on our ranches, even though all of them now are leased to tenants.

Liz is bright, energetic, and super organized. She is good at whatever she attempts, whether cooking, exercising, using her computer, or arranging events for friends and family. They have two children: Rachel is the elder, and Christopher came along three years later on *Diez y seis de Septiembre*, Mexican Independence Day.

Hiram and Liz, with Mahala and Jake, founded the Montessori School in Alpine, where Liz served as volunteer administrator for ten years, while Hiram worked as volunteer carpenter, electrician, and plumber. They have been deeply involved in every aspect of their children's lives. Their years of effort with the Alpine Montessori School helped provide all six of our grandchildren with an excellent foundation for learning.

In recent years, Liz and Hiram have been dividing their time between Alpine and Austin. I enjoy having them close by and hope they will continue to spend more time in Austin. Hiram and Liz have been married almost twenty-five years. They share and enjoy one of the happiest marriages I know.

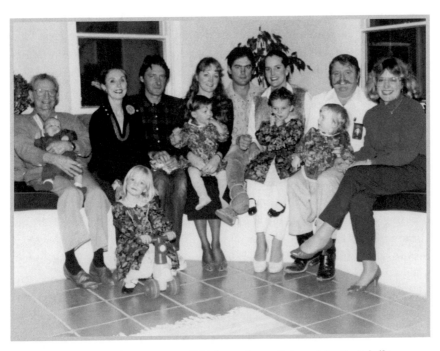

Here is our entire family at Hiram and Liz's new house. Left to right: D. J. holding Christopher, me behind Shiloh on her scooter, Roger, Mahala holding Kiowa, Hiram, Liz holding Rachel, Jake holding Sarah, and Jan. Our only missing grandchild that day was Jake and Jan's daughter, Elizabeth, who was not born yet.

24

D. J.

THE GREAT SURVIVOR

I BELIEVE a person should marry someone interesting. Physical attraction is important, but it is not what sustains a relationship. The qualities that last a lifetime are intelligence, a passion for learning, and mutual interests. D. J. was knowledgeable and active in so many fields. He was interested in archeology, art, ecology, geology, history, languages, and philosophy. He played the piano, and he served heroically in World War II when he received the Bronze Star medal.

He was a working rancher, a medical research scientist, a world traveler, and an excellent conversationalist. D. J. was many things, but boring was never one of them. Life with him was never dull. Of all the people I have ever met, the person I admire most is D. J.

My husband was born in 1913, one year before the outbreak of World War I, and he lived until 2005, only a few months shy of his ninety-second birthday. He had a long, rich, productive life, full and running over. He survived two near-fatal bouts with TB, three years of intense combat in World War II, hepatitis, and more broken bones than most rodeo cowboys endure. Through it all, D. J. lived a charmed life, and I will take some credit for helping him make it into his tenth decade.

Bedrails Are Not Just for Kids

One night we were resting peacefully in our bunks at the ranch when D. J., who must have been in a deep sleep, rolled over suddenly, falling six feet from the top bunk onto the tile floor below. That accident nearly

D. J. wearing his Glass Mountain bobcat vest

killed him, and it was our own fault. At the time, we had no railings on those bunks. We had always intended to install them, but had not gotten around to doing that.

After he fell, the sound of his landing was terrifying. At first, I thought one of the towers of The Castle was breaking apart. Then I looked down to see D. J. lying on the floor beside my bunk, bleeding and unconscious. I was not sure yet what had happened, but knew I had to act quickly.

First, I was afraid he might choke to death, so I opened his mouth to make sure he was not trying to swallow his tongue. I had seen that

done in the movies, so I did it, too. He was out cold, but next I found his pulse and checked for his heart beat. Only then, after I felt it beating, did I holler for help. Immediately, two of our Mexican workers came running. After I dressed quickly, the three of us made a packsaddle so we could move D. J. down the stairs.

Very carefully, we placed D. J. in the back seat of my car, even that small motion was terribly painful for him. At the time, we both drove Cadillacs. His ran beautifully, mine was a real lemon. Although my car was the size of a small tank, you had to step down to get into the back seat, making it difficult for us to settle D. J. safely and comfortably.

I was afraid he might succumb from shock, so I covered him with blankets. Finally, we got him settled and I prayed my car would start, because the ignition had been giving me trouble for months. Mercifully, the engine kicked over immediately, and I headed for Alpine, forty-two miles away.

D. J (opposite) and I in 1983, the year Hiram and Liz married.
Bill Wyman, a celebrated artist and art professor at UT, painted
our portraits.

Our first eighteen miles, all over unpaved, rutty ranch road were terribly rough going. D. J. was moaning in pain, but there was nothing I could do to help him. Our workers followed me to the highway, but I dared not let them go into town for fear they might be picked up and be deported as illegal aliens.

Getting D. J. to town was an awful experience for both of us. He was in shock and losing blood. Even today, thinking about that time, I can still hear his moans.

By the time I reached the hospital, it was barely two o'clock in the early morning when I ran into the emergency room, spattered with D. J.'s blood. My hair was a mess and I am certain I looked horrible.

Once in the ER, an ancient battle-axe of a nurse, the type often assigned to night duty in small towns, took one look at me, stuck both hands on her hips, and she barked, "What do *you* want?"

"Dr. Sibley is out in the car and he needs attention. Would you. . . ."

"Dr. Sibley? Huh! I have never heard of him."

"You will call Dr. Ponton *at once!*" I was almost shrieking. Possibly because I ignored her rudeness, that nurse was inspired to do as I demanded.

Within a few minutes, Dr. Ponton came rushing into the emergency room. Since there was nothing more I could do at the hospital, I went to the Ponton's home for the rest of the night.

Early the next morning, I called the Cadillac dealership in Austin. "Please have someone drive Dr. Sibley's El Dorado out to Alpine today, since I know it will start. I have had constant trouble with my car. I brought it into your shop several times, but you have not ever fixed it. If it had not started last night, my husband could have bled to death. I never want to see that car again."

Dr. Ponton told me D. J. had a concussion, and his left arm and left leg were broken, but he was going to live. D. J. always lived. Two days later, when he was able to travel, we hired a plane to fly him from Alpine back to Austin. They had converted the airplane cabin so it could accommodate D. J.'s stretcher.

Jake flew as co-pilot on that trip, while I stayed at the ranch to close up the house. On my way to the ranch, Jake's deaf dog was riding with me in D. J.'s Cadillac. I had the windows down and was enjoying the mountain air when that dog spotted a jackrabbit and jumped out of the window, chasing that rabbit up Burnt House Canyon.

I stopped the car and chased after the dog, since yelling at a deaf dog was useless. Finally, the jackrabbit stopped. So did the dog, and I was able to catch him.

About the time I was having my unplanned exercise chasing Jake's dog, D. J.'s plane had made its final turn into the Austin airport. At that precise moment, one leg of D. J.'s litter collapsed because someone forgot to lock it, and he rolled onto the plane floor. It is a miracle he survived his second fall in three days. Even medicated as he was, his pain must have been severe.

I had called Gaines Kincaid, a friend who had grown up in Fort Stockton, and asked him to go to the hospital in Austin to meet D. J. Gaines was waiting patiently at the admitting desk, but the ambulance bringing D. J. in had run out of gasoline on Twelfth Street, a few blocks from the hospital on that steamy summer day.

If this had been a movie, it would have been a slap-stick comedy, but

in real life, it was not funny at all. Eventually, once D. J. reached the admissions desk, despite all that had happened to him, he was reasonably alert.

He was in good spirits, too.

When the admitting clerk asked him, "What is your religion?

D. J. brightly replied, "I don't believe in God, I'm an Episcopalian."

That answer did not faze her at all and she continued. "Are there any visitors you don't want in your room?"

"Yes. Dr. John Silber." Dr. Silber was dean of the college of arts and sciences at the University of Texas, and an outspoken liberal. D. J. could not stand him and was eager for Frank Erwin and the board of regents to fire him, which they did a few years later. Actually, D. J. had never met Silber, and he meant to keep it that way.

Maybe D. J. was being funny, but he meant every word. He would rather have seen the devil himself than John Silber.

The One Time He Used Spurs

You might think that falling six feet to a tile floor in his sleep would be D. J.'s most painful experience at the ranch, but worse was coming just over the horizon.

I liked to ride my horse in the morning, but D. J. preferred sleeping late, so we usually rode together in the afternoon. The trouble with late afternoon rides is that once dusk begins, your options for recovery become fewer if you run into a problem.

I had a wonderful horse named "Pecoso," which in Spanish means "freckled," and his rear end lived up to his name. He was a special breed that the Appaloosa Indians in Oregon had developed. Pecoso was the easiest horse I have ever ridden. I could move the reins with my little finger and he would respond as if I was using power steering. Sometimes, I almost felt he was reading my mind. That horse treated me so royally that I felt spoiled whenever I rode him.

D. J. was on "Alisan Grande" or Big Red. He was just a big old cow horse, but D. J. liked him. D. J. was wearing spurs that day, which he never did. Those spurs had been hanging unused in the closet for years, but for some reason, D. J. put them on that afternoon.

We went down to the corral, saddled our horses, and were riding

D. J., riding "Oro" and me, riding "Pecoso," at our Glass Mountain Ranch, late afternoon

along the south fence line when we came to a small arroyo, which is really only a melodious-sounding Spanish name for a ditch. After my horse glided gracefully across to the other side, his act infuriated Alisan Grande. D. J.'s horse could not stand for another animal to get ahead of him. That is typical of horses. They always want to be in the lead or at least to be neck and neck with the leader.

D. J., who got his army commission in the cavalry, dug his heels in his horse's flank, which you do in the cavalry when you want your horse to jump. You do not do that when you are wearing spurs and riding a cow horse. Inexplicably, at that critical moment, D. J. had reverted to his cavalry ways.

Alisan Grande responded instantly to feeling those spurs. He leapt right over the arroyo, and tossed D. J. out of the saddle into the middle of some prickly pear cactus. Then his horse panicked and ran away.

Those cactus pads were covered with spines as sharp and nearly as long as needles. D. J. was sitting there rocking back and forth in the unforgiving arms of the cactus.

"I broke my clavicle, Jane." He kept a tight grip on his lower arm.

The doctor in him had made an instant and accurate diagnosis: he *had* broken his collar bone. That was the first comment he made, ignoring the excruciating pain he was feeling from the hundreds of cactus spines stuck in his back.

D. J. made it all the way through World War II virtually unscathed. His worst injury was skinning his finger when he fell down the ladder on a ship. Landing in that cactus patch, after D. J. was bucked off his horse that day more than made up for his benign war record.

We were several miles from the corral and by then, it was growing dark. I knew I had to get him back to safety, but first I had to catch D. J.'s horse. No way could I leave Big Red out there with night coming on. Horses always sense when something bad has happened and Pecoso was acting skittish.

After talking to my horse, gently and carefully, he finally calmed down. As I dismounted, I held onto my reins and walked slowly toward D. J.'s frightened horse. Big Red was standing quiet, a few yards away.

"Good horse. You old son of a bitch. Good horse." Calmly, I repeated again and again the words Big Red had heard so often. Heeding my soft-spoken words, Big Red remained calm.

Eventually, I eased Pecoso closer to D. J.'s horse, then reached down and picked up his reins. As I walked them back to D. J., leading both horses, I realized all my years of riding had paid off that afternoon. After tying the horses to a little shrub, I moved toward D. J.

And that was when I realized I would have to lift him off the ground so I could hoist him onto Pecoso behind my saddle. He could not help me because of his injured shoulder.

I remembered reading a newspaper article about a mother who had lifted a car to save her child who was pinned beneath it. I never quite believed the story. Except now, I saw that I was in a similar predicament. I weighed 95 pounds, D.J. maybe 160.

Thank goodness he was not a 200-pounder. I have no idea how I managed — it must have been an extra jolt of adrenalin — but I got him up and pushed him behind the saddle of my horse. Sometimes, we find the strength we must have to do the impossible, if only for a moment. Well, that was *my* moment. I got up on my saddle and held tightly to D. J., who was lying behind me on his belly with cactus spines sticking out all over his back.

Holding on to Big Red's reins, I guided Pecoso slowly back to our corral. Once there, I had to get D. J. off my horse without help, because the corral was too far from The Castle for any of our workers to see or hear us.

Standing on the ground, D. J. managed to hobble over to the car, where I eased him into the back seat on his stomach. Quickly, I unsaddled the horses, gave them some oats, and got into the car. Away I drove up the hill to The Castle, honking the horn all the way.

Arturo heard me, dashed out of the kitchen and stood there waiting for us with his hands covered in flour because he had been making tortillas. After I turned D. J. over to Arturo, he worked all night picking cactus spines out of D. J.'s back.

I was so exhausted from getting D. J. safely back home that I poured myself a tall Scotch and fell into bed. I knew his injury was not life-threatening, so the most important thing we could do right then was to remove all the cactus spines to ease that pain.

Bruce Pearson called the next morning to tell me he had a friend with an Indian belt he wanted us to see.

"I am sorry, Bruce. We will be coming to town today, but we will not be looking at any Indian belts." I went on to tell Bruce about our adventure from the previous day. Fortunately, he managed not to laugh. Not even once.

After we got D. J. into the car the next morning, I drove him over that bumpy ranch road back to town once again. There was little we could do to ease the throbbing of his broken collarbone, and those terrible potholes certainly did not help. Fortunately, his worst pain had come from those cactus spines and, thanks to Arturo' assistance, they had all been removed during the night.

D. J. never wore spurs again.

Cousin Maude's Funeral Almost Killed Him

One day, we were at the ranch entertaining guests, when we received news that Cousin Maude, D. J.'s mother's old maid cousin, had died in Austin. Maude had little family of her own, so D. J. felt obligated to attend her funeral.

I said, "D. J., she's dead."

He was adamant. "I feel like I should go, since mother is not able to be there."

After I drove him to Fort Stockton, a local pilot flew him on to Austin. D. J. rented an Oldsmobile at the Austin airport, went to the funeral, and performed his filial duty. After the service, he headed straight to the airport to fly back to the ranch.

As he drove down Fifteenth Street, past the old Brackenridge Hospital where he had not wanted Dr. John Silber to visit him, a car ran a stop sign, broadsided D. J., and pinned his car against a concrete pillar supporting the I-35 freeway.

While that accident cost D. J. his spleen, and he suffered major internal bleeding, on the positive side our family doctor's office was in the Medical Tower right next to the hospital. While trapped in his rental car after the accident, D. J. knew he was badly injured, but he was alert enough to say, "Call Dr. Runge."

About the time D. J. should have been landing in Fort Stockton, I

D. J. and I always invited mariachis when we entertained.

got a call from our friend, Dr. Tom Runge in Austin. He was also a distant cousin who loved coming out to Big Bend.

"Jane, this is Tom Runge."

"Are you in Fort Stockton? Come on out."

"I'm afraid I can't. D. J. has been in a bad accident here in Austin, and I just saw him in the hospital. We are examining him right now. But don't worry, he's going to live."

I knew Tom's statement really meant that my husband was damn near dead. Whenever a doctor says, "Don't worry, he's going to live," the patient is in big trouble.

Jake's girlfriend, Mary Ann De Barbarie, was at our house in Austin trying to write a term paper. She very graciously manned the telephones as everybody began calling to find out about D. J.'s condition.

Jake and Mahala were also in Austin and they hurried to the hospital to sign the release papers authorizing the doctors to perform D. J.'s emergency surgery. Besides his other injuries, D. J. also had suffered punctured lungs, broken ribs, and a broken leg.

As his doctor had promised me, D. J. did survive. He managed to survive disasters that would have killed lesser mortals. And he never complained. No matter how serious his injury or how intense his pain, D. J. kept it to himself.

I believe he had seen so many terrible things in World War II that he felt his problems paled in comparison. He also had excellent physicians, good hospitals, and a wife to take care of him. I often think I should have studied to be a nurse, I did so much nursing.

Halos Aren't Just for Angels

Following our trip to New Guinea in 1990, once we were at home, I began to notice that D. J. seemed to be feeling a lot of pain, but he would not talk to me about it. He would be walking along when without warning, he would suddenly collapse, which was terribly disturbing for me to witness. I tried and tried to get him to see a doctor, but he refused.

He said, "It's just my hip."

He was self-diagnosing, usually a big mistake, but all too common among physicians.

After I talked to one of my doctor friends and described the situation,

Dr. Lancaster told me, "Jane, to me, his symptoms sound neurological. D. J. must be seen by a specialist."

"I can't get D. J. to go to any doctor."

"Let me talk to him. Maybe I'll have better luck."

Somehow, Dr. Lancaster managed to convince D. J. to have his condition checked. In that single conversation, he succeeded where I had been failing for months. When I saw the results of the MRI done on D. J.'s spine, I almost collapsed myself.

The MRI revealed that D. J. was experiencing a sublimation of the second vertebra in his neck that was pushing against his spinal cord. The spinal cord in his neck, which should have been the width of a little finger, had instead narrowed to the width of a shoestring. That single vertebra was pinching and squeezing D. J.'s spinal cord. His doctors had to operate immediately to relieve that pressure. No wonder he had been falling over. It was amazing that he could walk.

The operation went beautifully and his X-rays showed that the doctor had wired the vertebra back where it belonged. After they moved D. J. to a rehab hospital, he made a silly mistake. When he reached to make a phone call, he tore loose all the wiring in his neck. A hospital attendant had forgotten to place a cervical collar around D. J.'s neck. I thought his neurosurgeon was going to die, since D. J.'s bones were already old and crumbly.

We had to rush him by ambulance from rehab and put him back into Brackenridge Hospital. The doctors there turned D. J. upside down so they could install a halo to immobilize his head. That halo was nothing like the ones in paintings that surround the heads of Jesus and Mary.

Nevertheless, D. J.'s halo had a miraculous effect. That contraption looked like a small stool. The doctors screwed its four steel rods right into D. J.'s skull to keep his neck from moving. The halo was terribly confining for an active man like D. J., but it worked.

For six long weeks, that device was attached to D. J., first while he was back in rehab, then after he was sent home. All that time the medieval-looking frame protected him while D. J.'s spine operation was healing completely. He was wearing that halo when we heard the devastating news of Jake's death.

No matter what difficulties D. J. ever faced, he always retained his dignity and his striking strength of character. Whatever D. J. believed

about God, his actions always showed his love and respect for other people, whether they were heads of state or impoverished Mexican laborers who had walked hundreds of miles to find work on our ranch.

He was a caring physician who worked long hours and who made house calls in the middle of the night. In his practice, there never seemed to be enough hours in his day. He was empathetic with his patients, no matter their financial status. He not only swore to the Hippocratic Oath, he lived it.

Few people ever knew that D. J.'s empathy also extended to other of God's creatures. D. J. did not hunt animals, an astonishing admission from a West Texas man who grew up around guns and who was such a keen marksman. One time, I thought he was going to throw a guest off our ranch—a man who had taken it upon himself to try to clear the rabbits from around The Castle. When D. J. came in, the guest told him proudly, "I took care of a bunch of those rabbits."

D. J. was silent for the longest time—talk about pregnant pauses—but finally he said, "I don't want you to shoot my rabbits."

Except for Dr. Silber, who he never met, D. J. got along well with everyone, even those from a wide range of political viewpoints he did not happen to share. Truly, our personal political leanings were conservative, but we were always bipartisan in our friendships. We loved Lady Bird Johnson, and treasured her friendship.

At the same time, D. J. and George W. Bush had a wonderful relationship. In the late nineties, Governor Bush came to our home for a fund-raiser in support of another of Ronnie Earle's unsuccessful Republican opponents for Travis County district attorney. The governor and D. J. had never spent a lot of time together, but they were certainly *simpatico.*

President Bush wanted D. J. to come to his 2004 inauguration, and sent him a personal invitation. D. J. was thrilled, but his trustee would not let us go, saying D. J. was too old. I already had our plane reservations and hotel room in Washington all lined up, but my husband could not attend the presidential inauguration of his friend after his trustee in Midland said "No."

In the early sixties, D. J. had placed all our assets in a trust, because he did not want to be burdened with managing his own financial affairs. I understand why he did it, since keeping records takes up so much

344

time. D. J. had no interest in writing checks and spending time worrying about money. He wanted to do his research, travel, think, and spend his time on all the things he loved. To relieve himself of those fiscal responsibilities, he contracted with a trustee to handle his finances.

However, you can sometimes pay a hefty price when someone else controls your affairs: that person has enormous power over your financial decisions. As D. J.'s health declined in his mid-eighties, having to abide by the trustee caused our whole family some frustrating legal, financial, and emotional problems.

The Bush inauguration story is merely one small example. That is all I care to say in print. However, there is more I could say on this subject—a whole lot more.

In his late eighties, D. J. became increasingly forgetful, slightly paranoid, and began making uncharacteristic statements. "You didn't tell me we were supposed to go to this party," he might say, although the event had been scheduled on his calendar for weeks. We began to paste notes about what was coming up that day on the window next to where he read his paper.

If it was time for us to go to a dinner or to a party and he refused to get ready, I would tell him "We are obligated to attend. I'll go and you stay here."

Then he would say, "No, I'll go." Once he arrived at the party, D. J. always had a better time than anyone. People always stopped and visited with him.

We continued to go to the symphony up until the last two or three years of his life. He could hear the music just fine, and thoroughly enjoyed it. He did not care to listen to music on the radio or from recordings, but enjoyed hearing our orchestra play.

Most evenings, we would have dinner in front of the television. I would sit beside D. J. and, after dinner, hold his hand and watch *Animal World*, his favorite program. I have not watched that show since D. J. died, but I can tell you about the hundreds of exotic animals we saw together.

On his death certificate, it states that D. J. had Alzheimer's, but I disagree with that. He always knew me and Raul and never displayed any of the rages so typical of Alzheimer's. Even though he was fretful, we could always work with D. J. and calm him. In his mother's last

years, she experienced what D. J. had diagnosed as a series of small strokes. I think he suffered from the same problem. I am glad he was able to stay at home where he wanted to be. I promised him he would die in his own bed. He did.

D. J. had a marvelous physique and good color. He was husky, fit, and did not lose much strength in his muscles until he was well into his eighties. On the day he died at ninety-one, he did not look at all like a sick person. Following D. J.'s death, I received a thoughtful, hand-written note from President Bush.

We held D. J.'s memorial service on August 13, 2005, at St. Stephen's, the church D. J. founded in Fort Stockton. Even though I was afraid the weather would be terribly hot, that weekend was the only one when most of our grandchildren could be present. To our surprise, it rained the week before the service and the land was a verdant green, which rarely happens in August out in our West Texas.

All five granddaughters were there, but Hiram's son, Chris, had just started football practice at his new school, St. Stephen's in Austin. He felt enormous pressure to stay in Austin to participate in the "two-a-day" drills. We let Chris make that decision, but he really did not have much of a choice. He was a junior, had just entered the school, and did not want to disappoint his coaches and get off to a bad start. We knew that D. J. would have wanted him to stay with his team and, albeit reluctantly, Chris remained on campus.

D. J.'s memorial was not what anyone would call a "traditional" service. I brought his beloved dog, Priscilla, and Shiloh had her dog, Killer, with us in the church. Thank goodness we had an understanding priest, Elaine Ponton. Like Father Sara, she had studied for the priesthood in her later years. After her husband died, she moved to Study Butte, from where she serves a number of churches in the area.

Several of our granddaughters had not been to a funeral mass and, when it came time for communion, I reached out and took Shiloh's hand and drew her up to the rail. The other girls followed her lead. Killer sat quietly, right there between us.

Shiloh could not leave him in the car because he chews upholstery and can do a thousand dollars' worth of damage in fifteen minutes. After Shiloh tucked him between her knees as we knelt, Killer held his head up and looked around with a bewildered expression.

We had two dogs in church that day, and I half expected Elaine to perform a blessing of the animals. One friend told me that having the dogs there was inappropriate, but I disagreed. D. J. had grown up with animals nearby and he departed the same way, with Priscilla still there, close to his side.

In our family cemetery, we do not have traditional headstones. We do things differently. Jake has a tinaja and a bronze plaque in the cavity with his name and dates. Mahala has a maguey (century plant) made of copper by Gary Thompson. D. J. will have a bronze shaman created by artist Bill Worrell, suspended over a hitching stone from the parade ground of Old Fort Stockton.* As for me, I plan to have a buzzard. Hiram will have to choose his own marker. I am not going to worry about it, as I expect Hiram to live to be at least ninety-one, just like his father did.

A great support during D. J.'s long illness was Raul P. Moreno. He took excellent care of D. J. We have always had good help, because we always treat our people with respect. Arturo worked for us for twenty-five years, until he retired. When his wife, Coco, became ill, I helped her deal with the morass of the medical bureaucracy. After she died in 2006, I took care of Coco's funeral details with some assistance from the Mexican consul.

George Slaughter, another fine man, worked for us for twenty years. George attended the "Gathering of Friends" we held in D. J.'s honor after his death. That event took place at our home in Austin, complete with mariachis and many dear friends, including Lady Bird Johnson.

* A hitching stone is a large piece of limestone with an embedded metal ring. Hitching stones were used during the nineteenth century for tying up horses.

25

⃰

The Joys of Unsolicited Advice

NOW THAT I am eighty-eight, I feel I have earned the right to offer some advice to my six grandchildren as well as to anyone else who might be interested. In this chapter, I mean to answer this question: *What are the ingredients of a meaningful, productive, and happy life?* I believe everyone can sum up that answer with these twelve words: good genes, good health, good values, a good spouse — and good luck.

None of us has any choice about our genetic makeup. Our job is to make the most of the genes we inherit.

Our choices about diet, exercise, and attitude have an enormous impact on our health and our vitality as well as on our longevity.

Our fundamental values are the foundation that sustains us through the inevitable ups and downs of life.

Choosing a spouse may be the most important decision of our life. Too often people base that choice on personal chemistry, instead of relying on a more patient assessment of his or her character, without ever ignoring your mutual compatibility.

Most often, you will discover that "luck" is like a surprise package, just waiting for everyone prepared to open it.

Health

I was the wife of a small town doctor for twelve years, so I have considerable respect for the medical profession. Doctors and nurses do a wonderful job of treating us when things go wrong, but it is not their

Holding the honorary doctorate presented to me by St. Edwards University, 1983

responsibility to keep us well. That is our job. It is up to us to eat right, to stay fit, all accomplished so we can reduce our odds of becoming patients.

Preventive care has everything to do with how we treat our bodies: the quality and amount of food we eat, the water we drink, and how much sleep we get. Wellness includes regular exercise, laughter, limiting stress, and making wise choices about alcohol, tobacco, drugs, and your driving habits. *We may not be able to control that wide, wide world, but we can control much of our own personal world.*

Because of my parents, I have always been health conscious. Mama was a good cook and that made a great difference to me in later life. Our family always ate healthy meals, and home was where I first learned my good eating habits. When I was growing up, the term "junk food" did not exist. If McDonald's had been around back then, my father would not have let me near it. He had very strong feelings about what we ate, sometimes going more than a little bit overboard.

For instance, we never ate sandwiches in our home. To my father, that meant you were eating left-over food. I never even tasted a peanut butter and jelly sandwich until I was in high school. When I finally tried one at a friend's house, I thought it was wonderful, but we never had one at home.

After D. J. contracted hepatitis during the war, we had to be very cautious with his diet. I cooked low-fat meals for us long before they were "in." Instead of frying meat or fish, I broiled meat and we always ate lots of salads. There were no chicken fried steaks served at our house. While I realize full well that is almost a criminal offense in Texas, the worse crime is letting fried foods clog your arteries, leading you toward an inevitable heart attack or stroke.

When D. J. was actively practicing medicine and working so many long hours, dinner was our main meal, when it gave us our best chance to be together. Even so, I had to be flexible if I wanted to eat a meal with my husband. Usually, that meant feeding our children long before their father arrived home. When, finally, D. J. walked in the door—and I never knew for sure exactly when that might be—we would then sit down to share a relaxing dinner. It was always good to see each other and to catch up on our day. During his years as a general practitioner, no matter what was going on in our lives, we continued that custom, one of the true joys of our marriage.

After D. J. retired from practicing medicine in 1962, we were able at last to sustain a more regular routine. We ate dinner around six thirty or seven when we were at home. At the ranch, we ate later, because we were so close to the western edge of our time zone that the sun rarely set before 8:30 or 9 o'clock during the late spring and summer.

Some people have asked me to tell them the "secret" of how I have always stayed slim. They often act as if I have some magic formula locked away. My so-called "secret" is a common metal object that rests on my bathroom floor. I call it "a scale" and I step on it every day. If I notice I have gained weight, then I cut back on what I eat for a few days. If I fail to keep track almost every day, some added pounds will sneak right up on me.

One thing that has motivated me to keep my weight stable is my considerable investment in beautiful clothes. I want to keep enjoying the ones I love. I can only continue to wear them if I can fit into them.

D. J. felt the same. He was still wearing jackets he had bought back in the fifties. And I have dresses more than thirty years old that still draw compliments. That is why investing in high quality clothes is so wise. I have always spent most of my clothes budget on "keepers."

Nancy Reagan and I share several traits: we both married strong, handsome men, we love fashion, we are careful about what we eat, and we agree on politics.

Values

Now, I am going to begin speaking specifically to my beloved grandchildren:

Each of you has an inner strength that will never leave you. Shakespeare said it best in *Hamlet:* "To thine own self be true." That means your individuality is your greatest gift. Never trade it for temporary popularity or to follow some fad of the day.

Distinguish yourself in your own way, wasting no time by being envious of other people's talents or achievements.

Always rely on your intuition. Listen to it and you will not be swayed by what others say or do.

Ignore false words and malicious actions. In the long run, they do not matter.

A positive outlook, day by day, keeps you on an even keel. No one can make you feel bad about yourself; only you have that power.

Three of the finest words in the English language are "please" and "thank you."

Whenever you can give someone a sincere compliment, do so.

Jealousy is poison to the spirit, whether it erupts during family feuds or between disgruntled nations.

Heed Winston Churchill's advice on perseverance: "Never, never, never, never give up."

If you have good fortune, give back to your community.

Inevitably, you will encounter disappointments and hard knocks, but why waste time worrying about them in advance? You will need all your strength to handle unexpected bumps in the road when they occur, and they will.

I have experienced my own share of bumps along the way. They may

have slowed me down temporarily, but I never let them stop me. I simply kept going, working toward worthwhile goals, doing what needed doing. I have never been a person who looked back with regret. I always keep my eyes and my will focused on tomorrow. I have been given some great opportunities and have always done my best to give some back. And may I add, I have had a lot of fun in the process.

Religion

Religion has always played a part in my life. My father was an elder in the church, and I sang in the choir and played the organ. We went to church every Sunday. In a small Texas town in the thirties, there was not much else to do. I can still see those funeral home fans with their pictures of Jesus on their backs, swishing back and forth in church on a steamy Sunday morning. Although we were a religious family, I never felt overwhelmed by religion. The Baptists and Methodists had prayer meetings on Wednesday nights, but we were Presbyterian and escaped them.

I do not believe in long eulogies at funerals. It has almost become a form of entertainment, with humorous stories and videos. That may be nice if you are in the audience and do not know the dead person. Instead, I believe that praising people after they are gone is too late. The time to praise your friends and family is when they are alive.

After some people read D. J.'s obituary in the paper, many of them said that they wished they had known about all his wonderful accomplishments before he died.

For myself, I want a formal Episcopal ceremony without long stories, humorous anecdotes, or slide shows displaying my life. For my final words, I prefer that my survivors hue to the burial service in our Book of Common Prayer.

Family

There is no greater gift than a loving family. My parents got along well and gave me a good stable foundation. Few of my old friends came from divorced homes. I am sure there were dysfunctional families in Fort Stockton, but we did not spend time with them. Growing up, I never experienced the ugly side of life that so many children are exposed

to today. Radio and movies were not filled with graphic sex and non-stop cursing. In 1939, when the movie industry allowed Clark Gable to tell Vivien Leigh, "Frankly, my dear, I don't give a damn," it created a sensation. There was a sense of safety and protection for children in our little town, and my friends and I grew up slowly. That is why they called it "childhood."

I believe strength of character must be a family trait. My father quit his position as vice-president and manager of the bank in Fort Stockton when, against his advice, the directors were drawing too much money. His motto was *Just do what's right.* The people I admire most are those who stand up for what they believe and who stay true to their principles.

We never know how our behavior will affect others. My mother always told me, "Jane, you must behave well because other people are watching you." Then she would name several of my friends and state to my horror, "Their mothers are having them look to you."

One friend's mother told Mama, "I am having Totsie watch Jane." I had to be good since Totsie was watching. My mother knew what she was doing by holding me to high standards. After all, I could not let Totsie down—or myself.

Today, our behavior is always being monitored. With hidden cameras everywhere, cell phones that record videos, and You Tube reaching every computer in the world, we never know who is watching us. Today, we must forever act as if we will be seen by a hundred million people on the Internet. We just might be.

Friends

I am lucky to have a potpourri of friends: family, Fort Stockton friends, college friends, ranchers, cowboys and oil men, symphony friends, Austin neighbors, friends from the worlds of art, fashion, and academia, physicians and researchers, politicians, and the people D. J. and I met on our travels.

I value my friends greatly and feel blessed to know so many interesting people in my life, but few of them ever came knocking on my door. Meeting and keeping friends is not a passive endeavor. It is a choice. Sometimes a friendship just happens, blossoming by surprise. However, you must be open to those opportunities.

Visiting my first cousin and only living relative, Dr. Horton Dunn, a scientist, in Cleveland

Friendships have been one of the great joys of my life. It is fun to bring people together, much like weaving a web. The more people you know, the wider your web will become. Today's webs are more likely to be electronic and their span global, but their basic concept is the same.

When my granddaughter Elizabeth went to China and was perched on the border of Tibet, she was able to call her mother back in distant Alpine, Texas. She was amazed to find that Chinese phone booths had cell phones in them. In Austin, I am afraid that cell phone would last about ten seconds before meeting an unanticipated new owner.

One of the gifts of knowing lots of people is the ability you gain to help others. I seldom say "no" when people ask me for a favor. I always try to accommodate them in some useful way. If I am unable to help them myself, I do my best to think of someone who can. There is no greater feeling than helping another person without expecting anything in return. It is even better if you keep your good deed to yourself. That is what I call committing a kindness and not getting caught at it.

Spouse

Selecting a spouse may be the most important choice of your life. If you choose wisely, you will be among the minority who avoid the pain of divorce and spend their married life happily with one person. In America, unlike some other cultures, women get to choose their husbands for themselves. I had a wonderful time dating in college, and met many young men who were handsome, charming, and intelligent. I am sure many of them made good husbands, but I never met anyone I considered marrying until I got to know D. J.

Marrying D. J. was the best choice I ever made. We dated for four years, which gave us time to get to know each other during a period when we both faced some difficult personal challenges. He was in the army hospital, Fitzsimmons, for six months, then home six months. At that time, he was too weak to court me in the traditional manner. Instead, we spent quiet evenings talking about everything under the sun, and we were never bored. That is when I knew I could spend my life with him.

Our love grew gradually, based not only on physical attraction, but on compatibility, common interests, and character. Thank goodness I did not just "fall" for D. J. Instead, I grew to know, respect, and only then to love him. I was fascinated by his mind and enjoyed our common interests. I had found a man of substance, depth, and determination. So I not only fell in love, I chose a man whose character I knew would stand the test of time.

In choosing your lifetime companion, you must use your head as well as your heart. Think carefully, take your time, and make sure your values and temperaments match. This is a person with whom you may share twenty thousand days. I was married to D. J. for fifty-five years and together we shared adventures, joys, and challenges that we could never have imagined when we took our vows in March 1950.

Luck

D. J. always said, "Luck falls on fertile ground." That means you have to be prepared for good luck. If you stumble upon a great opportunity and are not ready for it, or do not follow up on it, your ground is not

fertile enough, then you have wasted even the best of luck. Too many people miss opportunities that are staring them right in the face. Others, without realizing it, seem to attract luck like a magnet.

Let me close by describing a piece of my own pure luck. In 1952, we purchased a ranch in Culberson County in the Delaware Mountains, forty miles north of Van Horn, between El Paso and Fort Stockton. It is a large ranch and quite beautiful when it rains. El Capitan, the highest mountain in Texas, is only fifteen miles north.

From our ranch house we looked through a gap between two mountains across the Salt Flats to the Diablo Mountains where a large piece of the caprock had broken away. It was named for the famous Indian chief, Victorio, and stood as sentinel over the escape route he took in eluding capture by the US army. As I gazed through that gap, I began calling it "Jane's Window."

Years later, the United States Geological Survey was refining the mapping of that area, which they had first surveyed many years before. While they were working nearby, they asked the man who leased our property to name some of the local features. Pointing to the gap in the mountains, he said, "Well, that's 'Jane's Window.'"

The surveyors placed that name on the US Geological Survey map. You are supposed to be dead ten years before you get your name on a map, so I am pleased to say that I did not make the cut in the most usual fashion. I have been given some wonderful honors in my life, but few surpass being on an official government map as a mountain gap.

My Grandchildren

One of the great joys of my life are my six grandchildren—one boy and five girls—a numerical advantage that, coming from a long line of strong women, causes me to smile. Their parents must have done a lot of things right, as they all have good manners as well as good minds. There are fewer than five years between the oldest and the youngest, so they all have a lot in common and they do enjoy each other's company.

For Christmas 2006, I took Hiram, Liz, and all six grandchildren for a cruise week on the Queen Mary II, sailing the Caribbean. They could stay out late and have a great time, and we knew no one had to drive home.

"Pirates" aboard the Queen Mary II! Left to right: Chris, Liz, Hiram, Kiowa, Sarah, Elizabeth (above), Shiloh (below), me, and Rachel.

I will keep their biographies short as they are all in school, deciding on majors, and exploring options. By the time this book is printed some of them may have chosen entirely different directions.

Shiloh Jane Sibley-Cutforth,
Mahala and Roger's elder,
was born November 24,
1985, in Austin. She is a
student at Austin Commu-
nity College, planning to
study photography.

Rachel Anne Sibley,
Hiram and Liz's elder, was
born January 27, 1986,
in Alpine. She graduated
summa cum laude with a
bachelor of arts from the
University of Texas at
Austin, Plan II Honors.

Kiowa Sehoy Sibley-Cutforth, Mahala and Roger's younger, was born December 20, 1986, in Austin. She graduated from Texas Tech University with a degree in architecture and began attending graduate school, with a full scholarship, at Rice University in Houston in fall 2011.

Sarah Elaine Sibley, Jake and Jan's elder, was born December 23, 1987, in Alpine. She graduated with a degree in international business from the University of Texas at Austin in May 2011.

Here I am with my only grandson!
Christopher Michael Sibley, Hiram and Liz's younger, was born September 16, 1988, in Alpine. He graduated from St. Stephen's School in Austin, and attends Pitzer College, one of the prestigious Claremont Colleges in Claremont, California.

Elizabeth Victoria Sibley, Jake and Jan's younger, was born October 4, 1989, in Alpine. She graduated from Colorado Rocky Mountain School in Carbondale, Colorado, and is studying fine arts and anthropology at the University of Texas at Austin.

Chronology —
Jane Horton Dunn Sibley

1924	Born April 24 to Minnie Walker Dunn and A. Warren Dunn, Fort Stockton, Texas.
1941	Graduated from Fort Stockton High School.
1945	Awarded Bachelor of Fine Arts, University of Texas.
1948	Vigorously, but unsuccessfully, opposed destruction of the historic "Royal House" in Fort Stockton.
1950	Married Dr. D. J. Sibley, Jr. on March 1.
	Organized, with Dr. Sibley, the Fort Stockton Historical Society to save the Annie Riggs Hotel. A site later dedicated as the "Annie Riggs Memorial Museum," was awarded a Texas State Historical Medallion, and registered as a National Historic Site.
	Participated in the conversion of a large stone building, erected in 1912, into a medical clinic for her husband's practice. After Dr. Sibley's retirement, the building was donated to the city of Fort Stockton, and now serves as the Pecos County Mental Health Center.
	Participated, with Dr. Sibley, in organizing the Fort Davis Historical Society, which led to the Old Fort becoming a National Historic Monument.
	Dunn Jacobi (Jake) Sibley born October 24.
1950–51	Restored the Old Rollins home, built in 1906, turning it into a modern residence that became the D. J. Sibley family first home.
1952	Mahala Victoria Sibley born March 26.
1956	Painted a sixty-foot long mural for a local restaurant depicting scenes from Fort Stockton history.
1957	Hiram Andrew Sibley born January 1, first baby born that year in Pecos County.

1958 Donated land and helped move the small Episcopal church from Pecos, Texas to Fort Stockton, where it became St. Stephen's Episcopal Church after renovation. The building was later awarded a Texas State Historical Medallion.

1961 Purchased the Grey Mule Saloon, built in 1896, responsible for its renovation. It later received a Texas State Historical Medallion.

1962 Moved to Austin, Texas.

Invited to serve with Dr. Sibley on the International Hospitality Committee and to entertain guests of the State Department traveling in Texas.

1964 Fiesta Chairman of Laguna Gloria Art Museum, Austin.

1966 President of Laguna Gloria Art Museum Board of Directors.

1967 Member of the Austin Symphony Board of Directors.

1968–69 Contributor to the design of a hexagonal, glass and rock home — popularly known as "The Castle" — on the Sibley Glass Mountain Ranch.

1969 Founder, President, only member of the International Buzzard Society.

1970 Appointed to the Texas State Historical Commission for a six-year term by Governor Preston Smith.

1971 Cast the only vote against dissolving the Austin Symphony Orchestra; was asked to become President of the Symphony Board of Directors.

Article in *Austin People Today* entitled, "Sibley, She Orchestrates the Symphony."

Featured in two-page spread in December issue of *People Magazine* with Grace Jones and five fashionable customers of her Salado dress shop.

Worked with Rose Mary Jones to encourage the legislature to establish Seminole Canyon State Park to protect prehistoric rock art.

1976 Served as a Director on the original Board of the Paramount Theater for the Performing Arts.

Appointed to the University of Texas College of Fine Arts Advisory Council by Dr. Harry Ransom. Reappointed by five successive university presidents.

Along with Peggy Brown, worked with the Urban Renewal Agency of Austin to move, preserve, and renovate four pre-Civil War buildings in downtown Austin, creating Symphony Square, considered a model of urban restoration.

Spoke to students at the Graduate School of Environic Design, Department of Architecture, at Notre Dame University, emphasizing the importance of historic buildings in a modern city

Entertained the sisters of President Lopez-Portillo of Mexico, escorting them to an Austin Symphony concert, which led to an invitation for the Symphony to perform at the Bellas Artes in Mexico City and at Chapultepec Castle.

1980 Chosen as the only woman to serve with twenty-five business leaders in the Austin Area Research Organization.

1982 Along with Rose Mary Jones, planned Seminole Canyon State Park dedication ceremonies, featuring Chief Wendell Chino of the Mescalero Apaches and Texas Lt. Governor, Bill Hobby.

Entertained the Earl and Countess of Harwood with a luncheon to promote the English National Opera tour of the United States and its upcoming visit to Texas in 1984.

1983 Received honorary degree, Doctor of Fine Arts, *Honoris Causa*, from St. Edward's University, Austin.

Participated, along with her family, in the D. J. Sibley Family Centennial Faculty Fellowship in Prehistoric Arts, which holds scholarly seminars every three to five years in conjunction with the University of Texas at Austin.

Hosted the Youth Orchestra of China that was featured in an award-winning documentary, *From Mao to Mozart*.

Dr. and Mrs. Sibley toured the Republic of China as members of a State Department cultural delegation to observe cultural and educational activities.

1984 Member of the American Symphony Orchestra League Board of Directors. Served six years.

Featured in *Town and Country* magazine, August issue.

Dr. and Mrs. Sibley hosted the delegation from the Chinese People's Republic Association for Friendship with Foreign Countries and sponsored a performance of Peking Opera at the University of Texas

Dr. and Mrs. Sibley were guests of the Chinese government for three weeks in November, including a tour down the Yangtze River.

Austin Symphony Orchestra established the Jane Dunn Sibley Award for Outstanding Cultural Arts Leadership to be presented by the Austin Symphony Orchestra Society. First award presented to Jane Sibley at the Symphony Ball.

1986 Swam with Jean Ivey in the 50th anniversary celebration of the Fort Stockton Water Carnival.

Dr. and Mrs. Sibley donated ownership of the Parade Grounds of Historic Fort Stockton to promote restoration of the fort.

1990 Dr. and Mrs. Sibley were featured in *Town and Country* magazine, March issue, at their Castle in the Glass Mountains in the article, "Texas Desert Dwellers."

Featured in *Texas Monthly* magazine, April issue, in the article, "Texas Grande Dames."

Dr. and Mrs. Sibley photographed in front of their home on Windsor Road for the June issue of *National Geographic* for the article, "Deep in the Hearts of Texans: Austin."

1991 Participated in the D. J. Sibley Family Centennial Faculty Fellowship on Prehistoric Art. The seminar topic was "Kingship." Sponsored by the Department of Art and Art History, University of Texas.

Jake Sibley, oldest son, killed in traffic accident, near Alpine, TX.

1993 Jane Sibley, President of Austin Symphony, Jare Smith, President of Ballet Austin, and Jo Anne Christian, President of the Austin Lyric Opera, decided to explore the possibility of moving their organizations from Bass Hall at University of Texas by renovating and leasing Palmer Auditorium in Austin.

The University of Texas recognized Dr. and Mrs. Sibley with the Ima Hogg Award for carrying on the ideals of Miss Hogg in historical preservation, restoration, and love of the arts, especially music.

Participated in the D. J. Sibley Family Centennial Faculty Fellowship on Prehistoric Art. The seminar topic was "Cosmology and Natural Modeling Among Aboriginal American People."

1996 Rock Art Foundation gave Dr. and Mrs. Sibley the White Shaman Award for conservation of rock art.

After twenty-five years as President of the Austin Symphony Orchestra, appointed Chairman of the Board of the Austin Symphony in September.

1998 Became an Associate Member of the McDonald Observatory and Department of Astronomy Board of Visitors

1999 The "3 Js"—Jare Smith, Jo Anne Christian and Jane Sibley—received the President Emeritus Award for having the greatest impact on downtown Austin, owing to their efforts to restore Palmer Auditorium and convert it into a modern performing arts center.

Received Austin's Most Worthy Citizen Award for 1998 from the Austin Board of Realtors.

2000 Symphony Square officially renamed for Jane Dunn Sibley.

Participated in D. J. Sibley Family Centennial Faculty Fellowship on Prehistoric Art. The seminar topic was "The Representation of Altered States of Consciousness in the Art of Indigenous Americans."

2001 *Dream Drives,* nationally viewed TV program on the *Homes and Gardens Channel* did a segment on the Sibley home.

2002 Received Austin Community Keepsake Award from Meals On Wheels.

2003 Participated in the D. J. Sibley Family Centennial Faculty Fellowship on Prehistoric Art. The seminar topic was "The Art and Archeology of the Moche."

Mahala Victoria Sibley dies on October 24 from spontaneous hemorrhage of the brain stem.

2005 Voted into the Austin Arts Hall of Fame by the Austin Critic's Table Award Committee.

2007 Made an honorary Citizen of Mexico by the Mexican Consul

2008 Attended opening of Joe R. and Teresa Lozano Long Performing Arts Center, March 2.

2010 Attended Sibley Conference celebrating official opening of Casa Herrera in Antigua, Guatemala.

2011 Celebrated the hundredth anniversary of the Austin Symphony Orchestra, April 28.

Index

Entries in **bold** indicate photographs.

Adair, Red, 119
Aldrin, Buzz, 188
Alessandro, Victor, 159
Allred, Sammy, 278–80
Alpine (Texas), 131, 149, 197, 235, 237, 279, 288–89, 297, 314
American Symphony Orchestra League, 165–66
Amistad Dam and Lake, 219, 222
Anderson, Arthur, 244
Anderson, M. D., 110–11
Anderson Clayton Cotton Brokerage, 110
Annie Riggs Hotel (Annie Riggs Memorial Museum), 10–11; 98–**99, 100–101**; 259
Antigua (Guatemala), 231
Austin, Mary, 307
Austin Country Club, 215
Austin Heritage Society, 156, 172
Austin History Center, 272
Austin Lyric Opera, 268, 271, 281
Austin Symphony Orchestra, 152; administrative problems, 153–57; reorganization 158–61; renewed support among Jewish community, 161–62; Maurice Perez as conductor, 162; fundraising, 164; labor policy, 164; and Symphony Square, 182; performance in Mexico, 198–200; in presenting Chinese Youth Orchestra, 247; and University of Texas Performing Arts Center, 266; early performances, 267–68

Austin Urban Renewal Agency: see US Urban Renewal
Austin Women's Symphony League, 167, 177
Avery, James, 38–39

Baird (Texas), 244
Baker, Sheriff Charles, 41
Ballet Austin, 268, 271, 281
Ballet Folklórico de Mexico, 200
Balmorhea (Texas), 36–37
Barretta, Jack,
Barron, Elodia, 87, 102
Barnes, Michael, 274–75
Bass Concert Hall, see University of Texas Performing Arts Center
Bay, Peter and Sarah Jane, 169, 251
Bayou Bend (Houston), 191
Bays, Bob, 162–63
Bean, Judge Roy, 11, 98
Beard, Stan, 133–35
Beeman, June, 56–57
Beinecke, Bridgette, 231
Bell, Wayne, 179, 189, 275, 282
Bellingrath Gardens (Mobile), 72
Bentzin, Ben, 275–76, 282, 284
Berdahl, Dr. Robert, 272
Bergstrom Field, 30
Bernstein, Leonard, 161
Bertram (Texas), 43
Big Bend National Park, 148, 150, 235–36
Blood, Major General Gordon Fisk, 183, 186
Bloys Camp Meeting, 242

Endo, Akira, 169, 199, 292
Ennis (Texas), 236
Erwin, Frank, 181, 265, 272
Eudelia, 320

Fahey, Liz, 328–29
Fate Bell Shelter, 194
Fiesta (San Antonio), 307–10
Fisher Dachs, 283
Flawn, Peter, 199, 269
Forris, 137, 205
Fort Davis (Texas), 200, 241–42, 243
Fort Hood (Texas), 30
Fort Stockton (Texas), 10–12, 111–12;
 hosts Centennial Water Carnival, 24;
 pilot training school, 37–39; Cadet
 Club 38–39; Historical Society, 95,
 99–100; Garden Club, 167
Fort Worth (Texas), 46
Foster, Truman, 36–37
Fredericksburg (Texas), 36, 175

Garnett, Sara Kathryn, 107–**108**, 151,
 298, 313
Garwood, Ellen, 158
Garza, Jesus, 273
Georgetown (Texas), 67
Gilbert, Lennnis, 237
Glass Mountain Ranch, **150**
Glass Mountains, 65, 130, 131, 187
Goodall, Donald, 205
Godwin, Robert, 279
Graeber, David, 272
Gray Mule Saloon (Fort Stockton), 87,
 99–102
Green, Ben K., 59–60
Gregory Gymnasium (University of
 Texas), 267
Griffin, George and Margaret, **292**
Guarino, Michael, 272

Haas, Stan, 272, 283
Hall, Guy, **241**

Hall, Paul "Woody," 236–37
Hardeman House (Austin), 177–**180**
Harral, Caroline, 244–45
Harral, Gloster and Ruth, 244–46
Hat A Ranch, 244
Headliners Club (Austin), 198, 265,
 273
Heller, Andrew, 183
Henderson Ranch, 243
Highland Park (Texas), 55, 240
Hill, Dr. Malone, 243
Himmelblau, Betty, **160**
Hobby, Lieutenant Governor Bill,
 225–26
Hofbrau (Austin), 32
Hogg, Ima, 189–91, 275
Hogg Foundation, 191
Holland Hotel (Alpine), 235
Holtzman, Joan "Jo Jo," **160**
Houston Symphony, 191
Humanities Research Center (Austin),
 150
Humble Oil Co., 111, 115
Hunt, Judge Wilbur and Eugenia, 290
Hurok, Sol, 257
Hurricane Carla, 114, 118
Huston Tillotson College, 160
Huxley, Aldous, 202

Indian Petroglyphs, 193–94
Iraan (Texas), 83, 113
Ivey, Jean, 20, 24, 40, 72
Ivey, Mercer, 72, 239–40

Jaffe Holden & Associates, 283
Jane Dunn Sibley Award for Outstand-
 ing Cultural Arts Leadership, 171
Jane's Window, 356
Jeremiah Hamilton Building, 175–**176**
Jessen & Jessen, 272
Johnson, Lady Bird, 147–51, 202
Johnson, Ruben, 248
Jones, Albert, 189–90, 197